TIME TO TRAVEL – TRAVEL IN TIME

to Germany's finest stately homes, gardens,
castles, abbeys and Roman remains

TIME TO TRAVEL
TRAVEL IN TIME

*to Germany's finest stately homes,
gardens, castles, abbeys and Roman remains*

Official joint guide of the heritage administrations

Staatliche Schlösser und Gärten Baden-Württemberg
Bayerische Verwaltung der Staatlichen Schlösser, Gärten und Seen
Stiftung Preußische Schlösser und Gärten Berlin-Brandenburg
Verwaltung der Staatlichen Schlösser und Gärten Hessen
Museumslandschaft Hessen Kassel
Staatliche Schlösser und Gärten Mecklenburg-Vorpommern
Burgen, Schlösser, Altertümer Rheinland-Pfalz
Staatliche Schlösser, Burgen und Gärten Sachsen
Stiftung Dome und Schlösser in Sachsen-Anhalt
Kulturstiftung DessauWörlitz
Stiftung Thüringer Schlösser und Gärten

Front cover: Schloss Sanssouci with terraced vines, Photo: Hans Bach

With contributions by:

Baden-Württemberg: Anneliese Almasan, Hans-Christian von Wartenberg
Bavaria: Johannes Erichsen, Christoph Graf von Pfeil, Werner Helmberger, Peter Krückmann, Brigitte Langer, Uwe Gerd Schatz, Friederike Ulrichs, Katharina Heinemann, Sabine Heym
Berlin-Brandenburg: Stiftung Preußische Schlösser und Gärten Berlin-Brandenburg
Dessau-Wörlitz: Kulturstiftung Dessau-Wörlitz
Hesse: Staatliche Schlösser und Gärten Hessen, Museumslandschaft Hessen-Kassel
Mecklenburg-Western Pomerania: Friederike Drinkuth, Doreen Hennig, Heike Kramer, Carsten Neumann, Kristin Richter, Dorotheus Graf Rothkirch
Rhineland-Palatinate: Generaldirektion Kulturelles Erbe Rheinland-Pfalz, Direktion Burgen, Schlösser, Altertümer
Saxony: Staatliche Schlösser, Burgen und Gärten Sachsen, Bereich Marketing
Saxony-Anhalt: Monika Lustig, Jörg Peukert, Joachim Schymalla, Katrin Tille
Thuringia: Helmut-Eberhard Paulus, Bernd Löhmann, Susanne Rott, Michael Schmidt, Achim Todenhöfer

Translation:

Manjula Dias-Hargarter: Bavaria, Hesse, Mecklenburg-Western Pomerania, Saxony, Dessau-Wörlitz, Thuringia
Alison Thielecke: Baden-Württemberg
Katherine Vanovitch: Berlin-Brandenburg, Saxony-Anhalt, Rhineland-Palatinate, Welcome, Introduction

Bibliographic information published by the Deutsche Nationalbibliothek
The Deutsche Nationalbibliothek lists this publication
in the Deutsche Nationalbibliografie; detailed bibliographic
data are available in the Internet at http://dnb.d-nb.de.

5th edition 2010
© 2010 Verlag Schnell & Steiner GmbH, Leibnizstr. 13, D-93055 Regensburg
and the respective heritage administrations

Planning, preparation and coordination: Helmut-Eberhard Paulus, Kathrin Jung

Cover design: Anna Braungart, Tübingen
Image processing and layout: Florian Knörl, Erhardi Druck GmbH, Regensburg
Print: Erhardi Druck GmbH, Regensburg

ISBN 978-3-7954-2366-7

Further information about our publications can be found under:
www.schnell-und-steiner.de

Contents

Pictograms

 Disabled access

 Limited disabled access

 Restaurants

 Museum shop

 Car park

 Nearest rail station

 Nearest light rail station

 Nearest underground (subway) station

 Bus service

 Cable car/Chair lift

 Ferry service

 Museums run by others institutions on the heritage site

Welcome

The heritage administrations whose task is to manage the stately homes and gardens of various federal states in Germany have set up a working group to coordinate their activities at national level. This initiative has its roots in the period of German reunification, when the heritage administrations then in existence first came together to form a special interest group. Our objective today is to exchange information about our wide-ranging activities and experience in preserving, maintaining and presenting the valuable cultural and natural sites in our care, and to deepen our insights and convey them to the public in an accessible form. We hope this book, the fruit of our common labours, will be a stimulating and reliable companion for all our readers.

Did you know that Wilhelmine of Bayreuth was actually a Prussian princess, or that Queen Elisabeth of Prussia came from Bavaria, the land of palaces? Princess Augusta of Saxe-Weimar, for her part, became a German Empress. Look at the family trees of the old dynasties and you will see how they spread their roots and branches right across Germany, not to mention Europe.

The artists who fashioned the homes of those princes similarly crossed paths and inspired one another. Galli-Bibiena set his stamp on Bayreuth, but also on Dresden, whereas his pupil Gontard worked in Bayreuth and Potsdam. The Eyserbecks of Gotha worked in Anhalt-Dessau and created Potsdam's New Garden. Schinkel made his name in Berlin, but also on the Rhine. The list is potentially infinite. Moreover, all of them looked across the borders of their day to Italy, France and Britain, but also to India and China.

However, it is not the past alone which the heritage administrations have in common. Above all else, it is the unabating present-day relevance of the work they do to maintain and preserve their stately homes and gardens, their castles and abbeys, and above all the vital research they invest in this stewardship and in passing knowledge on to present and future generations.

And so we cordially invite you to travel into the past. Let yourself be enchanted by the castles and palaces of German emperors, kings and local overlords. Experience the unique fascination unfurled by the interplay of accomplished art and craftsmanship.

Follow with us in the footsteps of princes great and small and those they ruled. Learn about history on this entertaining journey.

Relax in our delightful historical gardens as you watch stunning displays of water and bask in the scent of blossoming orangeries and the magnificent colour of plants as they change with the seasons.

Make the most of myriad cultural events in settings that are sometimes grandiose, sometimes contemplative, amid these palaces and, gardens, castles, abbeys and other monuments that shape our landscape.

Germany's heritage administrations look forward to your visit.

Staatliche Schlösser und Gärten Baden-Württemberg
Bayerische Verwaltung der Staatlichen Schlösser, Gärten und Seen
Stiftung Preußische Schlösser und Gärten Berlin-Brandenburg
Verwaltung der Staatlichen Schlösser und Gärten Hessen
Museumslandschaft Hessen Kassel

Staatliche Schlösser und Gärten Mecklenburg-Vorpommern
Burgen, Schlösser, Altertümer Rheinland-Pfalz
Staatliche Schlösser, Burgen und Gärten Sachsen
Stiftung Dome und Schlösser in Sachsen-Anhalt
Kulturstiftung DessauWörlitz
Stiftung Thüringer Schlösser und Gärten

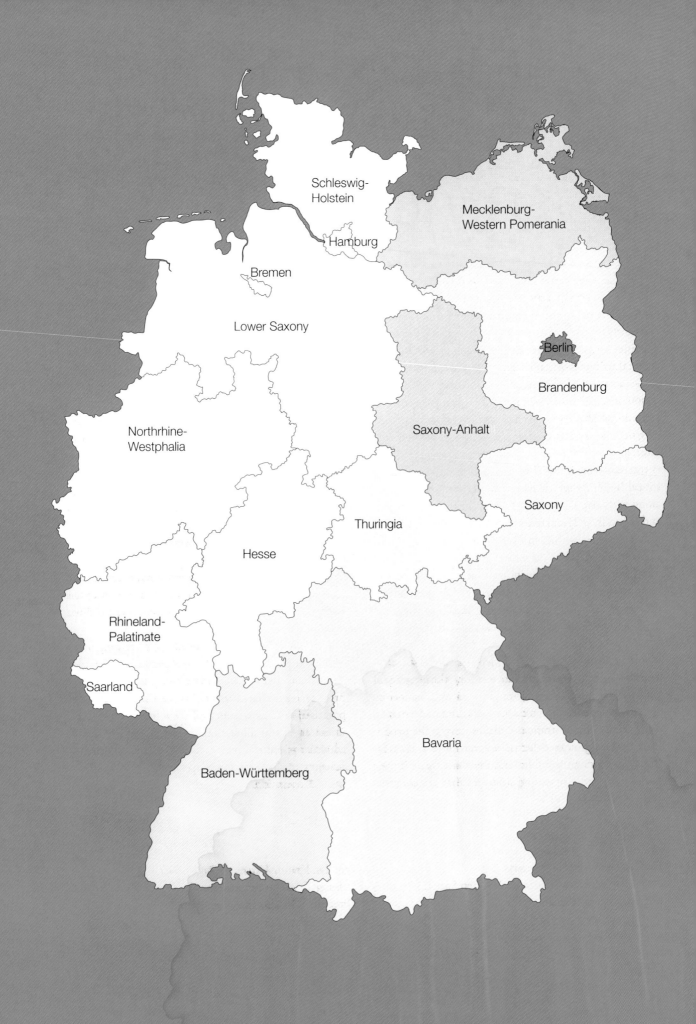

The working group of heritage administrations in Germany

The "Arbeitsgemeinschaft Deutscher Schlösserverwaltungen" facilitates exchange of experience between specialists and the development of joint projects by the public heritage administrations. These bodies, created to manage stately homes and gardens across Germany, serve to preserve, research, improve and disseminate a legacy that is unique in its cohesion, artistic input and history. The heritage consists of buildings, artworks, entire landscapes, artistic gardens and parks, and of course the interiors, designed and executed as works of art.

The listed sites in the care of the heritage administrations are total art works of major significance to art history, and at the same time important testimonies to the history of a region or culture. Because they play such a special part in the cultural identity of our various federal states, preserving them and placing them on display serves the public interest.

A total art work is understood to be an ensemble of historical buildings which have evolved over the centuries along with the art works which embellish their rooms and grounds. A distinctive feature is the orchestration of different genres within an overarching framework – the "Gesamtkunstwerk".

The German heritage administrations therefore have an important task to perform, because they are required to preserve and maintain not only the buildings in their trust, but also their artistic furbishing, and to approach these as a complex whole. This also means engaging in the scholarship that will place knowledge at the disposal of the public, or where appropriate restoring the integrity of sites so that they can be enjoyed in a suitable manner by visitors, experienced as a total art work, and understood.

The heritage administrations collaborating in the nationwide working group see themselves even more today as institutions serving the public, and they have made it their purpose to devise operating strategies that are commercially viable. They take it as given that cultural and commercial awareness can be reconciled – as, indeed, they were in previous centuries. To meet their objectives, at a time when tourism is growing and the demand for facilities is on the rise but financial and human resources are contracting, they know that they must each bundle the expertise required in a single institution. Consequently, depending on the structure of the total art works in their care, the heritage administrations focus their results-oriented activities around specific sites, drawing on in-house research capabilities with integrated specialisms and services all under a common management. Overall responsibility draws together oversight in the following areas:

· buildings, including both the architecture and its furbishment, with primacy attached to construction history and monument preservation;
· museum work designed to present artworks within the framework of the monument as it has evolved organically, including research, scientific inventory and object integrity;
· restoration, which includes conservation, repair and ongoing care;
· garden landscaping, including garden maintenance and landscape conservation, with primacy attached to the history of the gardens and the preservation of the listed site;
· public relations and communications, presenting information to the public in the form of publications, guided tours, education activities, exhibitions, advertising etc.;
· property management, to preserve the asset, manage it appropriately and use it in accordance with its listed status;
· initial and continuous training to enable the heritage administrations to operate their specific procedures efficiently, while helping to skill technical experts in all fields of operation.

Dr. Christian Striefler (Saxony)
Staatliche Schlösser, Burgen und Gärten Sachsen
Director and Chairman

Dr. Johannes Erichsen (Bavaria)
Bayerische Verwaltung der staatlichen Schlösser,
Gärten und Seen
President and Vice-Chairman

Prof. Dr. Helmut-Eberhard Paulus (Thuringia)
Stiftung Thüringer Schlösser und Gärten
Director and Vice-Chairman

Baden-Württemberg

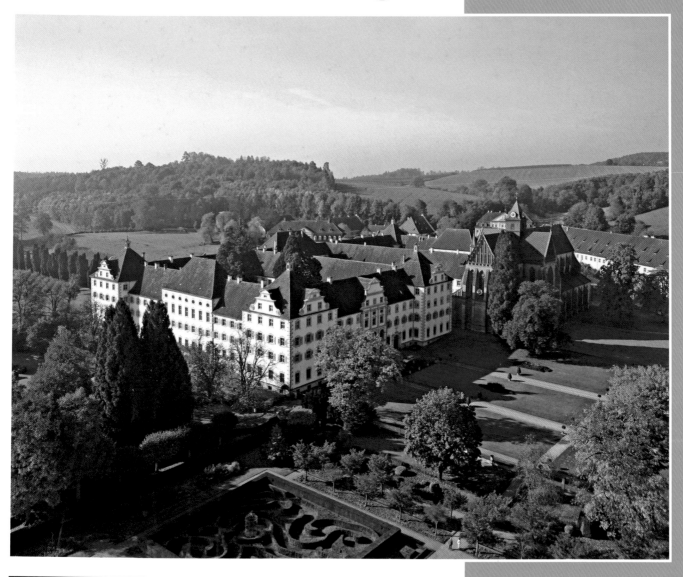

STAATLICHE
SCHLÖSSER
UND GÄRTEN

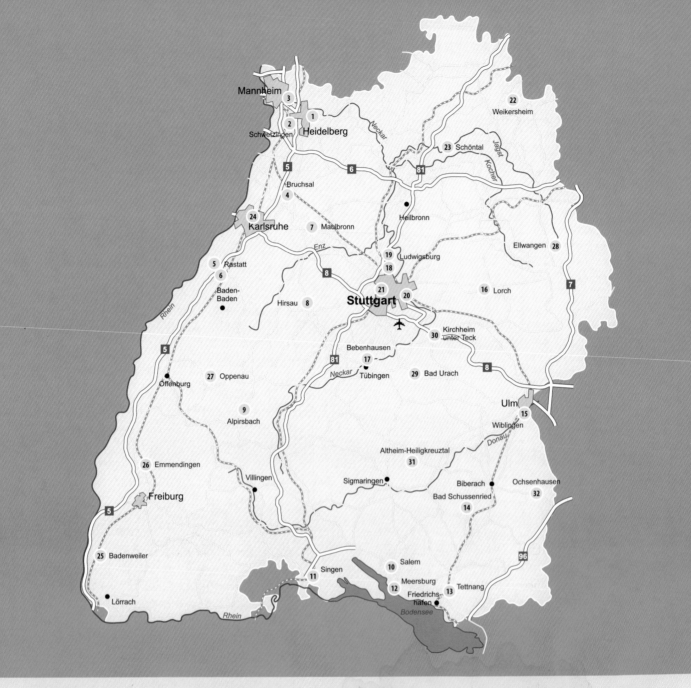

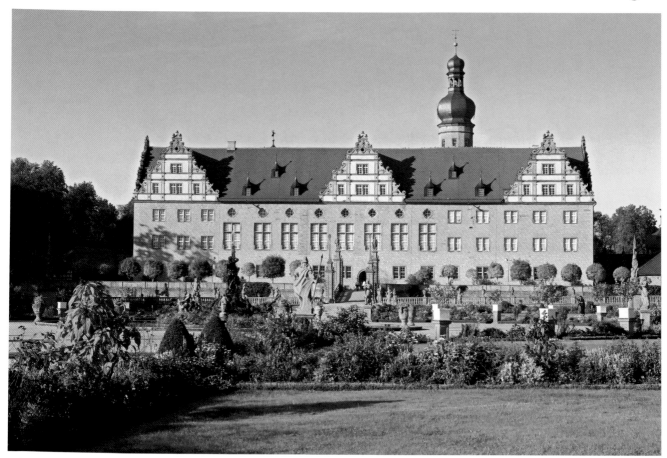

Schloss Weikersheim, view from the gardens

Baden-Württemberg, Land of Castles and Palaces

This region, with its magnificent stately homes, delightful gardens and impressive abbeys, invites visitors to go on a fascinating journey through a thousand years of history. Whether one is on the Rhine, in the Neckar and Tauber valleys or on Lake Constance, this federal state is exceptionally rich in historic sites of unusual beauty and incomparable charm. The palaces at Heidelberg and Ludwigsburg, the abbey at Maulbronn, and also Schloss Salem and its adjoining monastery, have an especially great attraction for visitors. All the fascinating history waiting to be discovered here promises exciting visits and lasting memories.

On the rolling plains of south-west Germany, the great number and variety of Baroque residences with mansions and extensive gardens bear witness to a desire for power, splendour and wealth. The sheer size and magnificence of the Baroque palaces at Rastatt, Bruchsal and Mannheim brought the pomp and luxury of Versailles to the Upper Rhine valley. Members of monastic orders chose the peaceful isolation of other more remote valleys to found splendid monasteries that reflect their piety and asceticism; foundations like those at Alpirsbach, Bebenhausen, Wiblingen and Schussenried became influential centres of art, learning and industry. The so-called 'rustic beauties' like the enchanting Baroque gardens at Weikersheim with its 18th-century gallery of dwarves have a charm all of their own. Amidst the idyllic scenery of the Rhine plain, Schloss Favorite, the precious summer mansion at Rastatt, contains examples of the earliest porcelain from Meissen.

Splendid marble banqueting halls, labyrinthine gardens, peaceful cloisters and ruined fortresses are among the many different sights offered by Baden-Württemberg. Guided tours, exhibitions, concerts, special programmes and events promise thrilling visits for young and old!

Baden-Württemberg 's state-owned palaces, stately homes and gardens are really worth visiting!

Schloss Heidelberg

Schloss Heidelberg
69117 Heidelberg

Telephone
+49 62 21/53 84 31

E-Mail
info@service-center-
schloss-heidelberg.com

Internet
www.schloss-
heidelberg.de

The tour of Baden-Württemberg begins mysteriously and romantically in Heidelberg. By night, especially, the facade of Schloss Heidelberg, bathed in golden light, catches the eye in almost magical fashion. What secrets are concealed behind it? Princes, kings even, resided here, enjoyed supreme power and suffered bitter decline. When the morning mist rises above the walls, an impressive picture is revealed in the sunlight. The red sandstone ruins of the palace stand imposingly and majestically above the Neckar valley. At the height of the Renaissance, the original castle, founded about 1300, developed into the most magnificence princely seat north of the Alps. Every single building in the complex is like a picture book telling exciting tales of past centuries. To give just one example, there is the story of the young Elector, Friedrich V, who ended up, tragically, as the 'Winter King'. In order to prove his love for his beautiful wife Elisabeth, he first had a gateway built overnight and then, at the start of the 17th century, laid out the Hortus Palatinus – the Palatine Garden. This unusual work of art remained only a fragment, but was nevertheless called the 'eighth wonder of the world' in those times. Although one of the garden's upper terraces has been restored, the splendour of Heidelberg in its Renaissance heyday can be only partially felt nowadays. The magnificent view of the city and of the Neckar and Rhine valleys is a real delight. Dilapidated and no longer 'appropriate' as a princely seat, the picturesque castle ruins later became the focus of a deep yearning for love and of the veneration of heroic deeds during the Romantic period in the early 19th century. Lonely poets meditated on death and mortality in its ivy-covered niches. This fascination also led to the beginning of tourism. Schloss Heidelberg became the world's most famous castle ruin. Both by day and by night, its mysterious walls still exert a special attraction and cast their spell on more than a million visitors each year.

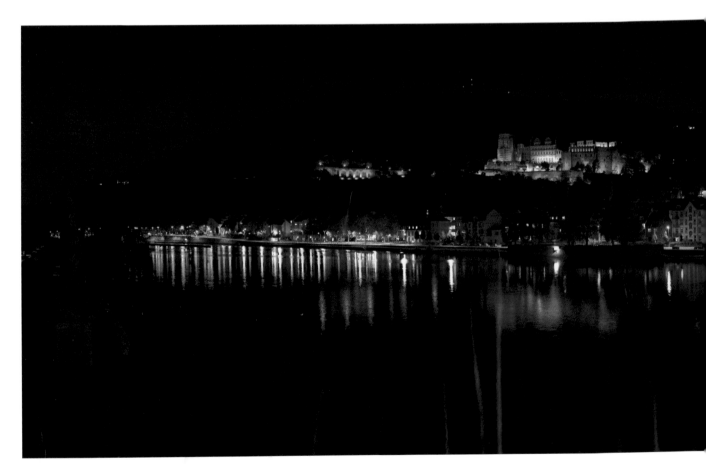

Romantic Heidelberg by night

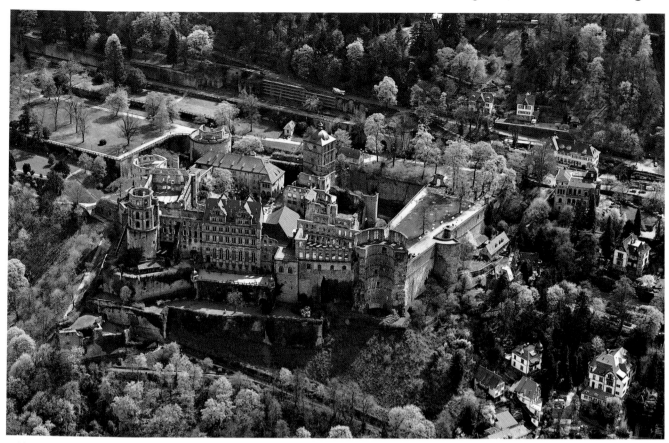

Schloss Heidelberg, aerial view of the palace complex

Schloss Schwetzingen and its Gardens

Schloss und Schloss-
garten Schwetzingen
Schloss Mittelbau
68723 Schwetzingen

Telephone
+49 62 21/53 84 31

E-Mail
info@service-center-
schloss-heidelberg.com

Internet
www.schloss-
schwetzingen.de

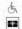

Hours spent in the gardens of Schloss Schwetzingen are almost like hours in Paradise. As soon as one goes through the gateway of the Electors' summer residence, one enters a magical world, a whirl of shapes and colours, all bathed in bright light. Lined by rotundas containing exotic plants in large tubs, the parterre of this Baroque pleasure garden is the dream come true of Carl Theodor, the Elector of the Palatinate. Versailles was his great model. The palace itself, once a mediaeval moated castle, was no longer compatible with his grandiose ideal of immortality. The central tract was converted for the greater comfort of the Elector and his consort as well as their courtiers; the rooms were lavishly decorated with gold, velvet and silk. The rococo-style salons in the rotundas and the palace theatre were the setting for world-class theatrical performances. Famous musicians competed for the Elector's favour. The gardens were an extension of the palace's living quarters and thus all of a piece with the palace architecture – an appropriate background for glittering court

occasions and princely amusements. Elegant flower-beds bordered with box hedges, Arion's Fountain and other smaller fountains, the Temple of Apollo and the Mosque all make the heart beat faster. The elector's wealth and power were reflected in the fountains and also in the number and size of the exotic plants in containers, particularly the orange trees; a whole area of the garden was laid out as an orangery. The adjoining English landscape garden, an extensive area of green trees and grassland with meandering paths and charming bridges offers unexpected vistas and encounters of all kinds. In fact, one of Schwetzingen's unique features is the fact that the palace gardens allow one to stroll through two different sorts of garden. No wonder the paradise-like beauty of this place transforms everyday life into a celebration.

View of the palace and gardens

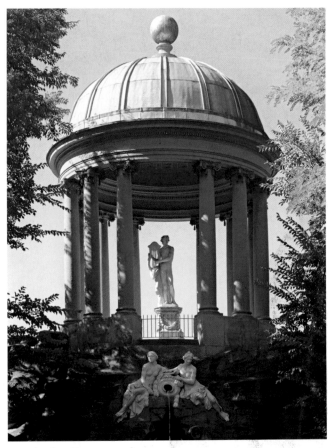

Temple of Apollo

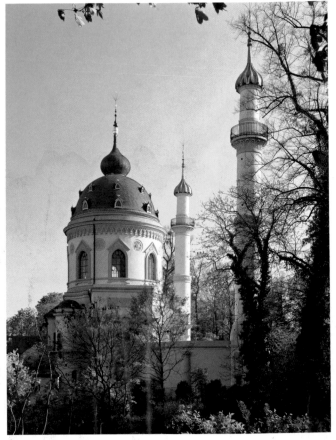

Mosque

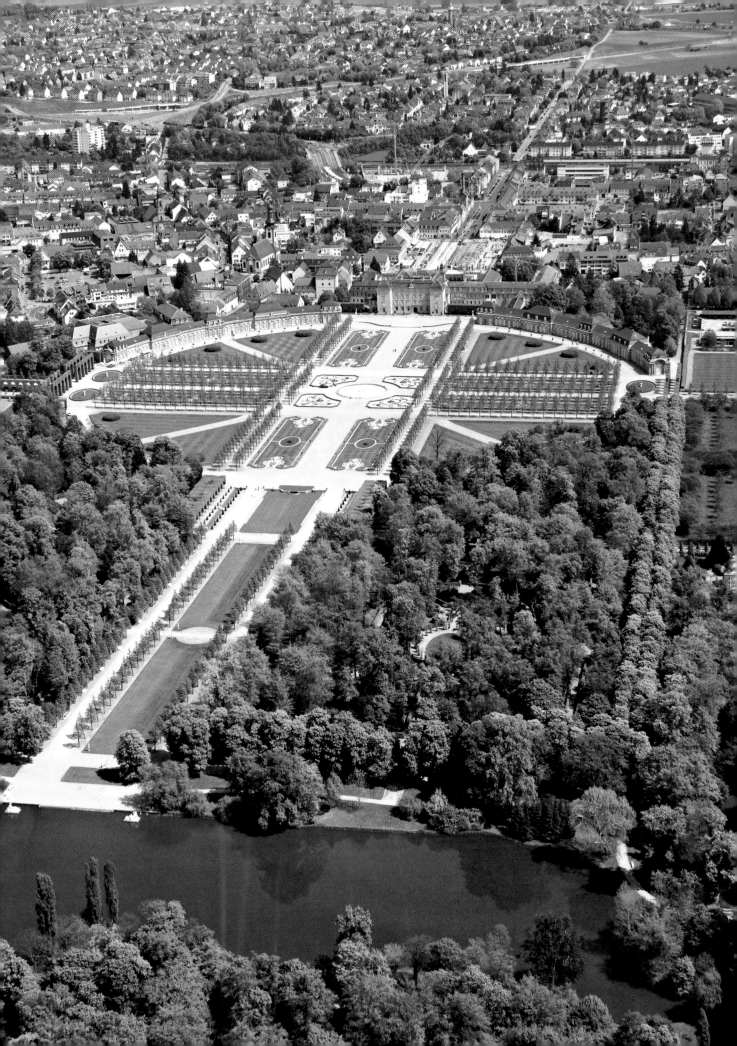

Schloss Mannheim

Barockschloss
Mannheim
Bismarckstraße
68161 Mannheim

Telephone
+49 62 21/65 57 18

E-Mail
info@service-center-
schloss-heidelberg.com

Internet
www.schloss-
mannheim.de.de

Schloss Mannheim is one of the most imposing palaces built as a residence for an 18th-century ruler. Carl Philipp regarded the previous seat of the Elector Palatine in Heidelberg as being no longer appropriate to his status. He thus decided in 1720 to erect a huge new palace beside the Rhine on the edge of Mannheim, a geometrically planned city. His model was, of course, Versailles. All previous residences – Rastatt, Karlsruhe – were to be overshadowed as regards size and magnificence. His project was successful! It was, however, decades before the building was completed. Under his successors, Carl Theodor and Elisabeth Auguste, Mannheim became a famous centre of the arts. Epoch-making music was composed here, and widely-acclaimed theatrical productions were staged. The young Mozart applied in vain for a post as a musician at the court. He had fallen in love with Mannheim and his greatest wish was to remain here. Sadly, Carl Theodor failed to recognise the composer's genius, even though he was an enlightened absolutist ruler with artistic and philosophical aspirations. He even carried on a lively correspondence with Voltaire. The illusion of eternal fame came to an end when the court moved to Munich in 1778. Not until the 19th century did the Grand Duke's widow, Stéphanie von Baden, bring a new brilliance to the palace.

The losses suffered by Schloss Mannheim in the Second World War were immense. After the buildings had been reconstructed, the university moved into the complex. In the piano nobile, however, the Elector's state apartments with their brocade, velvet and silk furnishings today recreate the epochs that were so important for the history of the palace; one enters a time machine, as it were. Over 800 original works of art and furnishings of exceptional beauty allow visitors to experience the life at court in all its variety.

Suite of rooms in the corps de logis

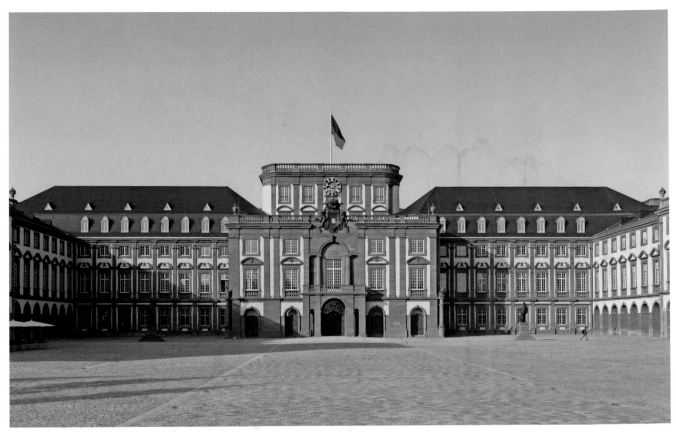

Schloss Mannheim, courtyard

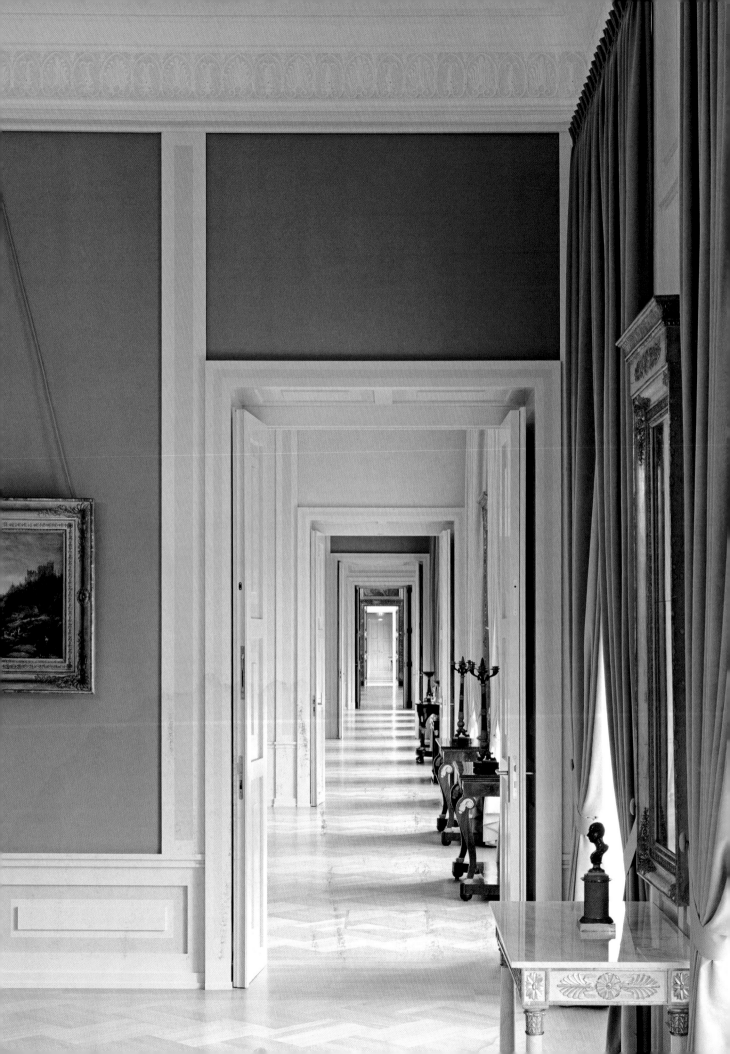

Schloss Bruchsal

Schloss Bruchsal
Schlossraum 4
76646 Bruchsal

Telephone
+49 72 51/74 26 61

E-Mail
info@schloss-bruchsal.de

Internet
www.schloss-bruchsal.de

The colourful, late-baroque world of Schloss Bruchsal takes one back to life at an ecclesiastical court in the second half of the 18th century. In this palace, the architecture, paintings and stucco work blend to form an artistic unity which radiates its former glory now that the whole palace has been rebuilt and the central structure magnificently refurbished. This complex was also built as a reflection of a ruler's desire for power. Damian Hugo von Schönborn, both Bishop of Speyer and a secular prince in addition to being a connoisseur of art, had the palace constructed, beginning in 1720. As prince-bishop, he was also determined to demonstrate his absolute power. Not only did he exercise influence on the overall construction of the palace, he also intervened personally in the construction work. This led to him having serious financial difficulties for decades on end.

Due to the fortunate circumstance that his brother Friedrich Karl was prince-bishop of Würzburg, he managed to secure the services of Balthasar Neumann, the well-known artist who was working there, to carry out his project. With his staircase and the adjacent principal banqueting halls, Neumann created a masterpiece of baroque architecture in Bruchsal, one which today continues to inspire deep admiration. Under Schönborn's successor, Prince-Bishop Franz-Christoph von Hutten, the finishing touches were added to the palace in the form of light-hearted rococo decorations in the Prince's Hall and the Marble Hall. After Secularisation, the changing balance of power meant the palace came into the possession of the Grand Dukes of Baden. Margravine Amalie came to live here after she was widowed. Work is now in progress on refurbishing all the splendid state rooms in the piano nobile, so that in future, probably from 2012, visitors will be given an even more impressive picture of the palace's former splendour.

Staircase

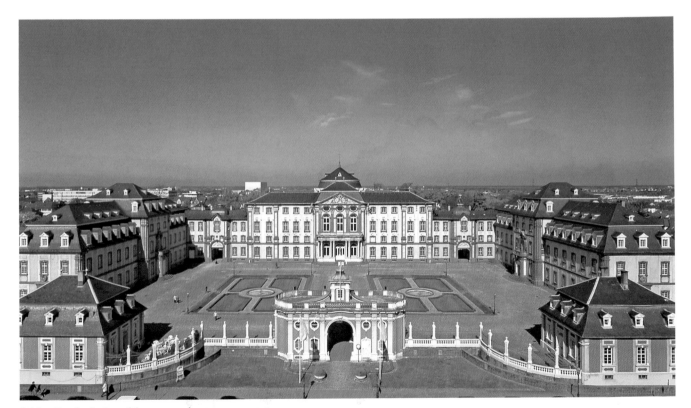

Schloss Bruchsal, view of the courtyard

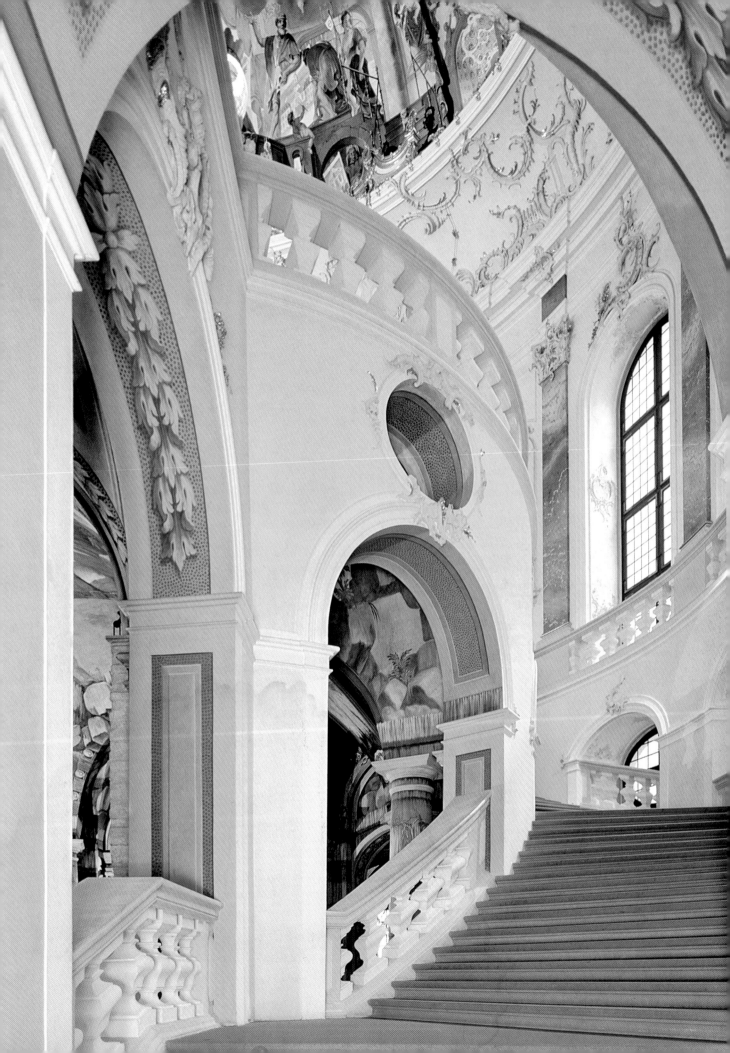

Schloss Rastatt

Barockresidenz Rastatt
Herrenstraße 18-20
76437 Rastatt

Telephone
+49 72 22/97 83 85

E-Mail
info@schloss-rastatt.de

Internet
www.schloss-rastatt.de

'I was seized by a lively desire to spend two or three days in one of these beautiful rooms with their splendid wall-hangings ...' wrote Alexander Dumas in his book 'A Journey to the Banks of the Rhine in 1838', after he visited Schloss Rastatt. Greatly impressed by the 'wonderful furniture from the times of Louis XIV', he became fascinated by the brilliant but sad history of the Margraves of Baden-Baden. At the end of the 17th century, Ludwig Wilhelm, the celebrated hero of the Turkish campaigns, decided to convert buildings originally planned in 1698 as a hunting lodge into a magnificent family seat and to make the village of Rastatt into a planned city. This was a bold undertaking in an age of wars and court intrigues. Self-assured and confident of success, he commissioned Domenico Egidio Rosso, an Italian architect who had made his name in Vienna, to realise his plan. In only seven years, Rossi had completed the first baroque palace on the Upper Rhine, a miniature Versailles. However, 'Turk Louis' was never able to enjoy the fame and glory of this palace with its precious furnishings. He died in 1707

and it was left to his young widow, the new regent, to bring his dream to completion. Endowed with 'remarkable taste and superior intelligence', she was able to make the court at Rastatt a significant factor in the European system of power. She sought the richest possible match for the heir to the throne, and married her daughter into the House of Orléans. Many tales are told about the contradictory figure of Baden's female ruler. If, like Dumas in his time, present-day visitors wish to experience the age of the 'Sun King' 'authentically' on the Upper Rhine, with all their senses, then they are in the right place here. Olympian gods, bolts of lightning in stucco, sculpted figures, colourful landscapes, gilded ornaments, billowing gowns, the brilliance of velvet and the magnificence of brocade embellish the splendid rooms in the piano nobile with a wealth of theatrical gestures, almost numbing the senses.

Ancestral Hall

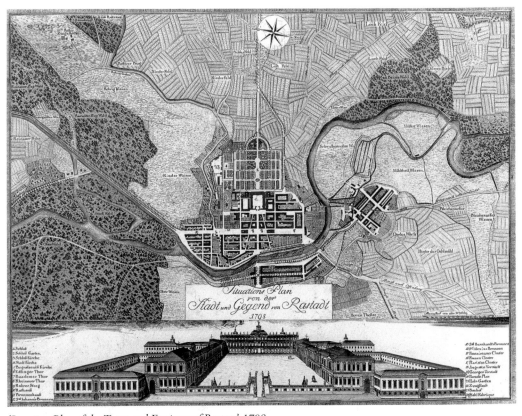

'Location Plan of the Town and Environs of Rastatt', 1798

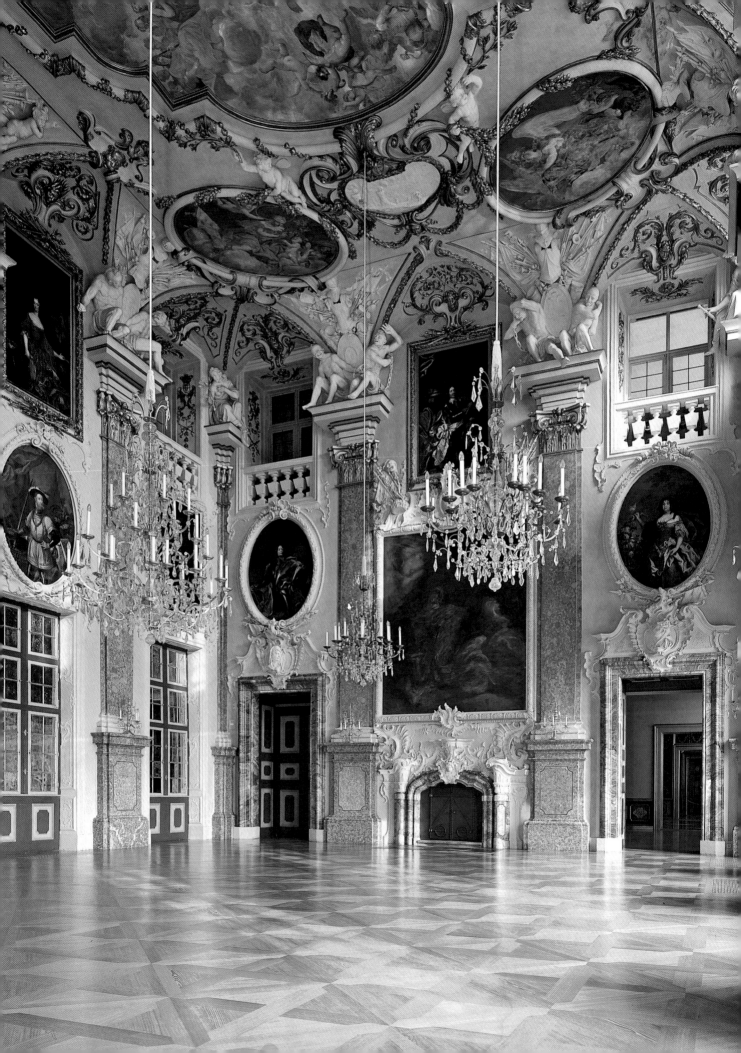

Schloss Favorite, Rastatt

Schloss Favorite
Am Schloss Favorite 5
76437 Rastatt-Förch

Telephone
+49 72 22/4 12 07

E-Mail
info@schloss-rastatt.de

Internet
www.schloss-favorite.de

If one follows Alexander Dumas' recommendation, a visit to nearby Schloss Favorite promises to be a real delight. 'It is the most perfect model of rococo in its purest form', the French writer enthused. And just as in his day, the little summer residence set amidst idyllic meadows remains an enchanted place in which ideal and reality merge together.

Schloss Favorite, 'the preferred one', was the much-loved summer residence of the Margravine Sybilla Auguste. In 1710/11 she commissioned her Bohemian architect Ludwig Michael Rohrer to build a summer abode just as she wished to have it. Indeed, the charm of the personal, intimate details combined with a clear predilection for the interplay of artistic forms of all kinds is what makes it so distinctive. A gently curving flight of steps leads from the garden to the graceful and elegant reception rooms on the first-floor. Coloured scagliola floors, richly decorated stucco ornamentation, colourful ceiling frescoes, splendid hangings with rare embroidery on the walls,

papier-maché ornaments (then highly-prized) and exquisite furniture all combine to form a harmonious picture of aristocratic extravagance. Precious collections of porcelain and faience, among them some of the first fine pieces of Meissen china, were used to decorate the rooms and were already famous in the Margravine's time. Designs for costumes and contemporary paintings show the costumed festivals, music and dance performances in the Margravine's pleasure gardens as well as the pheasant-shooting expeditions in the nearby forests. The hermitage erected for the deeply religious ruler and the extensive park designed in the English style with glimpses of meadows and pools, with vistas of avenues and water courses, help to emphasise the perfection of this design.

Great Hall, view from the balustrade

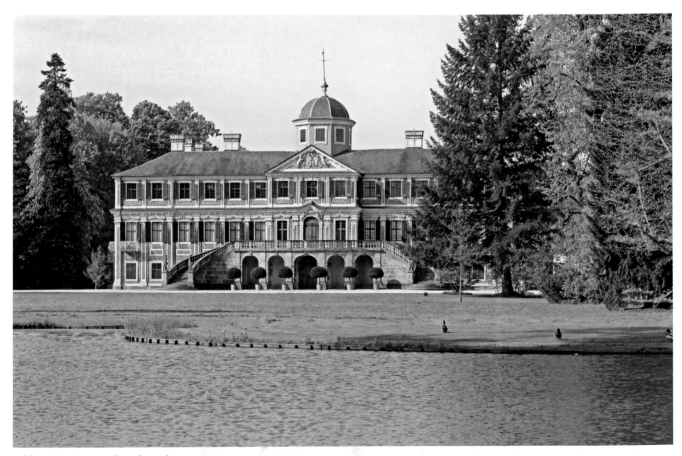

Schloss Favorite, view from the park

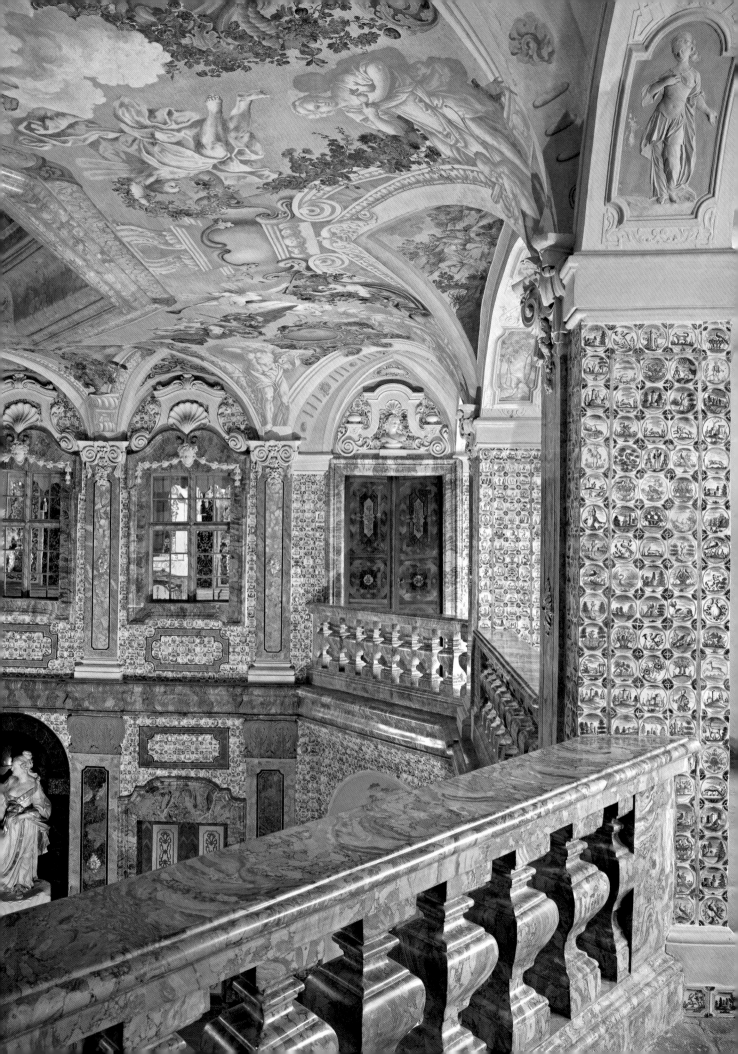

Maulbronn Abbey – UNESCO World Heritage Site

Kloster Maulbronn
Klosterhof 5
75433 Maulbronn

Telephone
+49 70 43/92 66 10

E-Mail
info@kloster-
maulbronn.de

Internet
www.kloster-
maulbronn.de

After so much secular pomp, a visit to the mystical places of the Black Forest is balm for the soul. Maulbronn Abbey lies on the road leading eastwards through the gentle rolling hills of Kraichgau-Stromberg and is surrounded by woodland, orchards and gardens. It is not surprising that, according to the legend about the monastery's foundation, a mule came to a stop just here and refused to walk any further. The magic and stillness of this spot – now a World Heritage site – still moves the present-day traveller.

More than 800 years ago, Cistercian monks guided by the ideals of Bernard of Clairvaux founded the abbey, which is regarded as the most fully preserved mediaeval monastery north of the Alps. A large, shady linden tree stands just in front of the oldest part of the monastery complex, the abbey church, a Romanesque pillared basilica with a nave and two aisles, which was consecrated in 1178. Its celebrated 'paradise', a porch-like structure added some time later, still confronts the visitor with some puzzles. The name of the gifted master-builder who constructed it in the Gothic period is still not known. It is equally unclear if he was also involved in the construction of the refectory. The large dining-hall used by the monks is one of the finest rooms in the monastery. Ingredients produced by the monks themselves were a feature of every meal in the refectory, as was a small glass of good wine from the monastery's own vineyard. Whether the legend of the 'eleven fingers' is true, and whether the wine at the monastery still tastes so good is something one can find out only here. The constant rhythmic bubbling of the water in the well-house emphasises how peaceful the abbey buildings are. During the 390 years the Cistercians maintained the monastery, they made it into an important centre of religious life and of industry. The Reformation put an abrupt end to this flourishing community. In 1556, Duke Christoph von Württemberg set up a Protestant monastery school here, which continued to function as a Protestant theological seminary after 1807. Pupils who later became famous, like Johannes Kepler, Friedrich Hölderlin and Hermann Hesse, attended school here and left behind literary memories.

Aerial view of Maulbronn Abbey

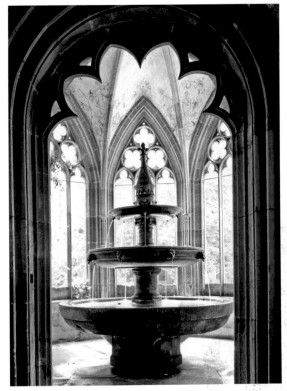

Well-house

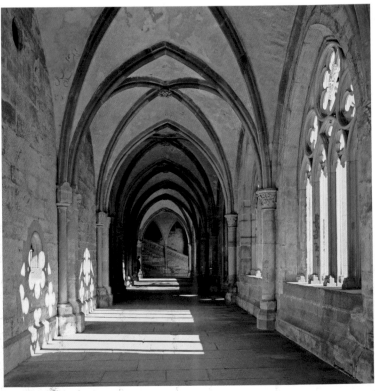

North cloister

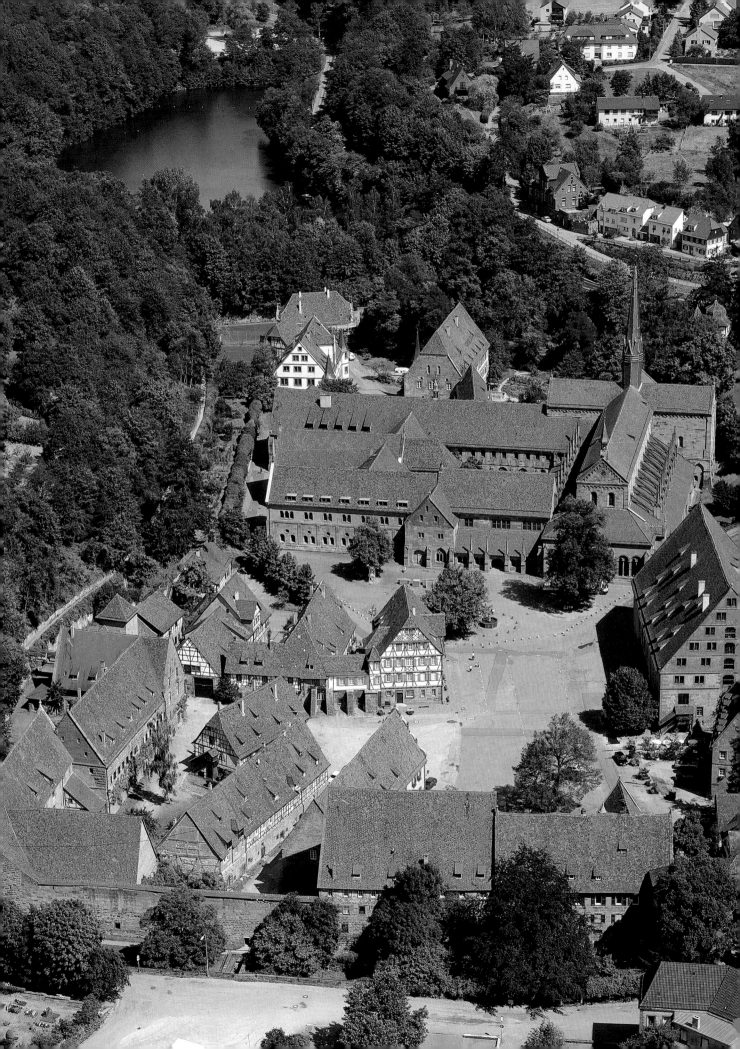

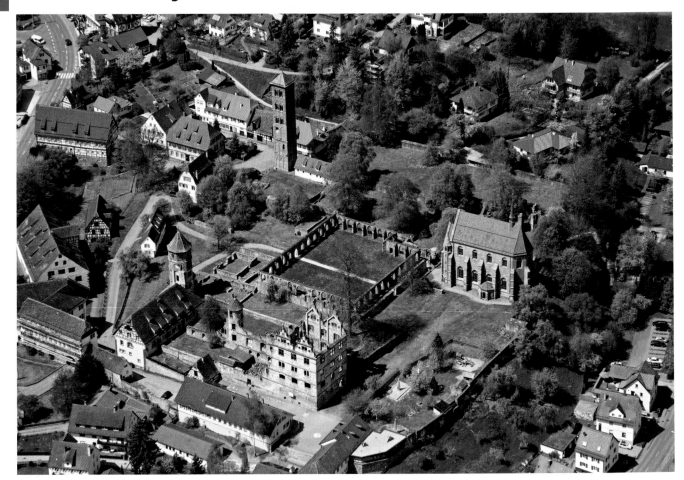

Hirsau Abbey

Hirsau Abbey

Kloster Hirsau
Klosterhof
73565 Calw-Hirsau

Telephone
+49 70 51/5 90 15

E-Mail
klostermuseum@calw.de

Internet
www.schloesser-und-
gaerten.de

There are other important centres of mediaeval piety and learning to be found in the picturesque valleys of the Black Forest and its foothills: Hirsau and Alpirsbach. The Romanesque and Gothic ruins of the once renowned Benedictine abbey of Hirsau lie amidst the densely wooded hills of the Black Forest not far from Pforzheim, in the deep valley of the River Nagold. The riddles posed by this place of peace and meditation cannot be solved at first glance. The still preserved nave of St Aurelius' Church, which was founded about 830, is the most ancient basilica in the Black Forest. The solid austerity of the Romanesque architecture makes a lasting impression. Hirsau was the first monastery in South-West Germany to introduce the Cluniac reforms, thus helping to move the reform process forward. A monastery dedicated to St Peter and St Paul was founded later, at the end of the 11th century, on the opposite bank of the Nagold. At the time it was built, this was the largest monastery complex on German-speaking territory. All that now survives of it – bearing witness to the huge dimensions of this foundation – is the 37-metre-tall Owl Tower with its enigmatic frieze. The riddle posed by the figure of a bearded man chiselled in stone and flanked by symbolic beasts and other human beings has never been solved. The extensive site of the ruined abbey of SS Peter and Paul is particularly atmospheric in the early morning and at dusk.

Alpirsbach Abbey

Alpirsbach Abbey lies in an idyllic position a few kilometres to the south, deep in the northern Black Forest. The glorious red sandstone of this imposing arrangement of buildings dominates the centre of the little town of Alpirsbach on the River Kinzig. The original abbey buildings, most of which have survived, were erected by the Benedictine Order. The simple, austere Romanesque architecture the order preferred was complemented in the 15th century by the construction of the lighter, pointed arches of the Gothic period in the cloisters. A walk through the part of the monastery once used exclusively by the members of the Order also leads through the rooms reserved for prayer and listening, for assemblies, and for silent contemplation. When one enters the monks' cells in the dormitory building, one almost feels transported back to those times. Here, there are also wall-paintings of a very special kind to inspect: initials, dates and sayings – 'graffiti' left behind by boys from the monastery school. This Benedictine abbey was also dissolved at the time of the Reformation and turned into a Protestant monastery school from 1556 until 1595. The Abbey Museum has a fascinating permanent exhibition called 'Monks and Scholars'; it contains a display of clothes, letters, drawings, games, vessels and much else dating from those times, artefacts which have, amazingly, been rediscovered.

The Romanesque abbey church deserves particular attention. It is a pillared basilica with a nave and two aisles and is in the form of a cross. Containing many precious treasures, it is striking because of its sheer size and simple beauty. At the end of one's visit, it is permissible to succumb to the temptation to drink a large mug of the monastery's famous beer.

Kloster Alpirsbach
Klosterplatz 1
72275 Alpirsbach

March 15 – Nov 1:
Telephone
+49 74 44/5 10 61
E-Mail
kloster.alpirsbach@
gmx.de

Nov 2 – March 14:
Telephone
+49 74 44/9 51 62 81
E-Mail
tourist-info@
alpirsbach.de
Internet
www.schloesser-und-
gaerten.de

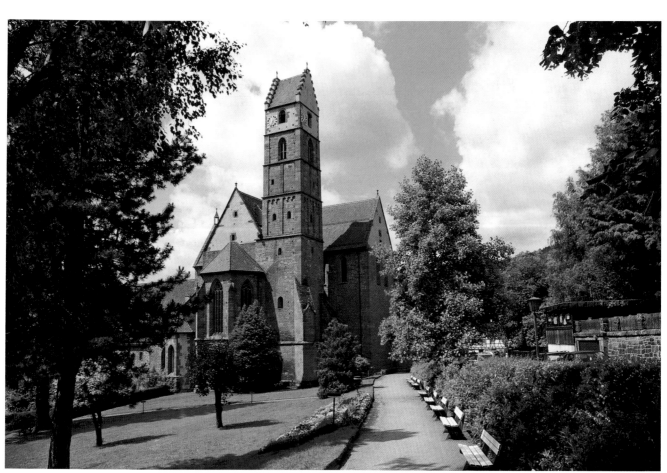

Alpirsbach Abbey Church

Schloss Salem and Salem Abbey

Schloss Salem
88682 Salem

Telephone
+49 75 53/8 14 37

E-Mail
schloss@salem.de

Internet
www.salem.de

Nestling in the picturesque landscape of the Linz valley, Salem is one of Baden-Württemberg's most precious gems on Lake Constance. One enters another world here. Right from the beginning of one's tour, one is impressed by the size of the buildings. The splendid monastery site is especially striking because of the amazing forms of architecture dating from the most varied epochs. High Gothic elegance, baroque magnificence, dainty rococo, and the austerity of early neo-classicism blend together to form a highly unusual ensemble. Salem Minster with the precious alabaster decorations in its interior is captivatingly beautiful; the interplay between the austere simplicity of Gothic style and the exuberance of early classicism reflects the power enjoyed by Salem's abbots. The pillared basilica with its nave and two aisles is a perfect example of the Golden Age of Gothic architecture in southern Germany. In the Middle Ages, this was the most important Cistercian abbey in the region. After the turmoil of the Thirty Years' War and a fire that almost completely destroyed the monastery buildings, the complex was re-erected in 1697. Yet the new buildings were not in the simple unadorned style decreed by the ideals of Bernhard of Clairvaux; instead they were imposing and grandiose, a reflection of the baroque zeitgeist. Today, one is transported back to those times in the abbot's private apartments, and in the other rooms with elaborate stucco decorations and wall paintings, such as the Imperial Hall, the Library and the Abbot's Hall. One is impressed by the unusual width and surprising brightness of the Imperial Hall, the imperial abbey's reception room. If one wishes to follow the trail of a famous rococo artist from the standpoint of an art historian, then one will be rewarded when one sees the stucco decorations in this room: it is Franz Joseph Feuchtmayer's masterpiece.

A stroll through the extensive grounds is just the right thing after so many artistic delights, and here the maze in the pheasantry garden suggests itself as the ideal destination. Afterwards, a glass of wine from the Margrave of Baden's cellars will round off a visit to Salem most enjoyably.

View of the minster and of the prelature

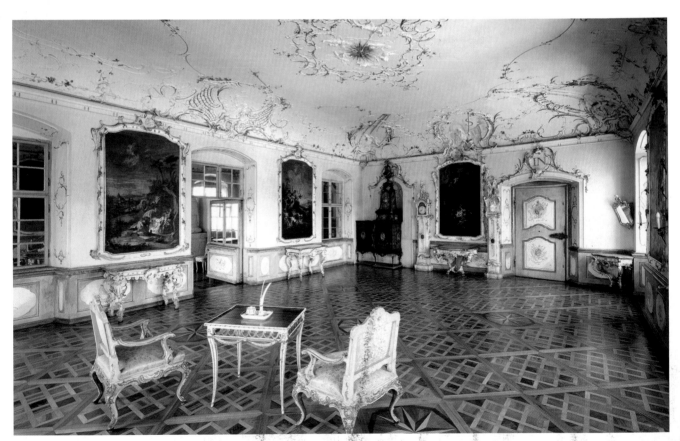

Salem Abbey and Schloss Salem, Abbot's Reception Room

Hohentwiel Castle Ruins

Festungsruine
Hohentwiel
Auf dem Hohentwiel 2a
78224 Singen

Telephone
+49 77 31/6 91 78

E-Mail
info@festungsruine-
hohentwiel.de

Internet
www.festungsruine-
hohentwiel.de

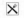 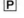 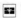

Further along the route towards Lake Constance, the climb up to Germany's oldest ruined fort on Hohentwiel is very rewarding. From this site, that of one of the largest forts in the country, there is a breathtaking panoramic view of the magnificent landscape stretching down to Lake Constance and, in clear weather, right to the Alps. It is, moreover, worth looking into the history of this massive ruined fortress. It was built in 914 on the summit of the most distinctive hill in the Hegau volcanic outcrop near Singen. It served as the main stronghold in Swabian-Alemannic territory and as the seat of the Dukes of Swabia. Various owners left their stamp on the site as the centuries passed. Extended by Duke Ulrich of Württemberg as one of his seven territorial fortresses, it withstood every siege and was never conquered in battle. In 1800/01, however, it was surrendered to the French without an armed struggle, and Napoleon decided to have it razed to the ground. From then on, the imposing ruins of the fortress became the scene of romantic encounters or the subject-matter of literary works. In 1855, for instance, Hohentwiel achieved poetic fame in Joseph Viktor von Scheffel's novel 'Ekkehard'. Nowadays, the ruins form an atmospheric backdrop for many tourist excursions.

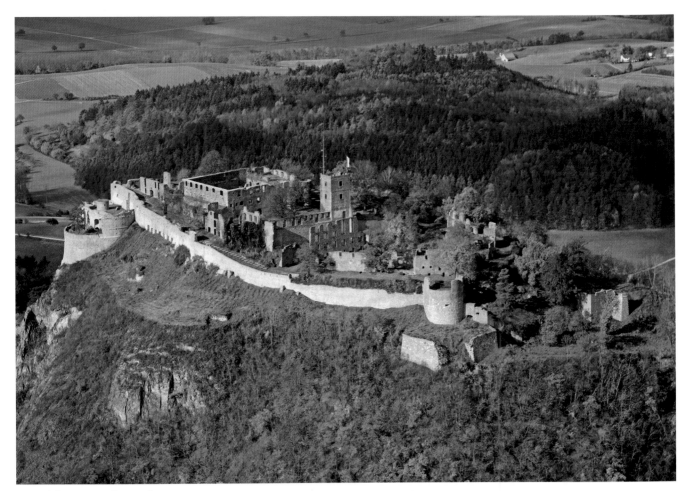

Ruined fortress at Hohentwiel

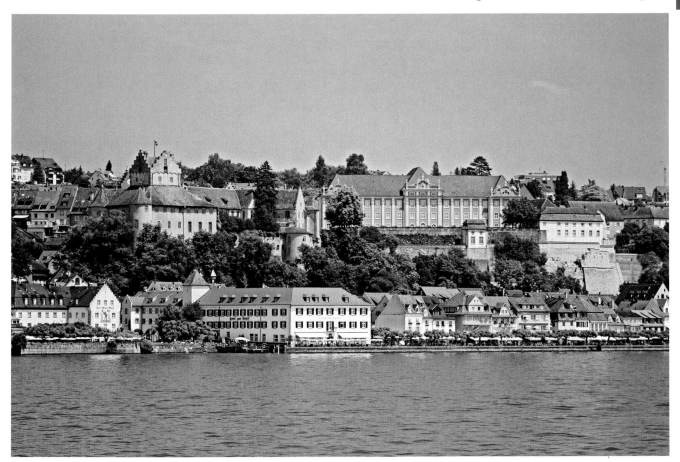

Schloss Meersburg, view from Lake Constance

Schloss Meersburg

Not far away, in Meersburg, the New Palace overlooks Lake Constance. Its garden terrace offers the most beautiful view of the whole lake and a panoramic view of the Alps beyond it. Constance's prince-bishops, too, were so taken with this vista that they established their seat here in the 18th century and had their new palace built on this site. Prince-Bishop Damian Hugo von Schönborn, already such a powerful figure in Bruchsal, also commissioned the brilliant artist Balthasar Neumann to decorate a chapel in Meersburg and to construct an impressive staircase. The bishopric's power and wealth were demonstrated in dignified baroque style. Impressive frescoes, elaborate stucco work and sculptures provide light-hearted decorations for the sumptuous rooms and emphasise their builders' intention to wield secular power. The precious furnishings and fittings allow visitors today to appreciate that past brilliance only in part. The refurbishment of the rooms and new furnishings will restore the palace to its former splendour in the coming years.

Neues Schloss
Meersburg
Schlossplatz 12
88709 Meersburg

Telephone
+49 75 32/44 04 00

E-Mail
info@meersburg.de

Internet
www.schloesser-und-gaerten.de

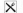

Schloss Tettnang

Neues Schloss Tettnang
Montfortplatz 1
88069 Tettnang

Telephone
+49 75 42/51 05 00

E-Mail
tourist-info@tettnang.de

Internet
www.schloesser-und-
gaerten.de

Looking at the magnificent palace on the Upper Swabian Baroque Route, one would not guess that its builders' lavish way of life was not compatible with their financial situation. Influenced by current attitudes and by their desire to impress, the Counts of Montfort had a new three-storey palace built on the site of their castle, which had been destroyed. In doing this, the noble Swabian dynasty, which had resided in Tettnang for more than six centuries, by far overestimated its financial limits. In 1712, Count Anton III commissioned the best artists and craftsmen from the region around Lake Constance to construct and decorate the splen-

did apartments. The fact that building work had to be suspended twice due to financial difficulties is now merely a footnote in history. The family's apartments in daintily elegant rococo style, the richly decorated palace chapel and the count's impressive reception room with its adjoining 'Travellers' Room' convey a vivid picture of the lifestyle of the family in those times. The lavish banqueting hall has a light, elegant feel to it; the room is decorated with gilded rocaille motifs and colourful paintings. The ample figure of Bacchus, the god of wine, sits contentedly astride a carved wine-barrel – thus the name 'Bacchus Hall'.

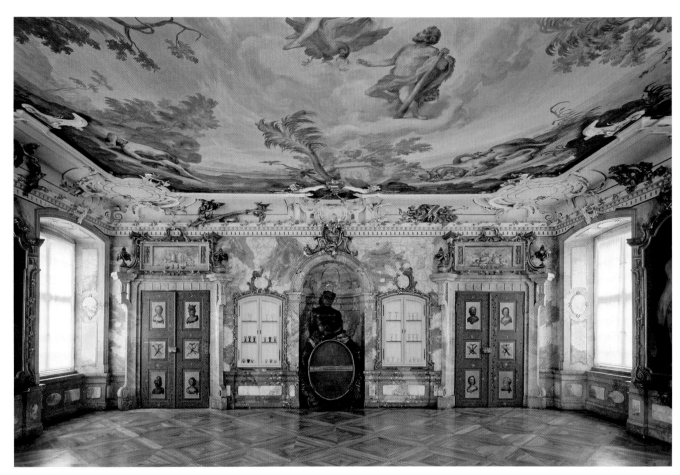

Schloss Tettnang, Bacchus Hall

Schussenried Abbey

The mighty abbey at Schussenried is the first stop when travelling along the Upper Swabian Baroque Route. It belonged to the Premonstratensian Order, which owes its existence to Norbert of Xanten. He sold all his possessions and went to France as an itinerant preacher. In 1120, he and his followers settled in Prémontré and founded the Premonstratensian Order there.

As one walks through the baroque gateway, the 'Little Gate', one discovers evidence of the varied history of this monastic order. One goes on a journey through time, as one sees all styles of architecture, from Romanesque and Gothic in the former abbey church of St Magnus and then on to late baroque splendour in the huge monastery building. The baroque choir stalls in St Magnus' Church with their wealth of carving are famous as a masterpiece of Upper Swabian baroque art. Another highlight is the abbey's rococo library, a room bathed in light. The elegant two-storey room with a gallery running all around it is impressive because of its marvellous frescoes and pictures. The principal theme of the series of brightly-coloured paintings is the Apocalyptic Lamb on the Book of Seven Seals, the symbol of divine wisdom. Since art reflected the views of those who commissioned it, the fresco also shows how the imperial abbey at Schussenried saw itself. A particularly well-known feature of the magnificent decorated ceiling is 'The Flying Father'. Like Icarus before him, the learned canon Caspar Mohr dreamed at the beginning of the 17th century that he could soar through the air with the aid of his own flying-machine made with feathered wings. He planned to fly by jumping out of the top storey of the three-floor dormitory building. He was, however, refused permission to do this and 'the wings were completely destroyed', as Abbot Mathäus Rohrer noted. It seems that there were restrictions on experiments of this sort at the abbey.

Kloster Schussenried
Neues Kloster 1
88427 Bad Schussenried

Telephone
+49 75 83/9 26 91 40

E-Mail
info@kloster-
schussenried.de

Internet
www.kloster-
schussenried.de

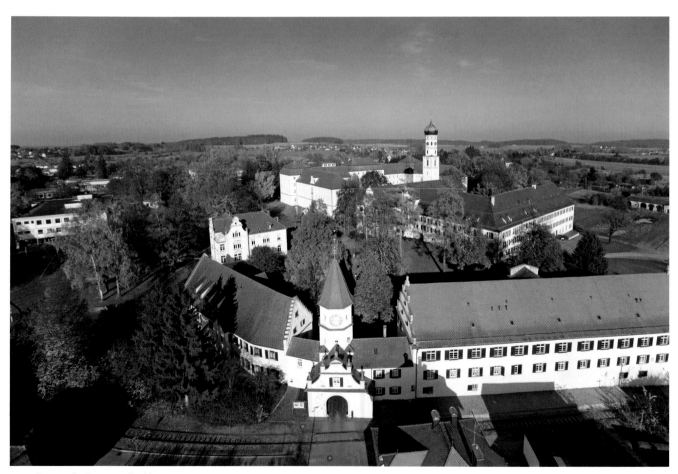

Aerial view of Schussenried Abbey

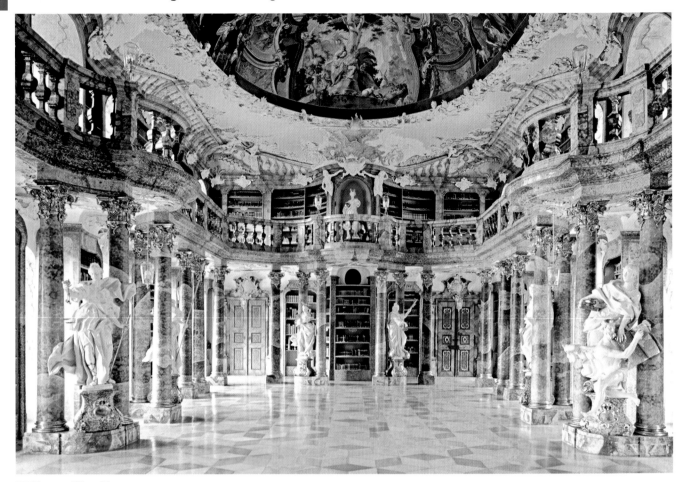

Wiblingen Abbey, library

Wiblingen Abbey

Kloster Wiblingen
Schlossstraße 38
89079 Ulm-Wiblingen

Telephone
+49 7 31/5 02 89 75

E-Mail
info@kloster-
wiblingen.de

Internet
www.kloster-
wiblingen.de

Wiblingen Abbey, a former Benedictine foundation just outside the gates of Ulm, is a complex of gigantic dimensions that cannot fail to impress. The ideas of the Counter-Reformation influenced the refurbishment of the monastery in the 18th century. At that time, the monastery and commercial wings of the building as well as the gardens were grouped around the church, one of the last great achievements of ecclesiastical baroque architecture. The building borrowed ideas from a grandiose model – El Escorial, the Spanish abbey and royal residence,. The decoration of the interior is indeed imposing and elegant. Sumptuously furnished public apartments in the north-western tract of the monastery were reserved for visitors and reflect the great wealth as well as the self-assurance of this renowned abbey. In the artistically decorated rooms, all of them painted in the same colours, the stucco ceilings – the originals are still preserved – illustrate important events in Wiblingen's history and in the life of St Benedict, the order's founder. The famous library is exceptionally beautiful. Of enormous size and lavishly decorated, it is like an ecclesiastical banqueting hall and was used for great receptions by the abbot and the leading members of his chapter. The complex theological and philosophical themes outlined here demand one's full concentration. Although painted with the gay extravagance of the 18th century, the ceiling fresco brings together a whole host of figures – Greek heroes, Biblical personages, and other famous people. Beautifully carved statues in white and gold represent allegories of sundry virtues and sciences. As a place of learning, the magnificent room contained precious treasures in the built-in bookcases. When the abbey was dissolved in the 19th century, the monks were the owners of about 15,000 manuscripts, incunabula – books printed before 1500 – and other printed works. The museum presents a vivid retrospective that brings the abbey's rich history to life again.

Lorch Abbey

The home of the Hohenstaufen royal family to the west of Baden-Württemberg's capital is a region shrouded in legend. A day trip from Stuttgart permits one to follow the traces of this proud dynasty of kings and emperors, which is now almost a thousand years old. Along the Hohenstaufen Route, there are Romanesque churches and defiant castles that reflect the history of the noblest of noble families in Swabia. At Hohenstaufen Castle, which gave the dynasty its name, visitors learn of the glorious days when this was the family's ancestral seat, while the castle in Wäscherbeuren has survived as a completely preserved Hohenstaufen residence. In about 1100, Duke Friedrich I of Swabia made an endowment for a Benedictine monastery at Lorch and decreed that it should be the burial place for the members of the Hohenstaufen dynasty. Following the rule of St Benedict of Nursia – ora et labora et lege (pray and work and read) – the monks made their foundation into a flourishing and wealthy abbey. The scriptorium in

Lorch was famous for its magnificent manuscripts. The first building on the site was the abbey church. Several Hohenstaufen rulers are buried in the pillared basilica, which has a nave and two aisles, a flat roof and a ground plan shaped like a Latin cross. The tombs and the murals in the church tell the story of the famous family. Because of her tragic fate, there is a particularly large number of legends about Irene, the daughter of a Byzantine emperor and wife to one of the Hohenstaufen kings. In his contemporary poem, Walther von der Vogelweide praised her as 'A rose without a thorn, a dove without a gall.' Lorch was rediscovered as a mediaeval monument during the Romantic period in the 19th-century; for many poets, artists, travellers and holiday visitors, the abbey became the memorial church for the Hohenstaufen dynasty. The picturesque buildings on a small hill overlooking the Rems valley, the Romanesque church, the well-kept monastery garden and the encircling walls still exert a special fascination today.

Kloster Lorch
73547 Lorch

Telephone
+49 71 72/92 84 97

E-Mail
info@kloster-lorch.com

Internet
www.kloster-lorch.com

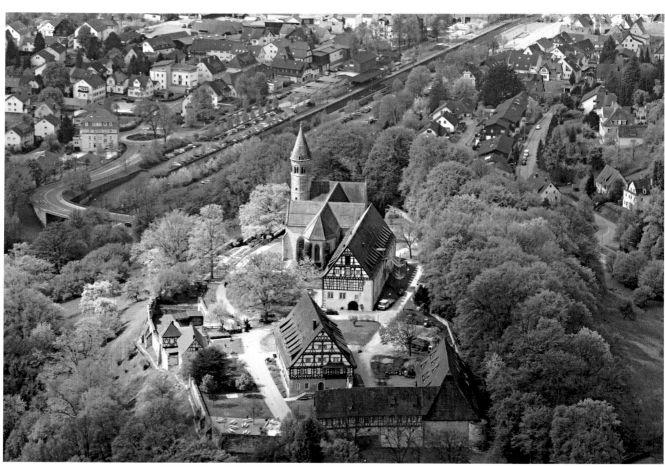

Lorch Abbey, aerial view

Bebenhausen Abbey and Schloss Bebenhausen

Kloster Bebenhausen
Im Schloss
72074 Tübingen-
Bebenhausen

Telephone
+49 70 71/60 28 02

E-Mail
info@kloster-
bebenhausen.de

Internet
www.kloster-
bebenhausen.de

The former Cistercian abbey at Bebenhausen lies in the middle of the Schönbuch nature reserve, not far from the university town of Tübingen with its rich traditions. Time almost seems to have stood still here. After walking through the village's narrow streets, one enters the abbey grounds. When the church, the cloisters and the adjoining buildings were erected at the start of the 13th century, the emphasis, as at Maulbronn Abbey, was on austerity, restraint, renunciation and asceticism. Yet today one is struck by the graceful elegance of the light-filled summer refectory, the brothers' dining-hall. Gothic fan-vaulting rises from the tall, slim pillars. The elegant atmosphere captivates today's guests, too. Other rooms to be seen on a tour of the abbey – the chapter-house, the parlatorium (the only room where the vow of silence did not apply), and the dormitory – all reveal the craftsmanship of the Cistercian monks. By the 15th century, they

had turned the abbey into a flourishing community, one of the richest in Württemberg. The abbey was dissolved in 1556, in the course of the Reformation. Duke Christoph von Württemberg set up one of his four monastery schools for advanced pupils here. King Friedrich I, however, had the school closed down and merged with the one at Maulbronn. Liking this region, he converted the former abbot's residence into a hunting-lodge for elaborate court hunting expeditions. Württemberg's last royal couple – Wilhelm II, an unassuming king revered by his subjects, and his consort Charlotte – spent the last years of their lives here after 1918. The original royal rooms in the hunting-lodge show how the king and queen lived in those days. In the kitchen, which is also on show, it seems as if the servants have just left the room, since the kitchen with its stove and warming-cupboards still looks so functional today.

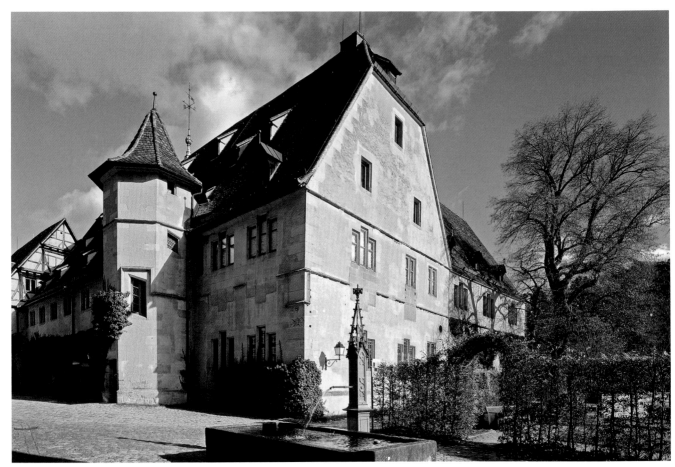

Schloss Bebenhausen

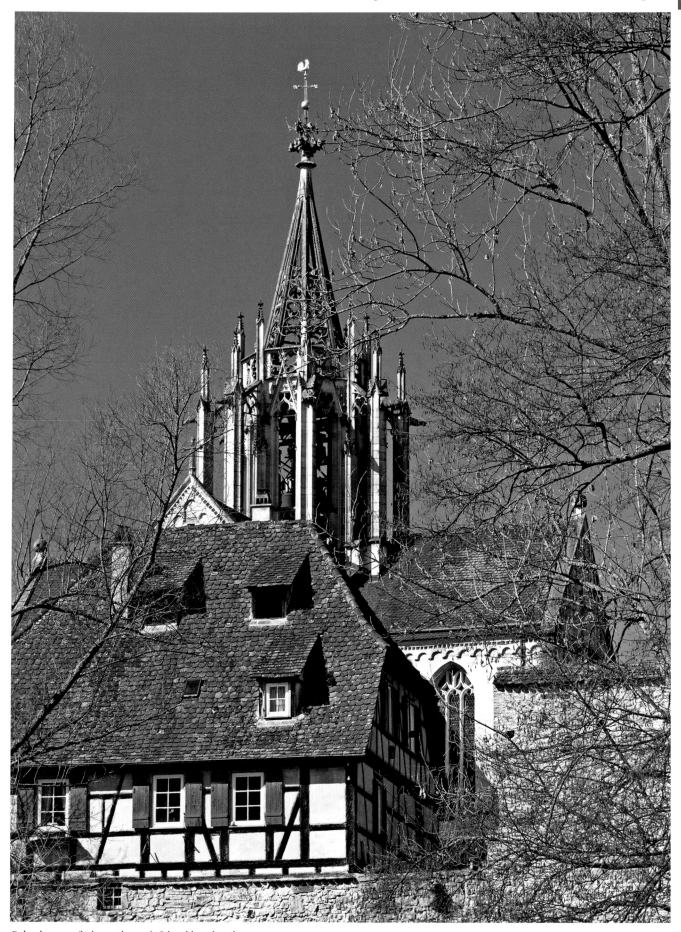

Bebenhausen, flèche on the roof of the abbey church

Schloss Ludwigsburg

Schloss Ludwigsburg
Schlossstraße 30
71634 Ludwigsburg

Telephone
+49 71 41/18 20 04

E-Mail
info@schloss-
ludwigsburg.de

Internet
www.schloss-
ludwigsburg.de

It is worth spending several days in Stuttgart and its lovely surroundings as the climax of a tour of Baden-Württemberg's palaces and castles. No less than five palaces in the area transport one to a courtly world full of treasures and royal nostalgia. Schloss Ludwigsburg, the residence of Württemberg's dukes just north of Stuttgart, is the most impressive and extensive baroque stately home. As one walks through the first courtyard into the Court of Honour, leaving behind the noise-filled street, one's eye is caught and held by the abundance of curving forms, gables and window pediments with a wealth of ornament. The numerous buildings convey an impression of grandiose splendour. Over the centuries, all the rulers here gave expression to their ideas about how to wield power and impress people. This applied above all to Duke Eberhard Ludwig. Maybe it was merely a whim of the prince's that caused him to have the little summer residence and hunting-lodge called 'Ludwigsburg' erected in baroque style in 1704. The ambitious duke strove to hold court in magnificent style, and of course, he had Versailles in mind. Wishing to outdo Rastatt and Munich, he ordered his hunt-ing-lodge to be converted into Germany's largest baroque palace, and the town of Ludwigsburg to be re-planned entirely. Ludwigsburg's period of pre-eminence began in 1724, when it was raised to the status of 'sole and permanent seat' – in place of Stuttgart. Here only a couple of important rulers can be mentioned: the youthful duke Carl Eugen proved to be very progressive in matters of art and culture. He had his predecessor's opulent baroque splendour replaced with the light and lively rococo style and also erected a court theatre with ingenious equipment and decorations. With its glittering festivals and spectacular productions of operas and theatre plays, the palace was then among the most brilliant courts in Europe. In the 19th century, after Württemberg had become a kingdom, Friedrich I had the interior refurbished in neo-classical style on the French model. The virtually complete preservation of Schloss Ludwigsburg makes it possible for its visitors to go on an exciting journey through the most outstanding epochs of modern times.

Peace Gallery

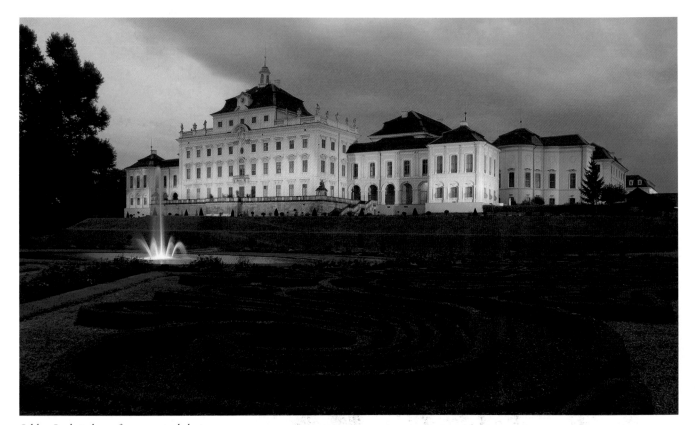

Schloss Ludwigsburg, former corps de logis

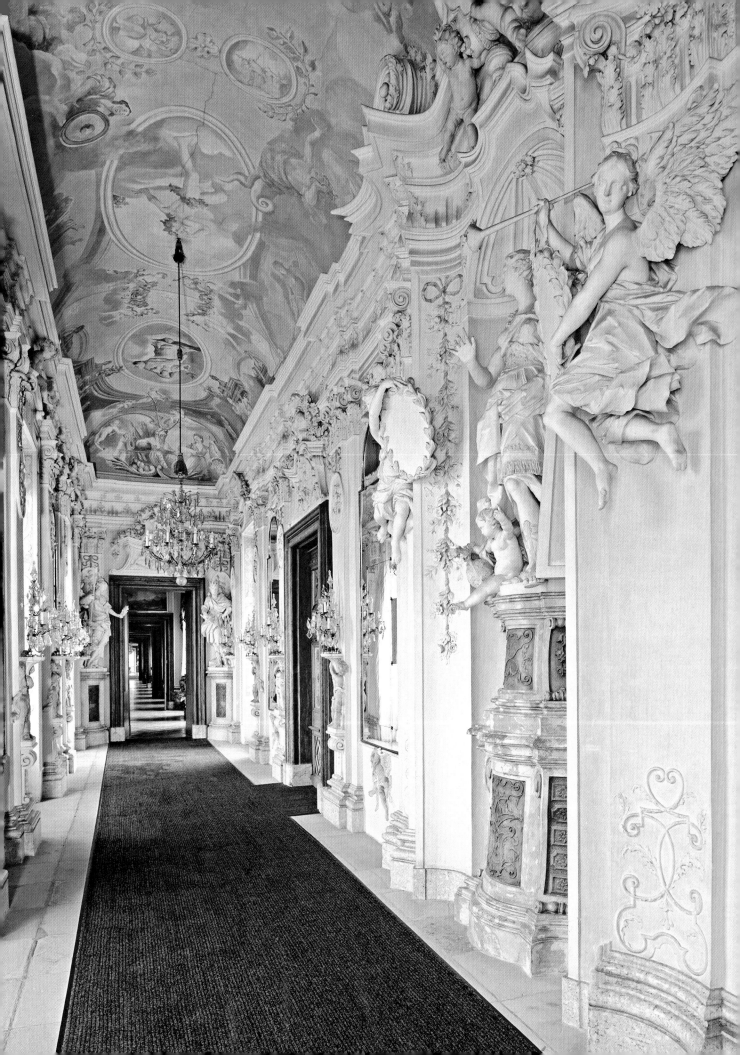

Schloss Favorite

Schloss Favorite
Favoritepark 1
71634 Ludwigsburg

Telephone
+49 71 41/18 20 04

E-Mail
info@schloss-
ludwigsburg.de

Internet
www.schloss-
ludwigsburg.de

After all this baroque pomp and the austerity of neo-classicism, a lengthy stroll through a green landscape is to be recommended, and the extensive gardens of the palace with masses of flowers, artificial waterfalls and grottoes are ideal for this purpose. At 'Baroque in Bloom', a fantastic fairytale world offers lots of surprises. After that, Schloss Favorite, the nearby summer palace and hunting lodge, is well worth visiting. All important baroque courts were expected to have charming summer residences, hunting lodges and splendid gardens on the same site as the imposing stately home. This is the reason why Duke Eberhard Ludwig, whose hunger for power has already been mentioned, had this smaller mansion erected. Set in a large park, Favorite was planned as an eye-catching baroque jewel at the northern end of the main axis of Ludwigsburg Park. The summer residence was used for relaxation and diverting festivities by the prince's entourage during hunting expeditions; from the piano nobile there was a splendid view of the 'endless' expanse of landscape. The enclosures where pheasants were reared were later moved elsewhere by Carl Eugen and the pheasants replaced by white deer. It is not hard to imagine the wonderful view that presented itself. Very appropriate in this context are the comments made by Giacomo Casanova in 'My Life History' (Vol. VI, Berlin 1985): 'In those days (1760), the Württemberg court was the most brilliant one in Europe...There was lavish expenditure on generous salaries, magnificent buildings, hunting expeditions and madness of all kinds'. Like the family seat, the nature of this summer residence was determined by the taste of the time and by the wishes of its owners. Soon after coming to the throne, King Friedrich I had the park turned into an enclosure for wild animals and had the interior of Schloss Favorite refurbished in neo-classical style. The central hall and the rooms at the east end were decorated with costly stucco ornaments and paintings with classical motifs.

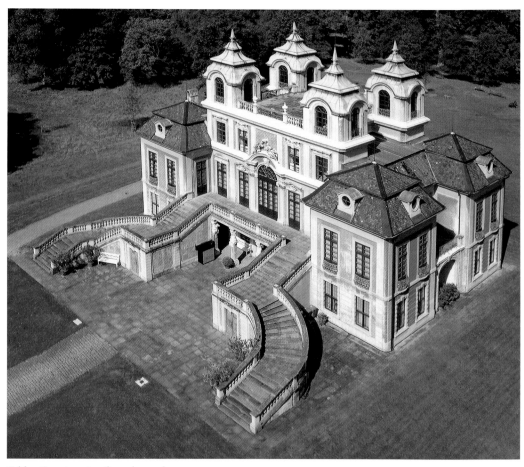

Schloss Favorite, view from the south-east

Memorial Chapel on the Württemberg

Before one leaves the Stuttgart area to visit the 'hidden' rural beauties of Hohenlohe and north-eastern Baden-Württemberg, a visit to the memorial chapel on the hill known as the Württemberg will offer a kind of memento mori. Standing alone so that it can be seen from afar, the family mausoleum of Württemberg's monarchs lies among vineyards high above the Neckar valley. King Wilhelm I had the chapel built in 1820–21 as an expression of his eternal love for his beautiful queen, Katharina, who had died far too young. He chose this idyllic situation because it was the site of his dynasty's ancestral seat and because the czar's daughter wanted this to be her last resting-place. She had quickly won the hearts of her subjects as the founder of various charitable institutions, and was a princess of exceptional intelligence and beauty. The news of her death was received in the country with great sadness and

dismay. The neo-classical rotunda was designed using local sandstone by the court architect Giovanni Salucci and became the memorial for the much-loved queen. The towering statues of the four evangelists in the wall-niches in the central hall of the rotunda as well as the two sarcophaguses in the crypt are made of costly white Carrara marble. When the sun is shining, a golden light falls through the glass roof in the centre of the dome into the chapel's interior and into the crypt below, enveloping everything in a mystical brilliance. Only Wilhelm and Marie, the couple's daughter, now lie in the double coffin: 'Love is eternal' are the words the king had inscribed above the entrance. Everyone is overwhelmed by a feeling of melancholy when they hear this love story in this setting. Yet the magnificent views of the splendid rolling countryside entice one to continue one's journey.

Grabkapelle Rotenberg
Württembergstraße 340
70327 Stuttgart

Telephone
+49 7 11/33 71 49

E-Mail
info@grabkapelle-
rotenberg.de

Internet
www.grabkapelle-
rotenberg.de

 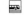

Aerial view of the memorial chapel on the Württemberg

Schloss Solitude

Schloss Solitude
Solitude 1
70197 Stuttgart

Telephone
+49 7 11/69 66 99

E-Mail
info@schloss-solitude.de

Internet
www.schloss-solitude.de

Schloss Solitude, an elegant summer residence, stands in a lovely position among wooded hills to the south-west of Stuttgart. The distant views as far as the Swabian plain and the lonely situation must have impressed Duke Carl Eugen of Württemberg. The 'Solitude' conceived by the duke was built from 1763 as a retreat that would enable him to enjoy some private life away from the ceremony of state. The monarch himself worked with famous architects on the plans for the building, and with its variety of form and its dimensions it became almost like his third residence. The public apartments – the White Salon, the Music Room and the Assembly Room – could be used for formal occasions, as could the duke's official suite of rooms with its Marble Hall and Palm Room. The ruler used all possible artistic means to portray his power and to compete with other courts in a display of splendour. Guided by the fashion of the time, the opulent public rooms were decorated with masterly skill in late rococo style, already with overtones of early neoclassicism. The brilliant colours of the fresco on the ceiling of the central White Salon extol Carl Eu-

gen's clemency and wisdom as a ruler. In these state rooms, life-like palm fronds made of stucco and artistically draped rose garlands create a fantastic background against which court etiquette had to be observed, even when the princes were amusing themselves with theatrical performances, ballets, festivals and the chase. This was something that Friedrich Schiller, the 'Sturm und Drang' poet, also discovered, though in those days he was not a writer of classic works but a strictly disciplined pupil at the 'hohe Carlsschule'. Duchess Franziska von Hohenheim, Carl Eugen's wife, was the patron of the young genius; after all Schiller's father was in charge of the upkeep of the extensive palace grounds.

Here in this jewel of a building surrounded by greenery, it is quite easy to imagine being at one of those splendid court festivals. 'The woods were illuminated; whole hosts of fauns and satyrs came leaping out of grottoes constructed among the trees, and performed ballets at midnight.' (Carl Eduard Vehse, Die Höfe zu Württemberg, 1853)

Palm Room

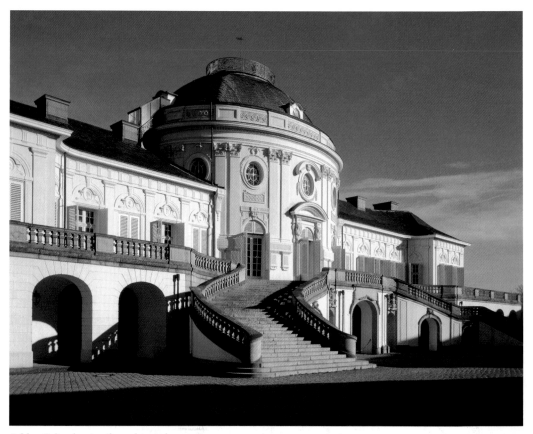

Schloss Solitude, view from the south-west

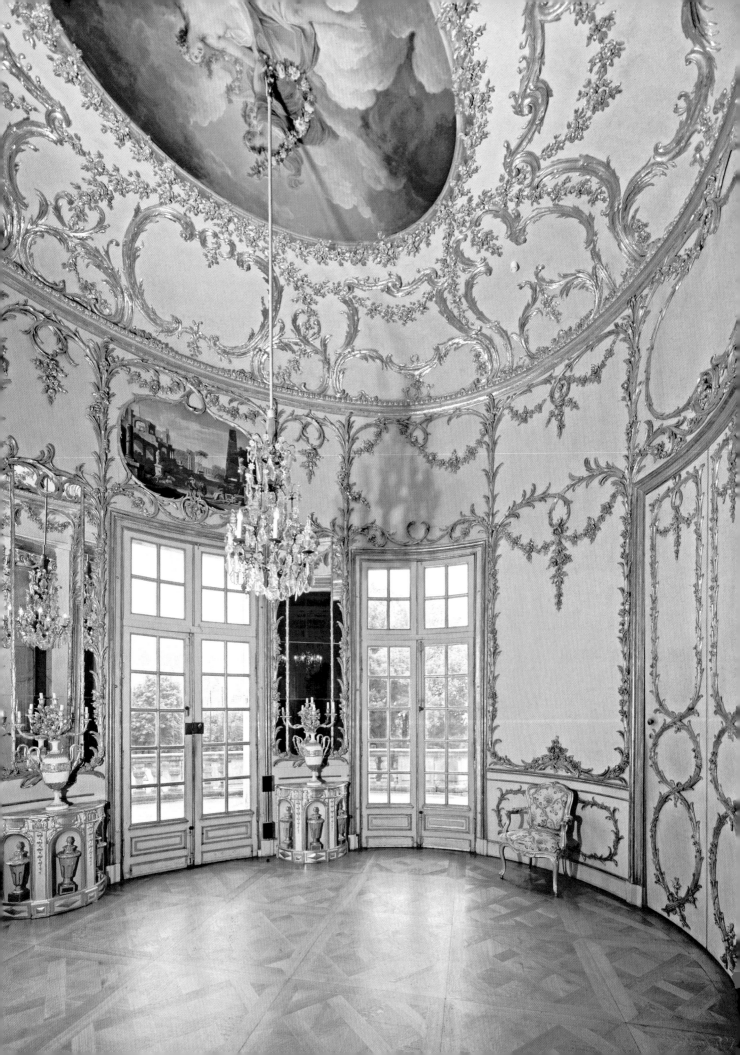

Schloss Weikersheim and its Gardens

Schloss Weikersheim
Marktplatz 11
97990 Weikersheim

Telephone
+49 79 34/99 29 50

E-Mail
info@schloss-
weikersheim.de

Internet
www.schloss-
weikersheim.de

The Tauber valley, part of the Romantic Route in Hohenlohe, is a heavenly spot for walks and relaxation. The gentle hills and delightful valley encourage one to make one of the last stops on this journey through many centuries – at Schloss Weikersheim and its gardens. 'The people of Weikersheim will not regard one as educated if one has not seen the Hohenlohe palace with its Knights' Hall and its French gardens. These people are right: the palace is one of the symbols of their town; it embraces the total sum of its artistic impressions. The spirit can relax in the palace gardens with its statues of male and female dwarves in all sorts of garments, and statues of goddesses and nymphs in almost no garments.' These impressions are still apposite though they were actually noted down by the historian Wilhelm Heinrich Riehl in his book 'A Stay in Weikersheim' in 1865. This place has lost none of its magic since that time. The great Knights' Hall still receives its visitors in all its magnificence; created about 1600, it is truly a masterwork of the Renaissance. Dazzled by the dimensions of this banqueting hall and by the beauty of its decorations, one suddenly glimpses an enormous elephant or a leaping stag, both placed as life-size three-dimensional figures on the wall. The brilliantly constructed coffered ceiling shows numerous aristocratic hunting-scenes. The huge chimney-piece with its artistic decoration and the stiffly posed portraits of Hohenlohe counts looking sternly down at the visitor reflect the brilliance of earlier days. The long row of windows offers a splendid view of the baroque pleasure gardens and the orangeries at the end of them and on into the Tauber valley beyond. The renovated state apartments at Weikersheim contain valuable furniture, mirrors, tapestries and Chinese porcelain dating from the baroque and rococo periods.

One can walk along avenues with formal plants and flower-beds, past well-kept fruit and vegetable plots and sculptures of mythological gods until one finally reaches the dwarves' gallery in Weikersheim's palace garden. One leaves this magical place with a wealth of impressions and sentiments – and hopes to return here again and again.

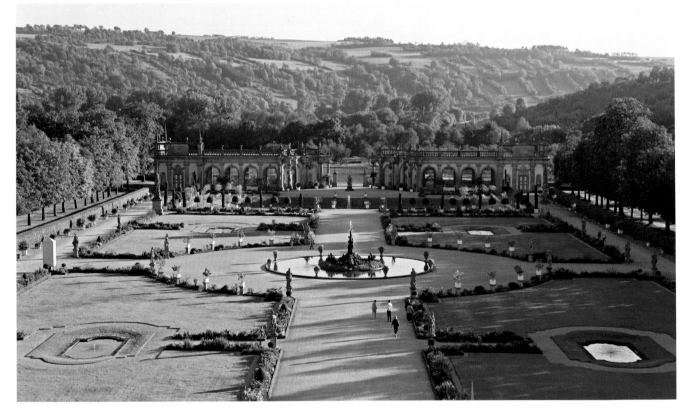

Schloss Weikersheim, gardens

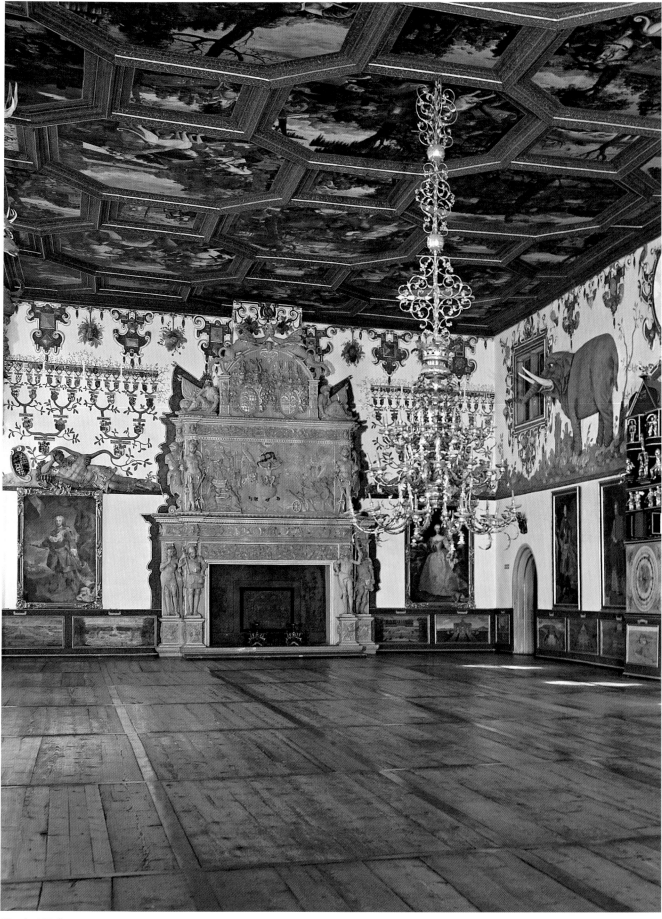

Knights' Hall

Schöntal Abbey

Kloster Schöntal
Klosterhof 1
74214 Schöntal

Telephone
+49 79 43/9 10 00

E-Mail
info@schoental.de

Internet
www.kloster-
schoental.de

The Cistercian monks from Maulbronn showed an instinctive feeling for a beautiful and fertile site when, about 1157, they established a branch of their monastery in the picturesque Jagst valley. Sweeping, flower-filled meadows and gentle wooded hills surround the former abbey, which lived up to its name – speciosa vallis in Latin and Schöntal, i.e. beautiful valley, in German –, a reference to the ideal geographical and climatic conditions. The brothers created a powerful and prosperous community here during the Golden Age of their order. Yet, as happened almost everywhere in the country, the abbey was plundered during the peasant uprisings, besieged during the Thirty Years' War, and was nearly closed down in the Napoleonic period. Its 850-year-old history, from the Middle Ages to the present day, can be read as if in an open book. Dominating the whole site, the mighty baroque abbey church with its twin-towered façade rises imposingly from the floor of the valley. Precious stucco work, frescoes on the walls and ceilings, altars and sculptures adorn the hall church, which is pleasantly cool, particularly in the summer months. The so-called 'New Abbey' adjoins it, an impressive building, almost like a small palace. As soon as one enters the hallway with a splendid flight of stairs curving upwards, richly gilded decorations and the colourful ceiling painting, one has the feeling of being in a princely residence. The urge to impress felt by the Cistercian abbots in the 17th and 18th centuries is palpable in this building. The order's assembly hall, the picture gallery, the banqueting hall and the cloisters complete this portrayal of ecclesiastical power. The monastery was dissolved in 1803 during the period of Secularisation. Since 1979, the buildings have housed a hospitable adult education centre belonging to the Roman Catholic diocese of Rottenburg-Stuttgart and a centre for school trips. Whether the ghost of the bold knight Götz von Berlingen, whose tomb the visitor will find in the cloisters, still haunts the abbey can be discovered only by visiting Schöntal.

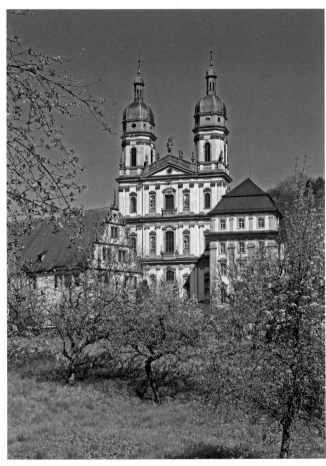

Schöntal Abbey Church

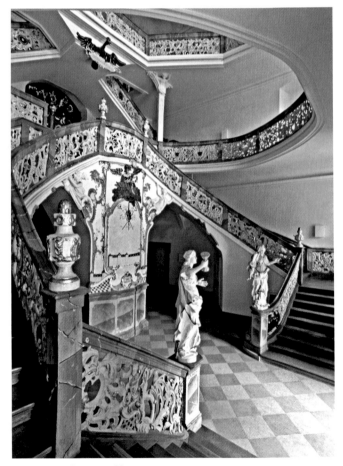

Staircase in the New Abbey

Grand Dukes' Memorial
Chapel, Karlsruhe
Klosterweg 11
76131 Karlsruhe

+49 72 22/97 81 78

www.schloesser-und-
gaerten.de

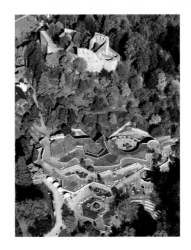

Badenweiler Castle Ruins
Schlossbergstraße
79410 Badenweiler

+49 72 22/97 85 70

stephan.hurst@
ssg.bwl.de

www.schloesser-und-
gaerten.de

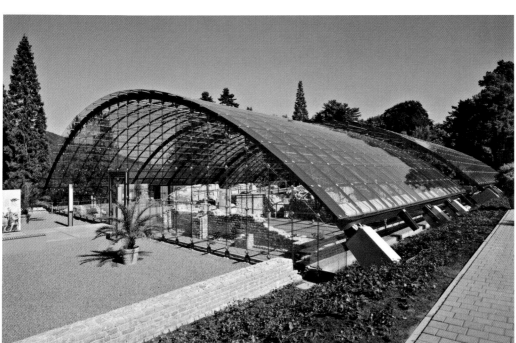

Ruined Baths, Baden-
weiler
79410 Badenweiler

+49 76 32/79 93 00

touristic@
badenweiler.de

www.badenweiler.de

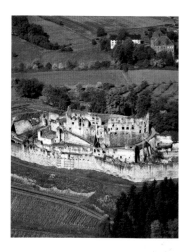

Society for the Preser-
vation of the Ruins of
the 'Hochburg'
Office in the Town Hall
Landvogtei 10
79312 Emmendingen

+49 76 41/45 22 17

info@hochburg.de

www.hochburg.de

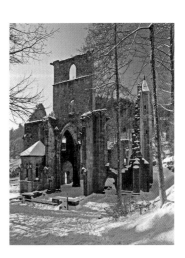

All Saints' Abbey Ruins
77728 Oppenau

+49 78 04/91 08 30

info@oppenau.de

www.oppenau.de

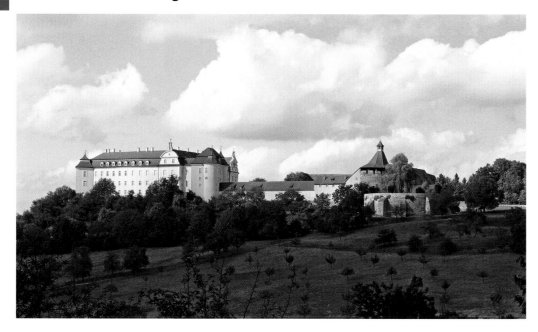

Schloss Ellwangen
73479 Ellwangen

+49 79 61/5 43 80

info@schlossmuseum-
ellwangen.de

www.schlossmuseum-
ellwangen.de

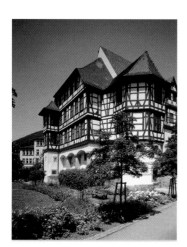

Schloss Urach
Bismarckstarße 18
72574 Bad Urach

+49 71 25/15 84 90

info@schloss-urach.de

www.schloss-urach.de

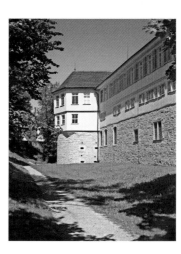

Schloss Kirchheim
Schlossplatz 8
73230 Kirchheim unter
Teck

+49 70 71/60 28 02

info@kloster-
bebenhausen.de

www.schloss-
kirchheim.de

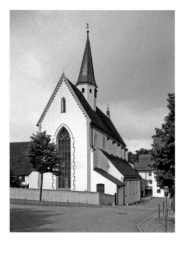

Heiligkreuztal Abbey
Church and Museum
Am Münster
88499 Altheim-
Heiligkreuztal

+49 73 71/1 86 45

fensterle.erich@
t-online.de

www.schloesser-und-
gaerten.de

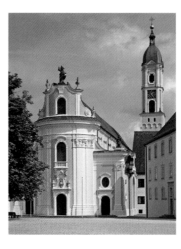

Ochsenhausen Abbey
Schlossbezirk 6
88416 Ochsenhausen

+49 75 83/9 26 90 82

info@
kloster-wiblingen.de

www.schloesser-und-
gaerten.de

Bavaria

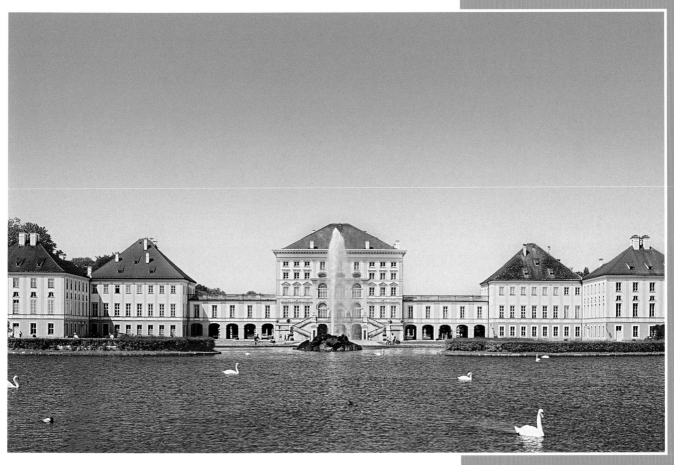

 Bayerische Verwaltung der
staatlichen Schlösser, Gärten und Seen

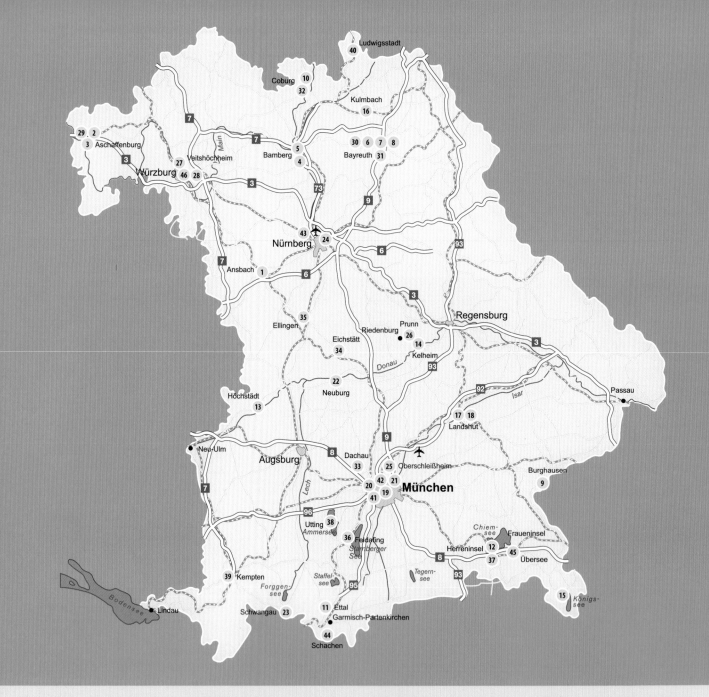

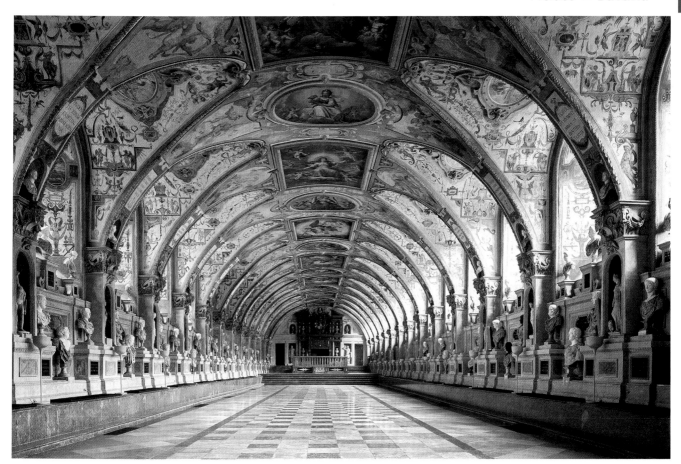

The residence at Munich, Hall of Antiquities

The Bavarian State Castles –
Unique Sites of Art, Culture, and History

In "Bavaria, the Land of Castles," unique ensembles of stately European architecture have been preserved along with their artistic interiors. A number of these have a worldwide reputation and are recognized as UNESCO World Heritage Sites. Reflected in these structures is the diverse history of the Free State of Bavaria: the 45 monumental edifices, which are run by the Bayerische Verwaltung der staatlichen Schlösser, Gärten und Seen (Bavarian Administration of State-Owned Palaces, Gardens, and Lakes) at one time served to represent a dozen independent political entities. They have become emblems of Bavarian and Frankish, even German culture; they provide a regional identity while attracting visitors from all over the world. Often they are surrounded by distinguished parks and gardens, historical masterpieces of garden design which play important ecological as well as recreational roles even today.

What distinguishes most castles from museums and makes them so intriguing to visitors is their direct confrontation with past realms of experience. Works of art are neither isolated nor displayed by tearing them from their former context, but are instead set in their primary historical environment and are thus integrated into their original milieu. Courtly art becomes experienced in its erstwhile capacity, still delivering its constitutive political message and providing not simply aesthetic pleasure. Amidst the increasingly virtual existence of our era, palaces, castles, and gardens allow us to delve into an authentic past. In addition, many palaces and castles are sites of a thriving culture – concerts, theatrical performances, and other events take place here, appropriate to and respectful of the monuments themselves.

The tasks of the Bavarian Palace Department, which was developed from the royal Bavarian Obersthofmeisterstab in 1918, are to cultivate, maintain, and appropriately present the cultural and natural heritage sites in their care to the public sphere. It aims to enhance the appeal of these precious ensembles via their optimal presentation and special exhibitions which illustrate their complex history. The head office of the Bavarian administration, with various departments for its properties and conscientous preservation of buildings, collections, and gardens, is located in Munich. The orderly upkeep of these buildings is supervised by on-site maintenance.

The Residence and Court Garden at Ansbach

Residenz und Hofgarten Ansbach
Schloss- und Garten-verwaltung Ansbach
Promenade 27
91522 Ansbach

Telephone
+49 9 81/95 38 39-0

E-Mail
sgvansbach@
bsv.bayern.de

Internet
www.schloesser.
bayern.de

The residence at Ansbach evolved from a medieval complex. In about 1400, the Gothic Hall was built, which displays Ansbach-manufactured faience and porcelain. From 1705–1739, the medieval structure was converted into a modern residence. The architect Gabriel de Gabrieli built the Mediterranean-flavored arcaded courtyard. The palace is renowned for its high-quality and stylistically unique interior, which was primarily constructed between 1734–1744 by French-schooled artisans under the direction of Leopold Retti. Silk wallpaper coverings, stucco, and furniture are of extraordinary quality. Even after the former margraviate of Brandenburg-Ansbach had fallen to the Bavarian king in 1806, the main floor underwent few alterations. It is comprised of three rooms, which are independently used for state ceremonies: the margrave's apartment, the margravine's apartment, and the guest apartment, with a fixed succession of ante-rooms, audience chambers, bedrooms, and closets.

Although always separated from the palace by existing buildings, the court garden with orangery is also part of the Ansbach residence. In front of the orangery, which was built from 1726–1743, is a parterre flanked by two rows of linden trees. The principal axis, with two rows of tall hedges, runs parallel to the front of the building. In keeping with Baroque pattern books, a wide array of plant species is featured in the parterre. The assortment of potted plants during the summer consists of lemons, bitter oranges, olives, pistachios, as well as laurel and strawberry bushes.

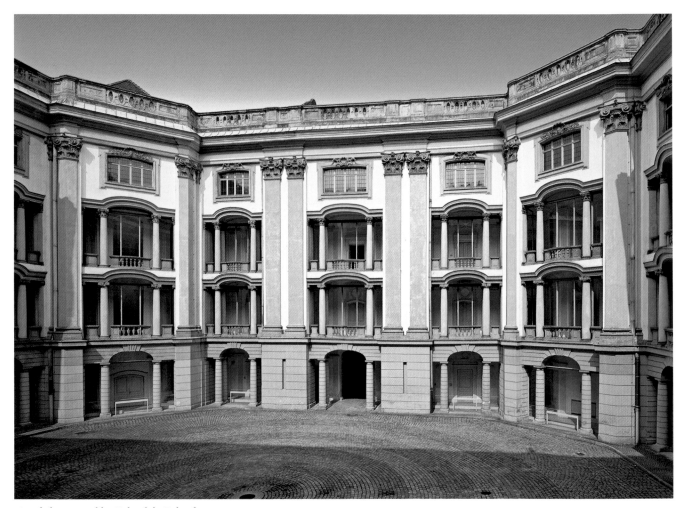

Arcaded courtyard by Gabriel de Gabrieli

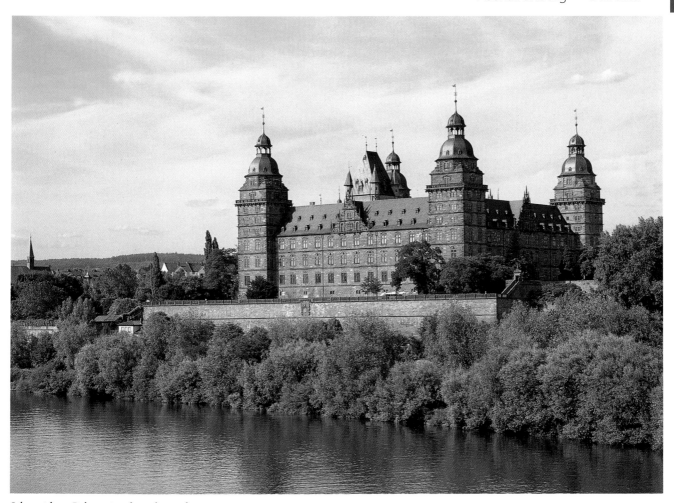

Johannisburg Palace, view from the south

Johannisburg Palace

Johannisburg Palace is located at the center of Aschaffenburg at the banks of the Main River. Until 1803, it served as the second residence for the electors and archbishops of Mainz. The massive, four-winged red sandstone complex, measuring nearly 90 by 90 meters, is one of the most outstanding palaces of the German Renaissance. Only the old 13th-century keep, built from 1605–1614 by the Strassbourg native Georg Ridinger under Archbishop Johann Schweikart von Kronberg, was integrated into the new construction of the palace. At the end of the 18th century, the architect Emanuel Joseph von Herigoyen refurbished the interior in the contemporary Louis-Seize style. Following damages sustained during the Second World War, the princely living rooms were reconstructed to a near-original state and decorated with what remained of the original furniture, includ-

ing valuable items by the Roentgen pupil Johannes Kroll. Also among the preserved treasures are the splendid ecclesiastical robes in the Vestment Chamber from Mainz Cathedral. A special attraction of the palace is its exhibition featuring the largest collection of historical cork models worldwide. The permanent display, "Carrying Rome Across the Alps" displays 45 of these astoundingly-detailed colored cork architectural models, which reproduce the most distinguished buildings of ancient Rome. The dimensions of these replicas, made by the court confectionist Carl May and his son Georg between 1792 and 1854, range from the 20-centimeter Cestius Pyramid to the largest cork model ever built, the Colosseum, with a diameter of over 3 meters. Other palace highlights include the State Gallery of the Bavarian State Collection of Paintings, as well as the city's Palace Museum.

Schloss Johannisburg
Schloss- und Gartenverwaltung Aschaffenburg
Schlossplatz 4
63739 Aschaffenburg

Telephone
+49 60 21/3 86 57-0

E-Mail
sgvaschaffenburg@bsv.bayern.de

Internet
www.schloesser.bayern.de

 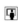

Schönbusch Palace

Schönbusch Palace and Park

Schloss und Park
Schönbusch
Kleine Schönbuschallee 1
63741 Aschaffenburg

Telephone
+49 60 21/62 54 78

E-Mail
sgvansbach@
bsv.bayern.de

Internet
www.schloesser.
bayern.de

Schönbusch is an early example of the new land-scape garden style in Germany. In addition to rare trees, it is also possible to spot a number of delightful Classical buildings composed within the park, charmingly designed with artificial hills and bodies of water. The palace and park are located amidst the wide strip of the Main River, across from the historic district of Aschaffen-burg and directly along the old main road head-ing towards Darmstadt which is known as the "Großen Schönbuschallee." Friedrich Carl von Erthal, elector and archbishop of Mainz, had the former electoral game preserve in Nilkheim Forest redesigned into a landscape garden. With substantial participation from his state minister, Earl Wilhelm von Sickingen, man-made lakes and streams were excavated, hills were built, and a serpentine path was laid around the exterior.

The architect Emanuel Joseph von Herigoyen designed the garden buildings. The first one to be built was the Electoral Pavilion, known today as Schönbusch Palace, a small, classical summer residence with exquisite furnishings in the Louis-Seize style. By 1788/89, picturesque rural decora-tions of farm buildings, shepherd's cottages, and the village were added, as well as the Temple of Friendship, the Philosopher's House, the View-ing Tower, the Dining Hall, and the Red Bridge. By 1783 at the latest, Friedrich Ludwig Sckell, the young court gardener from Schwetzingen, was called in to complete the garden complex. Sckell was able to apply the landscaping principles he had acquired in England towards the design of an entirely new park, making Schönbusch one of the most outstanding landscape gardens in Ger-many.

The New Residence and Rose Garden of Bamberg

With two elongated wings and concluding with the Fourteen Saints Pavilion, the imposing sandstone of the Bamberg residence surrounds two sides of the cathedral square. The prince-archbishops of Bamberg reigned here until 1802. Between 1697 and 1703, Archbishop Lothar Franz von Schönborn commissioned Johann Leonhard Dientzenhofer to build the first grand Baroque palace in Franconia. Two older wings were attached at the rear. The impressive appearance of the exterior, which escaped the ravages of war, is surpassed only by its interior. In over 40 state rooms, original stucco ceilings, inlaid floors, as well as over 500 furnishings and decorative fittings from the 17th and 18th centuries radiate the authentic atmosphere of an electoral residence. In the Emperor's Hall, Melchior Steidl painted wall frescoes (1707–1709) with oversized portraits of German emperors and the ceiling fresco with the allegory of "Good Governance." Next to the electoral rooms and the prince-bishopric apartment, a series of rooms commemorate King Otto of Greece, a Wittelsbach who was exiled to Bamberg in 1862. The imperial lodging, which was reopened in 2009, was the most politically significant suite of rooms. In 1900, it was furnished as the last representative apartment of the Bavarian monarch for Hereditary Prince Ruprecht and his wife.

Upon a large terrace at the residence's interior courtyard is the rose garden, which offers visitors a magnificent view of the city. During the summer months, the fragrance and bloom of approximately 4,500 roses extend across the garden. An architectonic reference point is the rococo pavilion, which was built in 1757 and now contains a café.

Neue Residenz Bamberg
und Rosengarten
Schloss- und Garten-
verwaltung Bamberg
Domplatz 8
96049 Bamberg

Telephone
+499 51/5 19 39-0
+499 51/5 19 39-1 14

E-Mail
sgvbamberg@
bsv.bayern.de

Internet
www.schloesser.
bayern.de

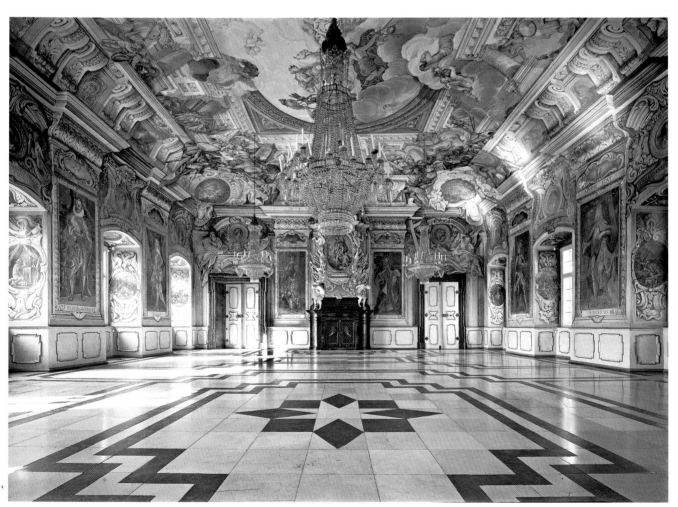

New Residence, Imperial Room

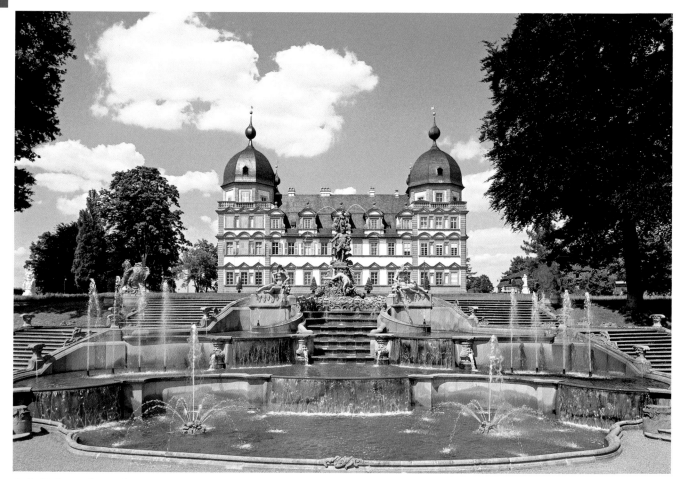

Seehof Palace with cascade

Seehof Palace

Schloss Seehof
96117 Memmelsdorf

Telephone
+49 9 51/40 95-70
+49 9 51/40 95-71

E-Mail
sgvbamberg@
bsv.bayern.de

Internet
www.schloesser.
bayern.de

Begun in 1686 and built according to plans by Antonio Petrini, Seehof Palace became the summer residence of Bamberg's prince-bishops. In doing so, the castle-like, four-winged structure with four corner towers, modeled after the palace in Aschaffenburg, may have already seemed somewhat outdated. Following its secularization and neglect under private ownership, the building with its enormous garden was acquired and renovated by the Free State of Bavaria in 1975. Today, the majority of the castle is used by an external branch of the Bavarian State Conservation Office.

In addition to the palace chapel, the princely apartments and the apartment used as the delegate's guest quarters are visitor-accessible. Beginning in 1760, both suites were newly furnished under Prince-Bishop Adam Friedrich von Sensheim and from time to time, components of the former art holdings have been successfully reacquired. In the center of the sequence of rooms is the White Hall, with its masterly painted ceilings by Joseph Ignaz Appiani. In his painting of 1751, themes of the annual seasons, music, gardening, the tilling of fields, as well as hunting and fishing are explored.

The focal point of the entire complex, however, consists of the starkly-formed and wall-enclosed park, which on the basis of preserved sections and original plans, has been undergoing reconstruction since 1975. Its renown is drawn from approximately 400 garden figures from the workshop of the sculptor Ferdinand Tietz, the majority of which have been lost and partially replaced by castings. Preserved originals can be viewed at the Ferdinand Tietz Museum. Above the extravagant cascade with its water features from 1764/71, stands Hercules as an allegory to the builder Adam-Friedrich v. Seinsheim, who towers over not only his enemies and vices, but also over the arts and sciences.

The Margravial Opera House

A jewel among historical theatrical buildings is the Margravial Opera House, one of the few originally-preserved opera houses of the Baroque era. The building was designed by Joseph St. Pierre (1709–1754). A magnificent temple front looms above the entrance doors. The grand auditorium, which is accessed through a vestibule and antechamber, was created by the eminent theater architect Giuseppe Galli Bibiena (1696–1757) from Bologna. Giuseppe, who had previously worked as the imperial theatrical engineer in Vienna and later in Dresden, was the star architect of his era. He and many other family members shaped theater and opera life with their innumerable buildings. At his side was his son, Carlo (1728–1780), who worked as a stage designer for an entire decade in Bayreuth. The wooden tiered-box theater is built above a bell-shaped floor plan. The boxes of the three tiers were ordered according to social status, with the margravial ruling pair presented on special occasions in the middle princely loge. The stage is approximately as deep as the auditorium. Mostly a form of Italian opera was performed here whose material was derived from ancient mythology and history. With its architecture and furnishings, the court theater sent a message to its visitors of the period: that the margravian pair of Friedrich and Wilhelmine signaled the advent an era of peace and wisdom, in which the arts could also flourish. The opera house was dedicated in honor of the marriage of their daughter Elisabeth Friedericke Sophie to Charles Eugene, Duke of Württemberg.

Markgräfliches Opern-
haus
Opernstraße 14
95444 Bayreuth

Telephone
+499 21/7 59 69-22

E-Mail
sgvbayreuth@
bsv.bayern.de

Internet
www.bayreuth-
wilhelmine.de

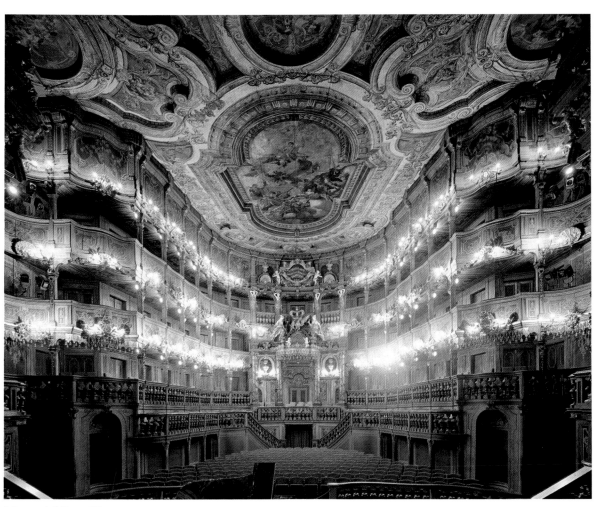

Margravial Opera House

The New Palace and Court Garden in Bayreuth

Neues Schloss Bayreuth
Ludwigstraße 21
95444 Bayreuth

Telephone
+499 21/7 59 69-21

E-Mail
sgvbayreuth@
bsv.bayern.de

Internet
www.bayreuth-
wilhelmine.de

It is thanks to Margravine Wilhelmine von Bayreuth (1709–1758), the favorite sister of the Prussian king Frederick II, that the Bayreuth court became a center of European arts during the Rococo period. In 1731, Wilhelmine was married to Friedrich, the hereditary prince of Bayreuth, who became margrave in 1735.

After the fire of the old palace, the court architect, Joseph St. Pierre (1709–1754) began work on the new city residence in 1753. Particularly distinctive among the margravine's private rooms and designed by Wilhelmine herself, are the Cabinet of Fragmented Mirrors, named for the inlaid mirrors within Chinese motifs, and the Old Music Room. The majority of the stucco was executed by Jean-Baptiste Pedrozzi (1710–1778). The sumptuous wall hangings in the inner antechamber and the audience chamber are from Alexander I. Baert's Amsterdam manufacturer. Characteristic for the Late Rococo style in Bayreuth is the Palm Room in the margrave wing, which gives the impression of being in a palm grove. The ground floor of the New Palace has a rich collection of faience from the Bayreuth manufacturer, founded in 1716. A branch gallery of the Bavarian State Collection of Paintings with 17th and 18th-century works is associated with the lavishly-decorated Italian palace, which Margrave Friedrich had built for his second wife.

The grounds of the court garden has been used as a garden since the end of the 16th century. The Late Baroque complex, laid in 1753/54, was converted into an English-style garden at the end of the 18th century.

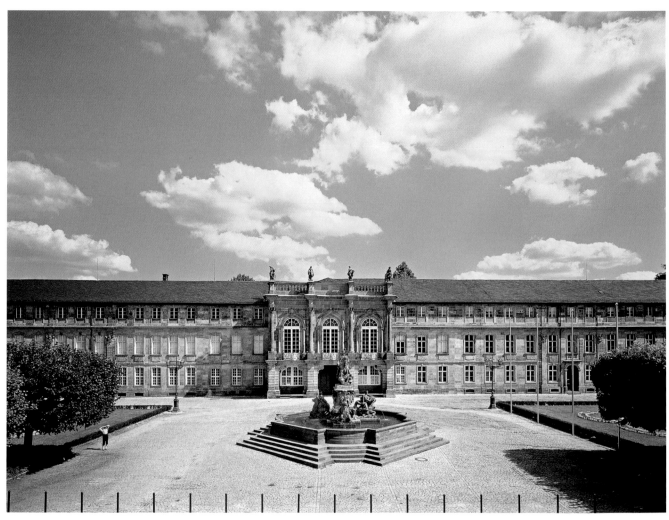

New Palace in Bayreuth

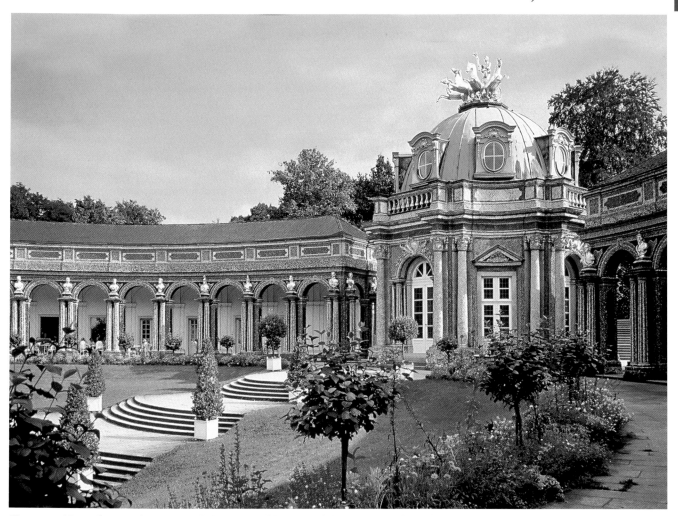

Hermitage, New Palace, north view towards the Temple of the Sun and the eastern circular building

Hermitage and Court Garden

In 1715, Margrave Georg Wilhelm had the Old Palace built as the center of a court hermitage with garden complex, waterfalls, and seven (no longer existing) hermit's huts. The small palace is dedicated to the Ordre de la Sincerité, founded by Georg Wilhelm. The hall through the hidden palace is conceived as the adepts' initiation into this dynastic order. Beginning in 1735, Margravine Wilhelmine expanded the building into a cheerful summer residence. Worth noting are the Audience Chamber, Music Room, Japanese Cabinet, and the Chinese Mirror Cabinet in which she wrote her celebrated memoirs. In the painted ceiling, she puts forth a fascinating concept of her vision of an ideal state in the Age of Enlightenment.

The garden, which was substantially influenced by the margravine, was outfitted with Baroque elements, such as parterres, bosquets, avenues, and a canal garden. The waterfalls of the "Lower Grotto" are meant to be viewed from the terrace or from the "hermit house" of Margrave Friedrich. A Roman theater, built in 1745 by Joseph St. Pierre, marks the earliest example of an artificial ruined theater.

The garden and adjoining forest are enclosed by a surrounding path – one of the elements derived from a landscape garden. The oval layout of the New Palace (1753–1757) creates a boundary for the work. Cut-rock crystal and colored glass brilliantly adorn the central facade at the Temple of the Sun and the circular constructions of the orangery. Crowning the middle temple edifice is Apollo with his sun chariot, with a water basin with mythological figures spread before it.

Eremitage
Eremitage Haus Nr. 1
95448 Bayreuth

Telephone
+499 21/7 59 69-37

E-Mail
sgvbayreuth@
bsv.bayern.de

Internet
www.bayreuth-
wilhelmine.de

The Castle at Burghausen

Burg zu Burghausen
Burg Nr. 48
84489 Burghausen

Telephone
+49 86 77/87 72 33

E-Mail
burg.burghausen@
gmx.de

Internet
www.burg-
burghausen.de

Extending over 1000 meters, Burghausen Castle is one of the longest castles in the world. At the same time, the sweeping castle belonging to the dukes of Wittelsbach is a distinctive symbol of medieval castle and defensive architecture. From 1255 to 1503, the castle served as the second residence of the dukes of Lower Bavaria, who lived in Landshut. It functioned as a domicile for their consorts and the hereditary princes. The rich dukes of Bavaria from Bavaria-Landshut also stored their gold and silver treasures here.

With its virtually intact surrounding walls, the complex extends to a narrow mountain ridge above the Salzach, high above the city of Burghausen. Five large courts, secured by way of moats and gates, divide the mountain plateau of the fortress into sections. With their defending walls, arches, and towers, as well as the domestic buildings and living quarters for court officials and craftsmen, they form the rhythm of the entire complex. This finishes with the powerful main castle at the inner castle court at the south tip of the castle mountain.

Duke Heinrich XIII of Lower Bavaria (reigned 1255–1290) had large sections of the main castle built with the great hall, knights' hall, the inner castle chapel dedicated to St. Elisabeth, and a wing of women's chambers. Duke Georg the Rich had the buildings of the main castle expanded and in keeping with fortificative innovations, had the fortress complex expanded and strengthened. The sprawling castle thus became an imposing bulwark which provided protection while at the same time exuding power and ambition. The museum arrangement in the great hall, featuring furniture, paintings, sculptures, and tapestries from the Gothic and Early Renaissance periods, corresponds to the character of a ducal residence.

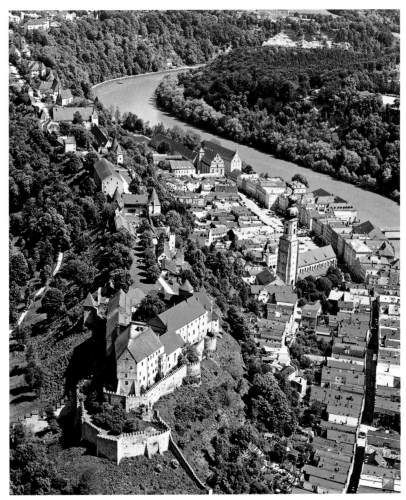

The castle at Burghausen

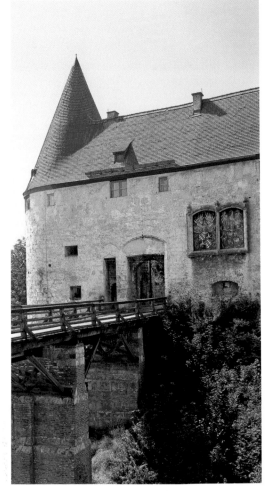

Georgstor

Ehrenburg Palace

In 1547, Duke Johann Ernst von Sachsen-Coburg (reigned 1542–1553) had his court entourage from the Veste moved downhill to the newly-constructed city residence. Within five years, it was built on the site of a dissolved Franciscan cloister. Emperor Karl V (reigned 1519–1556) was said to have given it the name "Ehrenburg" – Palace of Honor – for it had been built without socage. After a fire, Ehrenburg Palace was expanded into a three-winged, Baroque complex in 1690. Built at this time were the palace church and Hall of Giants, a splendid room whose name was given by the powerful Atlas sculptures which support the surrounding entablature. Under Duke Ernst I (reign 1806–1844), Ehrenburg Palace was provided with its Neo-Gothic facade, according to plans by the Berlin architect, Karl Friedrich Schinkel. The apartments were sumpuously decorated by the Frenchman André-Marie Renié-Grétry in the Empire style. Even the quality of the furnishings, with their furniture, bronzes, and textiles, in addition to the fine state of preservation of these rooms, are worth noting. As a result of strategic marriage alliances, the 19th century became synonymous with the international ascent of the house of Coburg. Numerous portraits in Ehrenburg Palace still recall these familial relationships to the royal houses of England, Belgium, and Sweden, among others. Decorative objects from the Historicist epoch represent the grand lifestyle at the turn of the century. In addition, the historic collection of paintings belonging to the Coburg dukes is remarkable. Two galleries display works by Lucas Cranach the Elder and Dutch and Flemish artists of the 16th and 17th centuries, as well as Romantic landscape paintings.

Schloss Ehrenburg
Schloss- und Garten-
verwaltung Coburg
96450 Coburg

Telephone
+49 95 61/80 88-32

E-Mail
sgvcoburg@
bsv.bayern.de

Internet
www.sgvcoburg.de

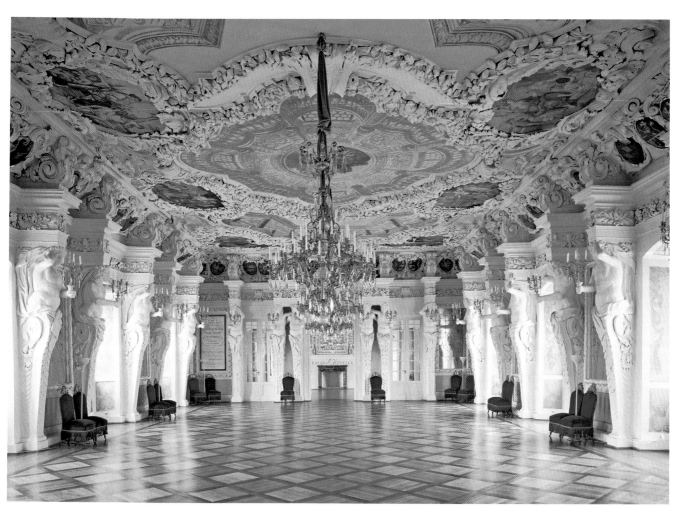

Ehrenburg Palace, Hall of Giants

Linderhof Palace and Park

Schloss Linderhof
Schloss- und Garten-
verwaltung Linderhof
Linderhof 12
82488 Ettal

Telephone
+49 88 22/92 03-0
für Anfragen:
+49 88 22/92 03-49

E-Mail
sgvlinderhof@
bsv.bayern.de

Internet
www.linderhof.de

The "Royal Villa" in Linderhof is the only architectural project of Ludwig II that was completed during his lifetime. The model for this building type and sumptuous decoration is the "Maison de plaisance," the small "pleasure palace" which in 18th-century France was usually placed within a park and in Germany, also frequently built within the park grounds of large palaces. Even the wall and ceiling paintings, as well as the ornamentation, stem from the directive of Ludwig II's French paragons during the era of Ludwig XV. However, the New Rococo style of Ludwig II, in its fullness and density, is extremely influenced by its role models that his predecessor, Emperor Karl VII (reigned 1742–1745) had built in Munich. Over time, Ludwig II's references to him became increasingly marked.

The park of Linderhof Palace, one of the the most qualitative of the 19th century, unites elements of the French Baroque garden and the English landscape garden. Baroque elements include the terrace with water basins placed at the central axis of the palace, the geometric flowerbeds, the long waterfalls with fountains and the two focal points of the Pavilion and Venus Temple. Derived from English examples are the natural-appearing, irregular arrangement of the surrounding park with its exotic trees. The park buildings stem in part from Oriental fashion, which Ludwig II also treasured: the Moroccan House and the Moorish Kiosk, and also from Ludwig's enthusiasm for the music dramas of Richard Wagner, specifically the three stages of the Hunding's Hut (Act I of Die Walküre), the Gurnemanz Hermitage (Act III, Parsifal), and the Venus Grotto (Act I of Tannhäuser) that were built in the park. Through visual axes and kilometer-long paths, the surrounding mountainscape is integrated into this inspired artistic synthesis.

Linderhof Palace, main façade from the south

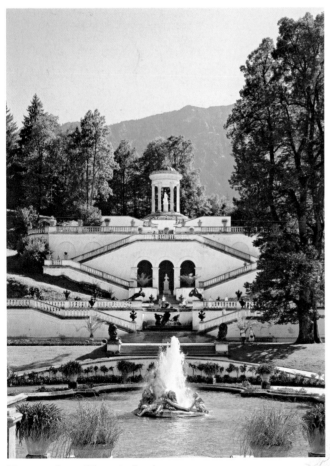

Terrace in front of the main façade

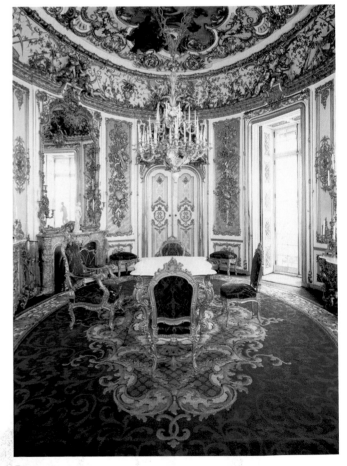

Dining room

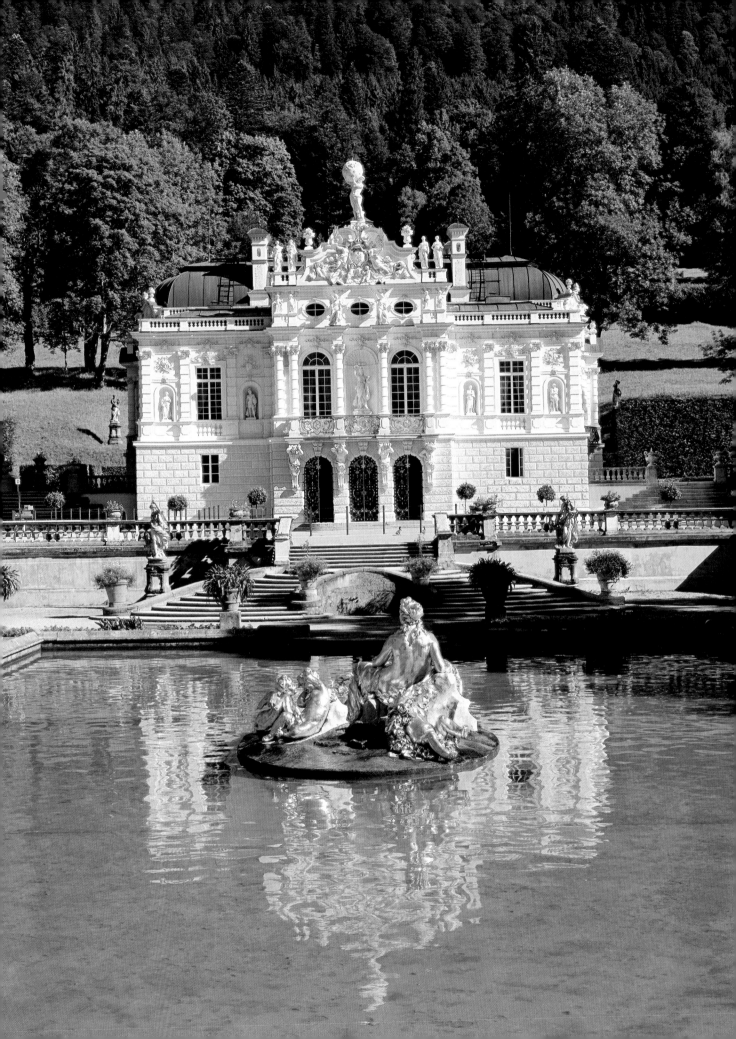

The New Palace at Herrenchiemsee

Neues Schloss Her-
renchiemsee
Schloss- und
Gartenverwaltung
Herrenchiemsee
83209 Herrenchiemsee

Telephone
+49 80 51/68 87-0

E-Mail
sgvherrenchiemsee@
bsv.bayern.de

Internet
www.herrenchiemsee.de

Ludwig II purchased the island of Herrenchiemsee in 1873 in order to salvage its trees from prospective timber developers, but also because it was the ideal site for his most ambitious palace project: a paraphrase of Versaille as a monument to Absolutism. Already in the planning stages elsewhere since 1868, the project finally had sufficient room, even for a model of Versaille's park complex. Yet the "New Palace of Herrenchiemsee" is not a replica; only the most essential wings and rooms were reproduced and the palace became more richly decorated than Versailles had ever been. With Ludwig II, the showcase bedroom known as the "Paradeschlafzimmer" belonging to Ludwig XIV was transformed into the most expensive room of the 19th century. The "Small Apartment," which was furnished as his residential quarters, contains a porcelain exhibition, which represents the artistic and technical zenith of European porcelain art. In his palace, Ludwig II paid tribute to not only Versailles, but also to the Baroque structures of his own forefathers. Hence, the painted ceilings (which extend over the entire room) and the mirrored chamber have nothing to do with France, but are instead references to the rooms of Elector Max Emanuel and Karl Albrecht (1742–1745 Emperor Karl VII). In doing so, Ludwig II also wished to establish a memorial to the Wittelsbachs and with it, to align himself with their tradition. The palace and park remained unfinished at the king's death; still, only a few of the originally-planned rooms are missing and the body of the park is similiarly splendid. Only the main parterre was completed with its rebuilt water features. It is embedded into the undisturbed nature of the island, which had already fascinated Ludwig II. He had installed a 7-kilometer circular path, which made use of the diverse impressions of nature, as well as the distant lake and mountain vistas.

Great Hall of Mirrors

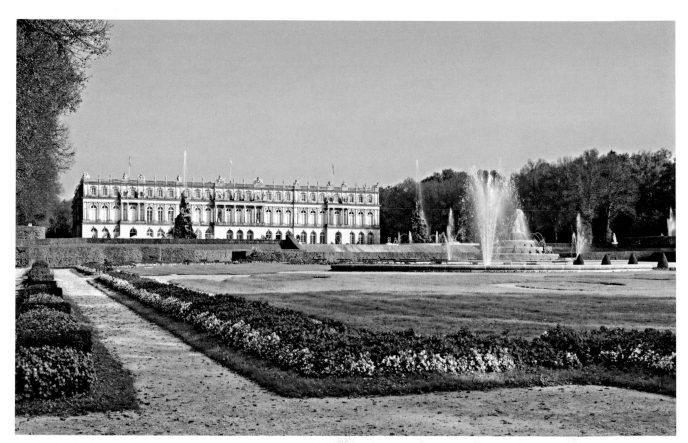

Garden façade of the New Palace

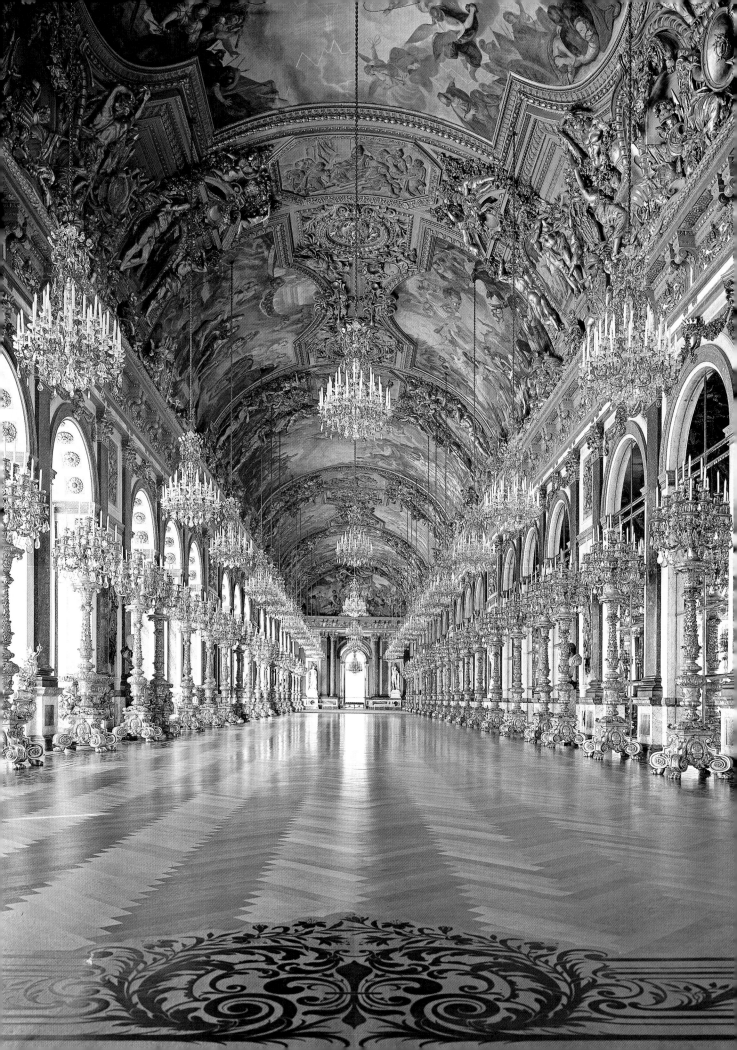

Höchstädt Palace

Schloss Höchstädt
Schlossverwaltung
Neuburg
Außenstelle Höchstädt
Herzogin-Anna-Straße 52
89420 Höchstädt

Telephone
+49 90 74/95 85-7 00
cell. +491 72/8 25 56 02

E-Mail
wiedemann-schloss
hoechstaedt@gmx.de

Internet
www.schloss-
hoechstaedt.de

From 1589 to 1602, Count Philipp Ludwig of Palitinate-Neuburg had Höchstädt Palace built for his wife, Anna of Kleve-Jülich-Berg. Masters from Graubünden built the massive four-winged complex with round towers in the Renaissance style. The painted Protestant church was distinctive in the predominantly Catholic region of Bavaria. After the death of the duchess in 1632, the palace served a variety of functions; as a result, no furnishings from this period have survived. However, the stucco ceilings from 1600 and after 1714 can be seen in the museum rooms, as well as the newly-revealed wall frescoes from the 18th century. Höchstädt became famous in the aftermath of a battle which made history in the Spanish War of Succession: the triumph of Höchstädt signaled a turnaround of the imperial and British troops against the Bavarian and French allies. A captivating and in-depth exhibit provides information about the battle and the dimensions of its carnage, in which 25,000 men were killed or injured. In addition to warfare methods of the period, the display elaborates upon the fate of the inhabitants who suffered under the army's passage.

With the title, "Beyond the Potter's Wheel," the newly-designed Museum of German Faience has created a varied display for young and old. Approximately 1000 examples over a 900-meter space provide detail about the manufacture of faience in Germany and clearly illustrate its significant impact upon the cultural lifestyle of that era. Discovery and experimentation are encouraged by way of hands-on exhibits and sensory-filled, entertaining presentations.

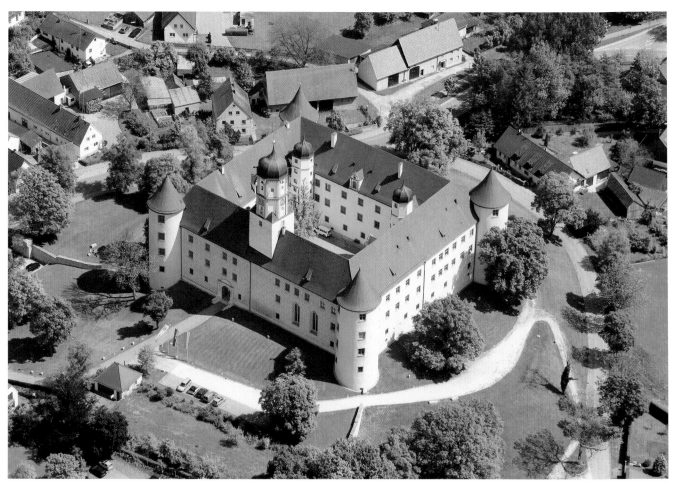

Höchstädt Palace

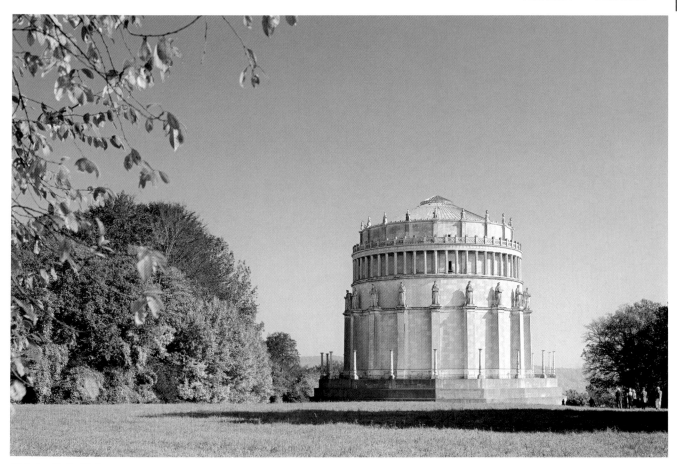

Kelheim Hall of Liberation

The Hall of Liberation at Kelheim

The imposing rotunda of the Hall of Liberation towers above the city of Kelheim at Mount Michelsberg, upstream of the junction of the Danube and Altmühl rivers. The Bavarian king, Ludwig I, hired his architect Friedrich Gärtner to build a memorial honoring the German victory against Napoleon in the Wars of Liberation (1813–1815). After Gärtner's death in 1847, Leo von Klenze, one of the most eminent German Neoclassicist architects, completed the memorial using altered architectural plans. With the Hall of Liberation, Klenze created an edifice which was reminiscent of an ancient temple as well as a medieval grail tower. The festive dedication took place on October 18, 1863, on the 50th anniversary of the Battle of Nations near Leipzig. The Hall of Libera-

tion is conceived as an 18-sided polygon. Eighteen colossal statues as allegories of the German tribes crown the exterior buttresses. Standing within the enormous domed hall in front of arcaded niches are 34 victory goddesses, who symbolize the 34 states of the German union formed in 1815. Their gilded shields made of gunmetal display inscriptions of the victorious battles of the Wars of Liberation. The sculptures were carved from Carrara marble by the Munich sculptor, Ludwig von Schwanthaler. The Hall of Liberation at Kelheim stands alongside other monumental edifices which King Ludwig I had built to celebrate Bavaria and the German nation: the Feldherrnhalle, the Victory Gate and Bavaria statue in Munich, as well as the Wallhalla in Regensburg.

Befreiungshalle Kelheim
Verwaltung der
Befreiungshalle Kelheim
Befreiungshallestraße 3
93309 Kelheim

Telephone
+49 94 41/6 82 07-10

E-Mail
befreiungshalle.
kelheim@bsv.bayern.de

Internet
www.schloesser.
bayern.de

St. Bartholomew at Königssee

Königssee –
St. Bartholomä
83471 St. Bartholomä

Telephone
+49 80 51/9 66 58-0

E-Mail
seeverwaltung.
chiemsee@bsv.bayern.de

Internet
www.schloesser.
bayern.de

Surrounded by rock cliffs and featuring grandiose views of the mountain summit, Königssee is one of the most frequently-visited Alpine destinations. Still, it would be a shame to miss it, for it is a source of fascination year-round. Situated upon a peninsula and accessible only by boat or via a four-hour hike, the prince-provostry of Berchtesgaden built the pilgrimage church of St. Bartholomew in 1134. Its Baroque façade, which is still intact today, was added in 1697 by Prince-Provost Joseph Clemens and furnished by masters from the Salzburg region. The church was an important pilgrimage site for the surrounding area. In the present era, the church kermesse, which takes place on the Sunday after St. Bartholomew's feast day (August 24), continues to attract numerous visitors. During the 18th century, the neighboring hunting palace of the prince-provosts was expanded into a summer residence. After Berchtesgaden came under Bavarian rule, the Church of Saint Bartholomew, ideally situated as a hunting destination, became a favorite spot for the Bavarian king. Landscape painters throughout the entire 19th century were extremely fond of this area. In 1978, the Königssee area was declared a national park. Around St. Bartholomew, the landscape and fauna provide a rich hiking experience.

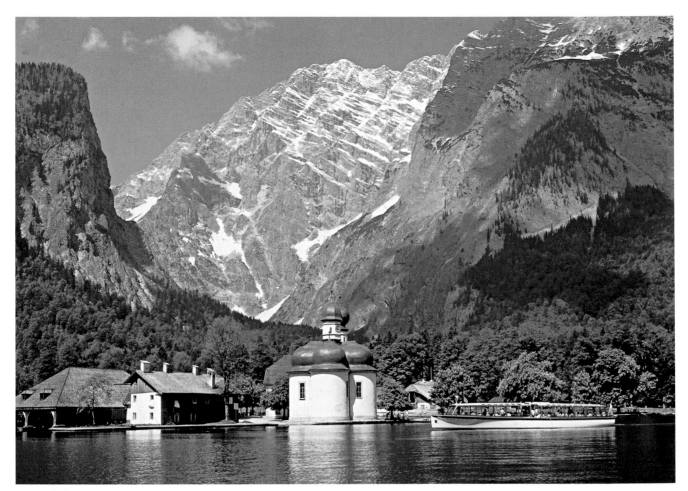

St. Bartholomew

Plassenburg

High above Kulmbach, Plassenburg is one of the most majestic fortresses in Bavaria. From 1338 to 1791, it belonged to the burgraves of Nuremberg and later, the margraves of Brandenburg from the Hollenzollern family. Margrave Georg Friedrich (reigned 1543–1603) had the war-damaged castle rebuilt by the master architect Caspar Vischer. Thus emerged one of the most distinguished creations of the German Renaissance: the "Beautiful Courtyard," an impressive arcaded tournament courtyard with expansive sculptures. The powerful building of the "High Bastion" was only built in 1606/08. The complex combines a representative castle with what was at the time a highly-modern fortress that had been partially razed in 1806.

The "Hohenzollerns in Franconia" Museum, which opened in 2003, spans a period from the medieval burgraves through the Baroque-era principalities (Ansbach and Kulbach/Bayreuth) to the Prussian lordship of around 1800, presenting the Renaissance interiors with magnificent exhibition pieces. Views and models illustrate the building phase of the complex. After the resignation of the last margrave, Alexander, to the benefit of the King of Prussia in 1791, Karl August Freiherr von Hardenberg used the two principalities as a testing ground for his reform ideas. After the transfer of territories to the new Bavarian kingdom, the Prussian kings attempted to maintain the Franconian monuments belonging to their family.

In addition, the castle houses additional major collections, such as the Army Museum of Frederick the Great, with the largest accessible collection of 18th-century Prussian militia in the world, the Museum of the Upper Main Region, as well as the German Tin Soldier Museum.

Plassenburg
95326 Kulmbach

Telephone
+49 92 21/82 20-0

E-Mail
sgvbayreuth@
bsv.bayern.de

Internet
www.schloesser.
bayern.de

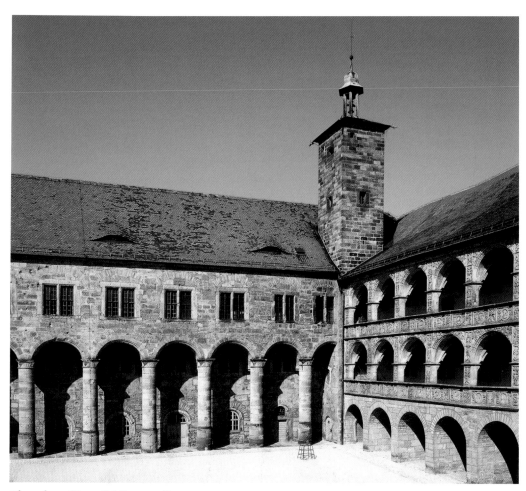

Plassenburg, "Beautiful Courtyard"

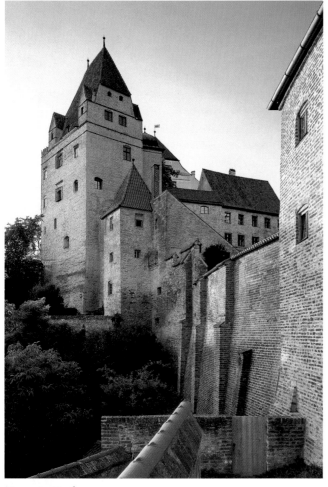

Trausnitz Castle

Fools Staircase

Trausnitz Castle

Burg Trausnitz
Burgverwaltung
Landshut
Burg Trausnitz 168
84036 Landshut

Telephone
+49 8 71/9 24 11-0
Infoline
+49 8 71/9 24 11-44

E-Mail
burgverwaltung.
landshut@bsv.bayern.de

Internet
www.burg-trausnitz.de

Trausnitz Castle, located high above the city of Landshut, is the oldest of the preserved castles belonging to the house of Wittelsbach. It was founded in 1204 by Duke Ludwig I. During the Late Middle Ages when the Bavarian duchy was split into partitions, Landshut was at the center of the Lower Bavarian duchy. At the time, Trausnitz Castle basked in its esteemed glory as the residence of the Lower Bavarian dukes. From 1514 to 1545, it served as the seat of the Bavarian co-regents of Duke Ludwig X. The castle again enjoyed an especially glorious era from 1568–1579, as the royal household of the hereditary prince of Bavaria, Wilhelm (V).

In keeping with its renown, the castle underwent expansion throughout the years and was furnished with works of art. Distinguished examples from every era of its history have survived; the keep, entry, and old knight's hall give an impression of the period in which it was founded. Moreover, the castle chapel of St. Georg possesses the most significant examples of preserved 13th-century Bavarian sculpture with its original figurative decorations (1230/35). Also renowned are the altars by the Master of the Pfarrwerfen Altar of 1420/1430, dating to the era of the Rich Dukes. The latter influenced the castle's 15th-century fortificative expansion, which remains largely intact even now.

The pergolas in the inner courtyard and the famous wall frescoes of the "Fools' Staircase," featuring scenes from the Commedia dell' Arte and carried out under the direction of Friedrich Sustris, bear witness to the Italian-influenced Renaissance court of Hereditary Prince Wilhelm. The exhibition "The Chamber of Art and Curiosities" at Trausnitz Castle recalls the tradition of the Bavarian dukes who built art chambers of this type.

The City Residence at Landshut

The residence of Landshut is a spectacular witness to Italian Renaissance architecture in the European realm. At the same time, it represents a political legacy of its patron, Duke Ludwig X (1495–1545), who in 1514, successfully contended for the communal reign of the Bavarian duchy from his brother and resided at Landshut as a co-regent.

In 1536, Ludwig X hired Bernard Zwitzel to construct a city palace according to the innovative Augsburg Renaissance style. His intention took a new turn when during a trip to Italy in that same year, he encountered modern Renaissance palaces, particularly the Palazzo Te in Mantua built by Giulio Romano. Under the guidance of Italian builders from Mantua, the "German Building" was now juxtaposed against the "Italian Building," with its façade, arcaded courtyard, and vaulted rooms in the Italian style. By consciously referring to the already-renowned Mantuan palace belonging to his cousin, Federico Gonzaga, the Renaissance prince of Landshut positioned himself at the height of that era. His city residence, which was completed in 1543, is recognized as the first Renaissance palace on German soil.

The Italian Building's sequence of rooms, with their beautifully vaulted and stuccoed rooms, marble fireplaces, and portals, was painted with a sophisticated humanist pictorial program which simultaneously conveyed the brothers' political union. This unique painterly cycle was completed by the Salzburg painter Hans Bocksburger the Elder, the Dutch artist Hermann Posthumus, who was trained in Italy, and the Munich painter Ludwig Refinger. Visitors may also visit the living rooms belonging to Count Palatine Wilhelm von Birkenfeld, the first ancestor of Empress Sisi, with references to early wallpaper.

Stadtresidenz
Altstadt 79
84028 Landshut

Telephone
+49 8 71/9 24 11-0
+49 8 71/2 51 42

E-Mail
burgverwaltung.
landshut@bsv.bayern.de

Internet
www.burg-trausnitz.de

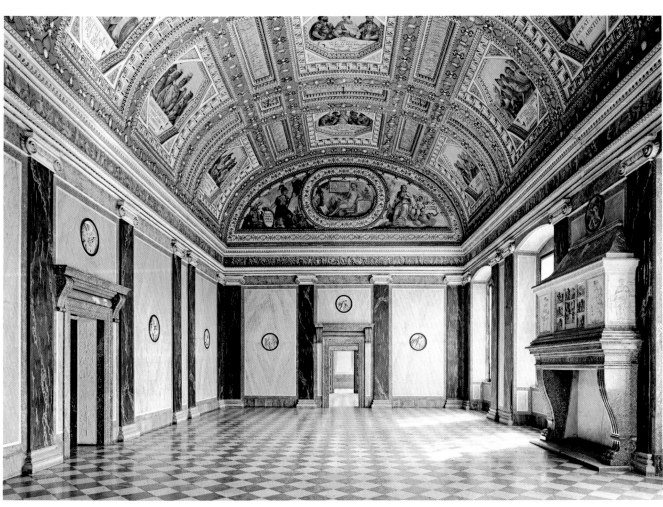

Italian Building

The Residence, Treasury, and Cuvilliés Theater in Munich

Residenz München
Verwaltung der
Residenz München
Residenzstraße 1
80333 München

Telephone
+49 89/2 90 67-1

E-Mail
ResidenzMuenchen@
bsv.bayern.de

Internet
www.residenz-
muenchen.de

The Munich Residence evolved from a moated castle from 1385 into a sprawling palace complex surrounding ten courtyards. For hundreds of years up until 1918, it served as the residential and governing seat of the Bavarian rulers from the house of Wittelsbach. In 1944, the complex suffered extensive damage, although for the most part, it was possible to salvage the moveable art inventory. Owing to major restoration and reconstruction procedures, this residence, now with approximately 130 rooms from four centuries, ranks among the most notable palace museums in Europe.

The oldest surviving and most historic room is the Antiquarium (Hall of Antiquities). Begun in 1568 for the ducal antiquities collection belonging to Albrecht V, the breathtaking Renaissance hall was converted into a ballroom by 1600. The expansion of the residence (including, among others, the Emperor's Courtyard, Trier Room, Stone Room, and Ornate Room) under Duke Maximilian I bears witness to 17th-century castle architecture. Splendid Rococo designs are represented by the Gallery of Ancestors and the Ornate Rooms, decorated from 1729–1737 under Elector Carl Albrecht using sketches by the architect François Cuvilliés the Elder, as well as the Cuvilliés Theater auditorium. Until 1835, King Ludwig I had the Neoclassical apartments in the royal palace furnished using designs by the architect Leo von Klenze.

The sumptuous furniture, paintings, sculptures, bronzes, watches, and tapestries in the exhibition rooms are supplemented by special collections featuring reliquaries, silver, and porcelain. Since 1565, the Wittelsbach Treasury has kept unique jewelery pieces and gold work, but also cut glass vessels and the Bavarian crown insignia.

Hall of Antiquities

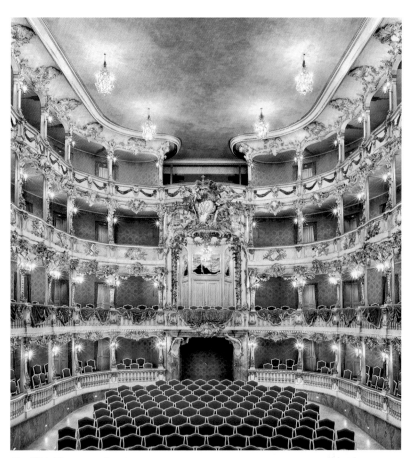

Cuvilliés Theater, auditorium

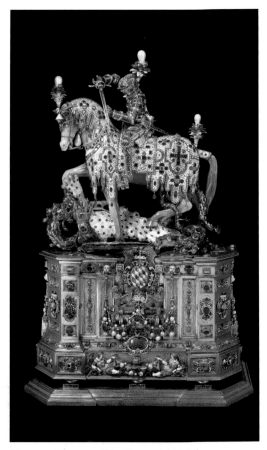

Treasury, Statuette of St. George the Knight

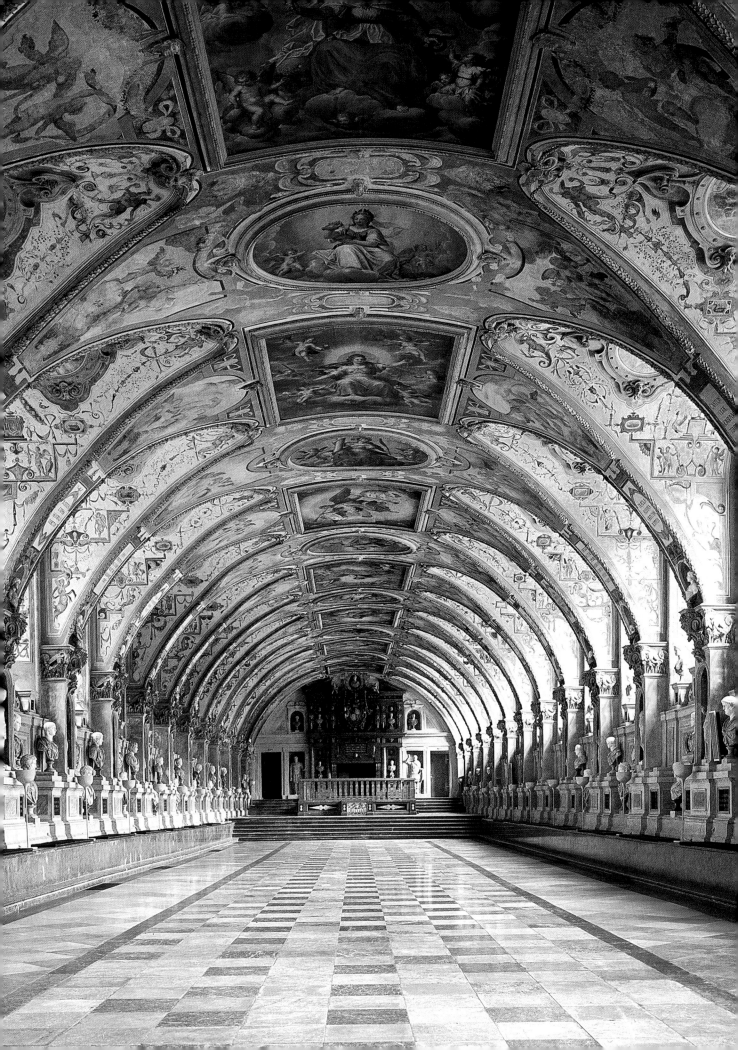

Nymphenburg Palace

Schloss Nymphenburg
Schloss- und Gartenver-
waltung Nymphenburg
Schloss Nymphenburg,
Eingang 19
80638 München

Telephone
+49 89/1 79 08-0

E-Mail
sgvnymphenburg@
bsv.bayern.de

Internet
www.schloss-
nymphenburg.de

To celebrate the birth of Max Emanuel, the heir to the throne, Elector Ferdinand Maria and his consort, Henriette Adelaide of Savoy commissioned the architect Agostino Barelli in 1664 with the construction of Nymphenburg Palace. In 1701, Max Emanuel had the cube-shaped "Villa Suburbana" expanded with side galleries and residential pavilions by Henrico Zuccalli. Beginning in 1714, Joseph Effner designed the adjoining four-winged complex of the side buildings and in keeping with French examples, modernized the façade of the central building. In this way, a simple hunting lodge became an expansive summer residence of Absolutism.

Elector Max III Joseph ordered the redesign of the interior. Particularly outstanding is the "Great Hall" in the late Rococo style, which was built by Johann Baptist Zimmerman and François Cuvilliés the Elder. Currently on display is the world-renowned "Gallery of Beauties" painted by Joseph Stieler. The tour also features a view into the room where King Ludwig II of Bavaria was born.

The 18th-century park palaces provide accents within the sprawling park: the Pagodenburg pavilion, a beautiful testimony to Chinese fashion, Badenburg, with heated bathtub, as well as the faux retreat of the Magdalenenklause, all of which were designed by Joseph Effner on behalf of Elector Max Emanuel. The hunting lodge of Amalienburg, a major work of the European Rococo era, was built between 1734 and 1739 according to designs by François Cuvilliés the Elder.

The Marstallmuseum houses splendid coaches and sleighs belonging to the Bavarian rulers, while the Bäuml Collection showcases products of the Nymphenburg Porcelain Manufactory since its foundation in 1747.

Stone Room

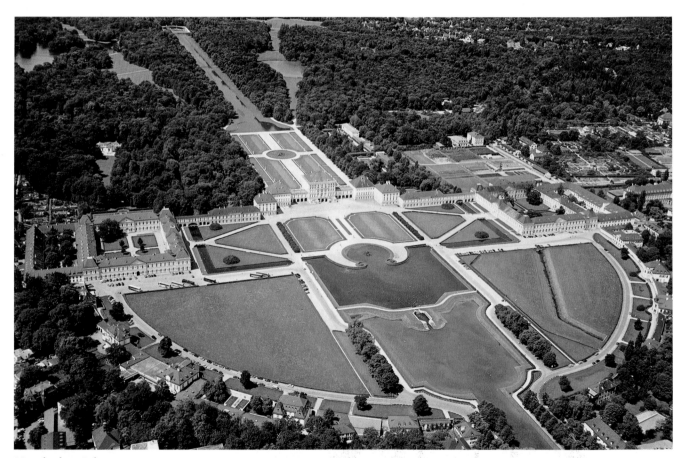

Nymphenburg Palace

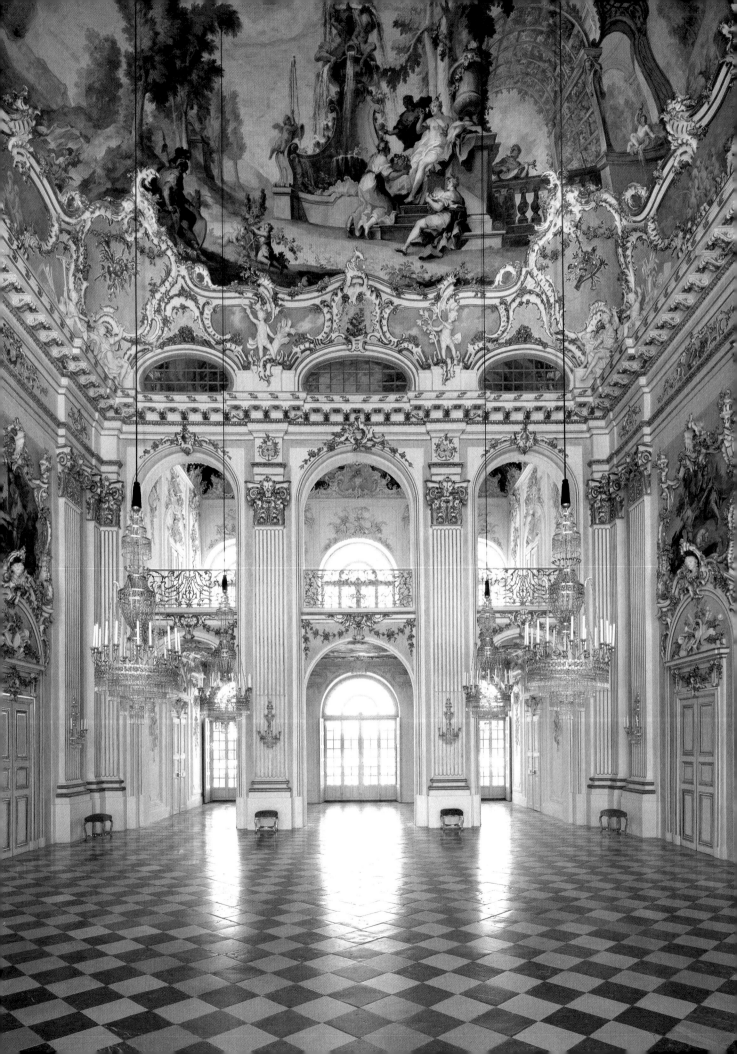

English Garden

Englischer Garten
Verwaltung des
Englischen Gartens
München
Englischer Garten 2
80538 München

Telephone
+49 89/3 86 66 39-0

E-Mail
gvenglischergarten@
bsv.bayern.de

Internet
www.schloesser.
bayern.de

Influenced by the French Revolution, Elector Carl Theodor decided to create a public park at the Isar's hunting grounds in 1789. The plans were initially directed by Sir Benjamin Thompson (who was later elevated to Count Rumford), followed in 1798 by Reinhard Baron von Werneck. In 1790, the first plantings and park architecture were implemented, including the Chinese Tower and the Agricultural Buildings, with the Military Hall (now known as Rumford Hall) completed in 1791. In 1799, the military gardens at the outskirts of the garden were removed and along with approximately 100 hectares of land from the Hirschau region, were incorporated into the park. In 1800, work on the Kleinhesseloher Lake began.

In 1789, the court gardener Friedrich von Sckell was called from Schwetzingen to Munich. Using drawings and an exposé, he demonstrated how the complex could be converted into an artistically modeled park. The execution of these plans continued until his death in 1823. In honor of Friedrich Ludwig von Sckell, a memorial to him was constructed at a peninsula of Kleinhessloher Lake. In 1838, an additional memorial was built at the north dock of this lake for Baron von Werneck. Both were designed by the architect Leo von Klenze, who had built the round temple of Monopteros upon an artificial hill between 1832 and 1837. Together with the Chinese Tower, Monopteros became a landmark of the garden.

The English Garden in Munich is an outstanding example of a classic landscape garden. Yet in addition to its superior artistic quality, its status as the first public park within the continent makes it significant from a socio-historic point of view. Its surface area of over 374 hectares makes it one of the largest metropolitan green spaces in the world.

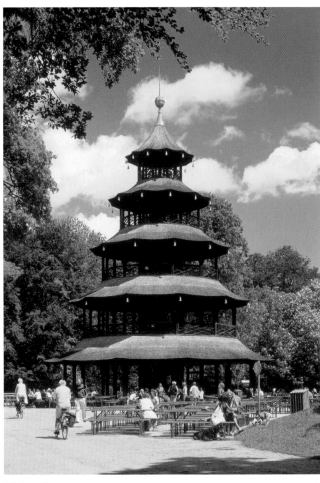

Chinese Tower

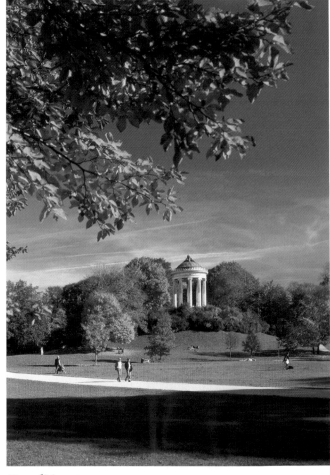

View of Monopteros

Neuburg Palace

Set upon the Donau, Neuburg Palace enjoys a special status as the only residential palace of the principality of Palitinate-Neuburg. The splendid palace complex, whose four massive wings are grouped around a central courtyard with arcaded walkways, was completed at the site of a Late Gothic ducal castle.

Count Palatine Ottheinrich (1502–1559), the first state prince and subsequent elector, commissioned the three ambitious Renaissance wings, which had stood since 1530. His successor, Count Palatine Wolfgang, commissioned the Dutch master Hans Schroer to decorate the facade with Biblical scenes in sgraffito technique, which rank among the palace's distinct features. Between 1664 and 1668, Count Palatine Philipp Wilhelm converted the building with the Baroque east wing between the large round towers into one of the first Baroque residences. Of particular interest are the painted palace chapel, which is considered to be the first Protestant church space, the Renaissance wood-paneled knight's hall, and the Baroque palace grotto with shell decoration.

An impressive panorama unfolds in the former living and state rooms of the Palitinate-Neuburg princes: approximately 550 works of art – portraits and tapestries, including the renowned Otthenrich needlepoint, weapons, furniture, and elaborate handicrafts – illustrate the art and history of the Palitinate-Neuburg principality. In 2005, the superb branch gallery featuring Flemish Baroque painting in Ottheinrich's former representative rooms was opened. Approximately 120 paintings by major Flemish masters are on display, including the outstanding altarpieces by Peter Paul Reubens for the Neuburg court church.

Schloss Neuburg
Schlossverwaltung Neuburg
Residenzstraße 2
86633 Neuburg

Telephone
+49 84 31/64 43-0

E-Mail
svneuburg@
bsv.bayern.de

Internet
www.schloesser.
bayern.de

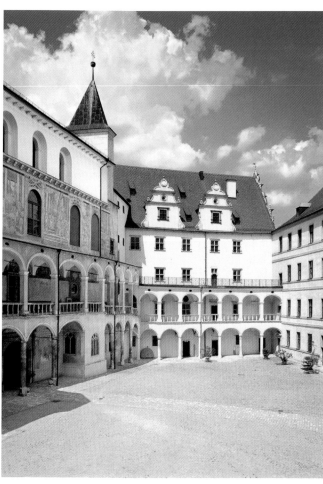

Renaissance wing in the inner courtyard

Tapestry with portrait of Count Palatine Ottheinrich

Neuschwanstein Castle

Schloss Neuschwanstein
Schlossverwaltung
Neuschwanstein
Neuschwansteinstr. 20
87645 Schwangau

Telephone
+49 83 62/9 39 88-0

E-Mail
svneuschwanstein@
bsv.bayern.de

Internet
www.neuschwanstein.de

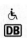

Begun in 1869 and never completed, the "New Castle" for Ludwig II was a memorial to the culture and royalty of the Middle Ages which he honored and wished to replicate. Built and designed using medieval forms while using techniques considered modern at the time, it is the most renowned construction of the Historicist era and is a chief emblem of German idealism. Ludwig II visited Wartburg Castle in 1867 and commissioned sketches of its decoration. Preliminary drawings were created by a scene painter from Munich's imperial opera house and included motifs from Wartburg, especially its great hall and architectural ornamentation, as well as designs from the "Lohengrin" and Tannhäuser" operas by Richard Wagner. In 1868, Ludwig II wrote to Wagner, saying that his "New Castle" would feature scenes reminiscent of these works. From the beginning, Ludwig II wished to have the Singers Hall of Wartburg built in his "New Castle" – albeit much larger and more splendid – as a memorial to the chivalric culture of the Middle Ages. From this, a combination of motifs from the Wartburg rooms were built: the Singers' Hall and the Ballroom, which, however, were not intended for performances or even festive occasions. The other commemorative room, the Throne Hall, was added only in 1881, for Ludwig II wished to carry out the reconstruction of the marvelous Grail Hall. However, the shape of the room also relates to his own dynasty. The room program, the most extensive and complex of the 19th century, was designed by the well-read and inquisitive Ludwig II himself. Each of the connecting living rooms is dedicated to a medieval legend. Only after the death of Ludwig II was his castle named "Neuschwanstein" and remains one of the most well-known, frequently visited, and most oft-illustrated structures in the world.

The east façade of Neuschwanstein Castle

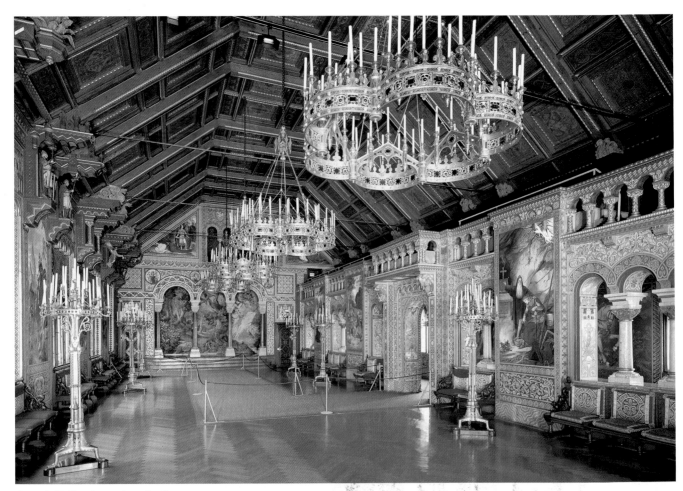

Singer's Hall with arcade and gallery

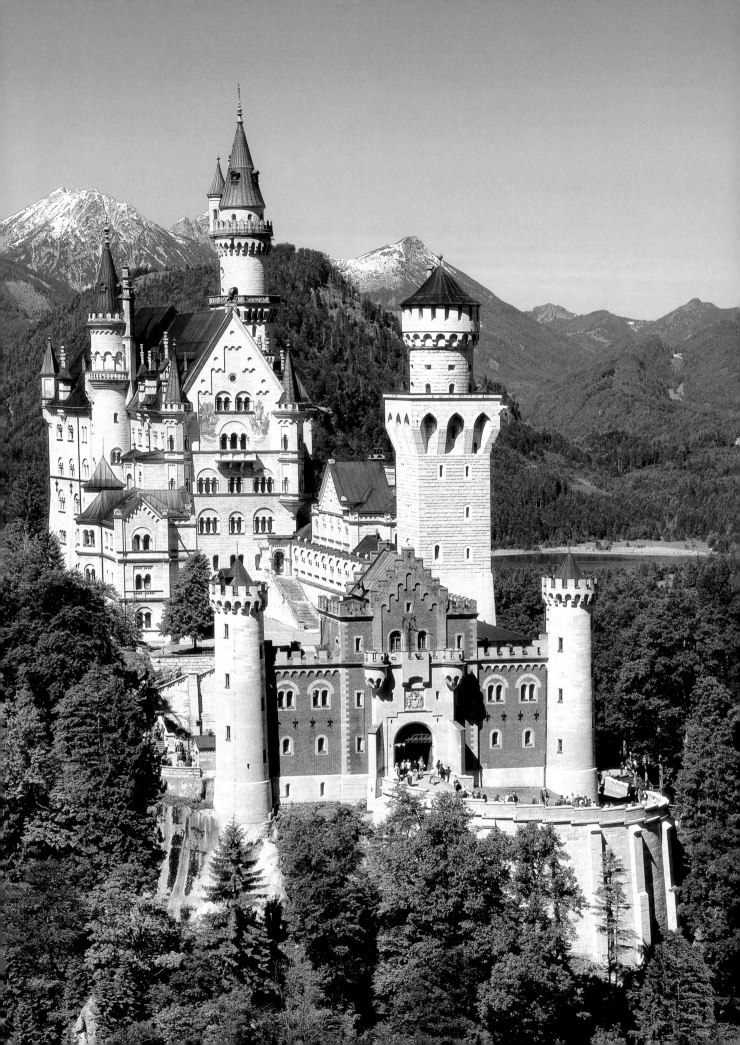

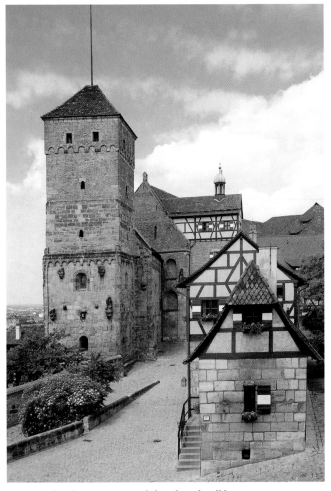

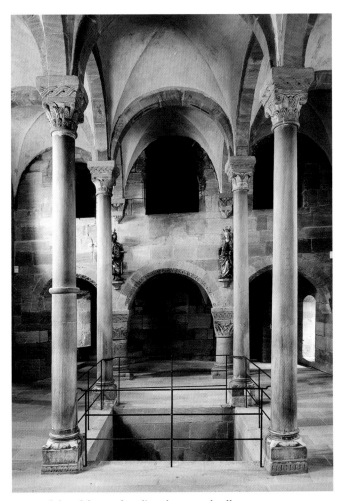

Courtyard with tower, imperial chapel, and well house

Imperial chapel (upper chapel) with imperial gallery

Nuremberg Imperial Castle

Kaiserburg Nürnberg
Burgverwaltung
Nürnberg
Auf der Burg 13
90403 Nürnberg

Telephone
+499 11/24 46 59-0

E-Mail
burgnuernberg@
bsv.bayern.de

Internet
www.schloesser.
bayern.de

Nuremberg Castle, landmark of the former imperial city, is among the most outstanding imperial palaces of the Middle Ages. Between 1050 and 1571, every German emperor and king of the Holy Roman Empire resided here. In 1356, Emperor Karl IV ruled that of every emperor's first Imperial Diet should take place in Nuremberg. Between 1485 and 1495, the imperial insignia was held for safekeeping in the castle chapel.

The complex was built over three different time periods: the royal castle of the Salier rulers was constructed during the first half of the 11th century. Under the Hohenstaufen Friedrich Barbarossa and his successors, the fortress was expanded into an impressive feudal imperial castle. This is demonstrated by the most significant monument of the castle, the entirely-preserved double chapel. In a unique fashion, it synthesizes the functions of an imperial private chapel, a court chapel, and a castle chapel. The upper chapel (imperial chapel) was intended for the court, with the annexed west gallery reserved for the imperial family. During the reign of Emperor Friedrich III in the 15th century, the Staufen great hall and women's chamber were replaced by Late Gothic buildings, which characterize the castle's present-day impression. The dual-aisled knight's hall also originates from this period. In 1945, bomb attacks inflicted grave damage to the imperial castle. However, the imperial chapel, substantial components of the great hall, as well as the crucial Romanesque towers were spared. The rebuilt women's chamber currently houses the Kaiserburgmuseum, a branch museum of the Germanisches Nationalmuseum. In addition to the dual chapel, a tour includes the imperial residential and representative quarters of the great hall, which are expected to be newly showcased in 2013.

Schleißheim Palace Complex

The extensive complex at Schleißheim encompasses three palaces: the founding structure of the old palace, which Duke Wilhelm V began in 1598 as a hermitage and starting in 1617, was built according to the designs of Heinrich Schön the Elder, the royal hunting lodge of Lustheim, and the splendid New Palace at Schleißheim, the last two having been established by Max Emanuel of Bavaria (reigned 1680–1726).

Soaring political ambitions led to the building of the New Castle. Originally intended as a multi-winged structure, the shell of the main wing – what is now the independent palace building – was built from plans by Henrico Zuccallis between 1701–1704. Construction was suspended with the twelve-year-long exile of Max Emanuel. Only starting in 1719 were the façade's construction and room decorations completed – this time according to plans by Joseph Effner. The monumental complex contains a generous stairwell, splendid ballrooms and apartments, whose decoration featured contributions by artists such as Johann Baptist Zimmerman, Cosmas Damian Asam, and Jacopo Amigoni. The branch gallery with European Baroque paintings takes up the collecting activity of Max Emanuel.

Appearing as a focal point at the end of the castle park, Max Emanuel had Lustheim Palace built by Henrico Zuccalli in 1684 to honor his marriage to the emperor's daughter, Maria Antonia. Ceiling frescoes exalt the goddess of hunting, Diana. A splendid collection of Meißner porcelain is on display.

Between the New Palace and Lustheim, the sprawling park is one of the few, scarcely-altered Baroque gardens. Zuccalli had already established the basis structure with its canals, and beginning in 1715, the garden was completed according to plans by Dominique Girard, a pupil of Le Nôtre.

Schlossanlage Schleißheim
Schloss- und Gartenverwaltung Schleißheim
Max-Emanuel-Platz 1
85764 Oberschleißheim

Telephone
+49 89/31 58 72-0

E-Mail
sgvschleissheim@bsv.bayern.de

Internet
www.schloesser-schleissheim.de

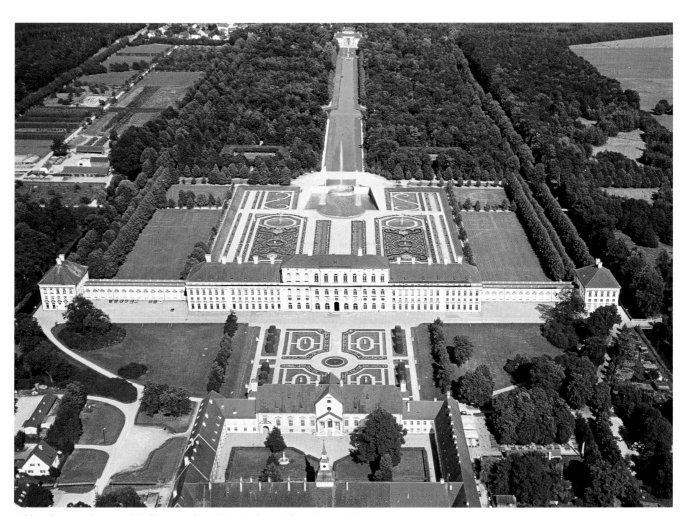

Old and New Palace at Schleißheim and Lustheim Palace with park grounds

Prunn Castle

Burg Prunn
93339 Riedenburg

Telephone
+49 94 42/33 23

E-Mail
befreiungshalle.
kelheim@bsv.bayern.de

Internet
www.schloesser.
bayern.de

High above the city of Prunn, Prunn Castle stands upon a limestone cliff. Documents mention it as the seat of the lords of Prunn in as early as 1037. The keep and foundation of the great hall suggest a medieval layout. In 1338, the castle fell into the hands of the von Fraunberg family of Haag. Their emblem, a white horse upon a red background, can still be seen upon the outer facade. Of the building projects which took place between 1672 and 1773 under the Jesuits who resided here, the lovely castle chapel with its Baroque stucco decoration and which was redesigned in 1700 merits attention. King Ludwig I of Bavaria protected Brunn Castle from impending deterioration during the 19th century. In 1827, he ordered that the medieval castle be preserved as a memorial to German history.

The museum tour leads visitors through the castle chapel and historically furnished rooms of the great hall, which provide an impression of life as it was in the castle. Fragments of medieval frescoes have been unearthed in the former guardroom. In the Gothic Room, the famed Middle High German poetry of the Song of the Nibelungs recalls that: the so-called Prunn Codex from the 14th century was discovered at the castle and in 1575, brought to the ducal library in Munich (now the Bavarian State Library). From the castle courtyard and great hall, the visitor can enjoy a splendid panoramic view of the Altmühltal landscape.

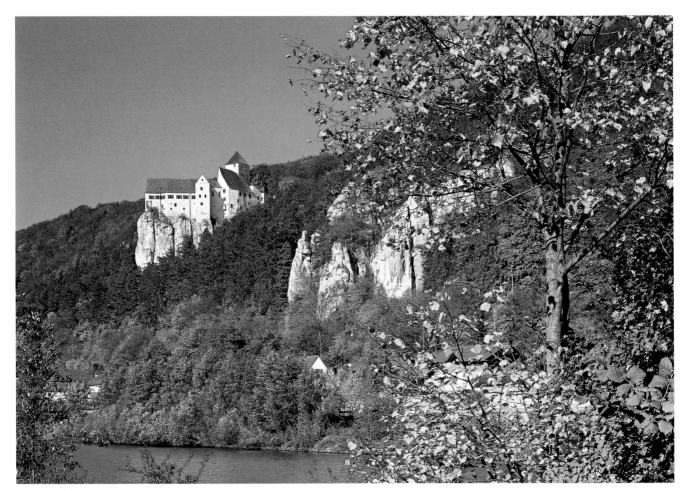

Prunn Castle

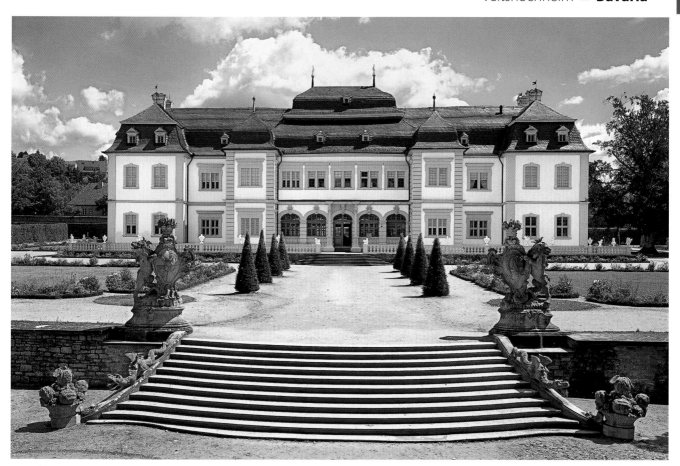

View from the western steps towards the castle

Veitshöchheim Palace and Park

Veitshöchheim Palace, formerly the summer residence of the Würzburg prince-bishops, is set within one of Germany's most beautiful Rococo gardens, approximately eight kilometers downstream of the Main near Würzburg. Beginning in 1701, an ornamental garden was laid out at the hunting lodge that had been built in approximately 1680/1682. From 1749–1753, the architect Balthasar Neumann expanded the palace with two side annexes. The avid gardener and prince-bishop from 1755–1779, Adam Friedrich von Seinsheim, arranged for the magnificent design of the Rococo garden. Over 200 spectacular sandstone sculptures by the Wurzburg court sculptor, Johann Wolfgang van der Auvera, Ferdinand Tietz, and Johann Peter Wagner now populate the garden, which is separated into small sections by bushes and hedgerows. Deities, animals, and allegorical figures are united into a grand cosmological scheme, whose peak culminates in the sculpture of the Muses at Parnassus at the middle of the lake. When the fountain water features play about the nine Muses, Apollo, and the peak of Parnassus with their shimmering streams, the winged horse of poets, Pegasus, almost appears to lift into the air. All of the sculptures have since been replaced with artificial stone molds, with the most beautiful originals on display in the Mainfränkisches Museum at the Marienberg fortress. In addition to the living quarters of the prince-bishops decorated in the Rococo style and a lovely billiard room of the Veitshöchheim Palace, visitors can see the apartment of the Grand Duke Ferdinand of Tuscany with its famous original wallpaper from 1810. On the ground floor is a small exhibition about the garden's construction and current maintenance.

Schloss und Hofgarten
Veitshöchheim
Echterstrasse 10
97209 Veitshöchheim

Telephone
+499 31/9 15 82

E-Mail
sgvwuerzburg@
bsv.bayern.de

Internet
www.schloesser.
bayern.de

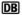 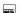 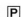

Würzburg Residence

Residenz Würzburg
Schloss- und Garten-
verwaltung Würzburg
Residenzplatz 2, Tor B
97070 Würzburg

Telephone
+499 31/3 55 17-0

E-Mail
sgvwuerzburg@
bsv.bayern.de

Internet
www.residenz-
wuerzburg.de

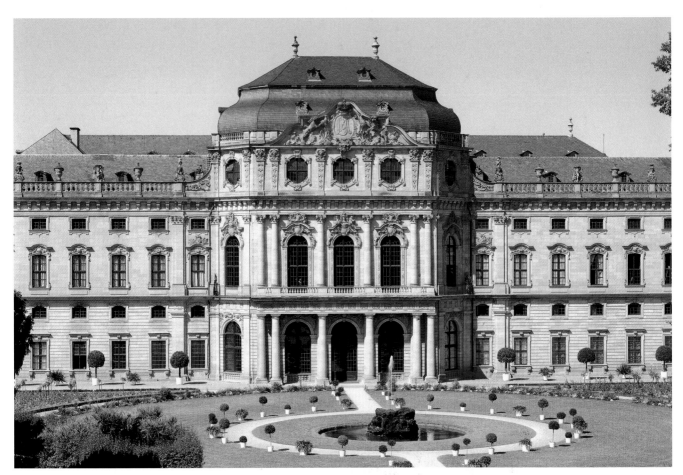

Organisation der
Vereinten Nationen für
Bildung, Wissenschaft,
Kultur und Kommunikation

Würzburger Residenz
und Hofgarten
Welterbestätte
seit 1981

The residence of the Würzburg prince-bishops is among the most significant palace complexes in Europe. Commissioned by Prince-Bishop Johann Philipp Franz of Schönborn and his brother and second successor, Friedrich Carl von Schönborn, it was built from 1720 to 1744 from plans by Balthasar Neumann. In the stairwell of the residence, two major works of European architecture and painting unite to form a stunning artistic synthesis. For the renowned 19-by-32.6-meter, free-standing vaulted stairway by Balthasar Neumann, the Venetian Giovanni Battista Tiepolo created a ceiling fresco in 1752/53. The largest in the world at the time, it featured an allegory of the four continents of the earth. Together with the already-existing fresco of 1751/52 in the Emperor's Hall, it is due to Tiepolo that two major works of art from an entire epoch are to be found here. The visitor is also greeted by magnificent decorations in the additional residential quarters, as well as 18th-century artworks of the highest quality, from Régence to Würzburg Rococo to Neoclassicism. By mid-2012, the chapel of the residence will reopen following extensive restoration. Visitors may enter the Court Garden, laid out by the court gardener Johann Prokop Mayer at the end of the 18th century. The complex, which rose sharply towards the bastions, was cleverly divided by Mayer into individual components and filled with clipped fruit trees, potted plants, flower beds, hedges, espaliers, and pergolas. After extensive war-related damages, it was possible to complete the restoration of the unique Mirror Cabinet in 1987. Since 1981, the Würzburg residence, along with its residence square and court garden, have belonged to UNESCO's World Heritage sites.

Imperial Room, view towards the south

Garden façade with Kaisersaalpavillon

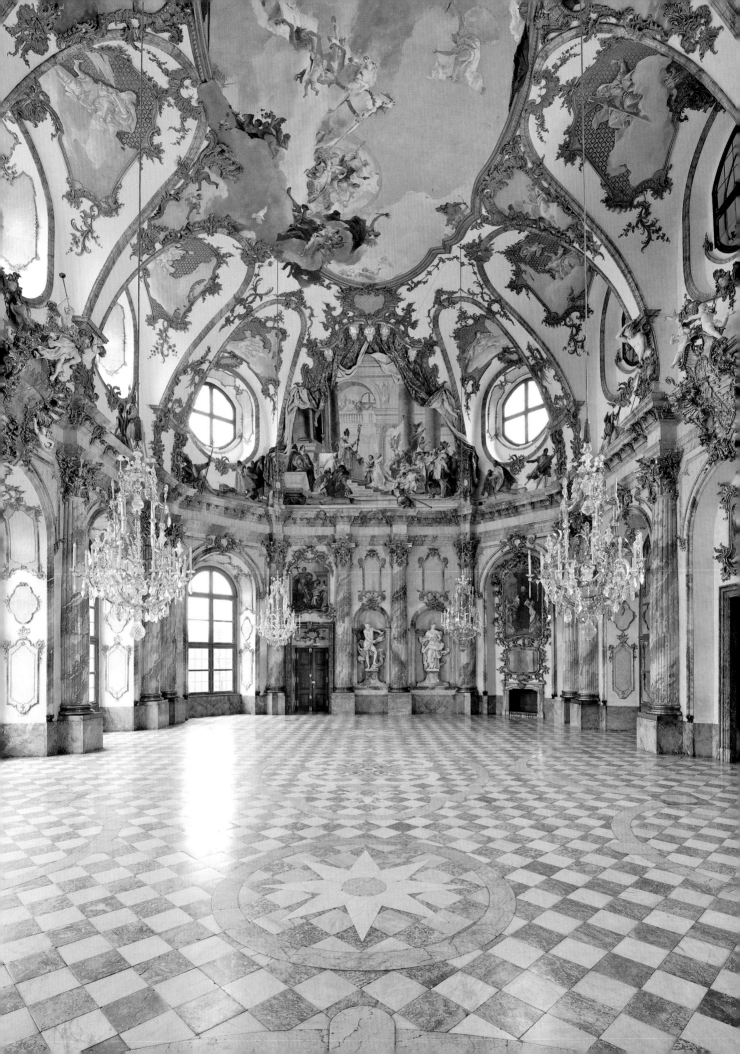

Aschaffenburg –
Pompejanum
Pompejanumstr.5
63739 Aschaffenburg

+49 60 21/3 86 57-0

sgvansbach@
bsv.bayern.de

www.schloesser.
bayern.de

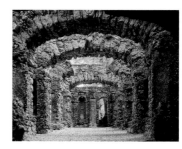

Bayreuth – Sanspareil
Rock Garden with
Oriental Building and
Zwernitz Castle
Sanspareil 29
96197 Wonsees

+49 92 74/9 09 89-06
or -12

sgvbayreuth@
bsv.bayern.de

www.bayreuth-
wilhelmine.de

 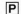

Bayreuth – Palace and
Fantaisie Park
Bamberger Straße 3
95488 Eckersdorf/
Donndorf

+49 9 21/73 14 00-11

www.gartenkunst-
museum.de
www.bayreuth-
wilhelmine.de

Coburg/Rödental
Palace and Rosenau Park
Palace and Garden
Administration Coburg
Rosenau Palace
Rosenau 1
96472 Rödental

+49 95 63/30 84-10

sgvcoburg@
bsv.bayern.de

www.sgvcoburg.de

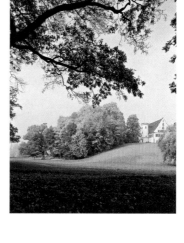

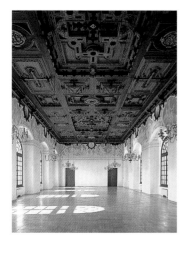

Dachau – Palace and
Court Garden
Palace and Garden
Administration
Schließheim
Dachau Field Office
Schlossstraße 7
85221 Dachau

+49 81 31/8 79 23

sgvschleissheim@
bsv.bayern.de

www.schloesser.
bayern.de

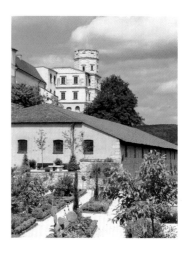

Eichstätt – Willibalds-
burg with Bastion
Garden
Burgstraße 19
85072 Eichstätt

+49 84 21/47 30

sgvansbach@
bsv.bayern.de

www.schloesser.
bayern.de

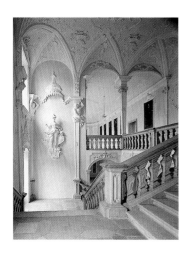

Ellingen – Ellingen
Residence with Park
91792 Ellingen

+49 91 41/9 74 79-0

sgvansbach@
bsv.bayern.de

www.schloesser.
bayern.de

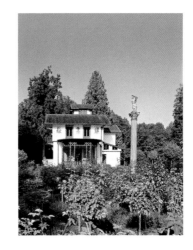

Feldafing – Rose Island
and Feldafing Park
Wittelsbacher Park 1
82340 Feldafing

+49 81 51/69 75

seeverwaltung.
starnbergersee@
bsv.bayern.de

www.schloesser.
bayern.de

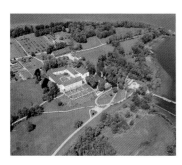

Herrenchiemsee –
Augustinian Monastery
Palace and Garden
Administration
Herrenchiemsee
83209 Herrenchiemsee

+49 80 51/68 87-0

sgvherrenchiemsee@
bsv.bayern.de

www.herrenchiemsee.de

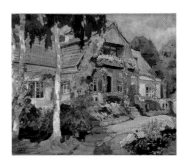

Holzhausen am Ammer-
see – Gasteiger's Atelier
Eduard-Thöny-Straße 43
86919 Holzhausen

+49 88 06/6 99

seeverwaltung.ammer-
see@bsv.bayern.de

www.schloesser.
bayern.de

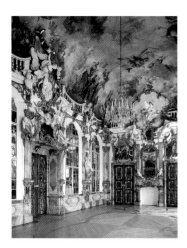

Kempten Residence
Residenzplatz 4–6
87435 Kempten

+49 8 31/2 56-2 51

poststelle@
fa-ke.bayern.de

www.schloesser.
bayern.de

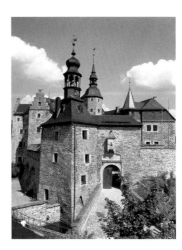

Ludwigsstadt –
Lauenstein Castle
Burgstraße 3
96337 Ludwigsstadt

+49 92 63/4 00

sgvbamberg@
bsv.bayern.de

www.schloesser.
bayern.de

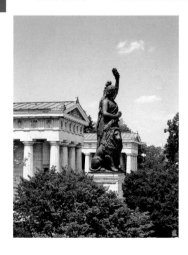

Munich – Hall of Fame
and Bavaria
Theresienhöhe 16
80339 München

+49 89/2 90 67-1

ResidenzMuenchen@
bsv.bayern.de

www.schloesser.
bayern.de

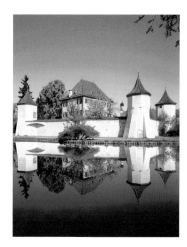

Munich –
Blutenburg Palace
Seldweg 15
81247 München

+49 89/1 79 08-0

sgvnymphenburg@
bsv.bayern.de

www.schloesser.
bayern.de

Nuremberg –
Cadolzburg
Castle Administration
Auf der Burg 13
90403 Nürnberg

+49 9 11/24 46 59-0

burgnuernberg@
bsv.bayern.de

www.schloesser.
bayern.de

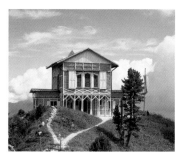

Schachen – Royal House
at Schachen
82467 Garmisch-
Partenkirchen

+49 88 22/92 03-0

sgvlinderhof@
bsv.bayern.de

www.linderhof.de

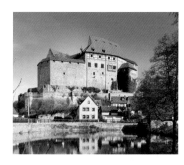

Übersee-Feldwies –
Exter's Atelier
Blumenweg 5
83236 Übersee-Feldwies

+49 86 42/89 50-83

sgvherrenchiemsee@
bsv.bayern.de

www.herrenchiemsee.de

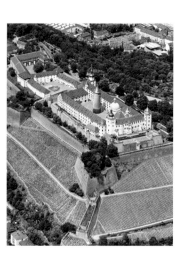

Würzburg –
Marienburg Fortress
97082 Würzburg

+49 9 31/3 55 17-50

sgvwuerzburg@
bsv.bayern.de

www.schloesser.
bayern.de

Berlin-Brandenburg

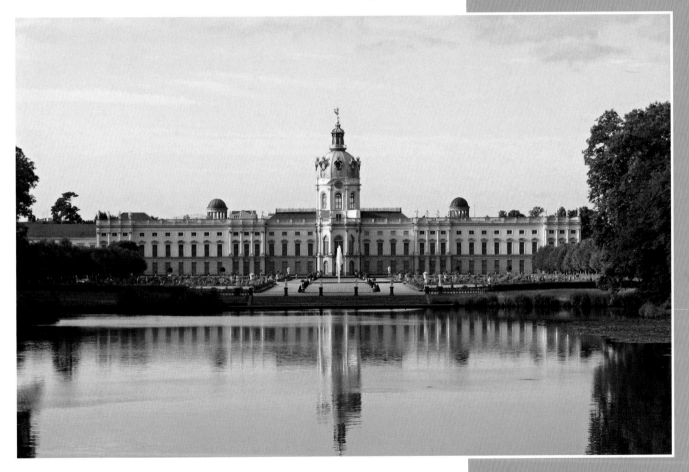

STIFTUNG
PREUSSISCHE SCHLÖSSER UND GÄRTEN
BERLIN-BRANDENBURG

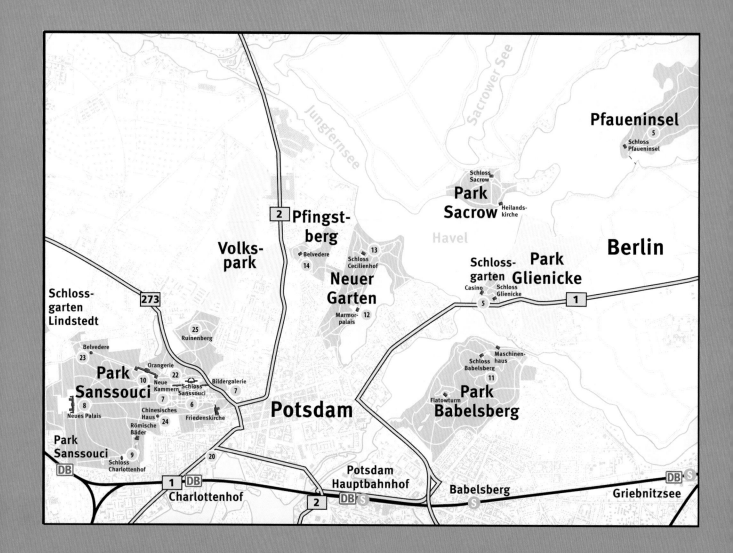

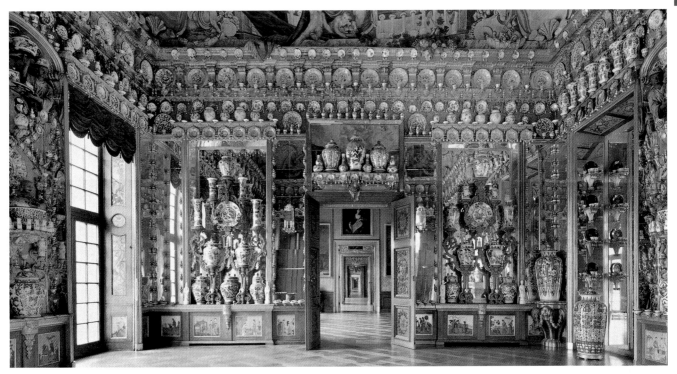

Schloss Charlottenburg, Old Palace, Porcelain Room

A journey through 400 years of history in Brandenburg and Prussia

The stately homes and gardens of Prussia invite guests to travel for themselves back in time to the grandiose era of prince electors, kings and emperors in their former residences at Berlin and Potsdam. These testimonies to sophisticated architecture and garden design have been restored to a splendour that attracts millions of admiring visitors each year from Germany and around the world. It is the task of the Stiftung Preussische Schlösser und Gärten Berlin-Brandenburg (SPSG) to maintain these works of art and make them accessible to the public in a variety of ways.

While keeping their principal residence in Berlin, members of the Hohenzollern dynasty built a number of palaces and gardens near the town and along the River Havel from the 17th century onwards. In the 19th century, garden designer Peter Joseph Lenné grouped several of these ensembles into an extensive park landscape. In 1990, UNESCO included this total art work, which reaches from Sanssouci via the New Garden and Sacrow to Pfaueninsel and Glienicke in Berlin, among the world's listed natural and cultural heritage sites.

This park landscape in Potsdam and Berlin is consequently a cultural legacy of international significance, and an inspiring place for people from all over the world who share a love for art, architecture and gardens. Apart from their artistic value, however, the palaces have been the scene of major historical events. In summer 1945, for example, Schloss Cecilienhof hosted the Potsdam Conference, where the Allies debated Germany's future. Schloss Schönhausen served as the official seat of the East German President and the guest house for state visitors to the GDR, until the country's Round Table met here following the peaceful revolution of 1989.

The complete landscape of Prussian stately homes and gardens consists of over 300 built complexes and almost 800 hectares of garden. 37 buildings are open to the public on a regular basis. In Potsdam, the major palace museums in the Sanssouci gardens include Schloss Sanssouci and the New Palace, the Orangery Palace and Schloss Charlottenhof. The New Garden is the setting for both Schloss Cecilienhof and the Belvedere on Pfingstberg, while Schlossgarten Babelsberg frames the grand Imperial Palace. In Berlin there is plenty to explore in the palace and gardens at Charlottenburg and Schönhausen, at Schloss Glienicke and on Pfaueninsel, and in the hunting lodge at Grunewald.

A visit to the stately homes and gardens in Rheinsberg, Caputh, Königs Wusterhausen, Paretz or Oranienburg can be combined with an unforgettable excursion to enchanting cultural landscapes outside the German capital.

For SPSG, recent years have been dominated by extensive restoration projects in our stately homes and gardens. Thanks to the tremendous expertise of our staff, but above all to financial support from Federal agencies and the States of Brandenburg and Berlin, not to mention countless private benefactors, our visitors are now once again able to enjoy the full spectrum and abundance of evolving artistic output in Prussian Brandenburg.

Schloss Charlottenburg

Schloss Charlottenburg
Spandauer Damm 10–22
14059 Berlin

Telephone
+49 30/3 20 91-1

E-Mail
info@spsg.de

Internet
www.spsg.de

Schloss Charlottenburg vividly demonstrates Hohenzollern court culture from the 17th until the early 20th century, despite suffering severe damage during the Second World War. The original nucleus for the future palace and gardens was Schloss Lietzenburg, a small summer residence built between 1695 and 1699 for Sophie Charlotte, Electress of Brandenburg, and designed by Arnold Nering. The gardens were the first in Germany to be laid out in accordance with the baroque French style of Le Nôtre. There were major extensions and conversions here after Friedrich I was crowned King of Prussia in 1701.

Baroque interiors such as the Porcelain Room and the chapel have now been largely restored to their original form. The complex was substantially enlarged after Friedrich the Great ascended the throne. In 1740 work began, to plans by Georg Wenzeslaus von Knobelsdorff, on the New Wing with its splendid banqueting chambers, the Golden Gallery and the White Room, and also the royal apartments. The paintings by Antoine Watteau are among the outstanding art works in the palace.

Friedrich Wilhelm II also commissioned improvements to Charlottenburg after taking office in 1786. He appointed Karl Gotthard Langhans to extend the building by adding a new theatre between 1788 and 1791. Friedrich Wilhelm III and his wife Queen Luise likewise favoured Charlottenburg as a summer residence. Luise occupied the former winter chambers of her father-in-law, Friedrich Wilhelm II, in the western section of the New Wing. In 1810 Karl Friedrich Schinkel was appointed to design a new bedroom for the queen.

Friedrich Wilhelm IV was the last Hohenzollern monarch to have his own quarters installed on the upper storey of the Old Palace at Charlottenburg. These apartments were lost when the building was destroyed, although his library has survived with its original interior. The crown jewels and silver tableware are on display on the upper floor of the Old Palace.

New Wing, Golden Gallery

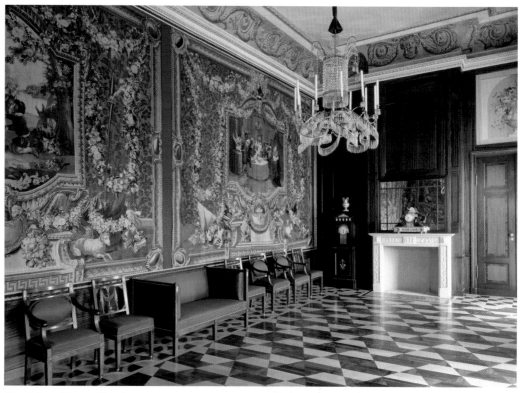

New Wing, Winter Chambers

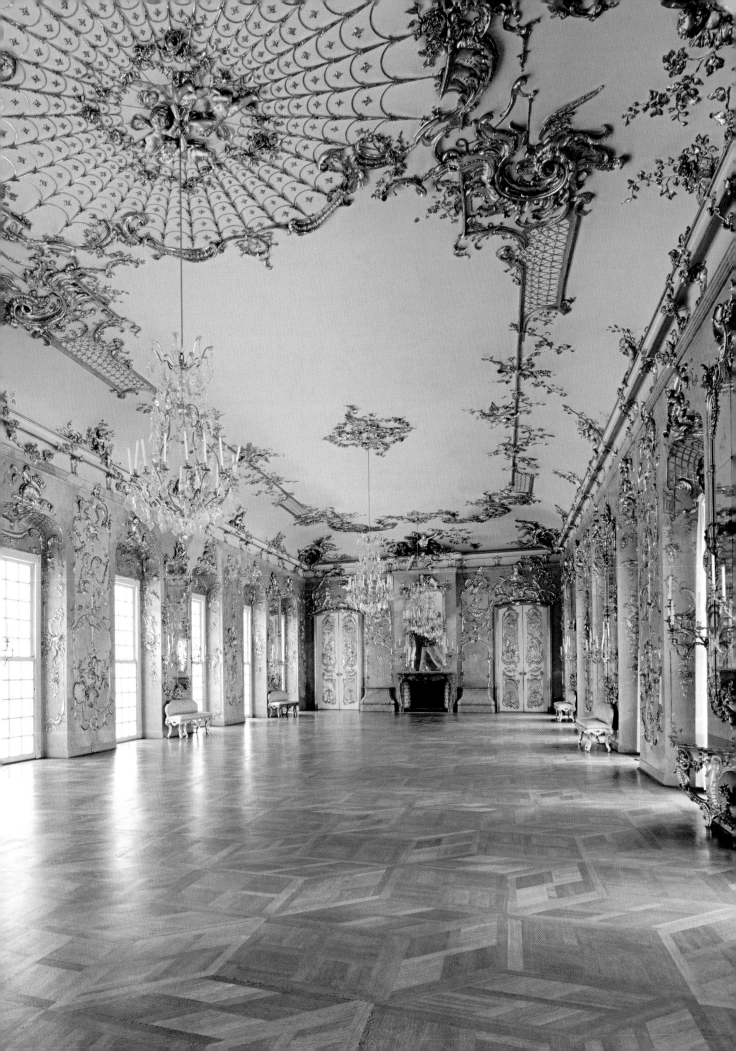

Belvedere, Mausoleum and New Pavilion

Schloss Charlottenburg
Spandauer Damm 10–22
14059 Berlin

Telephone
+49 30/3 20 91-1

E-Mail
info@spsg.de

Internet
www.spsg.de

The 55-hectare park at Charlottenburg is Berlin's leading historical garden monument, the baroque parterre having been recreated, in a free interpretation of the original, after the damage it suffered in the Second World War. Surviving sections of the original landscaped design have been reworked in compliance with the principles of monument preservation.

The Belvedere in the palace gardens formed part of the project commissioned by Friedrich Wilhelm II to redesign the park. The building, conceived by Karl Gotthard Langhans, was built in 1788 in the late baroque and early classical style, and it now houses the porcelain collection belonging to the State of Berlin. The focus here is on china from the Royal Porcelain Manufactory (KPM), acquired by Friedrich the Great in 1763.

The Mausoleum, to the south-west of the Belvedere, was commissioned by Friedrich Wilhelm III to house the tomb of his lady consort Luise when she died on 19 July 1810. The king had his own ideas for the design and, after consulting Karl Friedrich Schinkel, he appointed Heinrich Gentz to produce drawings. The tomb was built by Christian Daniel Rauch in 1811–1814 using marble from Carrara. The Mausoleum was first extended in 1841–1843 under Ludwig Ferdinand Hesse, after the death of Friedrich Wilhelm III himself, and then again around 1888–1894 to drawings by Albert Geyer, in order to incorporate the tombs – made by Erdmann Encke – of the first Imperial couple, Kaiser Wilhelm I and his wife Augusta.

In 1824–1825 Schinkel designed a summer pavilion for Friedrich Wilhelm III to the east of Charlottenburg Palace. The pavilion was completely destroyed in the war, but after its reconstruction in 1970 it re-opened as a museum. The key themes here are the creative versatility of Schinkel and art in Berlin during the early 19th century. Apart from the royal quarters, visitors will find paintings by Caspar David Friedrich, Carl Blechen, Schinkel and Eduard Gärtner.

Charlottenburg gardens, Mausoleum, tomb of Queen Luise

Charlottenburg gardens, Belvedere

Charlottenburg gardens, New Pavilion

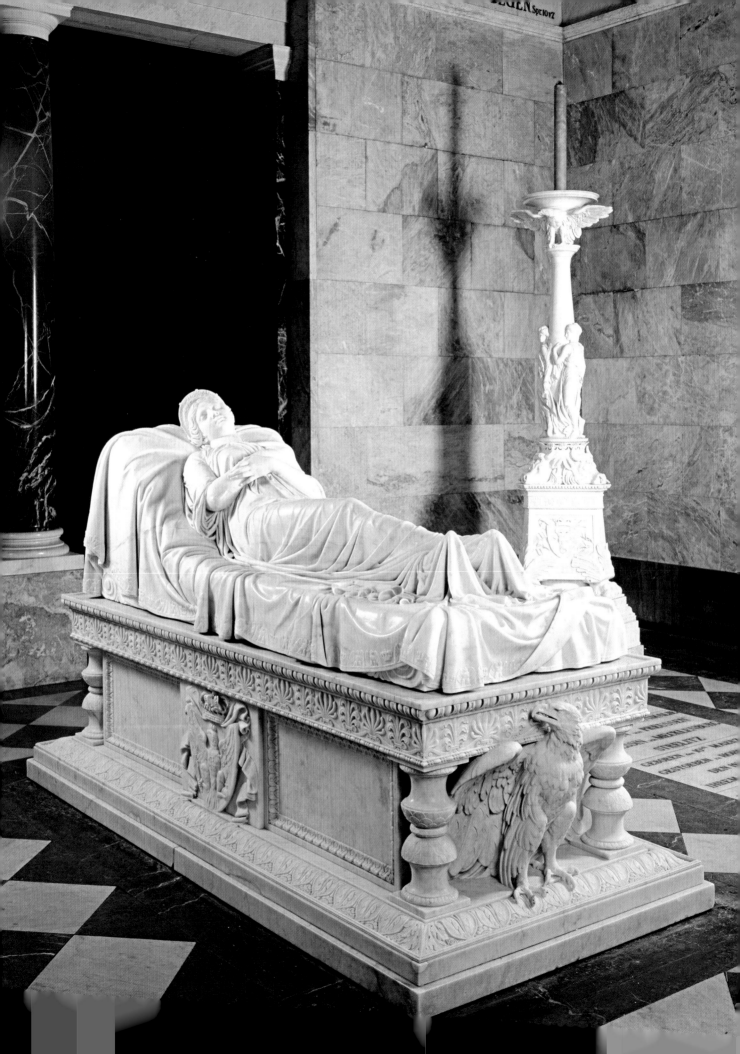

Schloss Schönhausen

Schloss Schönhausen,
Tschaikowskistr. 1
13156 Berlin

Telephone
+49 30/40 39 49 26 10

E-Mail
info@spsg.de

Internet
www.spsg.de

 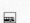

Schloss Schönhausen is one of the few historical buildings in Berlin that was never completely destroyed. It is therefore unique in assembling traces of history right down to the late 20th century in one place.

The Counts zu Dohna had already built a residence here in 1664, but that was replaced between 1685 and 1690 by a home for General Joachim von Grumbkow, the core of which survives. Shortly afterwards, Elector Friedrich III acquired the property, and he appointed Johann Friedrich Eosander von Göthe to work on it until 1709. The garden front and some of the stucco ceilings still convey an impression of that period. Between 1740 and 1797 the building served as a summer residence for the Prussian queen Elisabeth Christine, who was married to Friedrich the Great. She commissioned Johan Michael Boumann senior in 1763/64 to build extensions and transform the site into a rococo gem. Apart from the magnificent banqueting hall and the elegant stairway, precious wall hangings and the Cedar Gallery have been preserved in the queen's apartment.

Largely forgotten in the 19th century, Schönhausen experienced a surprising twist of fate after the Second World War. The little summer residence became the seat of a head of state. In 1949 Wilhelm Pieck was installed here as the first President of the German Democratic Republic. Pieck's official office is now on view, as is the elegant modern President's Garden designed by Reinhold Lingner.

The East German Council of State met here briefly from 1960 until 1964, and then the building served as a government guesthouse until the demise of the GDR in 1990. The apartment used by official guests survives and is presented in the style of the 1960s, whereas the fireside lounge reflects the final interior reappointment of the rooms in 1978. These rooms have accommodated many big names such as Fidel Castro and Mikhail Gorbachev, unique and tangible testimony to an important period in German post-war history.

The elegant Schönhausen stairs of 1764

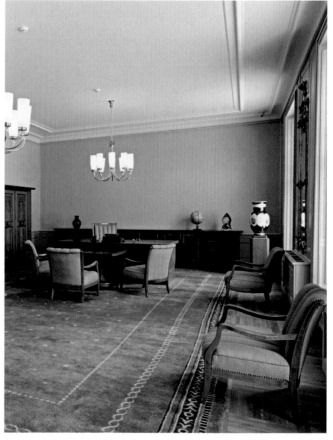

The office of East German President Wilhelm Pieck with its original furniture from 1950

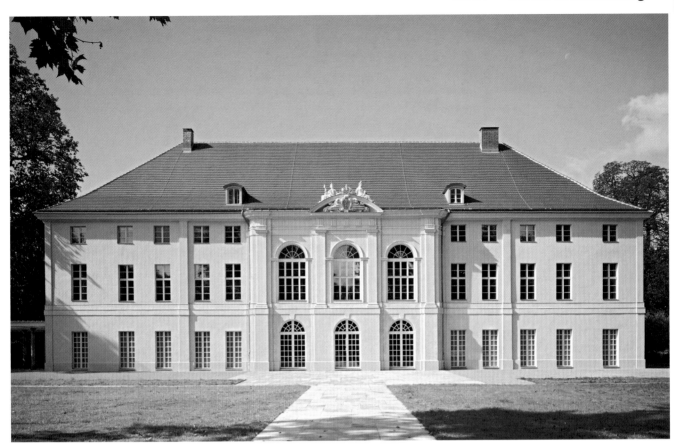

Schloss Schönhausen from the garden

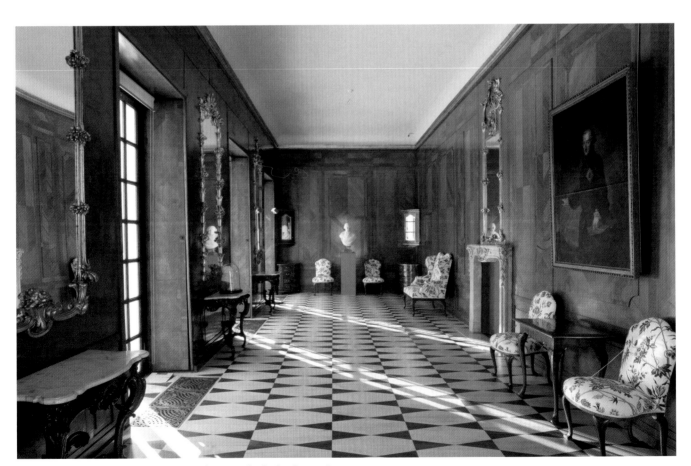

The Cedar Gallery of 1764 offers a taste of Queen Elisabeth Christine's interior

Grunewald Hunting Lodge

Jagdschloss Grunewald
Hüttenweg 100
14193 Berlin

Telephone
+49 30/8 13 35 97

E-Mail
info@spsg.de

Internet
www.spsg.de

In 1542, Elector Joachim II Hektor of Brandenburg, an enthusiastic hunter, had the foundation stone for a Renaissance lodge laid here on the shores of the lake. The house was known as "in the green wood", and that is how the surrounding woodland acquired its name.

Almost all Prussia's rulers enjoyed hunting in the Grunewald. The lodge underwent frequent conversions and extensions to meet changing needs. In the early 18th century, after crowning himself King of Prussia, Friedrich I sought to express his new status by ordering the construction of stately baroque extensions and small buildings for court functions. Friedrich the Great had the equipment store built from 1765, so that the diverse paraphernalia of hunting – such as carts, nets, banners and blankets – could be collected here from scattered locations used by the court hunt. The last conversions under the Prussian monarchy were carried out in 1901–1904 for Kaiser Wilhelm II, who wished to host large companies with all the protocol of court.

From 1927 the lodge was managed by the Prussian Administration of State-Owned Palaces and Gardens. In 1932, when little furniture remained, it was hung with 15th- to 19th-century paintings and run as a public museum. Largely unscathed in the war, in 1949 Grunewald Hunting Lodge became the first museum in Berlin to re-open its doors.

The ground floor provides an interesting history of construction at the lodge. The permanent exhibition in the store room not only displays equipment, but also describes various hunting techniques deployed in Grunewald.

In spring 2011 Grunewald is opening a new exhibition with works by Lucas Cranach senior and his son Cranach junior. Concerts and other events are held regularly in the courtyard and ancillary buildings.

Grunewald Hunting Lodge

Schloss Glienicke

Schloss Glienicke and Pfaueninsel

In 1794, Friedrich Wilhelm II of Prussia had a rural summer pavilion built on Pfaueninsel (the isle of peacocks) for himself and his mistress Wilhelmine Encke, the future Countess Lichtenau. It is a timber frame structure faced with wooden boards, but built to resemble a ruinous Romantic backdrop. The magnificent early classical interior comes as a surprising contrast. It is still largely in its original condition and conveys an authentic impression of living conditions at court around 1800. Under Friedrich Wilhelm II the island retained its original character. The landscaped garden was confined to the area around the palace, while a neo-Gothic dairy was built at the other end of the island.

Friedrich Wilhelm III and his wife Queen Luise used the palace as a summer residence. From 1818 Peter Joseph Lenné was commissioned to transform the island into a landscaped garden. Several new buildings were added, including the Palm House (razed by fire in 1880) and Schinkel's Cavalier House.

Just beyond the gates of Potsdam, on the banks of the Havel, Schloss Glienicke with its park is a major component of the local cultural landscape. Prince Carl of Prussia bought the property in 1824 for himself and his future wife Marie of Saxe-Weimar. Deeply affected by a recent Italian journey, he commissioned extensions and conversions to plans by Karl Friedrich Schinkel in 1824–1827. First, the old billiard house on the high riverbank was enlarged to create a casino, oriented completely around views of the lake. Then, in 1825–1827, the old manor house was converted into a classical villa. A tower was added in 1832, and the lion fountain enhancing the street elevation in 1838. Peter Joseph Lenné, who first began working on these pleasure grounds in 1816 under the previous owner, Prince Hardenberg, was now able to complete the project under his new client.

Schloss Glienicke
Königsstraße 36
14109 Berlin

Pfaueninsel
Nikolskoerweg
14109 Berlin

Telephone
+49 30/8 05 86 75 10

E-Mail
info@spsg.de

Internet
www.spsg.de

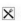 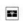

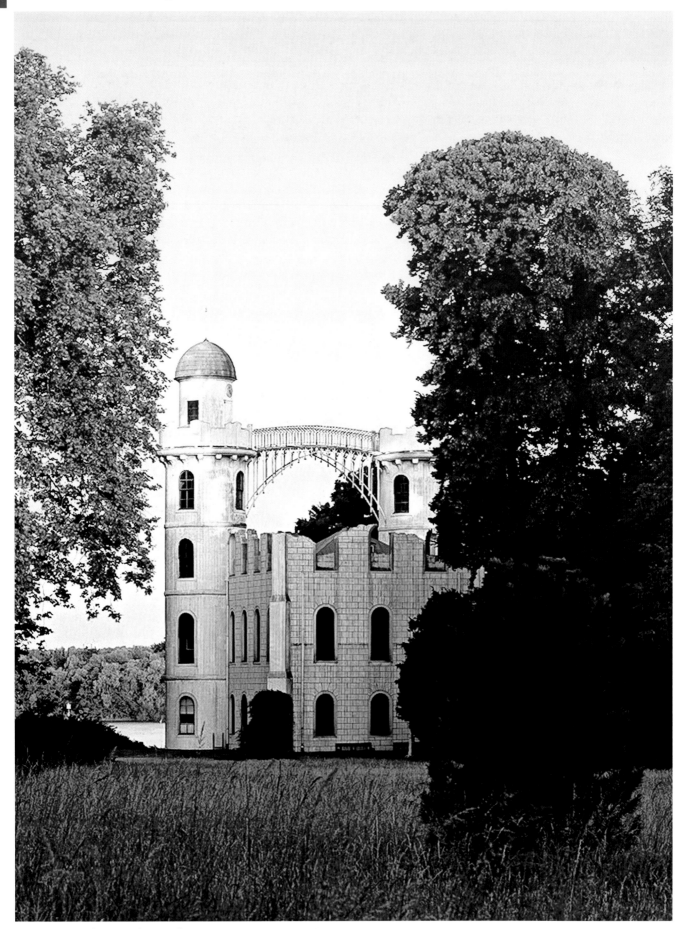

The summer residence on Pfaueninsel

Schloss Sanssouci

Friedrich the Great chose this "desolate hill" by Potsdam for its attractive location and fine view. As the name "Sans souci" (or "without a care") on the garden front of the palace proclaims, this summer residence was intended primarily to serve the King's private diversions. He hoped here to pursue philosophy, music and literature and to be buried one day in the crypt alongside the palace.

The single-storey building in the manner of a French "maison de plaisance" was built in 1745–1747 under the supervision of Georg Wenzeslaus von Knobelsdorff to specifications by the King. The middle consists of two magnificent halls, with Friedrich's apartments to the east and guest rooms to the west. The King received chosen guests at his famous dining table in the domed Marble Hall. The Library and Concert Room are supreme accomplishments of rococo interior art.

The side tracts – the kitchen and the Ladies' Wing – acquired their present form in 1840–1842 under Friedrich Wilhelm IV. The drawings were by Ludwig Persius. The west (or "ladies'") wing was intended as "lodging for ladies of court and elsewhere". The kitchen was accommodated in the east wing.

The colonnades of the cour d'honneur open the view to the Hill of Ruins, where a reservoir feeds water to the garden fountains. Artificial ruins were added in 1748 to create the illusion of an Ancient landscape.

Next page: Schloss Sanssouci with terraced vines

Schloss Sanssouci
Maulbeerallee
14469 Potsdam

Telephone
+49 3 31/9 69 4-2 00
+49 3 31/9 69 4-2 01

E-Mail
info@spsg.de

Internet
www.spsg.de

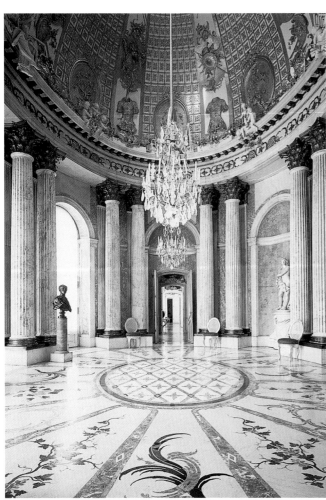

Marble Hall

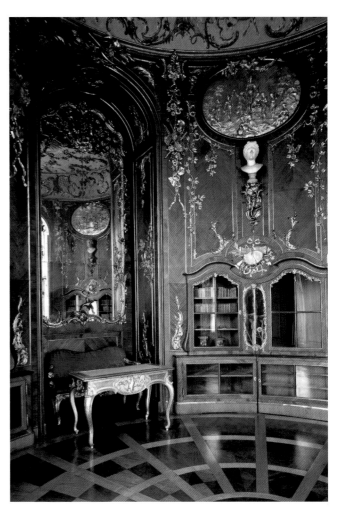

Schloss Sanssouci, library

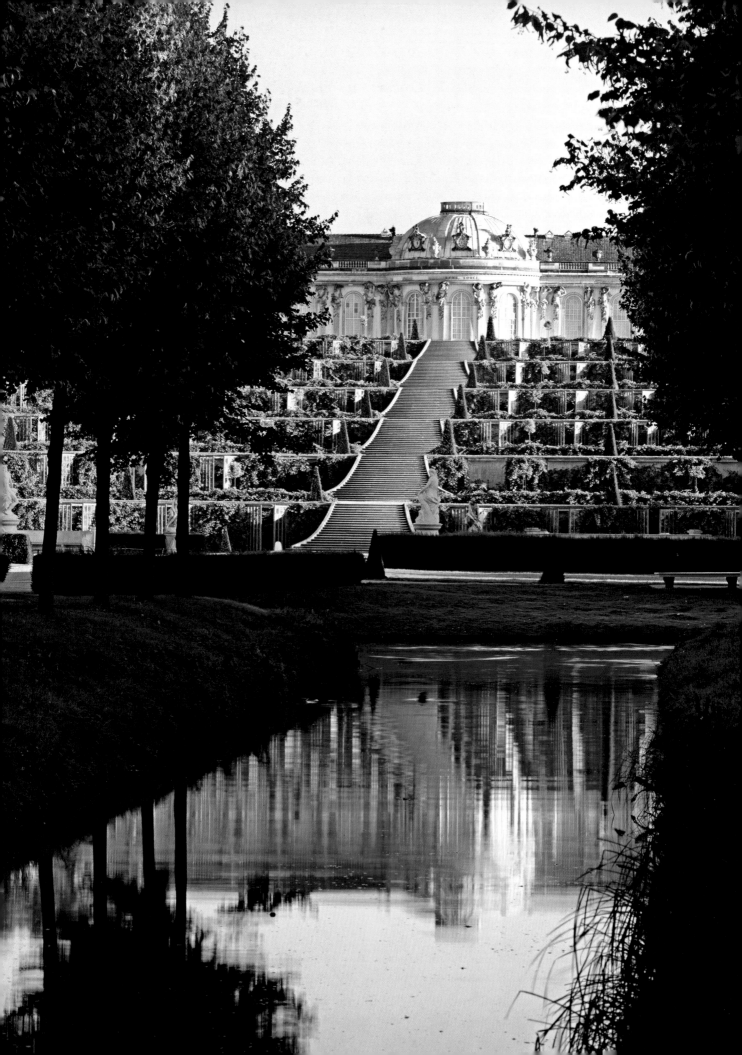

Picture Gallery/New Chambers

Friedrich the Great was a passionate collector of paintings. He filled his apartments with them, not very unlike his contemporaries. However, his idea of commissioning a building specifically to house his collection was an international novelty. The Picture Gallery was erected in 1755–1763 to drawings by Johann Gottfried Büring over the foundations of a former hothouse next to Schloss Sanssouci. It is one of the oldest surviving museum buildings in Germany and also one of the most beautiful galleries in the world. Divided in the middle by a tribuna, the hall is almost as long as the building itself, which appears very simple from the outside. The use of precious marbles and gilt stucco lends this room its unique festive atmosphere. Masterpieces by Caravaggio, Maratta, Reni, Rubens and van Dyck are hung frame to frame in baroque style. Caravaggio's "Doubting Thomas", one of the key attractions in today's collection, was a later addition. Friedrich the Great himself disdained paintings of "scoundrel saints who get martyred".

Although the King had adequate space to accommodate his guests in the New Palace, in 1771–1775 he had the orangery that formerly stood to the west of Schloss Sanssouci converted into a palatial guest-house. The structure with seven halls of plants, originally designed by Georg Wenzeslaus von Knobelsdorff, banqueting halls and guest apartments were appointed to drawings by Johann Christian Unger. The interior decoration betrays a late yet high-quality rococo. This exultant splendour is well concealed by the simple austerity of the façade. In the Ovid Gallery, a room in the fashion of a French gallery of mirrors, fourteen themes from the Roman poet's "Metamorphoses" exude a voluptuous sensuality in gilt stucco relief. The smaller guest rooms are ornately decked with marquetry, enamel or paintings. The marquetry finishing by the Spindler brothers is especially noteworthy.

Bildergalerie/Neue Kammern
Im Park Sanssouci
14469 Potsdam

Telephone
+49 3 31/9 69 4-2 00
+49 3 31/9 69 4-2 01

E-Mail
info@spsg.de

Internet
www.spsg.de

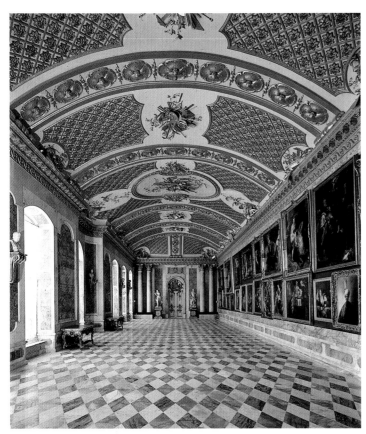

West wing of the Picture Gallery

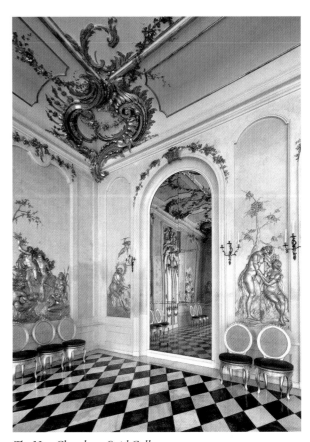

The New Chambers, Ovid Gallery

The New Palace

Neues Palais
Am Neuen Palais
14469 Potsdam

Telephone
+49 3 31/96 94-3 61

E-Mail
neues-palais@spsg.de

Internet
www.spsg.de

This spacious palace complex, described by the King himself as a "fanfaronade" (or "brag"), was intended to reflect Prussia's political power after the Seven Years War. Between 1763 and 1769, Friedrich the Great had the New Palace, or Neues Palais, set at the far western end of the main avenue, as a grand finale to this rigidly straight axis some two kilometres long. Designed by Johann Gottfried Büring, Heinrich Ludwig Manger, Carl von Gontard and Jean Laurant Legeay, the New Palace is one of the largest palace buildings of its day, 220 metres long with more than 400 statues on the façade, magnificent banquet halls, a theatre and lavishly fitted rooms for the Prussian King's guests.

The Schlosstheater in the New Palace is one of the few 18th-century theatres still extant, and the stage is used frequently for performances. Contrary to the fashion of the times, the seating is arranged as in an amphitheatre, with ascending rows. A royal box was superfluous, because Friedrich preferred to follow the proceedings from in front of the orchestra pit or from a seat in the third row.

Friedrich the Great's successors only used the New Palace for festive occasions or theatre productions. Not until Kaiser Friedrich III in 1859 did a monarch reside here regularly in summer. His son Wilhelm II made the New Palace his principal residence, adding a garden terrace, riding stables and a station to the original complex. The Communs, or functional buildings, opposite were conceived with their colonnade as an architectural backcloth to conceal the wasteland beyond. These buildings are now used by Potsdam University.

Marble Hall

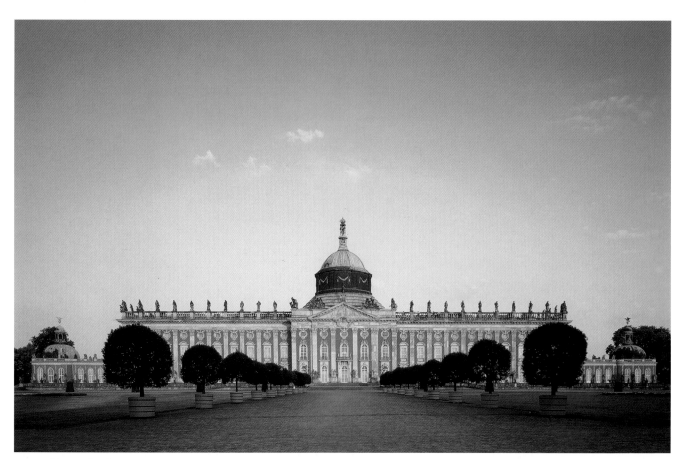

New Palace, garden front

Schloss Charlottenhof/Roman Baths

Schloss Charlottenhof
Geschwister-Scholl-
Straße 34a
14471 Potsdam

Telephone
+49 3 31/96 94-2 25

E-Mail
info@spsg.de

Internet
www.spsg.de

The enchanting park and palace of Charlottenhof are the product of a happy collaborative venture between two brilliant creative minds: architect Karl Friedrich Schinkel and landscape gardener Peter Joseph Lenné.

Friedrich Wilhelm III purchased the site southwest of the original Sanssouci Park in 1825 as a Christmas present for Crown Prince Friedrich Wilhelm IV and his wife Elisabeth of Bavaria. In 1826–1829 Karl Friedrich Schinkel converted the existing manor house into a classical villa to serve as a summer residence. The task of landscaping this former farmland fell to Peter Joseph Lenné. In the immediate vicinity of the house he created a garden of compact design and an east-west orientation, beginning with a rose garden to catch the morning sun, a terrace along the house for the midday sun, and further west the poets' grove and the Ildefonso group for the evening and nocturnal hours. The drive and broad sight-lines skilfully link the new park with the old park of Sanssouci. Nothing is left to chance, be it a movement of terrain, a cluster of trees or a free-standing structure. An artificial lake put the perfect finishing touch to this landscaped garden.

The buildings which make up the Roman Baths were constructed in 1829–1840 to drawings by Karl Friedrich Schinkel and Ludwig Persius. The court gardener lived in the villa with a tower. From the little garden with its beds of "Italian cultures", including maize, hemp, artichokes and tobacco, the arcades lead to the Roman Baths themselves. This structure resembles a house in an Ancient civilisation and was used by the Crown Prince as a museum for his Italian souvenirs. Friedrich Wilhelm IV liked to take tea at the pavilion on the banks of the artificial reservoir.

Roman Baths, the apodyterium from the atrium

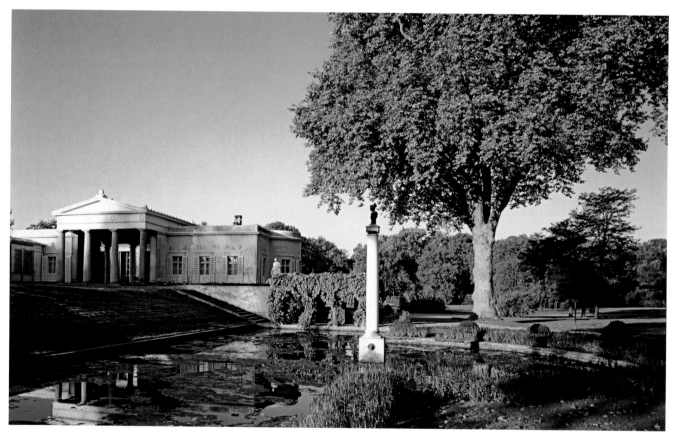

Schloss Charlottenhof

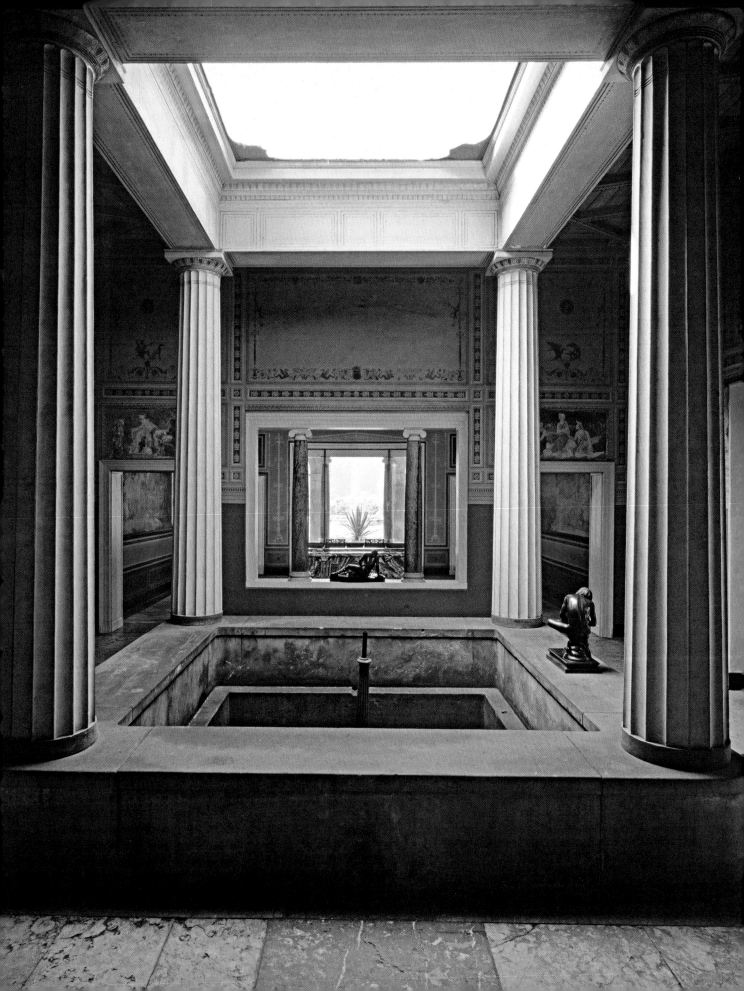

The Orangery Palace

Sanssouci, Orangerie-
schloss und Turm
An der Orangerie 3–5
14469 Potsdam

Telephone
+49 3 31/9 69 42 80

E-Mail
info@spsg.de

Internet
www.spsg.de

The terraces adorned with Mediterranean plants and the majestic structure in Italian Renaissance style indicate the great affection for Italy cherished by Friedrich Wilhelm IV. The complex was built between 1851 and 1864 to designs by Prussia's art-loving king. His prototypes were Italian villas and palaces such as Villa Medici and Villa Pamphili. There were originally ambitious plans for the architecture: an elevated road flanked by diverse buildings would lead from the triumphal gate, across the hill where the mill stands, past Schloss Sanssouci to the Belvedere on Klausberg, but the orangery was the only major feature to be implemented. The best-known Prussian architects of the day – Ludwig Persius, Friedrich August Stüler and Ludwig Ferdinand Hesse – were involved in the planning process.

Exotic pot plants from Sanssouci still spend the winter in the plant halls, each over 100 metres long. The villa-like pavilions linked by double portals which round off the complex to the east and west have been used ever since their construction to house court staff.

The viewing platform between the towers over the central section offers visitors a fascinating panorama of the landscape. Inside the palace, two royal apartments convey an impression of how people lived at the 19th-century court. The rooms are appointed to reflect the King's personal taste, with works by sculptors of the Berlin school, architectural ornament, furniture reminiscent of historical styles, wall coverings of precious silk and mineral decoration.

The heart of this palace complex is the Raphael Hall. Conceived by Friedrich Wilhelm IV as a museum space, the impressive roof-lit hall contains about 50 copies of paintings by Raphael from the King's collection, including such famous pieces as the "Sistine Madonna" and the "Transfiguration".

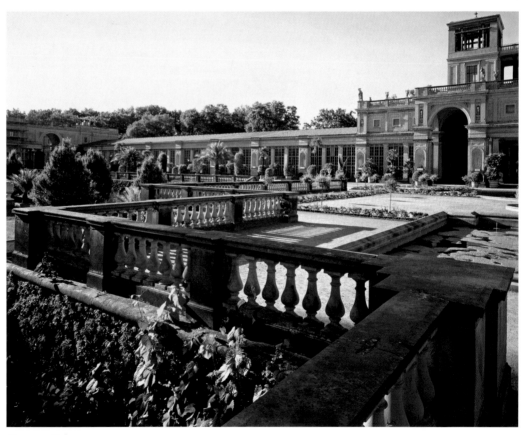

Orangery Palace

Schloss Babelsberg and Park

Prince Carl and Prince Friedrich Wilhelm already had their own summer residences, Glienicke and Charlottenhof, when in 1833 Prince Wilhelm – eventually to become Kaiser Wilhelm I – was finally granted permission by his father Friedrich Wilhelm III to use the slopes of Babelsberg for a stately home and park.

Before the year was out, Peter Joseph Lenné had produced preliminary drawings for the park, and Karl Friedrich Schinkel had been appointed to design a neo-Gothic palace. Work proceeded apace, although hindered by meagre finances and disagreements with the owners. Lenné was plagued by a run of bad luck on this commission. His ideas did not appeal to Crown Princess Augusta, and many of the plants he introduced dried out for lack of irrigation. He was replaced by Prince Pückler-Muskau, who retained Lenné's network of paths, but added a multitude of narrow walks with delightful views of Potsdam. Closer to the palace, he redesigned the pleasure ground and the flower garden, adding ornate decoration on the terraces.

For financial reasons, Schinkel only finished the first section of the palace, which was completed between 1844 and 1849 by Ludwig Persius and Johann Heinrich Strack. They modified Schinkel's original plans for partitioning the interior space, not least to reflect the wishes of the royal couple.

In the middle of the park, a ten-minute walk from the palace, Strack built the Flatow Tower. Constructed between 1853 and 1856 as an eye-catching feature and vantage point, it replaced a granulating windmill that burned down in 1848. The tower re-opened in 1993. The continuous gallery which runs round the outside at the top offers extensive views of the lakes, gardens and cultural landscape of Potsdam. Some of the tower rooms have been restored just as they were originally built and furnished; others house a modern exhibition where visitors can learn more about the history of the tower and the park.

Schloss Babelsberg
Park Babelsberg 10
14482 Potsdam

Telephone
+49 3 31/96 94-2 00

E-Mail
info@spsg.de

Internet
www.spsg.de

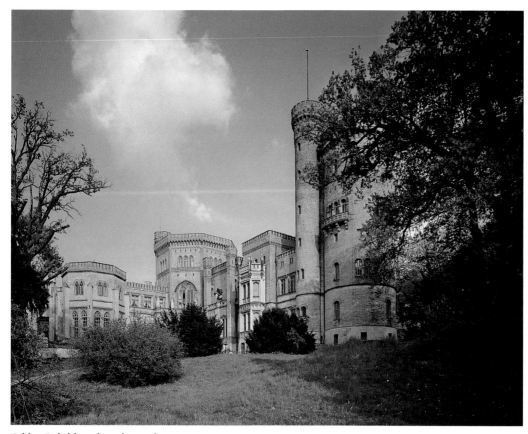

Schloss Babelsberg from the north-west

The Marble Palace

Marmorpalais
Im Neuen Garten
14467 Potsdam

Telephone
+49 3 31/96 94-5 50

E-Mail
info@spsg.de

Internet
www.spsg.de

 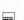

Between 1789 and 1791, Carl von Gontard built this palace on the shores of a lake, Heiliger See, as a summer residence for King Friedrich Wilhelm II. It marked the arrival in Prussia of classical architecture.

Carl Gotthard Langhans designed the interior, including the King's bedroom with ornate wooden panelling throughout, the unconventional Oriental Room and the concert hall inspired by an Ancient temple. The furnishings were acquired either by the King himself or the Countess Lichtenau, his mistress for many years. Among these are Ancient sculptures, valuable items of furniture, paintings – some by Angelika Kauffmann – and marble fireplaces from Rome made especially for this setting. The Marble Palace also boasts the second largest collection of Wegdwood pottery in Germany.

Extensions commenced in 1797 with the addition of side wings, although these were not completed until the mid-1840s, under Friedrich Wilhelm IV, to drawings by Boumann and Hesse. The wings are supported outside by marble columns, decorated with the Nibelungen Saga. In the orangery alongside, the two halls for plants are separated by a wood-panelled Palm Hall, where Friedrich Wilhelm II would play the cello to entertain his courtiers and the audience gathered in the adjoining plant halls.

A yellow silk chamber in the quarters of Friedrich Wilhelm II

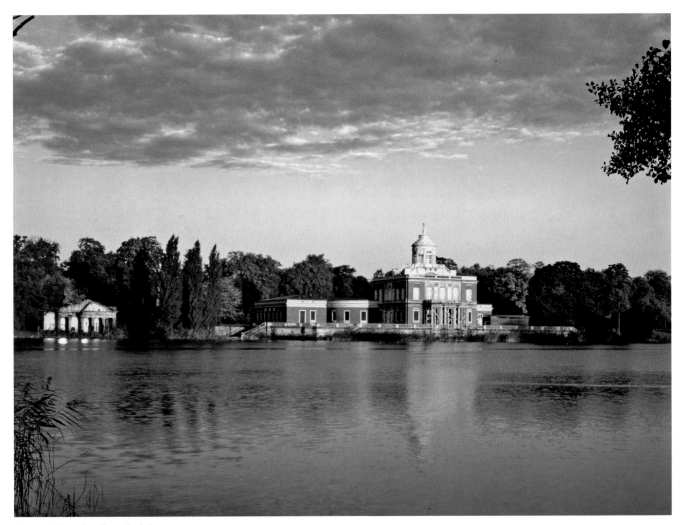

The Marble Palace from the lake

Schloss Cecilienhof

Schloss Cecilienhof
Im Neuen Garten
14469 Potsdam

Telephone
+49 3 31/9 69 45 20

E-Mail
schloss-cecilienhof@
spsg.de

Internet
www.spsg.de

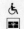

Built from 1913 to 1917 in the style of an English country house, the palace stands near the shores of a lake, Jungfernsee, at the north end of the New Garden. It was commissioned by Kaiser Wilhelm II as a residence for Crown Prince Wilhelm of Prussia and his wife Cecilie. It was to be the last palace for the Hohenzollern dynasty, because 1919 brought the November Revolution, and that in turn put an end to the monarchy. Architect Paul Schultze-Naumburg grouped the various structures around several courtyards, so that the true scale of the building with its 176 rooms was not apparent. The façade is enlivened by complex timber frames and decorative chimneys. The state apartment where the royal couple officially entertained was in the central section, and the family were allowed to continue using it until 1945. The private rooms were on the upper floor, and now that these have been restored they convey some impression of how wealthier families furnished their homes in the early 20th century. A room designed for the Crown Princess in the form of a ship's berth has also been preserved in its original state.

The palace acquired international fame as the venue where the victorious Allies held their postwar conference from 17 July to 2 August 1945. The main rooms were used for the talks and as studies for the "Big Three", and today they can be visited as the historical setting of the Potsdam Conference. The Great Hall was the hub of negotiations. The study and music salon once used by Crown Princess Cecilie became the study and reception room for Joseph Stalin, the Soviet head of state. Crown Prince Wilhelm's smoking room fell to President Harry S. Truman of the United States, while the library began as the office of the British Prime Minister Winston Churchill, until he was replaced by Clement Attlee following elections in the UK. The Communiqué signed at the end of the conference went down in history as the Potsdam Agreement, and it established the political and territorial order for Germany and Europe after the Second World War.

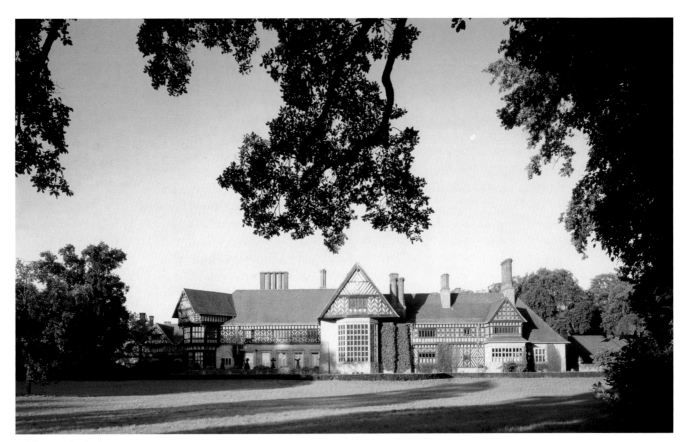

Schloss Cecilienhof

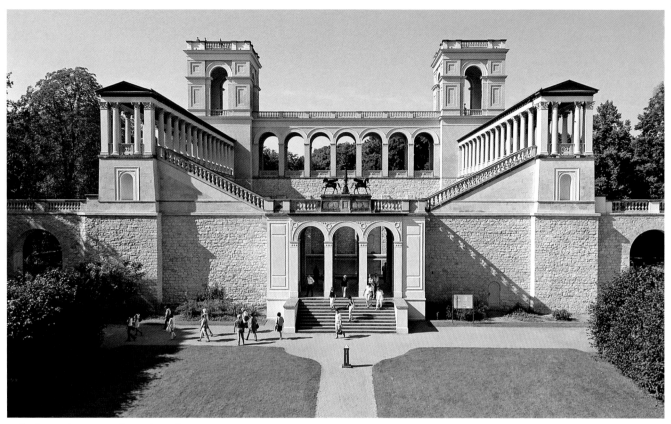

Belvedere with portico, colonnades and viewing towers

The Belvedere on Pfingstberg

The finest view of Potsdam and the lakes of the Havel is the one from the Belvedere on the hill known as Pfingstberg. Conceived by Friedrich Wilhelm IV as a large twin-towered structure with terraces, waterfalls and colonnades, it was intended to stretch to the edge of the New Garden. The King drew his inspiration from Italian villas of the Renaissance. During the two phases of construction, 1847–1852 and 1861–1863, the architects Ludwig Persius, Ludwig Ferdinand Hesse and Friedrich August Stüler merely completed the building with the twin towers. It encloses an inner courtyard, where a water basin flanked by arcades, colonnades and galleries grants access to two little rooms, one in Moorish and the other in Roman-Pompeian style. Open steps lead to the roof over the portico, offering views over a forecourt between wing masonry walls with a grass parterre and exterior galleries, and over the Temple of Pomona. This tea pavilion created as a Greek temple in 1801 is believed to be the first building constructed by the young architect Karl Friedrich Schinkel, just turned 19. The little one-roomed structure was named after Pomona, the goddess of fruit. The roof under an awning serves as a viewing terrace. Friedrich Wilhelm III bought the temple in 1817 and it was a favourite destination for excursions by the royal family.

The Belvedere and the Temple of Pomona are set within a garden landscaped by Peter Joseph Lenné in 1863. Numerous sight lines from the serpentine path establish links with the New Garden. This historical ensemble fell into serious disrepair after the Second World War, but in 1992 restoration began following an initiative by the Friends of Pfingstberg and donations of money. Today it again offers visitors the finest panorama of Potsdam and a unique atmosphere. During the summer months from May to September, the palace and park also provide a romantic backdrop for cultural events of all kinds.

Belvedere auf dem Pfingstberg
Große Weinmeisterstraße 45a
14469 Potsdam

Telephone
+49 3 31/2 00 57 93-0

E-Mail
info@pfingstberg.de

Internet
www.pfingstberg.de

Schloss Rheinsberg and Park

Schloss Rheinsberg
Mühlenstraße 1
16831 Rheinsberg

Telephone
+49 3 39 31/72 60

E-Mail
info@spsg.de

Internet
www.spsg.de

The history of Rheinsberg is closely associated with Friedrich the Great when he was a Crown Prince and with the life of his brother Prince Heinrich. After years of bitter conflict between father and son, "Soldier King" Friedrich Wilhelm I granted 22-year-old Friedrich permission to run Rheinsberg as his official seat. By this time, the Crown Prince had married Elisabeth Christine of Brunswick-Bevern.

The existing Renaissance building on the island in its picturesque Lake Grienerick setting was converted to meet the needs of its new occupants, first by Kemmeter in 1734 and then by Georg Wenzeslaus von Knobelsdorff from 1737. At a comfortable distance from his strict father, Friedrich created the "court of Muses", where for the first time in his life he was able to pursue his artistic interests unhindered among kindred spirits. As yet unburdened by the responsibilities of government, he spent extremely happy years here.

A few years after assuming the crown, he gave the palace to his brother, Prince Heinrich, who drew on plans by Carl Gotthard Langhans and others to undertake conversions which would accommodate his own court. Friedrich's park was expanded, becoming one of Germany's earliest "gardens of sensibility".

After many twists and turns – the palace served as a sanatorium for diabetics after 1953 – the property was placed in the Foundation's care in 1991, when it re-opened as a museum. A major restoration programme was initiated to regain the original character of both palace and park, and it is not yet complete. The setting entered literary history when Kurt Tucholsky published "Rheinsberg – A Picture Book for Sweethearts" in 1912.

The palace with its theatre

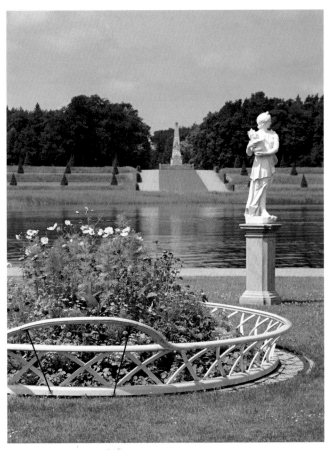

Palace island and obelisk

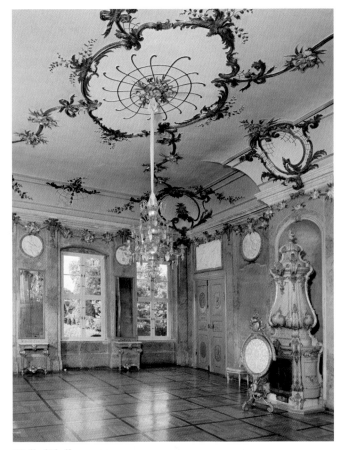

Hall of Shells

Schloss Paretz

Schloss Paretz
Parkring 1
14669 Ketzin

Telephone
+49 3 32 33/7 36-11

E-Mail
info@spsg.de
schloss-paretz@spsg.de

Internet
www.spsg.de

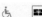

Between 1797 and 1804, the village of Paretz, 19 km north of Potsdam, was redesigned in Gothic style by David Gilly for Friedrich Wilhelm III, then still heir to the throne, and his wife Luise. While the village gained a reputation as a model of rural architecture in Prussia, the palace rooms were celebrated for their painted and printed wallpapers and outstanding examples of furniture-making in Berlin around 1800. Until 1945, the furnishings and fittings remained much as they had been since 1800, especially in the royal apartment. Until the Second World War broke out, the palace was accessible to the public as a museum. It was only when the wallpapers were removed in 1947 and the farming college was reorganised in 1948–1950 that sensitive alterations took place, depriving the palace of its identity. From 1999 to 2002 the site underwent rehabilitation and restoration based on its original appearance. In 2002 the palace was placed under SPSG's administrative care and it is now open to visitors again as a palace museum with an exhibition on the restoration project. Since 2006 the coach house has been used to house an exhibition devoted to "Carriages, Sledges and Sedan Chairs from the Royal House of Prussia". The hall, thoroughly redeveloped and modernised in 2008, can be hired for festive occasions and lectures.

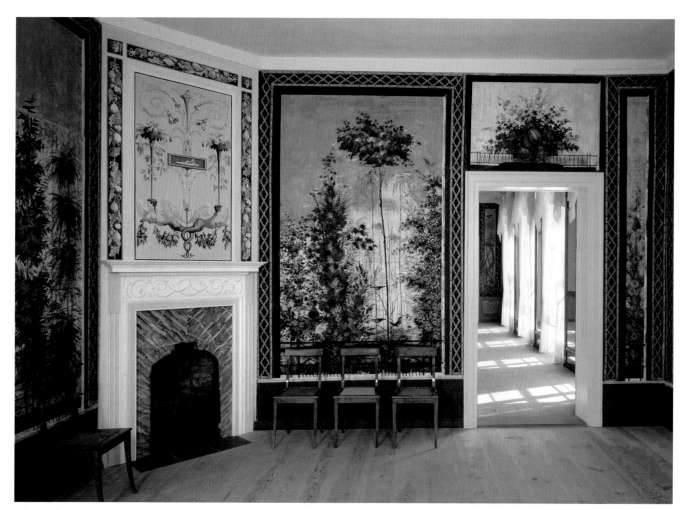

The Garden Room at the centre of the palace

Schloss Caputh and Park

Not far from Potsdam, on the south bank of the Havel, lies the little country residence of Caputh, which has served both electors and kings. The early baroque palace is the only palace from the age of the Great Elector Friedrich Wilhelm of Brandenburg to have survived in the cultural landscape around Potsdam. Built in 1662 by Philipp de Chièze, it was purchased in 1671 by the Elector, who gave it to his second wife Dorothea. The original ceiling designs, with their paintings and stucco, have been preserved in almost every room. The works on display today, which include lacquered furniture, porcelain, faience, sculpture and paintings, illustrate how arts flourished and people lived at court around 1700.

Schloss Caputh thrived again under Elector Friedrich III, who became King Friedrich I of Prussia in 1701. Friedrich Wilhelm I used Caputh for hunting jaunts, and around 1720 he had the summer dining room fitted out with about 7,500 faience tiles from the Netherlands. In the 18th century the building was leased out, and eventually it was sold off by the Crown.

Following restoration by SPSG, the residence at Caputh and the surrounding park have re-opened to the public.

Schloss Caputh is not just a museum, but a venue for guided tours, talks, concerts, exhibitions and events of many kinds.

The residence is set within a small landscaped garden inspired by P. J. Lenné. Sadly, few traces remain of the original baroque garden, but around 1700 it contained an abundance of fountains, floral parterres, fruit trees and statues.

Schloss Caputh
Straße der Einheit 2
14548 Schwielowsee

Telephone
+49 3 32 09/7 03 45

E-Mail
schloss-caputh@spsg.de

Internet
www.spsg.de

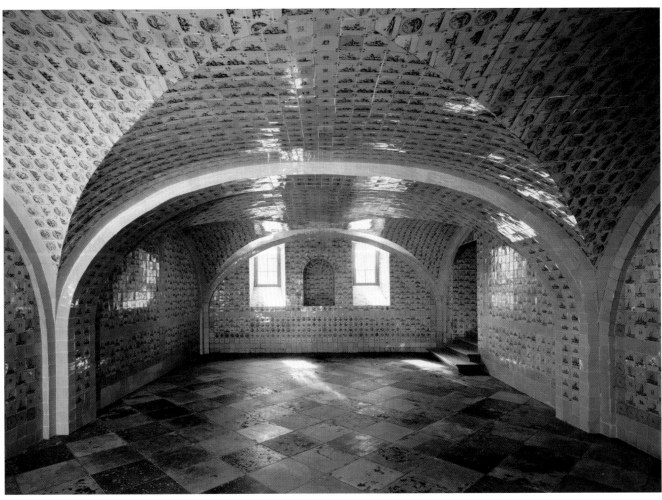

Schloss Caputh, Hall of Tiles

Schloss Königs Wusterhausen

Schloss Königs
Wusterhausen
Schlossplatz 1
15711 Königs
Wusterhausen

Telephone
+49 33 75/2 11 70-0

E-Mail
info@spsg.de

Internet
www.spsg.de

Originally a medieval castle, the palace still retains its Renaissance look, acquired when it was redeveloped as a fortified residence. It was heavily influenced by Friedrich Wilhelm I (r. 1713–1740), the "Soldier King", who was given the property as a drill ground in 1689 by his parents, Elector Friedrich III (who was to become the first King of Prussia) and his lady consort Sophie Charlotte. In Wusterhausen, renamed Königs Wusterhausen around 1717, Crown Prince Friedrich Wilhelm laid the groundwork for his administrative, commercial and military reforms. Here were the origins of his legendary tall guardsmen, the "lange Kerls". Friedrich Wilhelm I was particularly fond of this place, which he used as a hunting retreat but also as a residence, and every year he would spend a few months here with his wife, Sophie Dorothea of Hanover, and their numerous children, including Crown Prince Friedrich II.

After his death in 1740, the house underwent many changes of use over the next 250 years. It served the Kaiser as a hunting lodge, then as a museum, as a base for Soviet intelligence units and as the seat of a district council in GDR days. At the end of September 2000, after almost ten years of restoration work, SPSG re-opened the stately home as a museum. The former royal apartment, with works of art from the early half of the 18th century, is uncommonly austere for the baroque period, and that accounts for Königs Wusterhausen's distinctive character. Of particular note are the works by the Soldier King himself, almost 40 in number, as well as the Officers' Gallery, the painting of the celebrated Tobacco Club or "Tabakskollegium" dated around 1737 in the newly appointed room of the same name, and some striking portraits of the royal family.

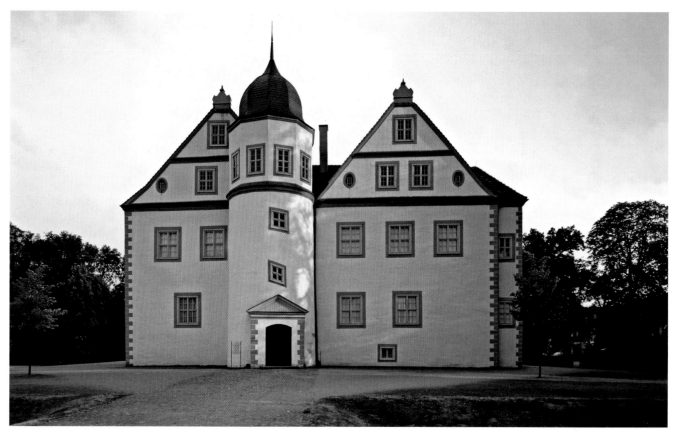

Schloss Königs Wusterhausen

Schloss Oranienburg

Schloss Oranienburg is one of the most striking baroque buildings in the marches of Brandenburg.
Its origins date back to the 13th century. A moated castle first mentioned in 1288 changed hands several times before finally ending up with the Hohenzollern dynasty in 1485 under Margrave Johann Cicero. Around 1550, Elector Joachim II built a hunting lodge on the same spot, and his successor Johann Georg had the interior completely redesigned. Traces of this Renaissance ensemble can still be found in the central section, later reworked in the baroque manner.

Today's building began as a country seat built from 1651 for the first wife of the Great Elector (1620–1688), Louise Henriette (1627–1667), born a Princess of Orange.

Her son, the future King Friedrich I, had the residence extended and magnificently appointed from 1689 by architects Johann Arnold Nering and Johann Friedrich Eosander.

Around 1700 it was considered to be the Prussian monarchy's finest residence. In the mid-18th century it experienced a second heyday under Prince August Wilhelm of Prussia (1722–1758), a brother of Friedrich the Great.

Following a dramatic sequence of uses, some with dire implications, the palace museum of Oranienburg now houses a collection of unique works, including the splendid etageres in the Porcelain Chamber. There is an outstanding ivory seating arrangement, made around 1640 in Brazil, and a series of tapestries from the Berlin manufactory of Pierre Mercier, a religious refugee from France, depicting the glorious feats of the Great Elector.

Statues and other sculpture by François Dieussart and Bartholomeus Eggers and paintings by, for example, Anthony van Dyck, Jan Lievens, Willem van Honthorst, Thomas Willeboirts (Bosschaert) and Antoine Pesne complete this extremely rich collection. Another highlight is the Silver Chamber with its selected display of magnificent royal silverware.

Schloss Oranienburg
Schlossmuseum
Schlossplatz 1
16515 Oranienburg

Telephone
+49 33 01/53 74 37

E-Mail
schlossmuseum-
oranienburg@spsg.de

Internet
www.spsg.de

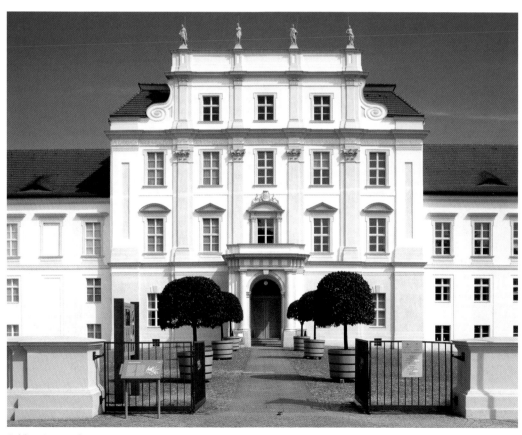

Schloss Oranienburg

Steam Pump House/
Mosque
Breite Str. 28
14471 Potsdam

03 31/96 94-2 00

info@spsg.de

www.spsg.de

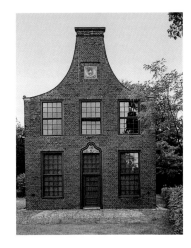

Stern Hunting Lodge
14469 Potsdam

+49 3 31/96 94-2 00

info@spsg.de

www.spsg.de

The Old Mill
Maulbeerallee 5
14469 Potsdam

+49 3 31/5 50 68 51

info@spsg.de

www.spsg.de

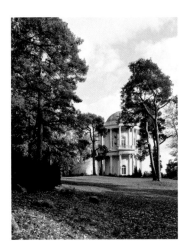

Belvedere on Klausberg
14469 Potsdam

+49 3 31/96 94-2 06

info@spsg.de

www.spsg.de

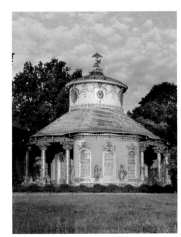

Chinese House
Am Grünen Gitter
14469 Potsdam

03 31/96 94-2 00

info@spsg.de

www.spsg.de

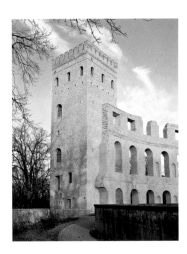

Norman Tower on the
Mount of Ruins
14467 Potsdam

03 31/96 94-2 00

info@spsg.de

www.spsg.de

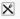 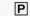

Hesse

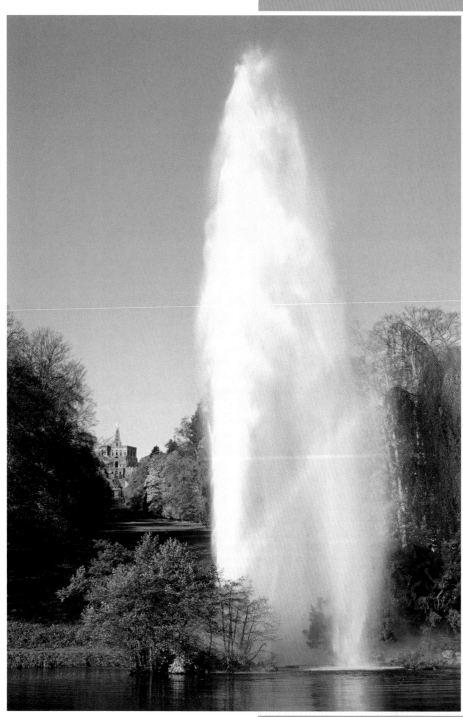

HESSEN

Staatliche Schlösser
und Gärten

mhk•
museumslandschaft
hessen kassel

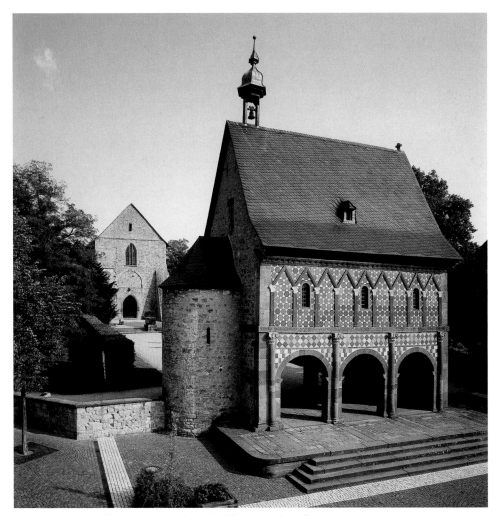

The UNESCO World Heritage Site of Lorsch Abbey – King's Hall

Serving the Cultural and Natural Heritage for Over 70 Years

In the land of Hesse, in the heart of the Federal Republic of Germany, we, the Office of State Palaces and Gardens and the Museum Region of Hesse Kassel, oversee a number of major testimonials to 2000 years of architectural and art history. These include the Roman forts at Limes, medieval churches and cloister complexes, castles and defensive structures, as well as palaces and gardens. With the three UNESCO World Heritage Sites of Lorch Cloister, the forts at Limes, and the Hessian portion of the Middle Rhine Valley, it is hoped that Kassel shall be entered into the list in 2012.

We see ourselves as a cultural and recreational organization, as well as an educational institution with cultural, historical, scientific, and social focal areas.

Our mission includes the state-run preservation, research, supplementation, and presentation of Hesse's artistic and historical legacy.

A number of these artistic entities, consisting of buildings and their accompanying inventory and surrounding parks, are:

- landmarks and auratic holders of identity and authenticity
- refuges of culture and created nature for centuries
- sites of education, recreation, and reflection

With approximately 400 employees, we maintain the cultural and natural heritage in our care, bringing many visitors closer to the history, value, and significance of these sites. Popular among visitors, the castles, palaces, and parks play an important role for their respective communes or regions from a touristic angle. We are especially thrilled that the diverse program of events at Hesse's cultural heritage sites enjoy such vibrant popularity. Among these are the numerous cultural festivals, such as the Bad Hersfeld Festival and the Weilburg Palace Concerts, but also hundreds of additional independent events. Not least of all, we are pleased to be able to offer an entire array of rooms and park areas for customized, private events.

Palace and Park

Bad Homburg vor der Höhe
Schloss und Schlosspark
61348 Bad Homburg vor der Höhe

Telephone
+49 61 72/92 62-1 48

E-Mail
info@schloesser.
hessen.de

Internet
www.schloesser-
hessen.de

The 14ᵗʰ-century free-standing keep towers above the Baroque complex, which is clustered around two courts. Paul Andrich designed it in 1678 for Landgrave Friedrich II, the hero in Kleist's drama, "Prince Friedrich of Homburg." The originally two-storied palace is the first addition to a larger modern residential complex in Hesse following the Thirty Years' War.

The show rooms of the palace display countless art treasures from the 17ᵗʰ to the 19ᵗʰ centuries, not only bringing to life the domestic culture of the landgraves, but also of the Hohenzollern emperors. Homburg Palace possesses the only still-furnished apartment of the last German imperial couple, who favored Homburg as a summer residence until 1918. Re-opened in 1995, the living quarters of the English Wing reflect the personality, wealth, and tireless acquisiton activity of the English daughter of the king, who by marriage became the landgravine of Hesse-Homburg.

The palace garden was re-landscaped in the second half of the 18ᵗʰ century, although certain areas of the prior Baroque garden remain. To the east of the palace is the orangery, which was built at the end of the 17ᵗʰ century, as well as the "Dutch Garden." Southwest of the palace is the landscape garden, whose central point is comprised of a large pond. In the northwest, the kitchen garden and orchard are reminiscent of geometric concepts. During the course of landscape planning in the vicinity of the palace, the landgravian garden complex northwest of the residence was expanded. Between 1770 and 1840, the Avenue of Firs and Elizabeth Path were created along the picturesque pleasure gardens of the latter's namesake. Even now, the fundamental contours of this artistic entity – the central palace park and axis of the pleasure garden which extends to the border of Limes – have survived.

View across the castle pond towards the castle with the White Tower

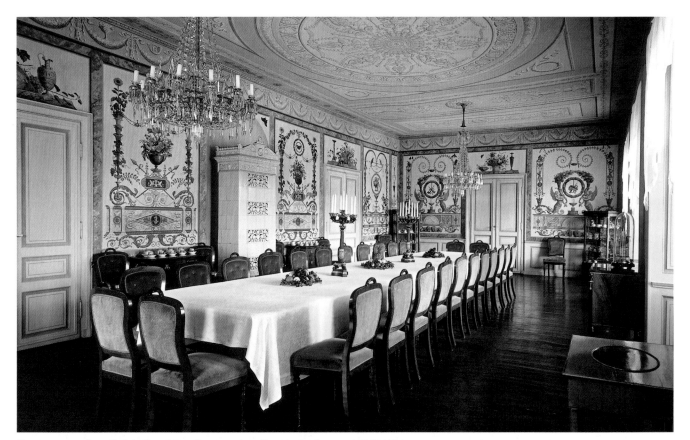

Dining room, also called the Pompeiian Room, with wall paintings from ca. 1826–1829

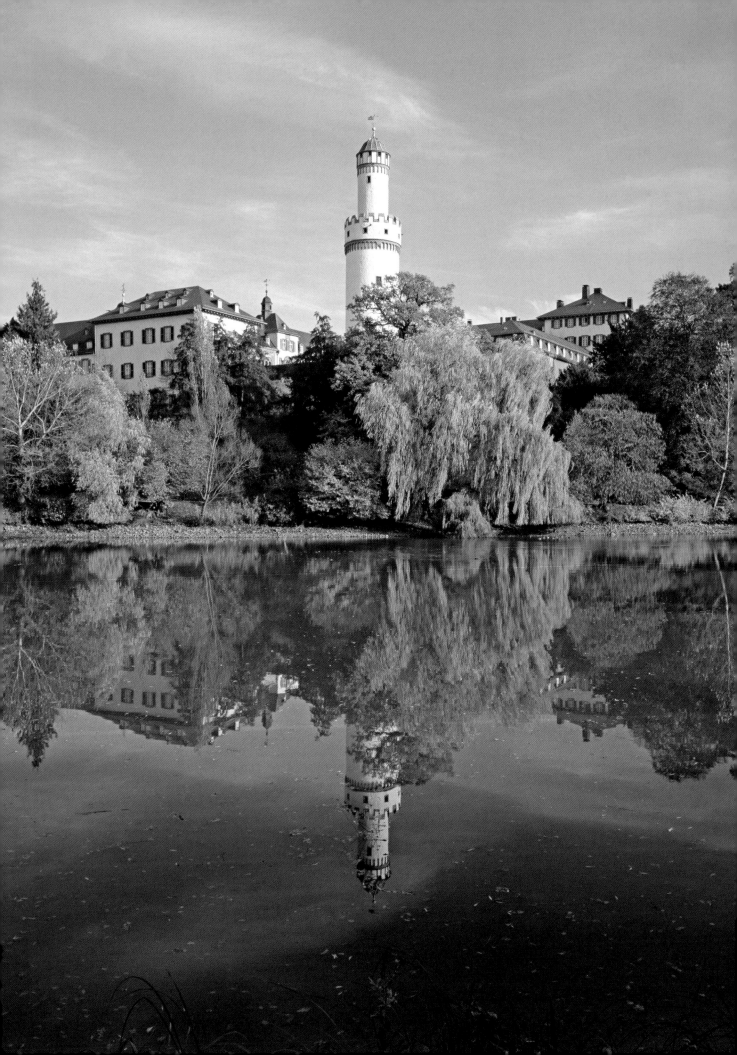

West choir with Romanesque bell tower

View from the west choir towards the nave, transept, and choir

Church Ruins

Bad Hersfeld, Stiftsruine
36251 Bad Hersfeld

Telephone
+49 66 21/7 36 94
E-Mail
info@schloesser.
hessen.de
Internet
www.schloesser-
hessen.de

Even though the church burned down in 1761 and has been a ruin ever since, the powerful architecture of the largest church building in Hesse dating to the 11th century continues to make an impact upon visitors today.

It was as early as 736 that Saint Boniface proselytized Hersfeld. One hundred years later at the site of the modern-day ruin, a newly-built Carolingian building emerged, which fell victim to fire in 1038. Immediately afterward, construction began of the church which was dedicated in 1144 and still stands today. The main entrance from the west proceeded through an originally open vaulted hall, above which the west choir is placed with its semicircular apse. The tower was added at a later date. Through the church portal, made of powerful stone ashlars, one enters the long nave, which lacks the clerestory as well as the curb of the central nave through large pillars with massive bases and capitals. Even more impressive are the smooth, almost bare walls of the divided transept, whose large windows are set so high above the ground that the light which passes through them seems to originate directly from the celestial heavens. At one time, a broad free-standing stairway led from the transept to the choir, whose sides are each divided by six niches. Beneath the choir is a crypt, whose vault collapsed during a fire in 1761. The large treasure of the cloister, the reliquary of Saint Wigbert, was kept here. Since 1950, the ruin serves as an impressive backdrop for theatrical and operatic festivals during the summer months.

Fürstenlager Park

Near Auerbach in the district of Bergstraße, Fürstenlager has retained its original character until today. Its origins are based upon a mineral healing source discovered in 1739. However, the court's spa activity which began in 1766 could not be permanently sustained. Starting in 1783, a rural summer residence that was set apart from the strict court etiquette of the residence city of Darmstadt emerged under the future landgraves Ludwig X and Luise of Hesse-Darmstadt.

Like a village, the residential and agricultural buildings are grouped around the central Gesundbrunnen (fountain of health). Only the two-storied mansion, which housed the landgravian and grand ducal families, was artistically distinct from the ensemble. Buildings for cavaliers, princes, and women served as living quarters for the court, but also as guest quarters in earlier times. Beginning in 1821, the apartment of Luise's second-eldest son, Prince Emil, was located in the building known as the outlander's quarters, or Fremdenbau. Refurnished in 1997, the rooms convey an impression of the Biedermeier lifestyle's simplicity and intimacy.

Using designs by the court gardener, Carl Ludwig Geigner, a large landscape park measuring approximately 42 hectares and modeled after the ornamental farm, was developed in 1790. Geiger took aesthetic as well as economical aspects into account, incorporating already-existing agrarian and grazing fields, vineyards, and fruit meadows into the park's design. The fascinating topography of the area also contributed to Fürstenburg's appeal. From the village, a net of sweeping avenues opens out to the narrow, elongated valley, leading to decorated spaces, small park buildings, and observation points at the peak of the surrounding hill. There, the visitor is presented with diverse views towards the village, the park with its decorated buildings and the varied landscape of the Bergstraße region. In 1865, the court gardener Georg Friedrich Schnittspahn had exotic trees planted at the meadow of the Herrenwiese and aviary. One of the oldest sequoia trees in Germany has been preserved from this period. Further dendrological treasures include a pyramid oak, a cucumber magnolia, and a ginkgo.

Staatspark Fürstenlager
64625 Bensheim-Auerbach

Telephone
+49 62 51/9 34 60
E-Mail
info@schloesser.hessen.de
Internet
www.schlosser-hessen.de

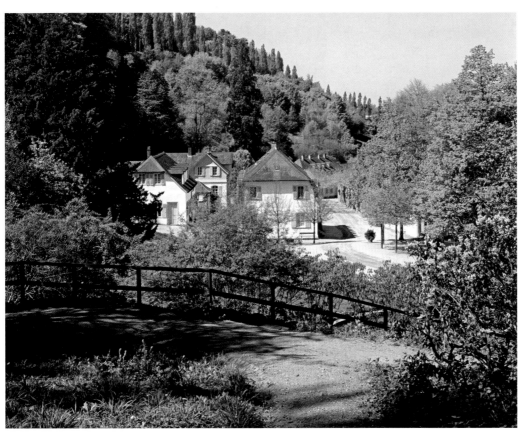

View of the village

Breuberg Castle in Odenwald

Touristik Service der
Stadt Breuberg
Ernst-Ludwig-Str. 2-4
65747 Breuberg

Telephone
+49 61 63/70 90

E-Mail
info@breuberg.de

Internet
www.breuberg.de

Breuberg Castle in Odenwald is one of the most distinguished and well-preserved castles in Hesse. The impressive, red sandstone castle soars above one of the hills which flows around the Mümling. It was commissioned in 1200 by the Fulda abbey in order to secure its Odenwald estates. The Romanesque portal towards Kernburg and the forceful rusticated keep still bear witness to the high architectural quality of the Hohenstaufen era. In 1323, the male line of the Breuberg noble family came to an end with the death of Eberhard III. As a result, the castle was divided up among various noble families, whereby the counts of Wertheim increasingly expanded their share and influence, eventually assuming ownership in 1499. With the further expansion of Breuburg, they began a major late medieval Dynastenburg and fortress. In the 15th and 16th centuries, the castle was accordingly expanded and fortified, as evidenced by the powerful castle moats, the so-called Schütt, and turrets.

With the death of Count Michals III, the Wertheim family line became extinct. The castle was newly distributed, this time among the counts of Erbach and Stolberg-Königstein. Because only a few usable rooms and living quarters fell to the Erbach counts, they constructed a new (residential) building including the gateway at the south side of the bailey.

As a result of an estate division, Count Johann Casimir of Erbach had his residence transferred to Breuberg Castle in the early 17th century. Originating from this period is the Johann-Casimir-Bau, whose impressive Renaissance-era stuccoed ceiling is still open to visitors.

Together with the counts of Löwenstein-Wertheim, the Erbach counts held sovereignty of Breuburg as an undivided property, until they lost their old rights of sovereignty in 1806. The sovereignty of Breuberg, which they had commonly shared, was added to the new grand duchy of Hesse-Darmstadt.

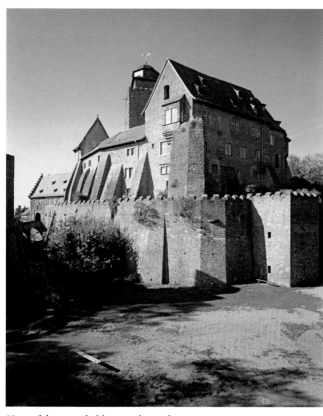

View of the stronghold across the castle moat

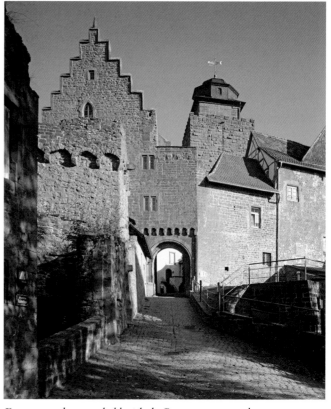

Entrance to the stronghold with the Romanesque portal

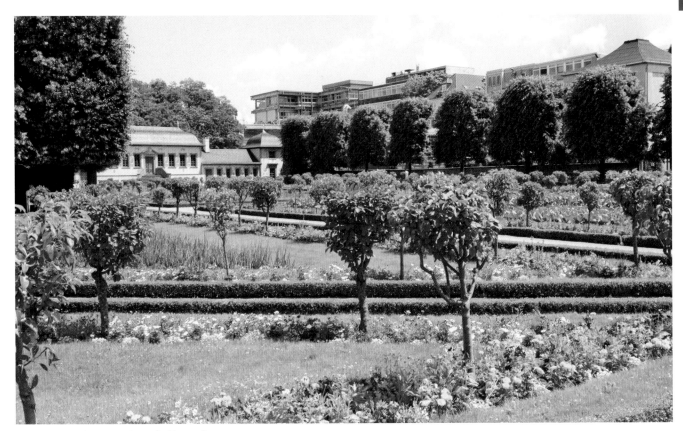

The garden with a view of Prettlack's Garden House

Prince Georg Garden and Prince Georg Palace

Beyond the city walls of Darmstadt, bordering the so-called "Herrngarten" with the residential palace, the almost bucolic pleasure garden was laid out for the landgraves in the 18th century. Set apart from official ceremony, the small complex became a favorite center for the more informal festivities of Rococo society. The main avenues of Prince Georg Palace and Prettlack's Garden House, which run at right angles to one another, show that the grounds merged together from two originally separate gardens. High walls surround the summer residence, conforming to the wish for intimacy and privacy often expressed in Rococo gardens. Not least of all, it was because of this "isolation" that Prince Georg Garden escaped the re-landscaping which took place at the Herrngarten and has been able to preserve its Rococo structure until today.

The entire complex is pervaded by a right-angled network of paths, in which fountains and sundials can be found at its points of intersection. Dec-orative and agricultural plants are grown in the flowerbeds, a mixture which makes the grounds particularly appealing. To the south of the palace is the landscaped outdoor theater (Heckentheater), which is used to perform theatrical productions beneath the stars.

The rooms of Prince Georg Palace open out to the garden and the surrounding landscape. On the upper floor, a large hall with finely-articulated stucco moulding constitutes its focal point. From the two balconies, visitors can take in a view of the garden. In front of the palace is a small Cour d'Honneur flanked by an orangery and a carriage house. In 1764, Landgrave Ludwig VIII presented his second son with the palace, which has borne his name ever since. Grand Duke Ernst-Ludwig had all the porcelain in the possession of the Hessian house brought to and displayed at Prince Georg Palace; since then, it has been referred to by locals as the "Little Porcelain Palace."

Darmstadt
Prinz-Georg-Garten
Schlossgarten 6 b
64289 Darmstadt

Telephone
+49 61 51/4 92 71 31
+49 62 51/9 34 60

E-Mail
info@schloesser.
hessen.de

Internet
www.schloesser-
hessen.de

Erbach Palace

Schloss Erbach
Marktplatz 7
64711 Erbach im
Odenwald

Telephone
+49 60 62/80 93 60

E-Mail
info@schloss-erbach.de

Internet
www.schloss-erbach.de

The construction of a castle at the palace's current site most likely dates back to the 12th century, when the imperial minsteriali of Erbach developed into a leading ruling house in Odenwald. Its earliest architectural evidence is the keep, whose imposing rusticated masonry suggests a date from the first half of the 13th century. The current palace was completed under Count Georg Wilhelm in 1736 after an existing Renaissance building was greatly expanded. The outstanding importance of the palace is ascribed to its valuable collection which Count Franz I assembled here during the late 18th and early 19th centuries. It is unusually complete and authentically preserved, as are only very few royal collections in Germany. At the same time, Franz I did not limit himself to one theme. The comital collection in Erbach consists of ancient works, as well as medieval glass windows, armor and weaponry, and a rich natural history collection. The collection has been assembled according to scientific criteria and as a result, is also a valuable witness to the state of knowledge and research in various subject areas of the late 18th century. The regent, who was interested in art and had studied in Strasbourg and had undertaken numerous trips to France, Italy, Vienna, and England, among others, hired the greatest thinkers of the era as consultants. In addition to the objects themselves, the completely preserved catalogue, including a number of comments by Franz I, provides indispensable information. Moreover, the collection displays prominent individual pieces, such as one of the most high-quality Roman copies of a Greek portrait of Alexander the Great. In approximately 1800, Count Franz I had the interior rooms redesigned to provide each of his collections with necessary space. In this form, they are still largely preserved and open to visitors.

*View of the Roman Room
with the statue of Emperor Trajan*

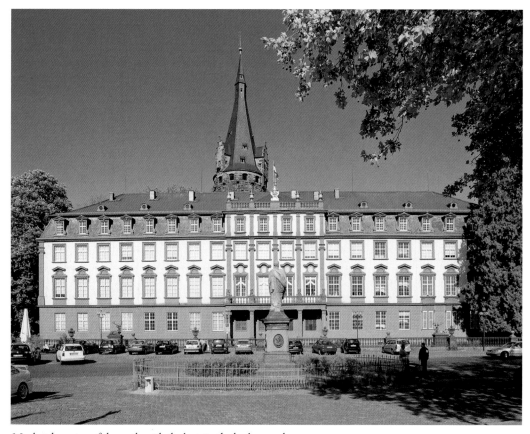

Marketplace view of the castle with the keep in the background

Wilhelmsbad Park with Castle and Carousel

Staatspark Wilhelmsbad
63454 Hanau-Wil-
helmsbad

Telephone
+49 61 81/9 06 50 90

E-Mail
info@schloesser.
hessen.de

Internet
www.schlosser-
hessen.de

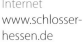
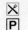

Wilhelmsbad was built between 1777 and 1785 as a princely spa bath, which was enjoyed by court society as well as the aspiring citizenry. After the builder Wilhelm IX departed from Hanau and assumed reign as landgrave in Kassel, the baths dried up and became unpopular. Based upon this "shadowy existence" the spa has been almost completely preserved from the 18th century. Late Baroque buildings are lined up along an avenue, surrounded by an English landscape park. It is one of the earliest creations of this type in Germany and an excellent record of a "sentimental" landscape garden, whose lyrical small buildings exemplify the sentimental creative desires of the age.

A masterpiece of engineering at the time of its creation, the large carousel recalls the recreational character of the idyllic park. Through an artfully-concealed mechanism, horses, and carriages spin around as if by magic.

The castle ruin, which was built between 1779 and 1781 close to the baths and yet situated upon an island behind knobby oak trees, is one of the earliest and therefore most extraordinarily outstanding examples of a pseudo-medieval castle with the character of ancient ruins. Built as a summer residence for Hereditary Prince Wilhelm of Hesse-Kassel, the apparently ruined castle aims to take the visitor by surprise. Namely, its interior houses an elegantly-furnished apartment and on the upper floor, a magnificent ballroom with portraits by Anton Wilhelm Tischbein.

View from the park towards the promenade

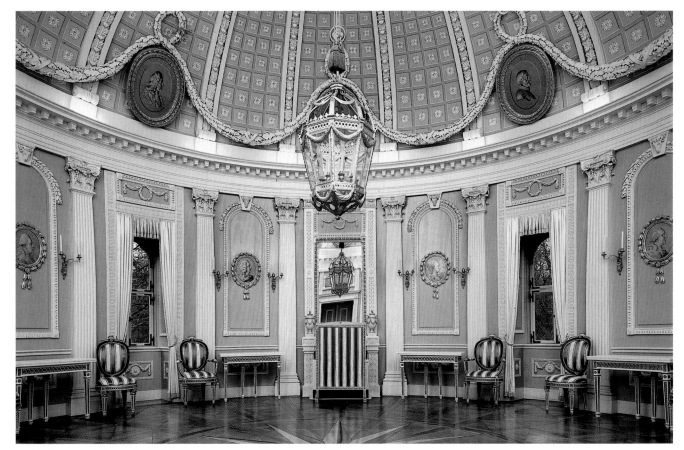

The ballroom in the upper floor of the castle

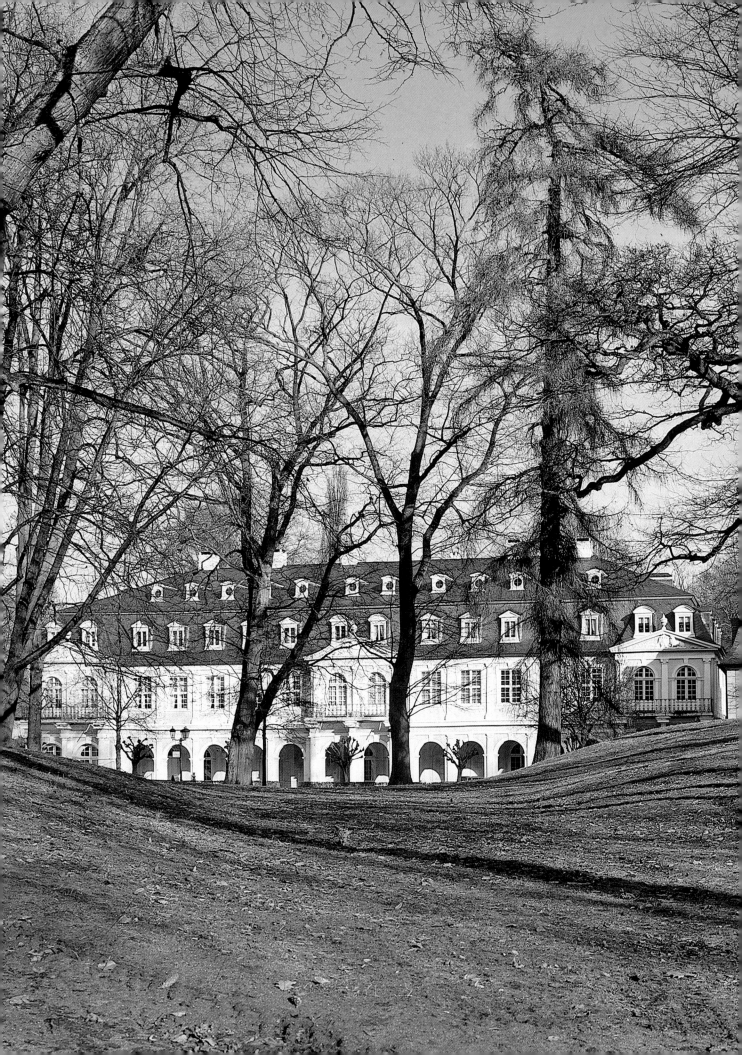

Wilhelmsthal Palace in Calden

Schloss und Schlosspark
Wilhelmsthal
34379 Calden

Telephone
+49 56 47/68 98

E-Mail
info@museum-kassel.de
besucherdienst@
museum-kassel.de

Internet
www.museum-kassel.de

The summer residence belonging to the Hesse-Kassel landgraves is a principal work of Munich's court architect, François de Cuvilliés. Based upon the richness and preservation of its precious furnishings, it is considered among the top achievements in German Rococo art. The three-winged complex, which was built between 1743 and 1761 for the artistically-minded regent and later landgrave Wilhelm VIII, is decorated at the interior with the designs of the Berlin sculptor Johann August Nahl, thus uniting Bavarian with Prussian Rococo. In the four grand apartments, numerous outstanding exhibition pieces have been preserved, such as a desk and a clock by David Roentgen, approximately 50 paintings by Johann Heinrich Tischbein the Elder, the "peacock feather" chest, so named because of its mother-of-pearl peacock pattern, and porcelain from Meißen, Berlin, Fulda, and Höchst.

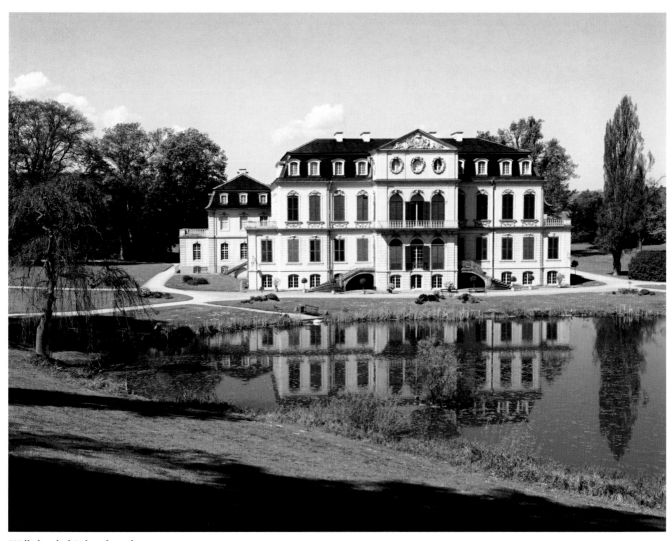

Wilhelmsthal Palace from the east

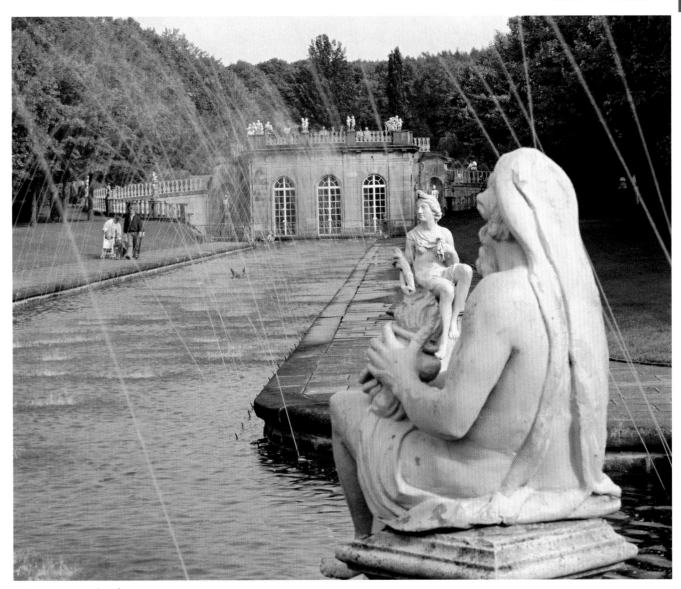

Water avenues with 18th-century grotto

Wilhelmsthal Palace Park with Waterworks

Together, the park and castle form an artistic entity which is guided by dominant axes. The richly-decorated southern axis with canal, water basin, and Chinese houses was completed in 1756. The middle axis was made in part into a water staircase in 1760.

In 1800, the court gardeners Karl and Wilhelm Hentze redesigned the grounds into a landscape garden under Landgrave Wilhelm IX, who in 1803 became Elector Wilhelm I (1785–1821).

In the area of the surviving grotto by Georg Wenzelaus of Knobelsdorff, the canal was rebuilt in 1963, conveying an impression of the Rococo garden in its bygone splendor. With the retained paths and avenues and the orchestrated landscape formed by the combination of free spaces and trees, the palace park signals the successful consolidation of both Rococo garden styles.

Schloss und Schlosspark
Wilhelmsthal
34379 Calden

Telephone
+49 56 74/68 98

E-Mail
info@museum-kassel.de
besucherdienst@
museum-kassel.de

Internet
www.museum-kassel.de

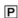 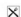

Wilhelmshöhe Palace and Palace Park

Schloss und Schlosspark
Wilhelmshöhe
Antikensammlung,
Gemäldegalerie Alte
Meister, Graphische
Sammlung, Weißenstein-
flügel, Herkules, Oktogon,
Plattform und Pyramide,
Großes Gewächshaus,
Wasserkünste
34131 Kassel

Telephone
+495 61/31 68 00

E-Mail
info@museum-kassel.de
besucherdienst@
museum-kassel.de

Internet
www.museum-kassel.de

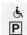

At the behest of Landgrave Karl, the Baroque complex was built at the beginning of the 18th century. It consisted of a giant palace with the statue of Hercules and a 250-meter cascade, based on plans by the Italian architect Giovanni Francesco Guerino. With one-third of the massive project completed, a new standard for aquatic staging was created. The conversion into a landscape park began after the Seven Years' War. An early Romantic phase under Landgrave Friedrich II was influenced by the wealth of lyrical park buildings. The design of a classic landscape garden followed with Wilhelm IX in 1785. On both sides of the middle axis, a sprawling "idealized" natural landscape with artificially-created waterfalls and water features was created by taking advantage of the natural environment. Twice weekly from May through October, visitors can admire the staged waterworks. It is through the connection of the Baroque axis with the natural-like structures of the diverse landscape garden that the famous decorative garden came into existence, which is nowadays the largest hill park in Europe.

Neptune grotto with a view of the cascades and Hercules monument in the castle park at Wilhelmshöhe

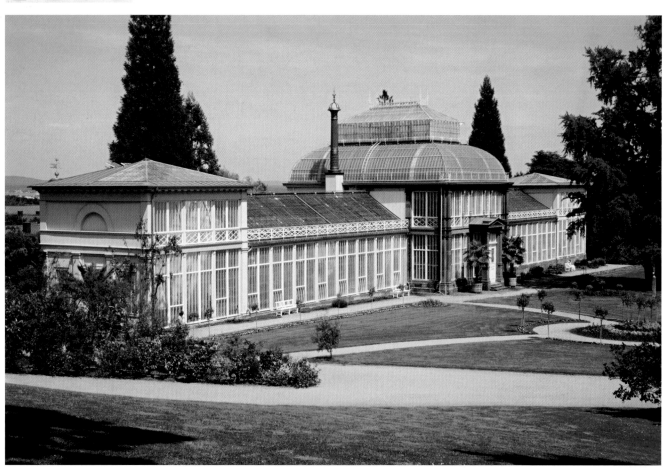

For his collection of exotic plants, Elector Wilhelm II had J.C. Bromeis build an impressive glass greenhouse in 1822/23

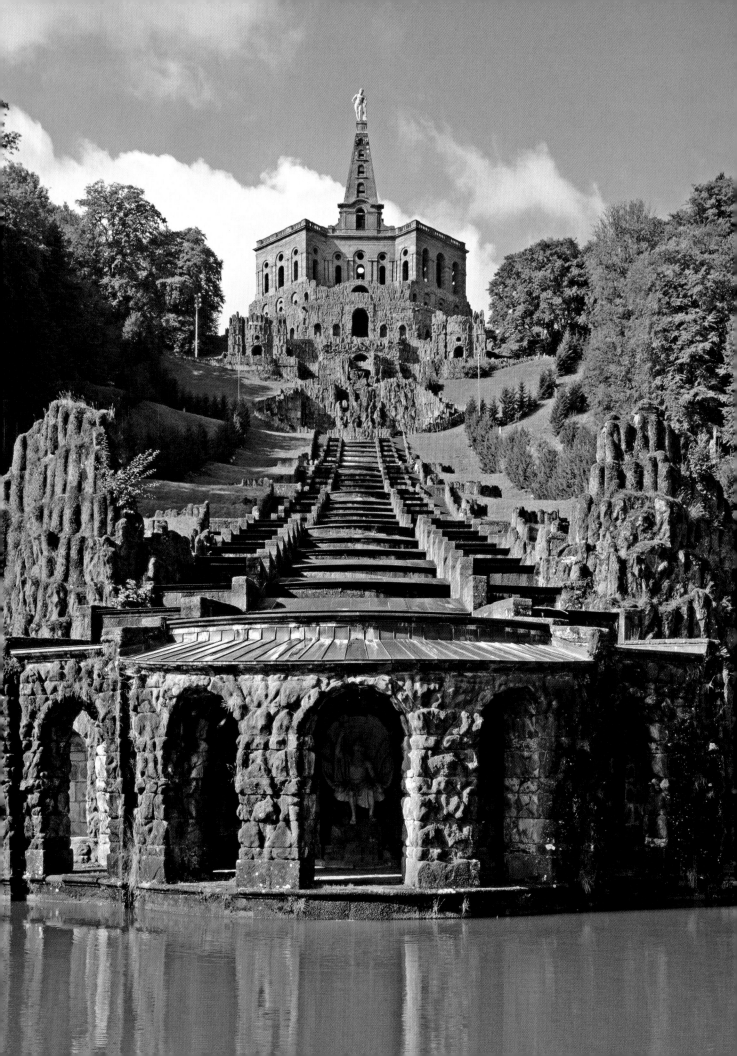

Wilhelmshöhe Palace

Schloss Wilhelmshöhe
Antikensammlung,
Gemäldegalerie Alte
Meister, Graphische
Sammlung, Weißen-
steinflügel
34131 Kassel

Telephone
+49 5 61/31 68 00

E-Mail
info@museum-kassel.de
besucherdienst@
museum-kassel.de

Internet
www.museum-kassel.de

From 1786–1798, Wilhelmshöhe Palace was newly built as a residential palace for Landgrave Wilhelm IX, later Prince Wilhelm I, in the Neoclassical style using sketches by the architects Simon Louis du Ry and Heinrich Christoph Jussow. Since the damages of the Second World War, only the Whitestone Wing has retained its original room distribution and furnishings. The latter is among the most significant examples of 19th-century art.

Neoclassical stuccoed walls and ceilings, Louis-seize and Empire-style furniture, and marble sculptures modeled after originals from Antiquity clearly demonstrate the shift away from Baroque tastes among the nobility.

The elegant simplicity of some rooms illustrates the shift in the character of stately residences towards the private during the late 18th and early 19th centuries, as the assertion of absolutist power thought strict, courtly ceremonies lost its meaning.

The main building, the corps de logis, contains the Gallery of Old Master Paintings and the Collection of Antiquities.

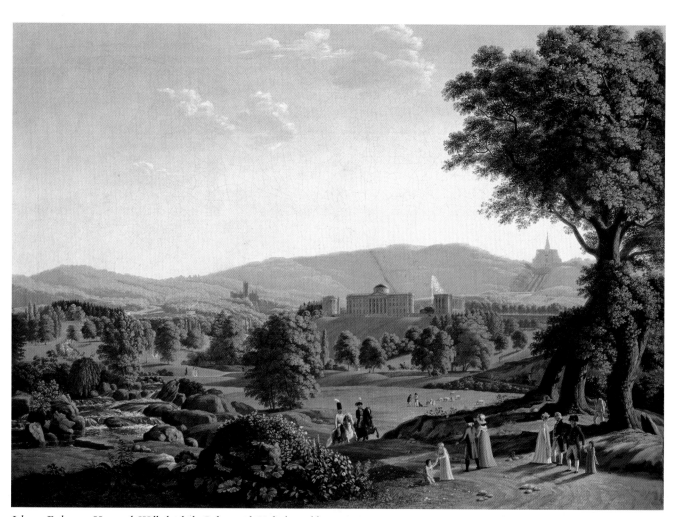

Johann Erdmann Hummel, Wilhelmshöhe Palace with Habichtswald, ca. 1800

Löwenburg in the Palace Park of Wilhelmshöhe

Löwenburg, picturesquely set at the edge of a slope in the palace park of Wilhelmshöhe, appears from the outside as a stout medieval fortress. Yet its interior contains princely living areas with a Baroque character which could accommodate a prince with his courtly entourage. At the end of the 18th century and in the era of the largest social turmoil by Landgrave Wilhelm IX, the dilapidated character of Löwenburg evoked not merely sieges and resistance battles, but with its seemingly venerable age, also attempted to legitimize the lengthy history of the princely house and with it, its right to rule in Hesse-Kassel.

In addition to the Weapons Room with weapons and knightly armor of the 16th and 17th centuries and the castle chapel with the patron's grave, visitors can access the princely living quarters in the women's and men's lodgings. Some of these are furnished, whereas others are used for exhibition purposes.

Löwenburg im
Schlosspark Wilhelms-
höhe
34131 Kassel

Telephone
+49 5 61/31 68 00

E-Mail
info@museum-kassel.de
besucherdienst@
museum-kassel.de

Internet
www.museum-kassel.de

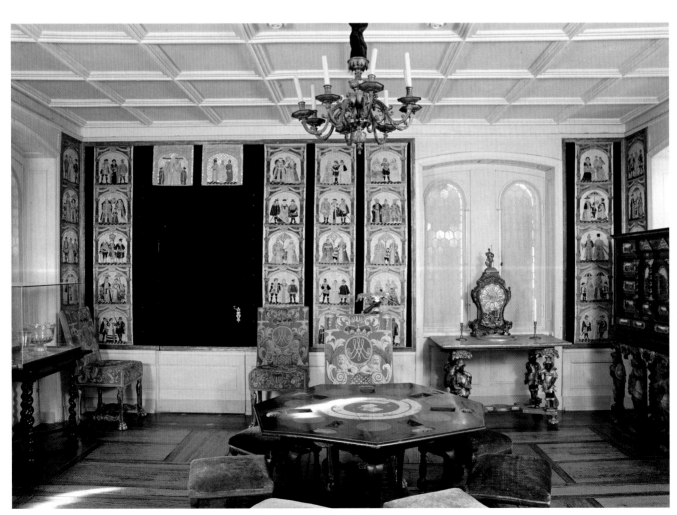

Antechamber of the women's residence at Löwenburg with sumptuous beaded wallpaper

Karlsaue Park with Siebenbergen Island

Staatspark Karlsaue
Insel Siebenbergen
34121 Kassel

Telephone
+49 5 61/31 68 05 00
+49 5 61/31 68 05 61
+49 5 61/7 39 21 73
(Insel Siebenbergen)

E-Mail
info@museum-kassel.de
besucherdienst@
museum-kassel.de

Internet
www.museum-kassel.de

For nearly 300 years, Karlsaue served as the summer residence for the landgraves and later, electors of Hesse-Kassel. The meadowland, which is flanked by two arms of the Fulda River, was successively acquired by the territorial lords. In addition to the Renaissance Garden which was laid out in the 16th century, the entire meadow (near the modern-day stadium) fell subject to the wishes of the absolutist prince, Landgrave Karl, with the design of a Baroque park. In the park, the water was channeled into man-made forms, such as pools and an ornamental framework of canals. Like many other Baroque decorative parks, Karlsaue was redesigned into a landscape park at the end of the 18th century, although its aquatic framework were largely preserved. The massive Baroque main axis, extending from the orangery Palace along Karl's Meadow, the middle avenue, the large pool with Swan Island, to the small pool containing Siebenbergen Island, possesses the picturesque and botanical variety of a preserved meadowland park.

The island was created in the 18th century under Landgrave Karl when the island-like meadowland, which was surrounded by two arms of the river Fulda, had been extended into a Baroque park complex.

From the outset, Siebenbergen was carefully planted as a "point de vue" at the south end of the Baroque axis and after 1763, was enriched with valuable trees under Landgrave Friedrich II.

Siebenbergen experienced a second awakening under Wilhelm Hentze, who supervised the electors' garden from 1822 to 1864. The island is still preserved in the manner which Hentze designed it from 1832 to 1864.

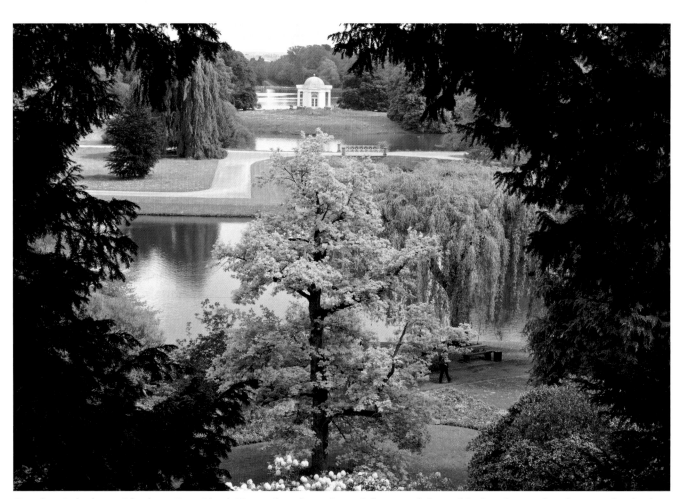

View from Siebenbergen Island over Swan Island. Hentze planted a garden with flowers and plants of the finest botanical quality upon the island, whose surrounding waters created favorable climatic conditions.

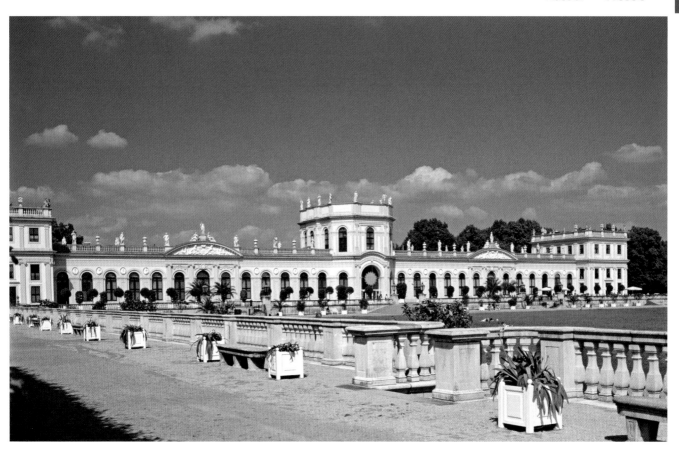

The orangery in Karlsaue Park

Karlsaue Park, Orangery, and Marble Bath

As a conclusion to the Baroque park's visual paths, Landgraf Karl had the orangery built between 1701 and 1710. It simultaneously functioned as a summer residence and winter storage option for orange, lemon, and laurel trees. At present, the orangery houses the Astronomisch-Physikalische Kabinett with planetarium. From 1722–1728, the buildings were expanded to the west with the pavilion of the Marble Bath, which incorporates sculptures and reliefs by Etienne Monnot (1657–1733). Monnot's sculptures show stories from the Metamorphoses of Ovid, including Daphne's transformation into a laurel tree. Recalling this are the laurel trees in the orangery, which are an essential part of the garden. The sensuality of Monnot's figures made of shimmering white Carrara marble is amplified by its sumptuous setting, wainscot panelling made out of diverse types of colored marble slabs, whose high polish gives them both luster and depth.

Staatspark Karlsaue
Astronomisch-
Physikalisches Kabinett
mit Planetarium
34121 Kassel

Telephone
+49 5 61/31 68 05 00

E-Mail
info@museum-kassel.de
besucherdienst@
museum-kassel.de

Internet
www.museum-kassel.de

Abbey with King's Hall and Church

Weltkulturerbe
Kloster Lorsch
Nibelungenstraße 32
64653 Lorsch

Telephone
+49 62 51/5 14 46

E-Mail
info@schloesser.
hessen.de

Internet
www.schloesser-
hessen.de

 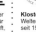

Organisation der
Vereinten Nationen für
Bildung, Wissenschaft,
Kultur und Kommunikation

Kloster Lorsch
Welterbestätte
seit 1991

Lorsch Abbey, which was first officially mentioned in 764, is among the most significant monastic centers of the European Early Middle Ages. In 767, it was moved from its former position to its eventual location. From 772 to 1232, it was an imperial abbey and in 876, served as the burial ground for the East Franconian Carolingian dynasty. As early as 850, its estates extended from the Dutch North Sea coast to what is now Switzerland, with particular density in the Middle Rhine area. The abbey had its own markets, trade settlements, and three mints. Its large library made Lorsch an important location for the consolidation and dissemination of knowledge until the abbey was dissolved during the Reformation in 1557. Following damages from the Thirty Years' War and the systematic erosion of the building in the 18th century, nothing was left of the monastic community save for the Carolingian-era King's Hall and a portion of the church. In 1991, the complex was honored as a UNESCO World Heritage Site.

The most distinguished construction is the King's Hall, whose exact date of construction and original function still remain unclear. It is an astoundingly intact example of the artistic will of the "Carolingian Renaissance." Architecture and fragments of interior wall paintings form an ensemble of outstanding artistic quality and expressive power. Since the end of the 19th century, archeological research of the abbey of Saint Nazarius reveals a monastic community, or "Klosterstadt" in which a distinctive artisan center also existed at a very early period.

Interior of King's Hall

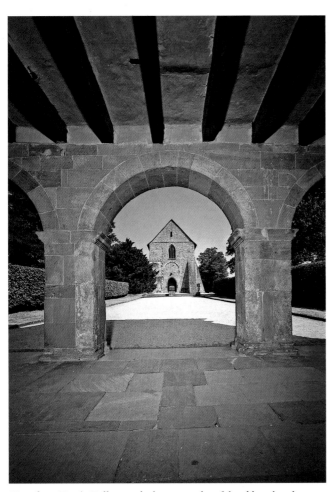

View from King's Hall towards the remainder of the abbey church

Gothic frescoes in King's Hall

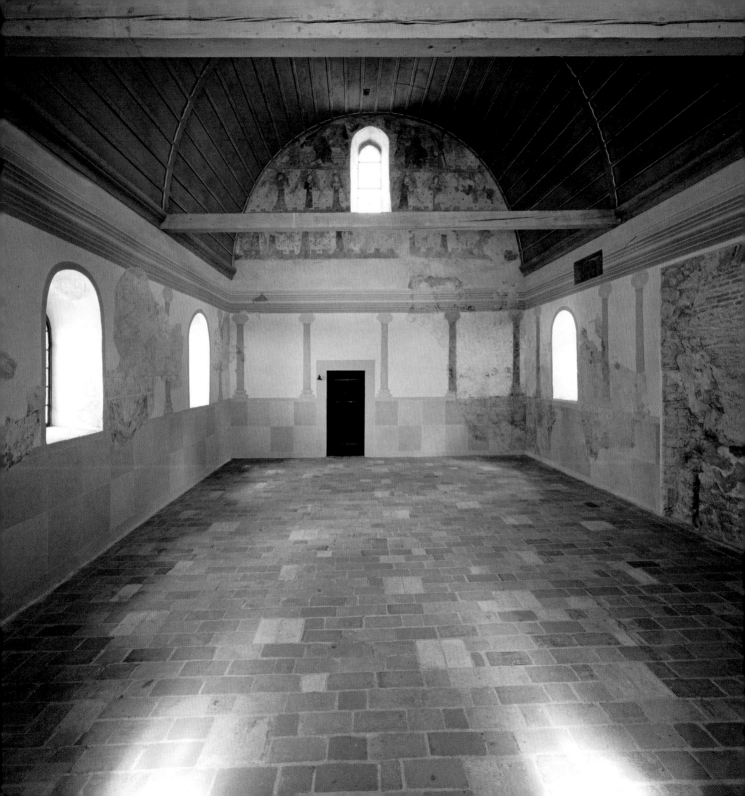

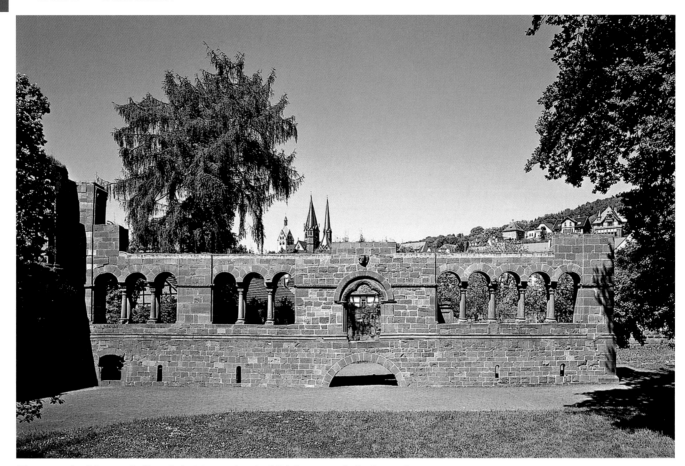

The court side of the great hall, with the Marian church of Gelnhausen in the background

Imperial Castle

Kaiserpfalz Gelnhausen
63571 Gelnhausen

Telephone
+49 60 51/38 05

E-Mail
info@schloesser.
hessen.de

Internet
www.schloesser-
hessen.de

In 1170, Emperor Friedrich II Barbarossa founded the city of Gelnhausen and at the same time, began construction of a palace below the city on the wetlands of the Kinzig River. Ten years later, it was completed and ultimately served on several occasions as a stage for imperial diets. It is surrounded by a sweeping circular wall whose irregular shape corresponds to the flow of the Kinzig. Its high masonry, which extends up to six meters, consists of rusticated stones at its exterior which give it a challenging and well-fortified appearance. By contrast, the interior architecture conveys imperial power through its variety and artistic embellishment. Upon entering, a vaulted entryway opens into two wide arches upon a large inner courtyard; the capital with four eagles in front of the middle column refers to imperial honor. From the entryway, steps lead to the overlying chapel and laterally connecting, formerly three-storied great hall. From this, the imperial great hall, the lower floors of the court façade and a section of the rear wall have been preserved. The façade is richly divided by arcades that are supported by double rows of columns. Their capitals are articulated in great detail, as are the trefoil arch above the portal and the fireplace located on the other side of the interior wall which once heated one of the halls. In the entryway are more richly-decorated pillars and stone sculptures which came from the great hall and symbolize imperial power. South of the entryway is the gate tower, or Torturm, which was conceived as a final escape in the event of conquest and was therefore built from rusticated stones in the manner of the surrounding wall. Although originally markedly higher, it now offers from its modern platform a far-reaching view of the Kinzig valley and city of Gelnhausen.

Einhard Basilica

At the beginning of the 9th century, Einhard was among the most influential scholars at the court of Charlemagne and his son, Louis the Pious. As a final place of rest, he ordered for a small church to be built in the then-remote city of Michelstadt in Odenwald. Modeled after Roman examples, its crypt was intended as a burial site for himself and his wife, Imma. Today, the church is one of the very few pieces of Carolingian architecture in Germany that has been so thoroughly preserved. Shaped like an ancient Roman basilica, the middle nave with its semicircular apse towers above the low side naves connected to large side choirs in the east. Upon the exterior wall can be seen the carefully-executed masonry with its evenly-spaced, broad joinings. Although the arch openings facing the side naves have been immured since the Late Middle Ages, one can still glean an overall impression of the original building's harmonious proportions. The nearly bare interior was originally plastered and whitewashed, as were the flat brick columns reminiscent of Roman masonry. Directly beneath the ceiling were painted corbels, of which traces have been preserved and which appear to have supported the formerly closed ceiling.

Einhard succeeded in transferring the bones of two major saints to Michelstadt from Rome. Following evidence which indicated that they did not wish to remain there, Einhard brought them to Seligenstadt. There, he founded a cloister which was remodeled during the Baroque era and is now a popular destination for visitors. Einhard's estate in Michelstadt fell into the hands of Lorsch Abbey, where the famous King's Hall, also from the 9th century, is located.

Einhardsbasilika
64720 Michelstadt-Steinbach

Telephone
+49 60 61/7 39 67

E-Mail
info@schloesser.
hessen.de

Internet
www.schloesser-
hessen.de

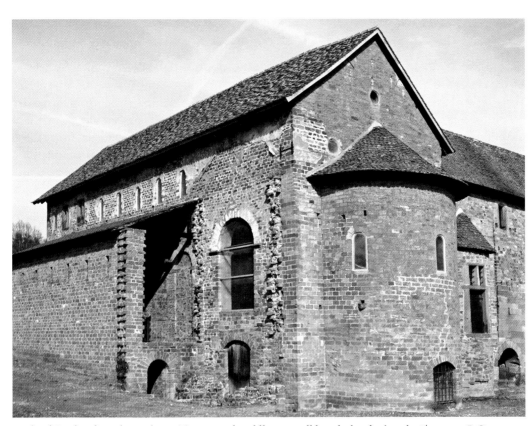

Einhard Basilica from the southeast. The apse and middle nave still largely date back to the 9th century B.C.

Castle Ruins

Burgruine Münzenberg
35516 Münzenberg

Telephone
+49 60 04/29 28

E-Mail
info@schloesser.
hessen.de

Internet
www.schloesser-
hessen.de

One of the most distinguished Staufen castles in Germany, Münzenburg Castle calls for comparison with those such as Wartburg in Eisenach or Kaiserpfalz in Gelnhausen. Its two characteristic round towers make it a visible landmark which dominates the entire Wetterau region. This situation made the basalt cone so appealing for the construction of an elevated castle in the 12th century, especially since Wetterau had been expanded into a ruling territory of the Hohenstaufens.

The castle's patrons originated from the influential families of the imperial ministerialis of Hagen-Arnsburg. The imperial ministerialis, high officials and court officers were an important support to the Staufen ruling politic, which however, always relied upon the emperor and were thus nominally dependent.

It can be assumed that construction of the castle began in the last third of the 12th century. The oldest part of the complex is the main castle with its impressive rusticated outer wall, with the large-format stones made from sandstone. The most splendid building was the richly-decorated, Romanesque great hall on the south side of the castle.

After the male lineage of the Münzenberg family came to an end, the castle underwent expansion under Phillip von Falkenstein in 1260. The surrounding wall was completed first. On the north side which faced the city, an additional residential structure was built. This is clearly more decoratively furnished than the Romanesque great hall. The façade is characterized by tall two-and three-part lancet windows.

The most recent building component of the castle is the fortress, which was built in the 15th century. The castle has three doors – one lower and one middle entryway, as well as the one towards the main castle. The castle's decline began in the 16th century.

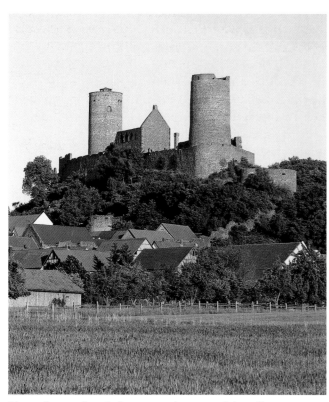

The castle grounds with the two round towers and the Falkenstein great hall

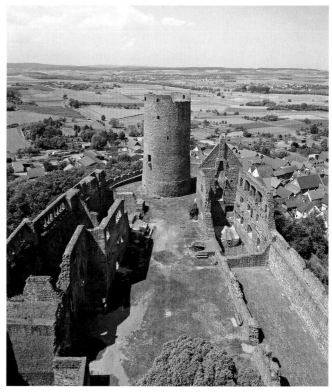

View across the castle court with the Romanesque great hall (left), the west tower, and the Falkenstein great hall (right) in Wetterau

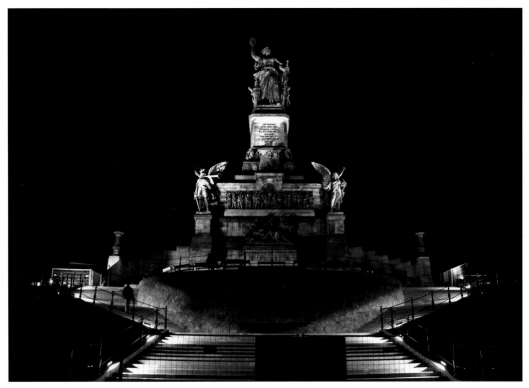

After a new lighting concept, the monument is also a widely visible landmark amidst the evening landscape

Niederwalddenkmal

High above the Rhine and prominently displayed, the Niederwalddenkmal with the figure of Germania was created between 1877 and 1883 by the architect Karl Weißbach, the sculptor Johannes Schilling, and the brass founder Ferdinand Miller. Measuring over 38 meters including its base, the monument is visible from a distance, creating a marked point of orientation within the landscape. It was built to commemorate the victory over France during the 1870/1871 Franco-Prussian War, its consequence being the foundation of the German Empire. As personified by the figure of Germania, the Niederwalddenkmal aimed to demonstrate German unity and strength under Prussian leadership. The choice of its location is connected to the Romanticism of the 19th century and to the national spirit of the age. The Rhine was considered a symbol of the fatherland, which was also manifested in the castle expansions of the Prussian kings.

The Niederwalddenkmal is not a unique work. In the late 19th century, a number of victory and peace monuments, Bismarck towers and imperial monuments were built, such as the equestrian statue at the Deutsche Eck (or German Corner). Yet specific to the Niederwalddenkmal is its emphasis of the Reich's unified mentality, expressed in the representation of all the German princes in the central base relief. Because the statement of a nationalistic monument like this one is no longer suitable, wall charts explain the monument's history and background. Approximately 1.5 million people from diverse nations visit this monument, whereas the attractiveness of the regional landscape plays a central role. The Niederwalddenkmal lies at the base of the mid-Rhine valley, which became a UNESCO World Heritage Site. Built in 1787 by François F. Mangin for the earls of Ostein, the monument was in an English landscape garden with a hunting lodge. Since the 13th century, the Niederwald represents the cultural landscape of an elevated historical continuity. Originally a hunting area, the entire park was part of the medieval Ehrenfels Castle located below it.

Rüdesheim Tourist AG
Geisenheimer Strasse 22
65385 Rüdesheim am
Rhein

Telephone
+49 67 22/1 94 33

E-Mail
touristinfo@t-online.de

Internet
www.ruedesheim.de

Organisation der
Vereinten Nationen für
Bildung, Wissenschaft,
Kultur und Kommunikation

Oberes Mittelrheintal
Welterbestätte
seit 2002

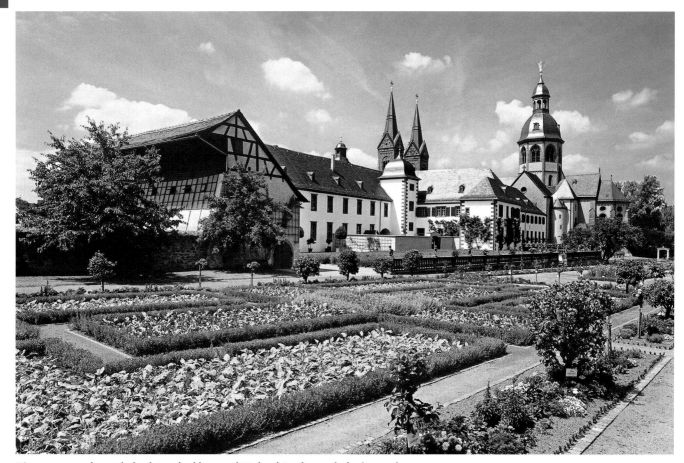

The convent garden with the cloister buildings and Einhard Basilica in the background

Former Benedictine Abbey with Convent Garden

Ehemalige
Benediktinerabtei
Seligenstadt
63500 Seligenstadt

Telephone
+49 61 82/2 26 40

E-Mail
info@schloesser.
hessen.de

Internet
www.schloesser-
hessen.de

The Benedictine abbey Seligenstadt was founded in 828. With its church, cloister and functional buildings, gardens, and a surrounding wall, it displays a rare and impressive example of an independent community.

As the largest Carolingian basilica north of the Alps, the abbey church towers high above the remaining buildings, most of which were built from 1685–1725. The extravagant decoration of the prelature with vestibule, a large stairwell, splendid guest quarters, and a spacious apartment for the abbot himself follows the examples of princely palaces – proof of the confidence of the Baroque prelates, who legitimized themselves as territorial lords through a standardized royal household. The history of the abbey, which remained an important, politically powerful, economic, and cultural center of the region until its dissolution in 1803, is recorded in the Landschaftsmuseum. In addition, the abbey apothecary, mill, bakehouse, and cold cellar are open to visitors.

The large gardens within the abbey provided an intrinsic basis which allowed this self-contained economic unit to provide for itself. The convent garden, which was newly designed as a symmetrical parterre in the 18th century, provided vegetables, fruit, kitchen herbs for the monks' kitchen, and healing herbs for the monastery's apothecary. Deer were kept in the mill or animal garden. The vineyards were also cultivated by the Benedictines.

While these kitchen gardens primarily served to supply food, there were also ornamental gardens, such as the traditional cloister garth. The "Angels' Garden" with its ornamental flower parterre, was laid out in 1700 as a pleasure garden in front of the prelature. It demonstrates that the courtly lifestyle was also imitated in the realm of garden design. This holds equally true for the greenhouse (1760) with its sloping glass wall and sub-floor heating, built to cultivate exotic table fruits, such as pineapple.

Palace and Memorial to the Brothers Grimm

Located on the former trade route from Frankfurt am Main towards Leipzig, Steinau Castle served the counts of Hanau from 1272 to 1736. It was a secondary location for the administration and defense of their dominion, as well as their living quarters, guest quarters for traveling princes, hunting palace, and toll station. Between 1525 and 1560, the medieval castle was converted into a powerful, inhabitable Renaissance palace, which was surrounded by a defensive complex with gatehouses, compound, and sunken moat. This would not have withstood a massive occupation, but through them it was possible to protect oneself from feuds and riots amidst the tumultuous times of the Reformation and Peasants' Wars. The building and its decorative details, such as Renaissance bays, arched windows, and partially-revealed wall paintings, all of which were highly modern at the time, bear witness to the former grandeur of one of the most significant Renaissance palaces in Hesse.

Visitors may enter the powerful keep, which provides a far-reaching vista over the city and land, as well as the two parlors, which were once used as dining halls and for celebratory events, as well as the large kitchen and the comital apartments in the piano nobile. In addition to the Steinauer Marionette Theater's marionette exhibit, the palace has a major collection relating to the Grimm brothers, who grew up in Steinau, with family portraits, sketches by Ludwig Emil Grimm, the brothers' childhood sketches, and original everyday objects.

Schloss Steinau
36396 Steinau an der Straße

Telephone
+49 66 63/68 43

E-Mail
info@schloesser.hessen.de

Internet
www.schloesser-hessen.de

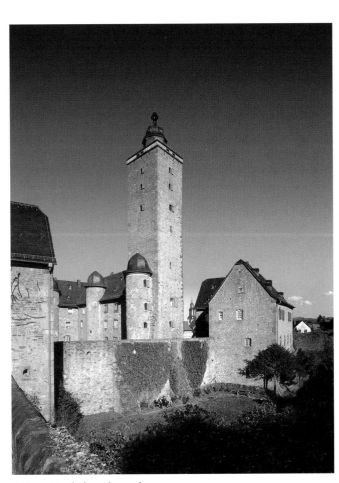

Steinau Castle from the southwest

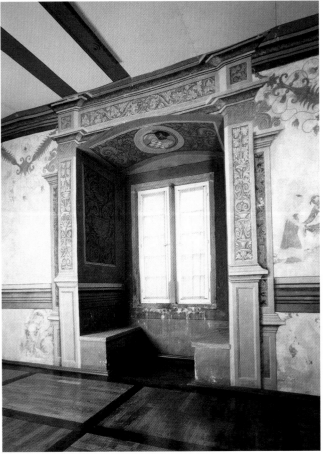

The Blue Room, formerly the bedchambers of the count, with its exposed wall paintings.

Palace and Palace Garden With Orangery

Schloss und Schloss-
garten Weilburg
35781 Weilburg/Lahn

Telephone
+49 64 71/9 12 70

E-Mail
info@schloesser.
hessen.de

Internet
www.schloesser-
hessen.de

High above the Lahn River is Weilburg Palace, one of Germany's most wholly-preserved small residences from the age of Absolutism. Built in the 16th century, the four-winged, Renaissance complex houses two parlors, formerly a backdrop for official state activities, such as tributes to newly-invested counts or court proceedings.

Beginning in 1702, the palace was expanded by J.L. Rothweil into a Baroque residence. In order to achieve an appropriate space for Baroque functions and courtly ceremonies, he had built a grand stairwell, a magnificent guest wing, as well as the new residential and drawing rooms for the count's family. The structural sequence and sumptuous decoration were inspired by the large courts of Europe. The guardhouse, royal stables, farmyard, and administrative buildings were rebuilt. The palace church, constructed according to plans by J.L. Rothweil from 1707–1713, is considered Hesse's most significant Protestant church building of the Baroque era.

The 16th-century Renaissance garden was designed in the style of French garden architecture by the court gardener F. Lemaire. Two orangeries, water features, grottoes, sculptures, as well as the typically Baroque division into symmetrical compartments with the palace as a reference point, adorn the split-level garden spaces. Surrounded by supporting walls and connected by a linden bosquet, these extend over two plateaus of the hill. The upper, more elaborately-decorated orangery unites a greenhouse with a banquet hall and at the same time, permits direct access from the count's residence to the oratorium in the palace church.

At the steep hill beneath the garden terrace is the "Gebück" – an expression referring to the intertwined, multiple rows of planted hornbeams. An impenetrable natural defensive wall used from the Middle Ages well into the 18th century, it marked boundaries and protected from military invasion. Since then, this forested area has been creatively incorporated into the garden's design.

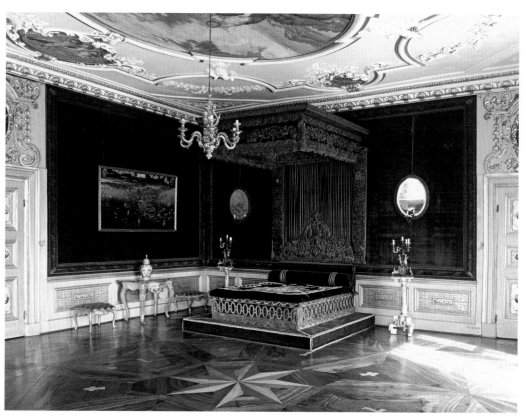

Electoral Chambers

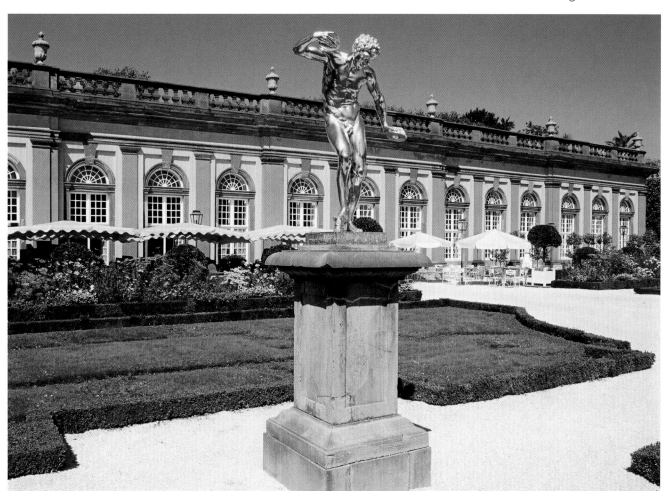

The lower orangery

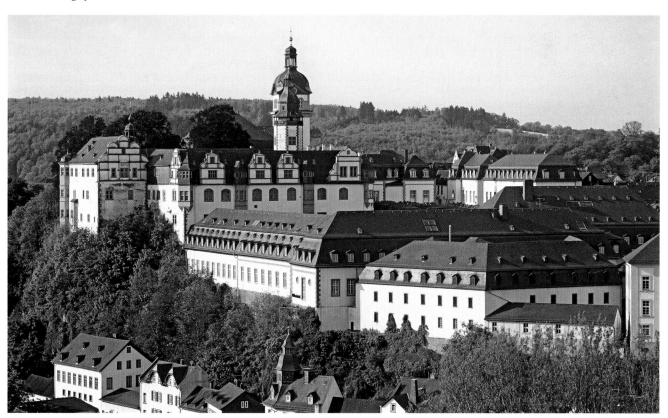

Weilburg Palace a. d. Lahn

Palace Park Wiesbaden –
Biebrich

Hessian Property
Management
65203 Wiesbaden-
Biebrich

+49 6 11/13 56 17 06

Schwarze@hi.hessen.de

www.hi-hessen.de

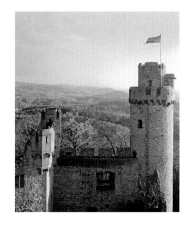

Auerbach Palace

Café and Restaurant
64625 Bensheim-
Auerbach

+49 62 51/7 29 23

Andreas.pietralla@
schlossauerbach.de

www.schloss-
auerbach.de

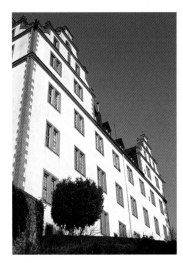

Lichtenberg Palace

Palace Museum
64405 Fischbachtal-
Lichtenberg

+49 61 66/4 04

gemeinde@
fischbachtal.de

www.schloss-
lichtenberg.de

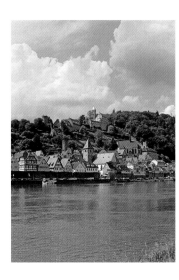

Hirschhorn Palace
am Neckar

Hirschhorn Palace Hotel
Auf der Burg
69434 Hirschhorn

+49 62 72/9 20 90

Schlosshotel-
hirschhorn@t-online.de

www.castle-hotel.de

Saalburg Roman
Fort, Kapersburg, and
Schmitten at Limes

Römerkastell Saalburg
Archäologischer Park
Saalburg 1
61350 Bad Homburg
v.d.H.

+49 61 75/9 37 40

info@
saalburgmuseum.de

www.saalburg
museum.de

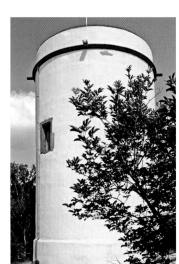

Veste Otzberg

Museum Otzberg
64853 Otzberg-Hering

+49 61 62/7 11 14

Historische-
veranstaltungen
@rolf-tilly.de

www.veste-otzberg.de

Organisation der
Vereinten Nationen für
Bildung, Wissenschaft,
Kultur und Kommunikation

Grenzen des Römischen Reiches:
Obergermanisch-raetischer Limes
Welterbestätte
seit 2005

Mecklenburg-Western Pomerania

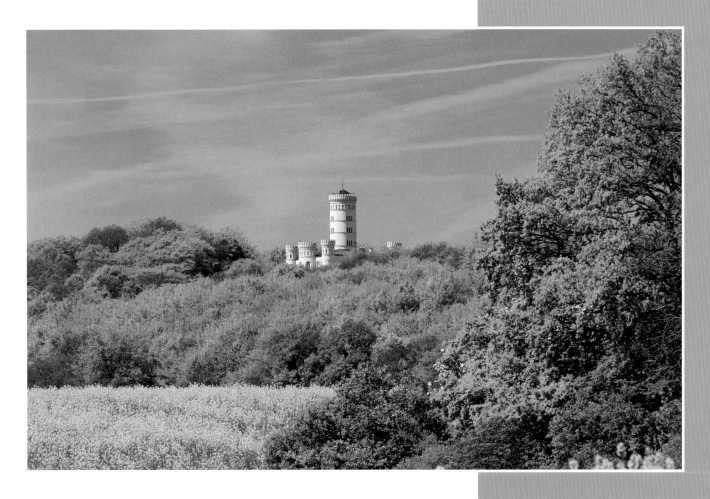

STAATLICHE SCHLÖSSER
UND GÄRTEN
MECKLENBURG-VORPOMMERN

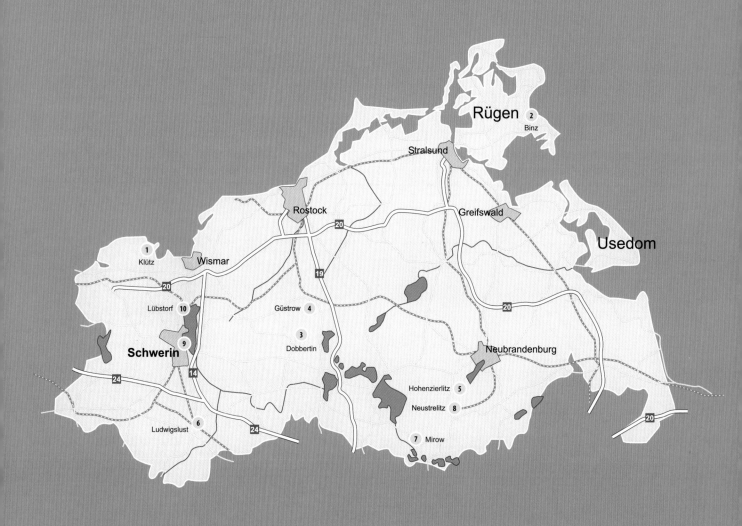

The festooned avenue of linden trees at Bothmer

Amongst Fields, Lakes and Woods –
Palaces, Gardens and Cloisters in Mecklenburg-Western Pomerania

Mecklenburg-Western Pomerania is the land of countless fields, lakes, forests, and the picturesque Baltic coast, which even once cast its spell over Caspar David Friedrich. Hundreds of palaces, parks, manors, and abbeys are set within this sprawling and unique landscape within Germany.

The administration of the State Palaces and Gardens is affiliated with the Office for Buildings and Estates of Mecklenburg-Western Pomerania (Betrieb für Bau and Liegenschaften Mecklenburg-Vorpommern, or BBL M-V). The northernmost state palace administrative department within Germany is also the youngest. It was established in the fall of 2003 and is subordinate to the Ministery for Transport, Building, and Regional Development. As the uppermost federal state authority, it oversees the most magnificent witnesses to architectural history and garden design in Mecklenburg-Western Pomerania. These include the state-owned palaces and gardens in Ludwigslust, Güstrow, Schwerin, Klütz, Wiligrad, Mirow, Neustrelitz, Hohenzieritz, Granitz, and the abbey in Dobbertin. These cultural monuments extend across the vast time period between the Middle Ages and Historicism.

Only after the administration was established did it become possible to address the urgently-needed restoration of all the palaces and gardens in its care. The organization's work is currently defined by this major challenge. The exterior façade of Schwerin Palace, seat of the Landtag, already shines in new splendor. Ongoing projects focus upon securing foundations and restoring historic rooms. Work on the façade at Ludwigslust has also been completed; here, historic rooms are undergoing restoration while a completely new exhibition concept is under development. The same is true for the Baroque palace of Mirow. Work has commenced at the palace ensemble of Wiligrad, as well as at the recently-acquired (2008) Bothmer Castle. The Renaissance residence of Güstrow and the pleasure garden that belong to it are being comprehensively restored. The most spectacular aspect of the projects at the hunting lodge in Granitz is the self-supporting cast-iron staircase in the tower designed by Schinkel. At Hohenzieritz, restoration of the English landscape garden is nearly complete, whereas it is still in progress at the palace park of Neustrelitz. Future plans include the completion of Dobbertin Abbey, whose exterior has already been restored.

In addition to major restoration projects, the responsibilities of the palace administration are to care for and develop concepts which support the preservation and long-term usage of the properties entrusted to them. The basis of its daily activity consists of the scientific research of architectural, regional, and cultural history. An additional and significant focus is its outreach work, in order to present nearly 500,000 visitors, in addition to the unburdened enjoyment of the region, a glimpse into its rich artistic and cultural history.

Bothmer Palace and Park

Schloss Bothmer
Am Park
23948 Klütz

Due to ongoing restoration work, the palace is closed until 2014.
The park is open to the public. Restrictions may apply.

E-Mail
info@mv-schloesser.de

Internet
www.mv-schloesser.de

Only a few kilometers away from the Baltic coast, Bothmer Palace, the largest Baroque palace complex in Mecklenburg-Western Pomerania, stands in front of the city gates of Klütz. The grand ensemble with its shimmering red brick façade, was deliberately integrated into the picturesque landscape of the Klützer Winkel region. Bothmer Palace was built between 1726 and 1732 for Imperial Count Hans Caspar von Bothmer (1656–1732) by the architect Johann Friedrich Künnecke (died 1738). As a diplomat in the service of the Hannover electors and future British kings, the imperial count traveled extensively and from 1720 until his death, he lived in London at Number 10 Downing Street. Bothmer was not only the "Kingmaker" of the Hannover electors, but also the most important minister of the German court in London following the ascent of George I to the throne.

The imperial count was familiar with Europe's distant regions. It is therefore not surprising that the palace, with its exterior complex, draws upon English, Dutch and French examples and influences. It was with foresight that Bothmer had acquired land and manors in Klützer Winkel since the 1720s, had the palace built as a standard residence, and instituted a majorat upon the newly-acquired property. As he had no male heirs, his nephew Hans Caspar Gottfried von Bohthmer (1694–1765) ultimately became the palace's first inhabitant and the beneficiary of the majorat. The palace and park, which was converted from a garden in the 19th century, is located upon a rectangular island and is surrounded by a four-sided moat that was adapted from Dutch examples. Remaining from the original Baroque structure are the avenues of linden trees. Additionally, the unique festooned avenue made of pruned and garland-like linden trees linked to one another is an original Baroque element, which formerly served as the main road to the outlying estate of Hofzumfelde.

Impressions of spring from Bothmer Palace Park

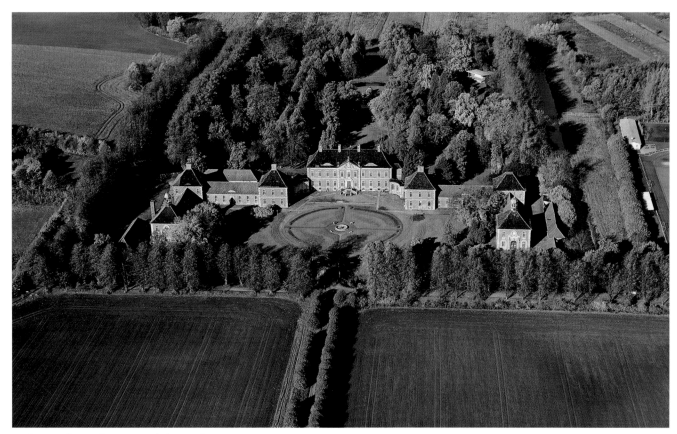

Bothmer Palace and its park with festooned avenue

Granitz Hunting Lodge

Jagdschloss Granitz
18609 Binz

Telephone
+49 3 83 93/66 38 15

E-Mail
info@mv-schloesser.de

Internet
www.mv-schloesser.de

In the truest sense of the word, the hunting lodge at Granitz is a high point for nearly 200,000 visitors per year who travel to Rügen. It is situated on a hill amidst one of the island's largest connecting woodlands. From its tower is a spectacular view above the treetops over all of Rügen.

The palace was built from 1837–1851 on behalf of Prince Wilhelm Malte I of Putbus, who was closely acquainted with the artistically-gifted Prussian crown prince, the future King Frederick William IV. He stepped in and designed the ultimate of Romantic architectural creations which was topped by a slender-looking tower. Karl Friedrich Schinkel (1781–1841) was called in as an advisor. Under the direction of the architect Johann Gottfried Steinmeyer, a structure was thus built which showed a tendency towards a chivalric Romanticism, shaped by the Middle Ages, combined with the Italian-influenced, so-called Round-arch style. Prince Malte had visited Italy during his youth and had been schooled in international architecture. All of this is reflected in the plastered brick construction with rounded arch windows, many of which were decorated with tracery, as well as the apse-like annex on the east side, the four corner towers, and towering above everything else, the round tower and its crenelated rim.

Designed in the Historicist style and historically furnished, the rooms bear the hallmarks of the architect Friedrich August Stüler (1800–1865). Here can be found countless industrially-manufactured zinc and paper maché decorations. The free-standing iron staircase displays a technical and engineering feat of genius. Made in the iron foundry of Franz Anton Egells (1788–1854) in Berlin, it is considered a technical marvel and demonstration of the ambitious Prussian cast iron industry.

The palace museum provides information about the history of the palace and its inhabitants.

The spiral staircase at Granitz Hunting Lodge

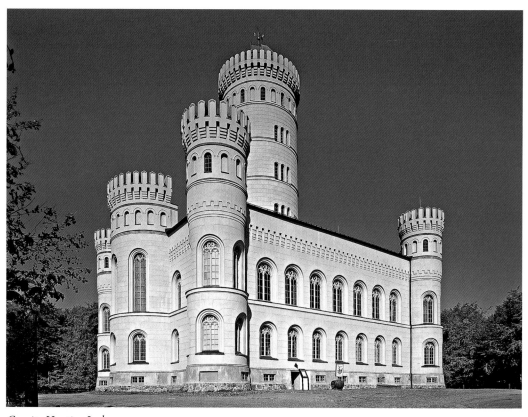

Granitz Hunting Lodge

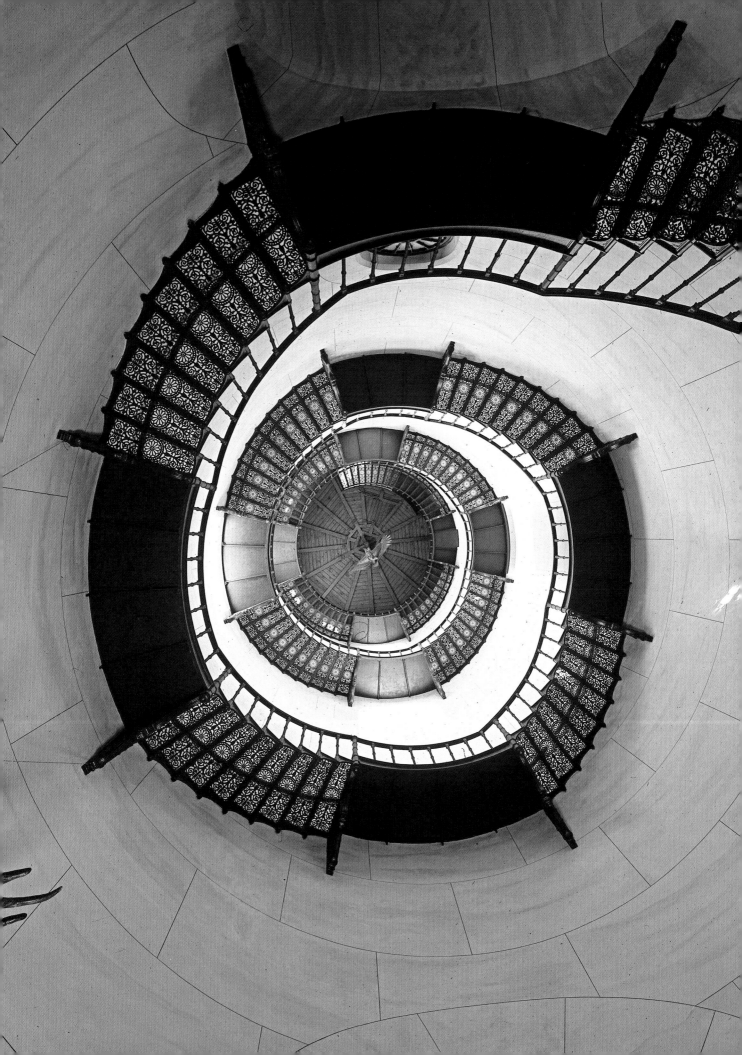

Dobbertin Abbey

Klosterkirche Dobbertin
Am Kloster
19399 Dobbertin

E-Mail
info@mv-schloesser.de

Internet
www.mv-schloesser.de
www.kloster-
dobbertin.de

Amidst the painterly landscape of the Mecklenburg lake district, Dobbertin Abbey is located at the lake promontory of the same name. The complex was founded as a Benedictine monastery by Prince Heinrich Borwin I and was remodeled into a convent as early as 1235. The interior of the abbey church and the enclosed courtyard of the adjoining enclosure still bear witness to the Gothic monastery complex. In 1572, Dobbertin was secularized, although it continued to be operated as a collegiate foundation for women of the nobility. It was only in 1919 that the chapter was dissolved and the property was transferred to the state.

After the Middle Ages, the complex underwent continuous expansion, as is demonstrated by the 18th- and 19th-century buildings. The church was ultimately redesigned between 1828 and 1849 through the Schwerin palace master builder Georg Adolf Demmler (1804–1886) using plans by Karl Friedrich Schinkel (1781–1841). It was in reference to Schinkel's Friedrichswerder Church in Berlin that the precise dual-tower Neo-Gothic complex was built, whose spires towered far above the surrounding landscape. In 1857, the church was newly dedicated. The interior retained, among others, the Gothic matroneum (gallery) and the Renaissance baptismal font from 1586, while the choir was equipped with extensive Neo-Gothic decorations with a Sauer Organ, altar, figures of the Evangelists, and glass paintings by various artists mostly from the Mecklenburg region.

The abbey church is maintained by the Administration of State Palaces and Gardens of Mecklenburg-Vorpommern. The abbey building serves as a residential complex for the church deaconry. The attached cloister and its courtyard is used for concerts and additional events.

Dobbertin Abbey, dual-tower complex

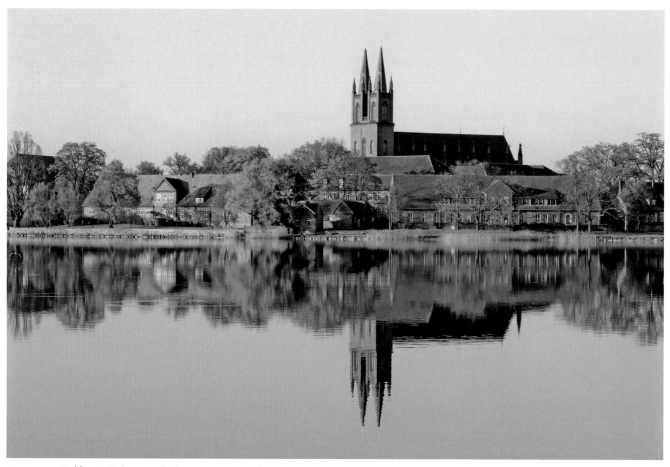

View across Dobbertin Lake towards the monastery complex

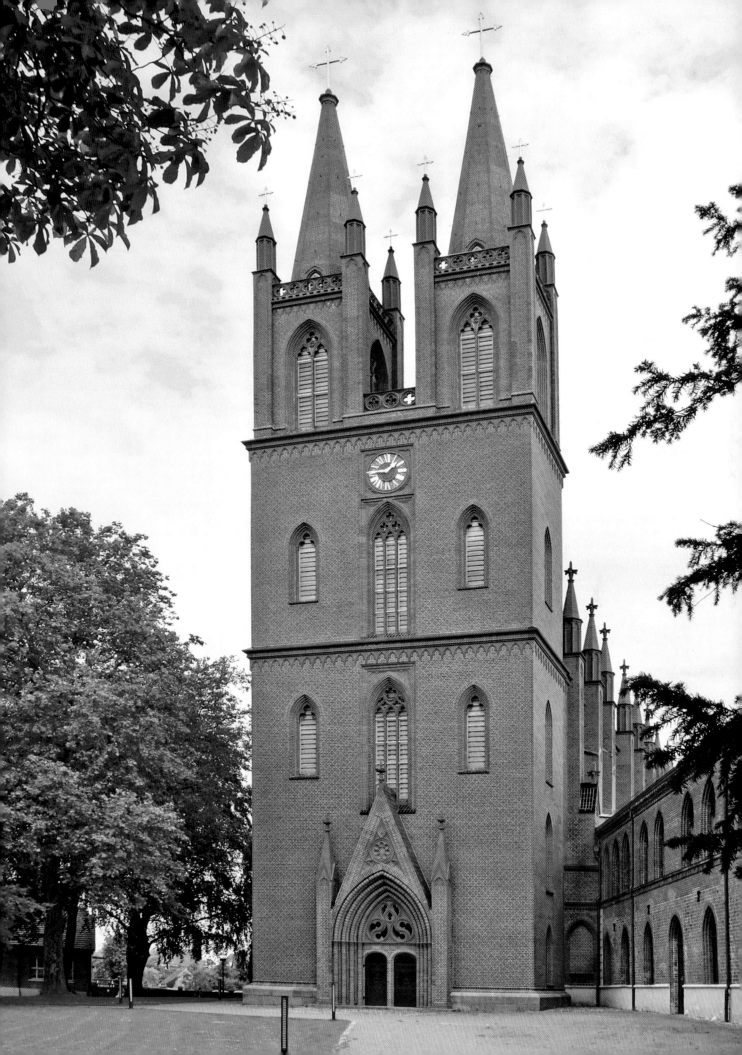

Güstrow Palace and Palace Garden

Staatliches Museum
Schwerin
Schloss Güstrow
Franz-Parr-Platz 1
18273 Güstrow

Telephone
+49 38 43/75 20

E-Mail
info@mv-schloesser.de
info@schloss-
guestrow.de

Internet
www.mv-schloesser.de
www.schloss-
guestrow.de

The palace at Güstrow is among the most significant testimonials to the Renaissance in the entire Baltic region. In two stages, from 1558 to 1598, the artistically-inclined Ulrich, Duke of Mecklenburg had the magnificent structure built as a hybrid of Italian, French, Dutch, and German influences by the architects Franz Parr (died 1580), Philipp Brandin (died 1594), and Claus Midow (died 1602). This stylistic conglomeration made it particularly appealing and unique to Middle European architecture of that period.

The 17th century saw additional expansions to the residence. The stucco ceiling by Daniel Anckermann, which was richly decorated with hunting scenes from all parts of the world was thus added to the ballroom in 1620. Moreover, the imperial Generalissimus Wallenstein, who resided in the palace in 1628/29, made plans for extensive Baroque remodeling. The last person to reside in Güstrow, Duke Gustav Adolph (1633–1695) had for example, the Early Baroque gatehouse with the palace bridge made into a splendid entrance by the architect Charles Philipp Dieussart (ca. 1625–1696?). After the Güstrow ducal line died out, the residential palace was neglected and in some parts, fell into decay. At the end of the 18th century, the entire east wing and half of the north wing were ultimately torn down; in doing so, the unified character of a four-winged complex was lost. From 1817 to 1945, the palace served as a peasant lodge for Mecklenburg and was significantly altered, particularly in the interior. Fortunately, the most significant rooms were preserved. In the 1960s and 1970s, the palace interior and exterior underwent extensive restoration. At this time, the long-neglected palace garden, which drew from Renaissance and Early Baroque gardens, as well as copperplate patterns, was newly designed. A shady pergola and fragrant lavender beds encourage visitors to linger.

Güstrow Palace from the southwest

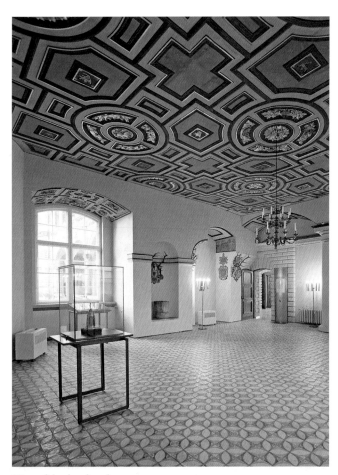

View of the ducal parlor

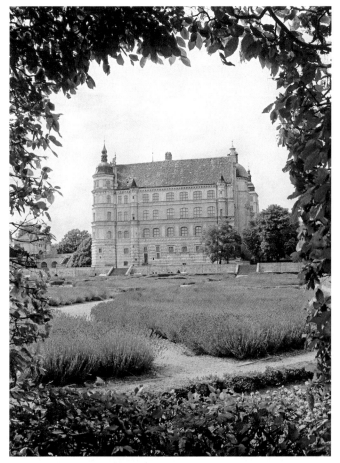

Lavender blossoms in the palace garden

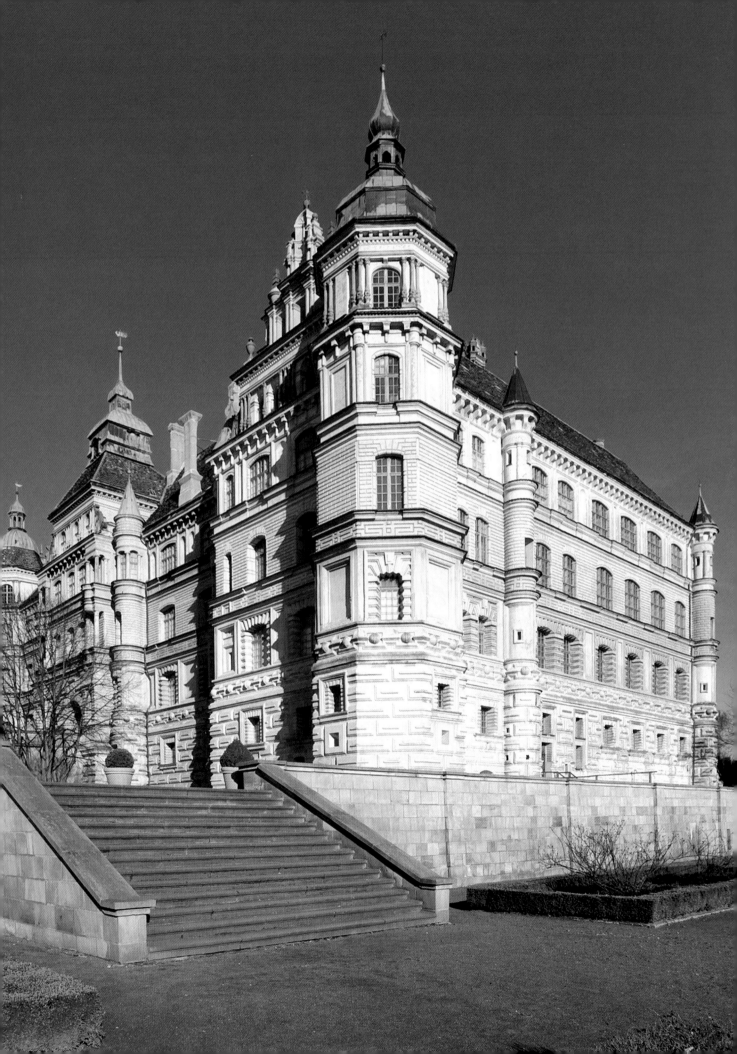

Hohenzieritz Palace and Park

Schloss Hohenzieritz
Schulstraße 1
17237 Hohenzieritz

Telephone
+49 3 98 24/2 00 20

E-Mail
info@mv-schloesser.de

Internet
www.mv-schloesser.de
www.Louisen-
Gedenkstaette.de

Hohenzieritz Palace went down in history as the place of death of the legendary Queen consort of Prussia, Louise of Mecklenburg-Strelitz. In 1790 and 1791, the old Hohenzieritz mansion was expanded into a castle and lavishly decorated with furniture and sumptuous wallpaper. After her father, Charles II (1741–1816) assumed reign of Mecklenburg-Strelitz in 1795, Louise often came to Hohenzieritz during the summer months, and died quite unexpectedly in 1810 at the age of 34. Her father had a temple built in the park in memory of his beloved daughter. Only a few remnants survive of the palace's once-magnificent interior furnishings. The former summer residence is now the seat of the Müritz National Park Office. Thanks to the work and commitment of the society dedicated to preserving the monuments in her honor (Schlossvereins Hohenzieritz Louisen-Gedenkstätte e.V.), the restored death chamber belonging to Queen Louise and a palace memorial are open to visitors. In the castellan's quarters, special exhibitions are organized on a regular basis. Already in 1770, Duke Adolphus Frederick IV donated the estate to his younger brother, Charles II, the father of Queen Louise. In 1771, he decided to have a landscape garden installed at Hohenzieritz. The project was executed by the English gardener Archibald Thomson, who came from the circle of the famous garden architect, Lancelot (Capability) Brown. Thus emerged the earliest North German English landscape garden embedded within scenic terminal moraines. Virtually unchanged, this jewel of landscape art remains on display up until the present.

Death chamber of Queen Louise of Prussia

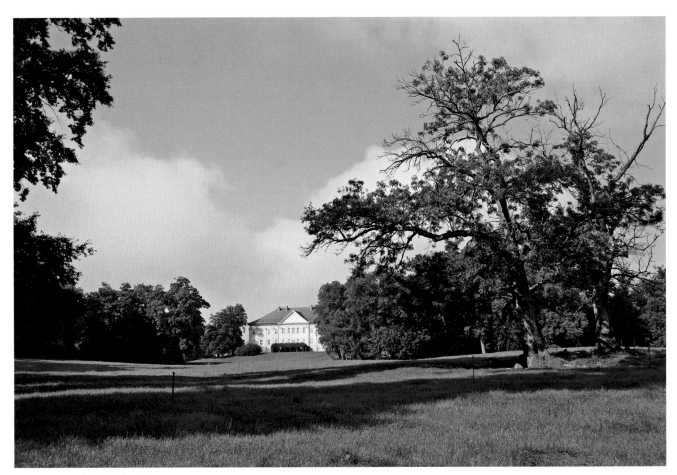

Hohenzieritz Palace and Park

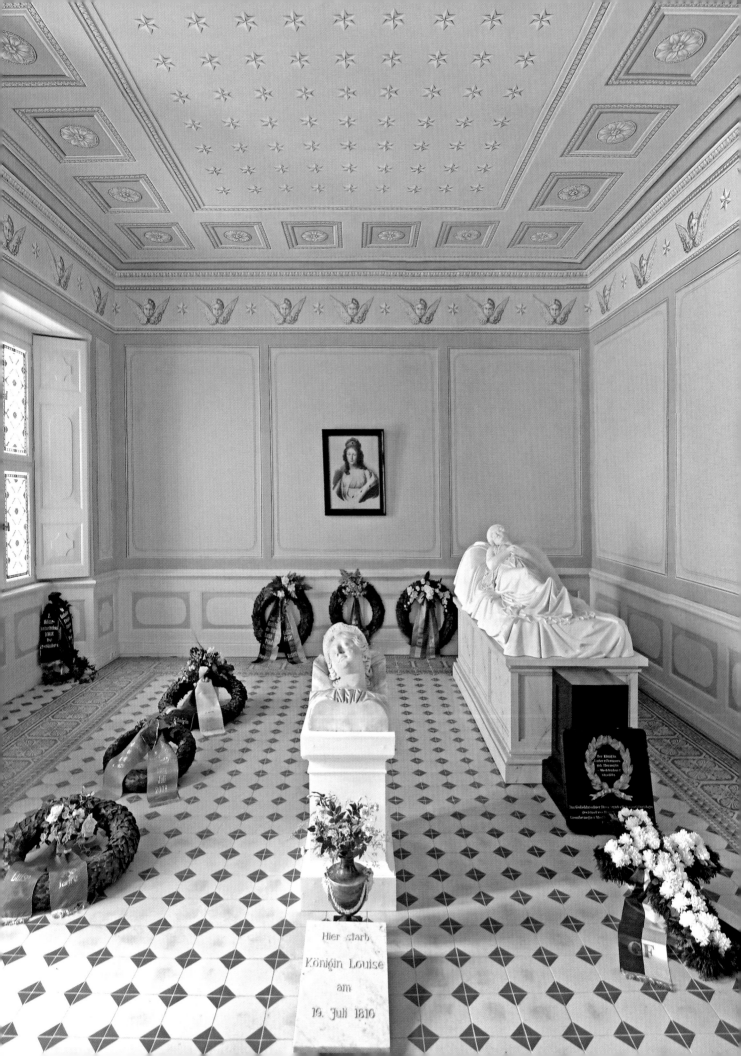

Hier starb
Königin Louise
am
19. Juli 1810

Ludwigslust Palace and Park

Schloss Ludwigslust
Schlossfreiheit
19288 Ludwigslust

Telephone
+49 38 74/5 71 90

E-Mail
info@mv-schloesser.de
info@schloss-
ludwigslust.de

Internet
www.mv-schloesser.de
www.schloss-
ludwigslust.de

Located in the region of Griese Gegend, the city of Ludwigslust became transformed over its history from a small hunting lodge to a residence of the Mecklenburg dukes. Prince Christian Ludwig of Mecklenburg-Schwerin (1683–1756) arranged for the architect of Bothmer Palace, Johann Friedrich Künnecke, to build a hunting lodge near the village of Klenow in 1735. In 1747, Christian II Ludwig became the reigning duke and renamed the village "Ludwigs-Lust." His son and successor, Duke Friedrich the Pious (1717–1785), transferred the court administration from Schwerin to Ludwigslust.

Beginning in 1758, the architect Johann Joachim Busch (1729–1802), who had designed the city of Ludwigslust, was given the task to construct a new, grand residence. From 1772 to 1776, the palace was built in the transitional Baroque-Neoclassical style. Alternating with sandstone vases, 40 larger than life-size allegorical sandstone figures by Rudolf Kaplunger (1746–1795) adorn the parapet wall in a crowning finish. In the first and second upper floors, the looming central risalit houses the richly-decorated Golden Hall, which is used as a banqueting and concert hall. Due to its excellent acoustics, the Golden Hall also remains a popular performance venue for chamber music concerts. Most of the palace room decorations are made of paper maché, the so-called "Ludwigslust Cardboard." The use of this economical material as an alternative to more precious materials brought fame to its local artisans. At the same time, the expansion of the sprawling park commenced in 1785 with an extension of the garden which had originally been planned by Künnecke. During the mid-19th century, the garden was redesigned into a landscape garden with plans according to Peter Joseph Lenné. In the process, significant Baroque elements such as arbors, avenues, cascades, and canals were preserved.

Within the palace, the State Museum of Schwerin exhibits courtly art of the 18th and 19th centuries.

Ludwigslust Palace as seen from the carp pond

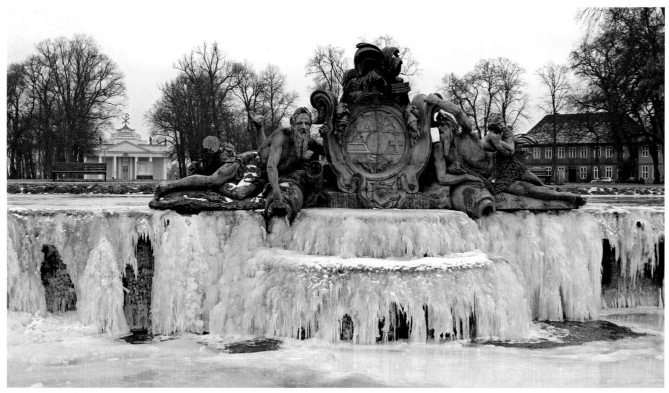

Waterfall with city church in the background

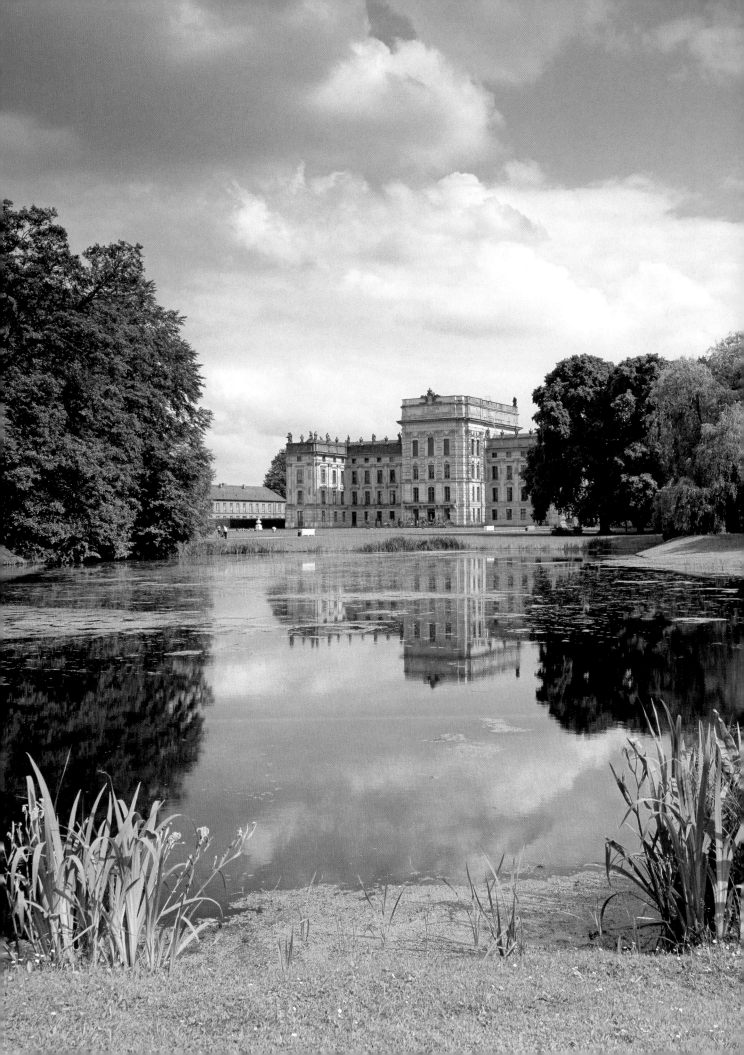

View of the palace island of Mirow

Mirow Palace

Schloss Mirow
Schlossinsel
17252 Mirow

E-Mail
info@mv-schloesser.de

Internet
www.mv-schloesser.de

Amidst the far-reaching lakeland area of Mecklenburg-Western Pomerania, the palace ensemble of Mirow is ensconced within a romantic island setting. Here, palace, gatehouse, church, and surrounding landscape park come together to form a unique testimonial to nearly 800 years of architectural and cultural history.

The Baroque palace was built for the young widow, Christiane Emilie Antoine of Mecklenburg-Strelitz (1681–1751). She occupied the house for the next 40 years and brought up her son Prince Charles here. King Frederick II of Prussia, who visited here as the Crown Prince of Rheinsberg, jokingly referred to the Strelitz branch of the family as the "Miroquois." They produced a series of famous personalities, such as Queen Charlotte of England and her brother, Adolphus Frederick IV, Fritz Reuters Dörchläuchting. The father of the Prussian queen Louise was also a son of the prince from Mirow.

The leading architect of Mirow Palace was Joachim Borchmann. On the first floor is a High Baroque banquet hall, which is outfitted with fantastic stucco décor by the Italian Giovanni Battista Clerici. Beginning in 1753, the majority of the additional rooms was redesigned by the second inhabitant, Duchess Elisabeth Albertine (1713–1761). Among these include carved and set wall decorations in pure Frederican Rococo and the sole specimens outside of Prussia, painted oil wall coverings with scattered flowers, Watteau-like scenes and still lifes, Peking wallpapers, and hand-embroidered silk wall coverings. Until today, the vast majority of these precious accouterments from the era of the widowed duchess has been preserved. The palace is currently undergoing major restoration under the supervision of the State Palaces and Gardens Administration and is for this reason, not accessible.

Neustrelitz Park and Orangery

Beginning in 1726, the construction of a new residential palace and the installation of the Baroque pleasure garden (Lustgarten) by Duchess Dorothea Sophie of Mecklenburg-Streulitz (1692–1765) was the nucleus of the city of Neustrelitz. The palace was destroyed in 1945. Large sections of the large garden complex and the adjoining city still bear witness to its Baroque roots. The palace, the garden, and the city were designed and built by Christoph Julius Lowe.

The oldest section is the Baroque arbor between the palace and Hebe Temple with its terraces and avenues. It tapers off towards the temple, thus creating the perspectival illusion of an even greater distance. At the behest of Grand Duke Georg and including Peter Joseph Lennés, the garden was redesigned in the style of an English landscape garden. In the western section is the Memorial Hall for the Prussian queen, Louise of Mecklenburg-Strelitz and the sister of Grand Duke Georg, with a copy of the second tomb statue by Christian Daniel Rauch.

After the residential palace was destroyed, the most prominent building of the complex is the orangery. It was created in 1755 by Martin Seydel in order to store exotic plants during the winter. From 1840–1842, designs by Schinkel and Rauch gave the building its Neoclassical appearance. The person responsible for this was the Neustrelitz court architect Buttel. The orangery's interior features elaborate Pompeiian wall and ceiling paintings. They provide a vivid backdrop to the large collection of Ancient and Neoclassical cast statues.

Orangerie Neustrelitz
An der Promenade 22
17235 Neustrelitz

Telephone
+49 39 81/23 74 87

E-Mail
info@mv-schloesser.de

Internet
www.mv-schloesser.de

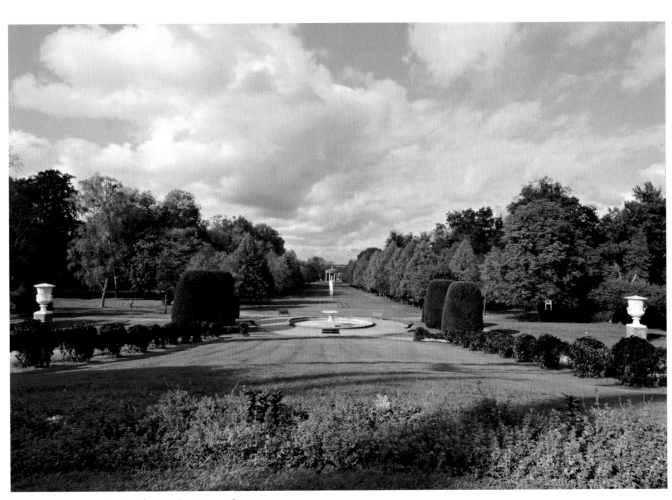

The Baroque avenue in the palace park at Neustrelitz

Schwerin Castle and Garden

Schloss Schwerin
Lennéstraße 1
19053 Schwerin

Telephone
+49 3 85/5 25 29 20

E-Mail
info@mv-schloesser.de
info@schloss-
schwerin.de

Internet
www.mv-schloesser.de
www.schloss-
schwerin.de

The former residence of the grand dukes of Mecklenburg-Schwerin is located at the romantic island setting of Lake Schwerin. Schwerin Castle is among the most significant Historicist buildings in Europe. Its striking form took shape during its last renovation from 1845–1857 under the leadership of the architects Georg Adolf Demmler, Friedrich August Stüler, and Hermann Willebrand. In doing so, older buildings, some of which date back to the 16th century, were combined to form a stately building of magnificence. Since 1990, the palace has been the seat of the Landtag of Mecklenburg-Western Pomerania. The noble residence additionally houses the Palace Museum within the historical rooms of the Beletage and Festetage and also provides facilities for events and conferences. Particularly striking are the banquet and residential rooms, with their high-quality furnishings featuring sumptuous sculpted and painted decoration, as well as ornate intarsia floors.

The castle garden surrounding the palace is characterized by water features, sculptures, and terraces, as well as elaborate flowerbeds and potted plants. Making substantial contributions to its design was the royal Prussian garden director, Peter Joseph Lenné. As one of the most beautiful Baroque complexes in North Germany, the castle garden extends southwest of the castle island like its French precedent and was given its formative design in 1748. Using sketches by the garden architect Jean Laurent Legeay, a central element of the canal emerged: sculptures from the workshop of the Saxon sculptor Balthasar Permoser. The garden was expanded using plans by Lenné in approximately the mid-19th century. In doing so, the fundamentals of the Baroque structure were retained, while the bordering surroundings were given a landscaped composition.

View of the castle from the garden canal

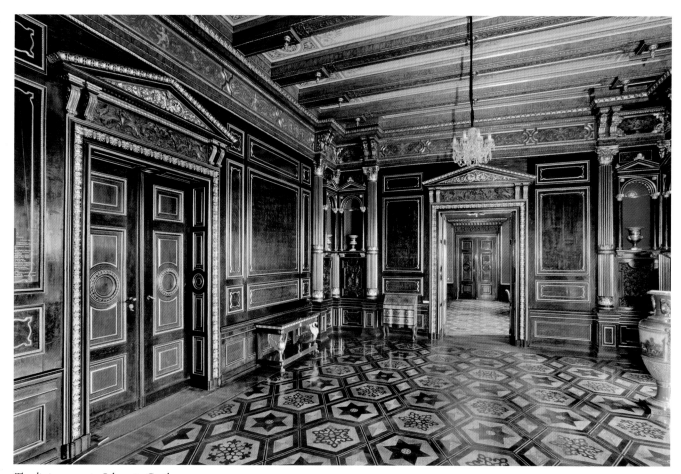

The dining room in Schwerin Castle

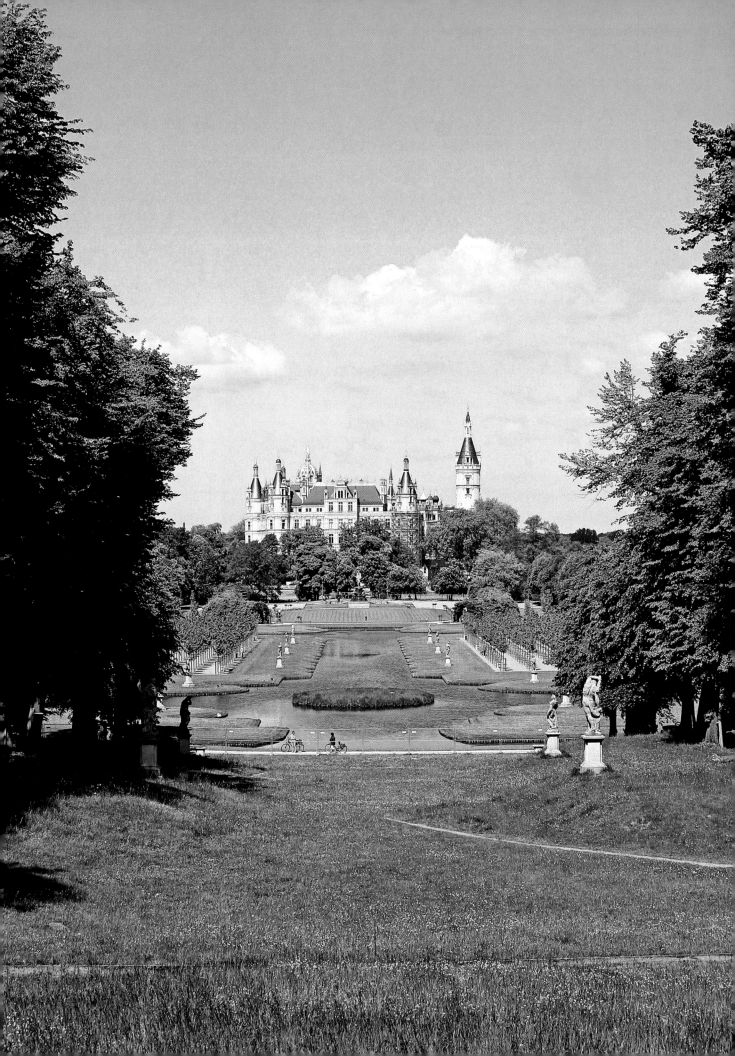

Wiligrad Palace and Park

Schloss Wiligrad
19069 Lübstorf

Telephone
+49 3 85/50 90

E-Mail
info@mv-schloesser.de

Internet
www.mv-schloesser.de

With its remarkable annexes and connected park, Wiligrad Palace, set in the middle of a woodland on the west coast of Lake Schwerin, is a Neo-Renaissance jewel. It was built within two years (1896–1898) as a deliberately Historicist structure by the well-known architect Albrecht Haupt (1852–1932). The palace is one of the youngest palaces in Mecklenburg-Western Pomerania. By making references to the architectural structure and materials of the 16th-century Johann Albrecht Style, it resembles the palaces in Schwerin, Wismar, and Gadebusch. Imaginative terracotta relief featuring ornamentation, masks, and botanical motifs adorn the pediments and façades of the castle, which sits enthroned atop the lake.

Duke John Albert of Mecklenburg-Schwerin (1857–1920) commissioned the building of the palace for his first wife, Elisabeth of Saxe-Weimar-Eisenach (1854–1908). For the building and its annex, he was involved in nearly every detail. The palace was named Wiligrad in reference to the Slavic reference for "large castle" and in so doing, acknowledges Mecklenburg Castle, which is situated slightly northward and near the modern-day village. With this, the duke wished to recall the historic roots of his ducal family and acknowledge that Wiligrad also had the character of a princely residence. A view of Schwerin Palace, the most notable grand ducal residence located 15 kilometers away, can be seen from the enormous panoramic window of the salon. The prince had the accompanying park planned and installed for his wife. Resembling Belvedere Park in her homeland in Weimar, Wiligrad Park merges seamlessly into the surrounding woods. The entire ensemble and park are currently undergoing restoration.

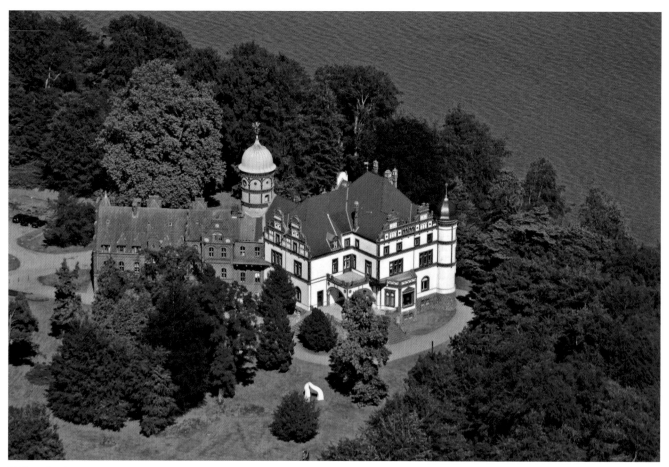

Wiligrad Palace

Rhineland-Palatinate

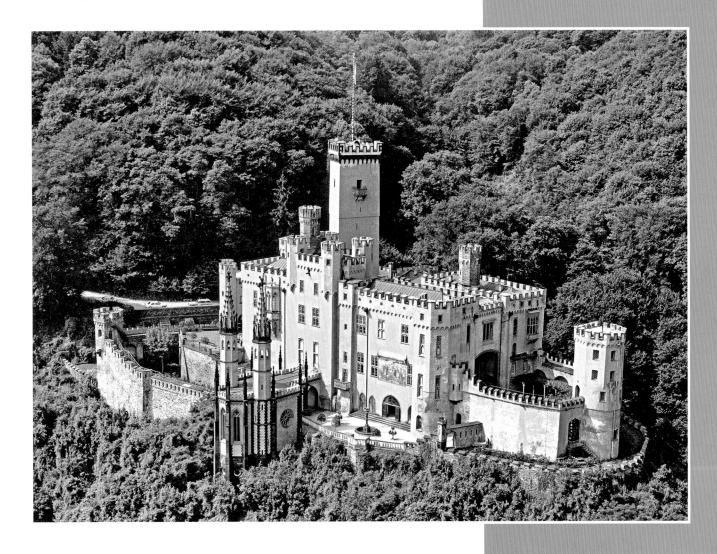

Rheinland Pfalz

GENERALDIREKTION
KULTURELLES ERBE

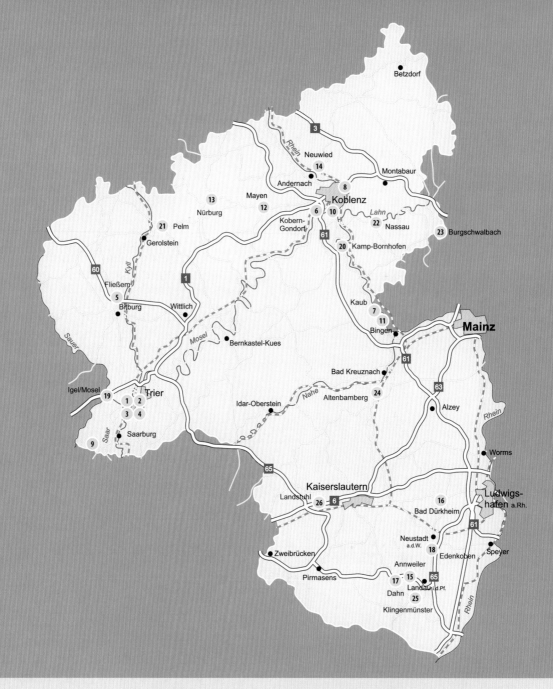

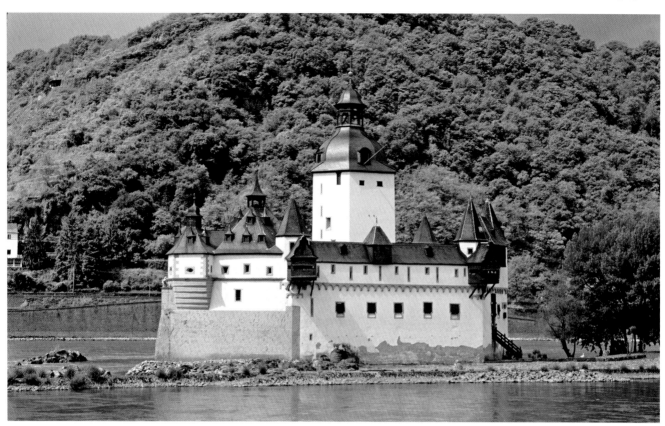

Pfalzgrafenstein Castle

Experience history –
from the Romans through the Middle Ages to the Romantics

The Castles, Stately Homes and Ancient Monuments of Rhineland-Palatinate invite you to live history in stout Roman fortresses, enchanted ruins, lavishly decorated castles and palaces, a medieval customs office in the middle of the Rhine, and one of Europe's biggest fortifications.

Rhineland-Palatinate was created as a federal German state a little over 60 years ago, but the cultural landscapes that it unites within its borders look back over two thousand years of history. Trier is often called "the Rome of the north", having been an important focus of power in the Roman Empire. The Palatinate and Rhine-Hesse were core territories of the medieval German constellation known as the Holy Roman Empire. Today's state contains three principalities once ruled by electors: Trier, Mainz and the Palatinate. Prussia's kings were bewitched by the magic of the Rhine, while Bavaria's followed the lure of Palatine scenery. In many cases the sites bearing witness to this past harbour little more than stone ruins, for this region at the heart of Europe has been ravaged by many wars. Our organisation – Burgen, Schlösser, Altertümer Rheinland-Pfalz – now has 82 of these castles, stately homes and ancient monuments in its care. These sites reflect the diversity of our architectural history, across all its functions and stylistic periods: Ancient Roman structures in Trier, such as the Porta Nigra, the Amphitheatre, the thermae of Barbara's and the Emperor's Baths; castles and castle ruins such as Pfalzgrafenstein straddled by the Rhine, Nürburg in the Eifel Hills, Nassau on the River Lahn, and Trifels and Hardenburg in the Palatinate; richly endowed museums in stately homes like Schloss Bürresheim, which took several centuries to evolve as we know it, or Schloss Stolzenfels, built by the Romantics as a Gothic Revival castle; neo-classical palaces such as Villa Ludwigshöhe, and military fortifications like the Prussian fortress of Ehrenbreitstein in Koblenz. Burgen, Schlösser, Altertümer Rheinland-Pfalz was founded in May 1998 under the roof of the Rhineland-Palatinate Preservation Agency, replacing the former Administration of Public Stately Homes in Rhineland-Palatinate. In the wake of major restructuring, a new Cultural Heritage department was created in 2007, embracing not only the three regional museums in Mainz, Koblenz and Trier but also the state's resources in monument preservation and archaeology and our own agency. Our specific task is to ensure that the cultural heritage, buildings and collections entrusted to us are protected, maintained and preserved for future generations. At the same time, these monuments are made accessible for cultural events and tourism and presented in a lively fashion that our visitors will find easy to understand. Thanks to these principles, visiting our heritage sites will prove a thrilling experience.

The Emperor's and Barbara's Baths

Verwaltung Kaiser-
thermen
Weimarer Allee 2
54290 Trier

Telephone
+49 6 51/4 36 25 50

E-Mail
bsa@gdke.rlp.de

Internet
www.burgen-rlp.de

As one of the four capitals of the Imperium Romanum, Trier offers more traces of Roman culture than any other town in Germany. Excavation of these Ancient sites began under Prussian government, when the key Roman buildings in Trier became public property. Today they are in the care of our heritage administration. The sturdy remains of the Imperial thermae, built around A.D. 300, are but modest vestiges of a once gargantuan complex. Romans of standing came to relax and enjoy themselves here in the public baths, which were probably begun under Emperor Constantine and, it seems, never finished. The masonry of the great apse – some of it original and some reconstructed later – provided the walling for the hot bath, or caldarium. This was not the only facility. There was also a cold bath, sauna and massage rooms. Sports were played in the courtyards while poets and musicians provided entertainment in the lobbies. Slaves toiled without respite in the underground passages, preparing hot, clean water for the bathers. Barbara's Baths are older, built around A.D. 150. In fact, these are the largest surviving Roman baths north of the Alps, and like the other monumental Roman structures in Trier they form part of the World Heritage site. The walls of the cellars, where a horde of slaves kept the underground heating running, have survived particularly well. The masonry foundation walls of the ground floor, which housed two covered swimming pools, are also impressive. The rooms were lavishly adorned with marble, relief and sculpture.

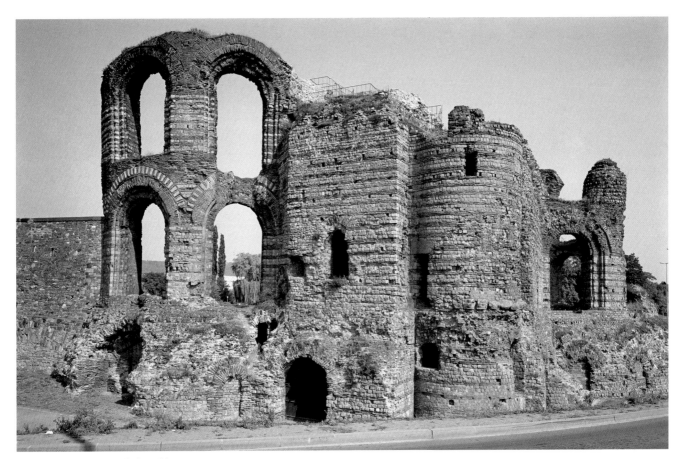

The Emperor's Baths with the caldarium apse

Porta Nigra

All the Roman buildings in Trier are included in UNESCO's list of World Heritage sites. The Porta Nigra is probably the most popular of them and it attracts the largest number of visitors. Although it was never quite finished, it is the best preserved monument to Roman architecture north of the Alps.

The Porta Nigra was built around A.D. 180 as part of the Roman fortifications for the town. It is a double gate flanked by two towers with huge arched windows which had wooden shutters, and it was designed for defence purposes. However, its function was also to advertise the town's commercial and cultural prestige to the flocks of travellers as they approached.

The Roman masons piled stone block upon stone block with no mortar between. Even today, the masonry is held together by iron clasps and sheer weight. Although medieval scrap thieves managed to prise out some of these iron "dogs", the gate remained unshakably stable. The Porta Nigra owes its survival to the itinerant Greek monk Simeon, who moved into it in 1028 to lead a pious life in solitude. When he died, it was converted into a dual-purpose church, serving both a religious order and the parish, and that was its salvation.

The French Emperor Napoleon I was the first to "liberate" the gate from most traces of its turbulent history. Driven by cultural policy and preservation concerns, he ordered the removal of all medieval fittings. Work to expose the Roman features did not end with the hand-over to Prussia in 1816. Carl Friedrich Quednow, the town's Prussian conservation officer, succeeded in preserving the Romanesque eastern choir of the church.

Centuries of weathering turned the stone of the Porta Nigra dark, and so by the 11th century it had already acquired its name: the Black Gate.

Porta Nigra
Simeonstraße 60
54290 Trier

Telephone
+49 6 51/4 60 89 65

E-Mail
bsa@gdke.rlp.de

Internet
www.burgen-rlp.de

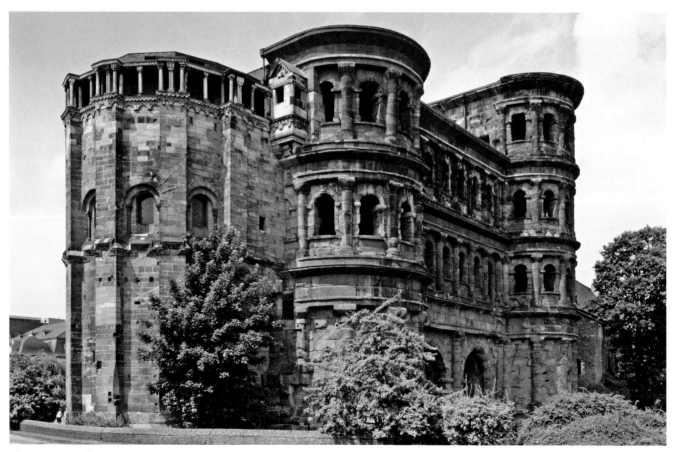

The Porta Nigra from outside

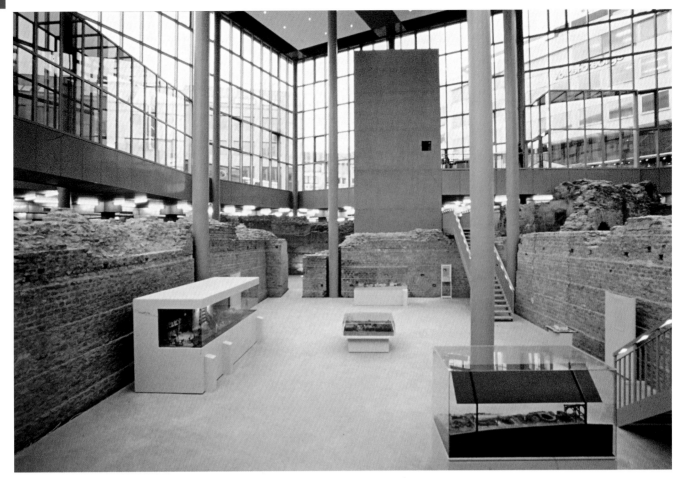

Inside the Cattle Market Baths

Cattle Market Baths

Thermen am Viehmarkt
Viehmarktplatz
54290 Trier

Telephone
+49 6 51/9 94 10 57

E-Mail
bsa@gdke.rlp.de
viehmarktthermen@
burgen-rlp.de

Internet
www.burgen-rlp.de

The baths at the cattle market offer insights into the history of Trier unmatched by any of the other Ancient sites. A residential Roman district in the 1st century A.D. gave way to a large building where, in the 3rd and 4th centuries A.D., the inhabitants of Augusta Trevorum were able to enjoy the comforts of the Roman bathing culture. These were "public baths", offering everyone health and hygiene for a small price. Palatial luxury was never the object.

The cathedral chapter used the ruins as a "quarry" in the 13th century, and so the fabric of the building suffered in the Middle Ages. In the 17th and 18th centuries, the garden of a Capuchin monastery was the precursor to a cattle market, established once the monastery was dissolved in 1802. Awoken from its long slumbers in 1987 by the construction of an underground car park, the entire site was excavated until 1994 by the Trier Museum of the Rhineland. The striking vestiges of cattle market history now offer an unusual, intriguing interplay of contemporary and Ancient features, due in part to the equally impressive mantle placed over the complex by architect Oswald M. Ungers.

Nowadays the Cattle Market Baths serve as a venue for festivities, receptions, lectures and concerts.

Amphitheatre

By the end of the 2nd century A.D., with Trier's population growing fast, the wooden amphitheatre was clearly too small. A new theatre was built, integrated into the town walls, its entrances doubling up as fortified gateways to the town.

Of the 70 or more Ancient amphitheatres we know about, Trier's is about the tenth largest, with room for an audience of roughly 18,000.

While Ancient amphitheatres varied in size, their layout was always the same: a flat, usually oval, surface for the contest between beasts, gladiators and fighters, encompassed by ascending rows of spectators. Cages for animals lined the arena, and in the middle steps led down to subterranean cellars where sets and accessories were kept for the often bloody spectacle.

In the Middle Ages, the monks at Himmerrod stripped the amphitheatre of stone. Later they turned the arena slopes into terraced vineyards. In 1816, under Prussian rule, work was begun to expose the theatre. In the 1950s and 1960s, experts in the preservation of gardens and monuments carried out investigations and modelled the site so as to suggest the theatre's original basic shape.

Verwaltung
Amphitheater
Olewiger Straße
54295 Trier

Telephone
+49 6 51/7 30 10

E-Mail
bsa@gdke.rlp.de
amphitheater@
burgen-rlp.de

Internet
www.burgen-rlp.de

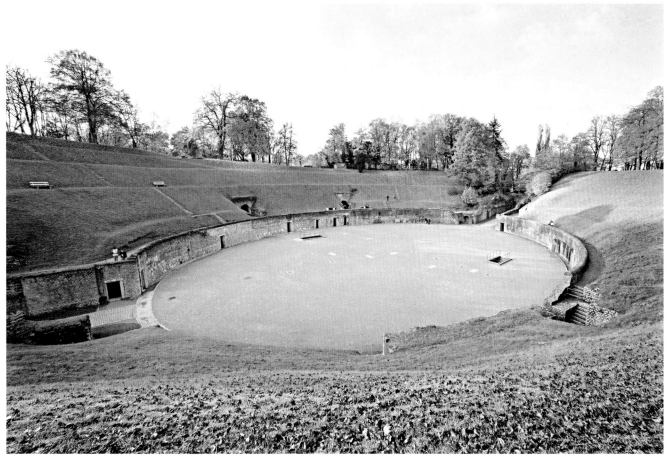

Amphitheatre

Roman Villa, Otrang

Verwaltung
Römische Villa Otrang
Otranger Straße 1
54636 Fließem

Telephone
+49 65 69/8 07

E-Mail
bsa@gdke.rlp.de
hedrich@villa-otrang.de

Internet
www.burgen-rlp.de

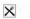 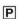

The Romans established numerous villas in the area around Trier, including the one near Otrang. This was an agricultural estate with a house for the master, including a shrine with two temples and graveyards. Roman settlers were already living here in the first century A.D. Today it is one of the biggest and best preserved Roman villas in the Rhineland.

The villa was extended several times until it had about 66 rooms and bath-houses with several underfloor heating systems. Its scale and embellishment testify to the prosperity and culture of its former owners. It was destroyed during the great wave of migration around 400 A.D. From 1838, after the ruins were rediscovered, they were excavated at the behest of Friedrich Wilhelm IV, soon to be King of Prussia. The remains exposed in the process were roofed over, an early example of monument preservation in Germany. The marvellous mosaic floors have survived in four rooms. Notable features include the depictions of animals: beasts pursue their prey through arches of ornamental foliage, while a crane devours a serpent. This is the kind of luxury which the upper classes would have expected in their homes in Rome.

Villa Otang

St Matthew's Chapel

St Matthew's Chapel

The Chapel of St Matthew, high above the Mosel Valley, stands amid the ruins of the Oberburg, long since destroyed. Not only is the location unique (though comparable with the castle chapel in Vianden), but so is its architecture, the result of its original function as a chapel of relics and pilgrimage: the head of the apostle Matthew was kept here. A knight from Isenburg may have brought this relic home from a Crusade. Around 1230 he had the chapel built, probably to resemble the Church of the Holy Sepulchre in Jerusalem. The relic was kept here in Kobern until 1347 at the latest, and was then taken to various places, including the fortress of Ehrenbreitstein near Koblenz. Finally, in 1927, it was placed in the Benedictine Abbey of St Matthew in Trier, where it remains until today. St Matthew's Chapel is a hexagonal structure on a central plan with a complex interior. The columns and capitals are Early Gothic masterpieces. The chapel owes its survival to the Catholic parish in Kobern, which sold it to the Prussian state in 1819. After Crown Prince Friedrich Wilhelm (IV) visited the chapel, he commissioned its restoration by the Koblenz architect Johann Claudius von Lassaulx. The work lasted until 1844 and produced the precious floor of multi-coloured discs.

Care of the chapel is now provided above all by the Brothers of St Matthew in Kobern. Oberburg's well-preserved Romanesque keep, immediately next-door, now houses a restaurant.

Matthiaskapelle
an der Oberburg Kobern
56330 Kobern-Gondorf

E-Mail
bsa@gdke.rlp.de

Internet
www.burgen-rlp.de

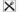

Pfalzgrafenstein Castle

Burg Pfalzgrafenstein
56349 Kaub

Telephone
+49 1 72/2 62 28 00

E-Mail
bsa@gdke.rlp.de

Internet
www.burgen-rlp.de

The castle of Pfalzgrafenstein reminded the French writer Victor Hugo of a stone ship anchored for all eternity. Strikingly, Pfalzgrafenstein is one of the few castles for which we have a precise date of construction: 1327. This casts light on the primary purpose of its owner, King Ludwig the Bavarian, a palatine count of the Rhine. He had recently acquired territories in Kaub and wished to secure them by military means from his neighbours, the electors of Mainz and Trier. He also wanted to be sure of the customs extracted from passing traffic in Kaub. Unlike most other castles and residences along the Rhine, then, Pfalzgrafenstein was built for purely commercial purposes and has always functioned as a toll-house. Its location, on an island in the middle of the river, clearly reflects its role. Even the Pope caught wind of the annoyance this caused, as his abbeys and prelates were expected to pay duties on their shipments of wine. It is hard to imagine today that barges travelling between Mainz and Cologne stopped twelve times on their journey for customs officials. Although the castle was modernised in 1607 and 1755, most of it dates from the 14th century. The austere rooms still convey the modest lifestyle of the 20 to 30 men deployed here.

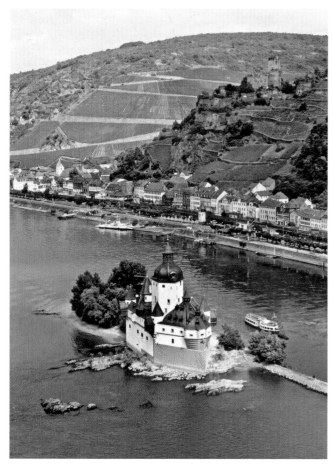

Pfalzgrafenstein

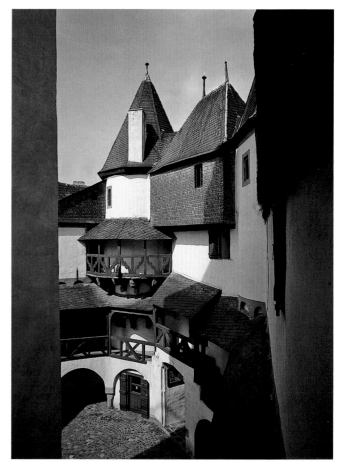

Inside the courtyard at Pfalzgrafenstein

Fortress Ehrenbreitstein

The fortress of Ehrenbreitstein was built from 1817 to 1828 to replace the Elector of Trier's fort blown up by the French in 1801. When finished, it was regarded as impregnable.

There was room here during hostilities for 1500 soldiers and 80 cannon. The provisions would suffice to withstand a six-month siege. Ehrenbreitstein actually forms part of the Fortress of Koblenz, with another two major complexes on the left bank of the Rhine and a multitude of smaller forts. At the time, Koblenz was Europe's second largest fortress after Gibraltar. Apart from being one of the biggest, it was one of the most homogeneous, having been built in the neo-Prussian manner, and it has retained this stylistic consistency until today. In the 19th century, the view from Ehrenbreitstein across to the Deutsches Eck was already a must for any Rhine traveller. Now it is being spruced up for the national garden exhibition in 2011. During and after this event, it will bask in a new radiance, offering far more than its imposing architecture. It is to be a hub of cultural activity, housing many facilities and with a broad programme to offer: the Landesmuseum Koblenz, a circular path through 3000 years of fortress history, the Army Monument, a restaurant, a youth hostel, and numerous events, including concerts, historical performances and open-air cinema.

Festung Ehrenbreitstein
56077 Koblenz-Ehren-
breitstein

Telephone
+49 2 61/66 75-40 00

E-Mail
bsa@gdke.rlp.de

Internet
www.burgen-rlp.de

Landesmuseum Koblenz

Telephone
+49 2 61/66 75-0

E-Mail
info@landesmuseum-
koblenz.de

Internet
www.landesmuseum-
koblenz.de

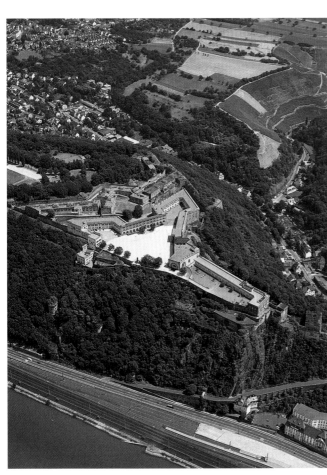

Fortress Ehrenbreitstein

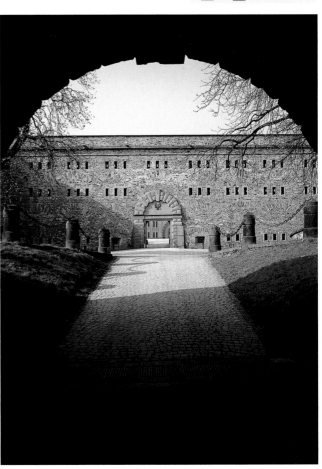

The curtain wall at Ehrenbreitstein from the north

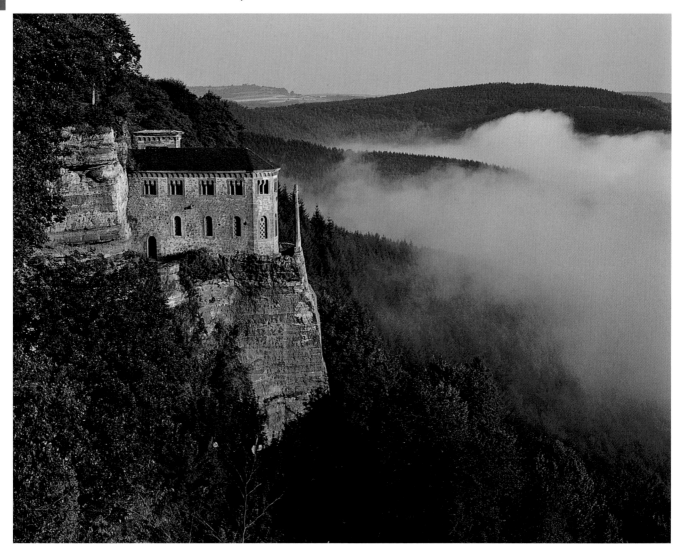

Kastel Hermitage

Kastel Hermitage

Altertumsverwaltung
Klause Kastel
König-Johann-Str.
54441 Kastel-Staadt

Telephone
+49 65 82/5 35

E-Mail
bsa@gdke.rlp.de

Internet
www.burgen-rlp.de

In the Middle Ages, pious hermits were already digging caves in the soft sandstone, seeking a secluded life far above the Saar valley. Around 1600 a Franciscan monk built a chapel on this narrow ledge. After 1833 Crown Prince Friedrich Wilhelm of Prussia – the future King Friedrich Wilhelm IV – had this long abandoned ruin converted into a chapel of rest for the Bohemian king John the Blind.

John of Bohemia, of the House of Luxembourg, did not allow his lack of sight to exclude him from the Battle of Crécy in 1346, but he perished there. The heir to the Prussian throne revered him as a paragon of brave chivalry, and had his bones placed in the chapel over the River Saar. Karl Friedrich Schinkel, the celebrated Prussian architect, produced the chapel design. The sarcophagus made for the bones of the legendary king still stands inside. Forged in black marble, its cover supports a bronze image of the Bohemian crown and orb. In 1946, King John's remains were moved to Luxembourg Cathedral.

Schloss Stolzenfels

The castle at Stolzenfels burned down during the Palatine wars of succession, but it was rebuilt, not only because of the contemporary Romantic enthusiasm for Rhenish landscapes and medieval history, but also to serve Prussia's cultural policy on the Rhine. In 1823 Crown Prince Friedrich Wilhelm, later King Friedrich Wilhelm IV of Prussia, received the ruined castle in this beautiful location as a gift. After taking careful stock of the medieval remnants, Friedrich Wilhelm decided to build a neo-Gothic summer residence from drawings by the celebrated Berlin architect Karl Friedrich Schinkel. In 1842, the completed palace and park composed a picturesque backdrop for a festival in historical costume. The castle exudes an almost Italian serenity with its light paint, its fountains and walled gardens. The royal quarters are still appointed just as the Romantic monarch disposed: paintings, weapons and furniture many centuries old alternate with neo-Gothic creations of the mid-19th century. The wall paintings in the palace chapel and the Lesser Knights' Hall are among the finest achievements of High Romantic style in the Rhenish region.

With a landscaped park and palace garden designed by the leading Prussian garden architect Peter Josef Lenné, a total art work was born as a major testimony to Prussian Romance on the Rhine. The gardens and surrounding landscaped park are undergoing restoration to mark the national garden exhibition hosted by Koblenz in 2011.

Schloss Stolzenfels
56075 Koblenz

Telephone
+49 2 61/5 16 56

E-Mail
bsa@gdke.rlp.de
Stolzenfels@
burgen-rlp.de

Internet
www.burgen-rlp.de

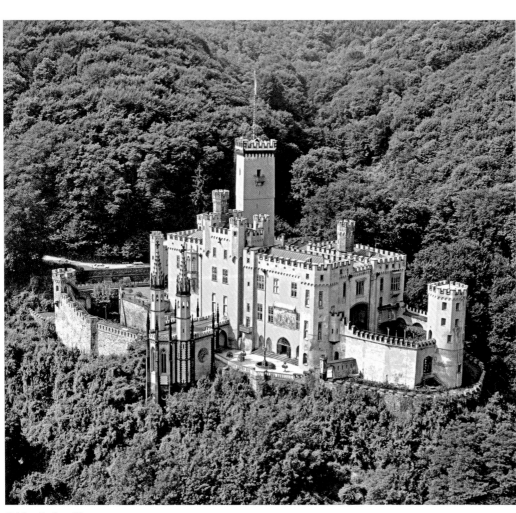

Schloss Stolzenfels

Sooneck Castle

Burg Sooneck
55413 Niederheimbach

Telephone
+49 67 43/60 64

E-Mail
bsa@gdke.rlp.de
sooneck@burgen-rlp.de

Internet
www.burgen-rlp.de

During a trip along the Rhine in 1842, King Friedrich Wilhelm IV of Prussia and his brothers, the Princes Wilhelm, Karl and Albrecht, agreed to convert the ruined castle of Sooneck into a hunting lodge. The king and his brothers hoped to hunt in the forest of Soonwald without their courtly entourage. This typically Romantic idea was thwarted by the Revolution of 1848, family disputes in the royal house, and ultimately the king's own illness and death. The Hohenzollern monarchs did restore the castle, but never resided here. The main building was a well-preserved ruin around 1840, lacking only roofs and flooring. Extension work in the 19th century was so circumspect that the Gothic masonry with its sawn-off beams and medieval rendering was carefully salvaged. The modest living quarters at the castle are furnished with items made in the first half of the 19th century and views of the Rhine from the Hohenzollern estate. In the dining room hangs a striking painting of 1825 depicting a battle scene during the Wars of Liberation against Napoleon I. On the second floor, the Koeth-Wanscheid Foundation exhibits views of the Rhine, portraits of nobility and furniture made in the 18th and 19th centuries. They belonged to a family of Rhenish aristocracy.

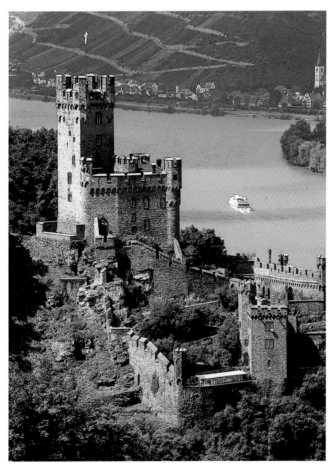

Sooneck Castle

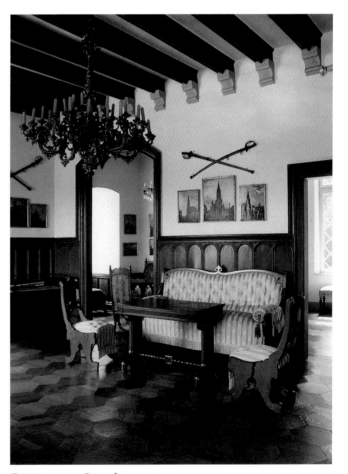

Dining room at Sooneck

Schloss Bürresheim

It is rare today to find such an old stately home which has stood in an undisturbed and uninhabited landscape for hundreds of years, alone with rippling streams and forested mountain slopes. Schloss Bürresheim has never been conquered or ransacked, unlike almost every other castle in the Rhineland. Over many generations, the aristocratic family who lived here until 1938 acquired a wealthy collection of furniture and paintings. It is unrivalled in showing how the Rhenish aristocracy lived and the interests they pursued. The buildings are clustered in a picturesque group which evolved from the 12th to the 17th century. The old keep has survived from

the original complex. The little baroque garden south of the castle was already depicted on paintings around 1700. The delightful courtyard is rich in timber frames and variously shaped roofs with slates and spires. The arrangement of the late medieval great hall illustrates how simply people lived around 1490. On each floor there is a large room with oak pillars, beam ceilings and huge hearths. It was only in later centuries that this space was divided into smaller and cosier rooms. Furniture from the 15th to 19th centuries has been lovingly preserved. Numerous portraits depict members of the family and overlords of past ages.

Schlossverwaltung
Bürresheim
56727 Mayen

Telephone
+49 26 51/7 64 40

E-Mail
bsa@gdke.rlp.de
buerresheim@
burgen-rlp.de

Internet
www.burgen-rlp.de

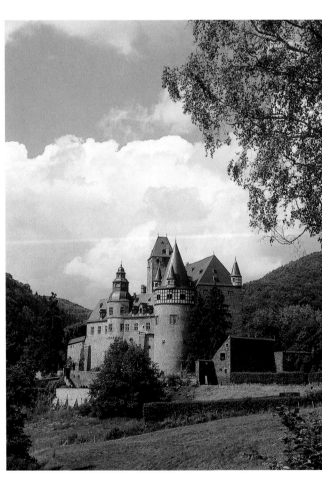

Schloss Bürresheim

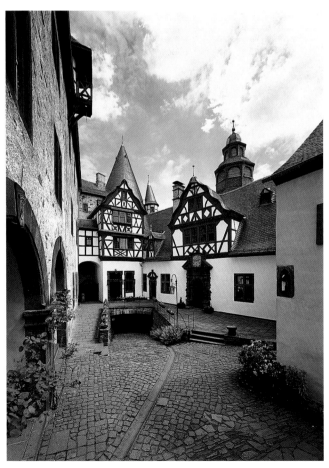

The castle yard at Bürresheim

Nürburg Castle Ruins

Burgverwaltung
Nürburg
53520 Nürburg

Telephone
+49 26 91/27 04

E-Mail
bsa@gdke.rlp.de

Internet
www.burgen-rlp.de

As racing cars roar round the Nürburg Ring, few people are probably aware that the hill crowned by the Nürburg was first settled long ago in Roman days. Its name derives from "mons nore", the black hill. The Counts of Are built a castle here in the 12th century, but nothing remains except the extensive ruins. At the foot of the castle mound, visitors will find last vestiges of a Romanesque castle chapel, built around 1200. A winding path leads to the principal point of access, a massive double gate.

With its myriad round turrets, thoroughly restored and covered once more by their distinctive polygon spires, it has an excellent command of the surrounding terrain. The inner castle, protected by a ring wall and its own gate, was built in the early 13th century. The sturdy circular keep still boasts its Late Romanesque ribbed vaults. The remains of a fireplace and a toilet oriel betray its residential function. Dwellings were once built onto the ring wall, and the western structure even has a large fireplace, which was probably part of a castle kitchen.

The steps of the keep lead to a platform with a sweeping view across the sprawling forests of the Eifel.

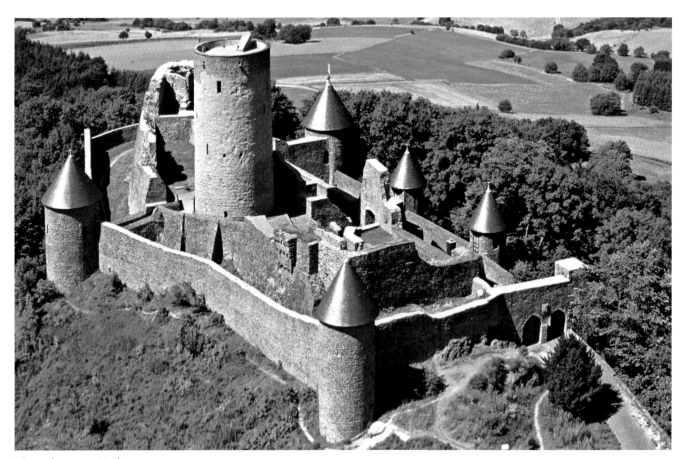

The castle ruins at Nürburg

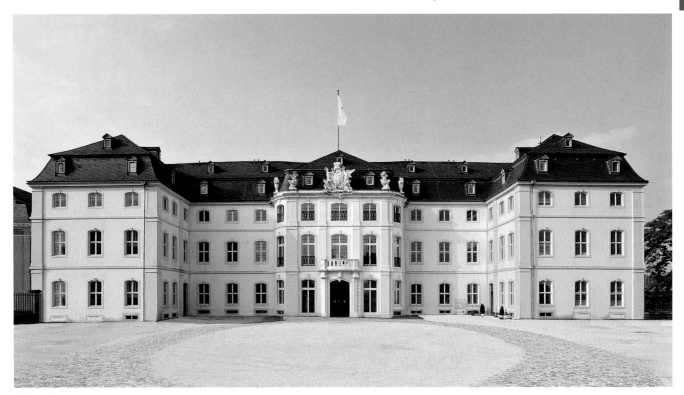

Schloss Engers, town prospect

Schloss Engers

One of the last Electors of Trier lived in a baroque palace on the banks of the Rhine. The hunting lodge for Johann Philipp von Walderdorff was built in 1759–1762. It is hard to tell, looking at today's splendid 18th-century baroque residence, that the history of its construction reaches back another 500 years, or that the records indicate an even older settlement. But Engersgau is mentioned in 773, and Engers was the hub of an Imperial district from Franconian to Hohenstaufen times. When the Trier Electors were expanding their territory along the right bank of the Rhine, Archbishop Kuno von Bolanden-Falkenstein (1362–1388) acquired Engers in 1371. In 1412, his successor Werner von Bolanden-Falkenstein (1388–1418) transferred the Rhine toll-house here from Kapellen near Koblenz. The castle with its mighty round keep was called Burg Kunostein. The only image we have is a town view by Wenzel Hollar dated 1636. In 1689 the castle was destroyed by French cannon.

To make way for the new residence, the Elector's architect Johannes Seiz, a pupil of Balthasar Neumann, was instructed to demolish the medieval castle of Kunostein. A gem of Late Baroque architecture and art then emerged on the river. The show side faces the Rhine. This is where the Elector's yachts moored when arriving from Trier. A spacious stairway with curvaceous steps and a beautifully wrought handrail leads to the main floor. The banqueting hall is especially sumptuous, with lavish stucco work and an original ceiling fresco by Januarius Zick, who was born in Munich in 1730 and had been painter to the Elector of Trier since 1760.

Schloss Engers appeals to cultural tourists today with its Villa Musica Foundation, a chamber music academy which regularly holds concerts in the banqueting hall. Its excellent restaurant is a further attraction.

Villa Musica
Schloss Engers
Alte Schlossstr. 2
56566 Neuwied-Engers

Telephone
+49 26 22/9 26 40

E-Mail
bsa@gdke.rlp.de
info@schloss-engers.de

Internet
www.burgen-rlp.de
www.schloss-engers.de

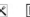 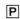

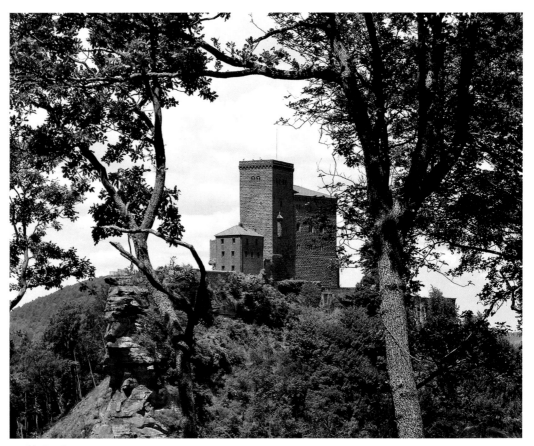

Trifels Castle

Trifels Castle

Burgverwaltung Trifels
76855 Annweiler

Telephone
+49 63 46/84 70

E-Mail
bsa@gdke.rlp.de
trifels@burgen-rlp.de

Internet
www.burgen-rlp.de

There it stands, high on the cliff top, where the rusty red sandstone is thrice cleft – hence the name "Trifels", no doubt. It was regarded as the sturdiest castle in the domain of the Hohenstaufen emperors and kings, and between 1088 and 1330 it was an imperial seat and the hub of political events. Together with the two nearby castles of Anebos and Scharfenberg it formed a defensive triad, making Trifels the "safest" castle in the Holy Roman Empire.

And so Trifels became the scene of a historical abomination: the English king Richard the Lionheart was briefly imprisoned here in 1193 by Emperor Heinrich VI, but in the end England paid the huge ransom of 23 tons of silver to buy his freedom. This lined Heinrich's coffers for a campaign to conquer Sicily.

The main tower, with the mighty, rusticated ashlars of the Hohenstaufen monarchs and the chapel oriel, recalls the castle's heyday from 1088 to 1330. The imperial treasure was kept in the beautifully vaulted Romanesque castle chapel on the upper floor. These trappings of regal power are extremely valuable, but their symbolic value as the insignia of legitimate rule and the divine right of king and emperor is even greater. After all: "Whoever holds Trifels holds the Empire."

The imperial gems had no permanent home until the 15th century. They were stored at Trifels from 1125 to 1298. Nowadays the treasure chamber houses extremely good replicas.

The great hall, not finished until after the Second World War, was designed by Rudolf Esterer in 1938. This makes it an invention of the Nazi years, when there were plans to make Trifels a national shrine. The permanent exhibition on "Power and Myth" not only explains the castle's history and construction, but describes the owners who held sway here.

Hardenburg Castle Ruins

The massive Hardenburg is one of the largest ruined castles in the state of Rhineland-Palatinate. It has been the seat of the Counts of Leiningen since the 13th century, although the present complex was built between 1500 and 1590. The robust fortifications indicate that the Counts of Leiningen were contentious gentlemen. They were party to about twenty belligerent feuds with neighbours during the 15th and 16th centuries. The trouble began with work on the castle, for which the counts had illegally appropriated land belonging to the Abbey of Limburg. Unlike other defence installations in Rhineland-Palatinate, the Hardenburg was not vacated when firearms were invented, but developed into a fortified residence for the dynasty from the 16th to the early 18th century. Today the Renaissance garden and the orchard have been restored. They had been destroyed, along with the sumptuous interiors, when revolutionary French soldiers burned the Hardenburg down in 1794. The round artillery tower which protected the castle from hill attack at its weakest point is impressive even as a ruin. Its mighty walls, more than twenty feet thick, withstood even enemy cannon. Little remains of the lavish living quarters apart from stair towers, windows and elegant portals. Visitors will wonder at the huge cellars with wide spans of ribbed vaulting built in 1509, which have survived both flames and the process of decay.

Burgverwaltung
Hardenburg
67098 Bad Dürkheim

Telephone
+49 63 22/75 30

E-Mail
bsa@gdke.rlp.de

Internet
www.burgen-rlp.de

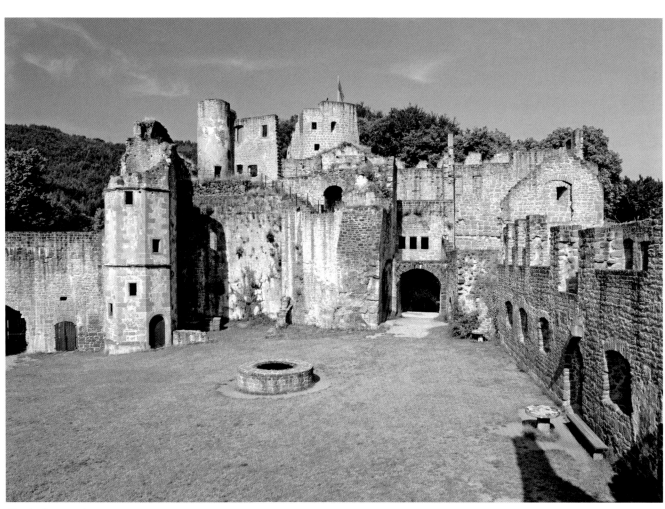

Hardenburg castle ruins

The Ruined Castles of Dahn and Neudahn

Dahner Burgen
66994 Dahn

Telephone
+49 63 91/36 50
+49 63 91/99 35 43

E-Mail
bsa@gdke.rlp.de
Dahner-burgen@
webmail.burgen-rlp.de

Internet
www.burgen-rlp.de

Three castles in succession grew from a sandstone cliff of five rocks. They are impressive examples of the craggy castles scattered across the Vosges Mountains. As their dilapidation proceeded, weathered walls fused with hewn rock as nature and architecture blended into one. The archaeological evidence shows that Tanstein is the oldest castle. Old Dahn probably dates back to the 13th century. Grafendahn, the middle structure, is mentioned in 1287 as a recently completed fortress. The three castles crown the cliffs like eyries. In days of yore, they would have been able to withstand each other's attacks. A reconstructed house in the complex contains an interesting museum with finds from the excavation sites. The display illustrates how many things can go astray in a castle: not only a pocket sundial of ivory, but broken jugs, numerous bowls, a corset chain, toys, many valuable silver coins and the beautifully worked silver wedding spoon for Johann Christoph von Dahn and Maria von Wallbronn.

Neudahn, in the forest two miles north-west of Dahn, was built around 1230 by Heinrich Mursal, descended from a collateral line of the knights of Dahn. The castle was adapted to resist gunpowder thanks to rigorous improvements in the early 16th century. Henri II of France visited in 1552, and he must surely have admired the robust battery towers which defended the approach to the lower castle and are still three impressive storeys high.

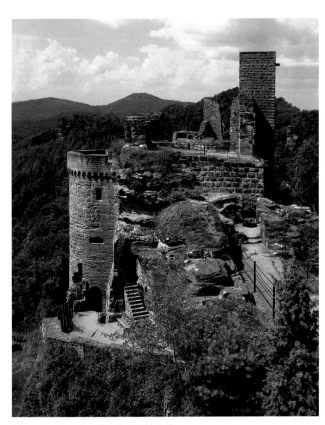

The ruined castles of Dahn, Old Dahn

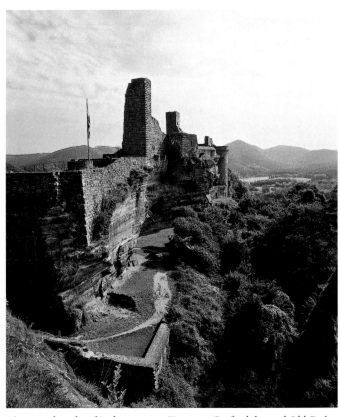

The ruined castles of Dahn, view on Tanstein, Grafendahn and Old-Dahn

Villa Ludwigshöhe

"A villa in the Italian manner, designed only for the warmer season and in the mildest region of the kingdom" was Ludwig I's great wish, and the Bavarian king was to accomplish it with Villa Ludwigshöhe near Edenkoben. The neo-classical building draws on prototypes of Antiquity, with its "Pompeii style" painted ceilings and a landscape setting reminiscent of Italy, replete with vineyards and groves of sweet chestnut (which the king had specially planted). The villa was built from 1846 to 1852 to drawings by the architect Friedrich Wilhelm von Gärtner. In 1848, Ludwig I was forced to abdicate, and so the work dragged on until 1851. Finally, the king acquired his magnificent home, financed from his personal coffers. However, the "Pompeian" murals which lend the villa its particular charm were not painted until 1899. The villa was never intended to be a permanent home, but the king came here every second summer to celebrate his birthday until he died in 1868.

The villa remained a family possession until the First World War. During the hostilities it served as a field hospital, and later French troops were garrisoned here.

In the Second World War, the villa became a storehouse. After the war it housed Allied troops, and then became a children's home.

In 1947 it was taken back by the Wittelsbach Settlement Fund, which administered the royal family's assets. The State of Rhineland-Palatinate acquired this unique ensemble in 1975, entrusting it to the care of what was then the Administration of Public Stately Homes (now the Cultural Heritage department of Burgen, Schlösser, Altertümer Rheinland-Pfalz). Since 1985 concerts have been held in the former dining room. Visitors can also benefit from numerous lectures, an annual castle festival, and two museums located on the premises. One is the Landesmuseum Mainz, with its Max Slevogt Gallery. Slevogt ranked with Liebermann and Corinth among the great German Impressionists. Upon request access is also granted to the collection of modern 20th-century ceramics in the historical cellar vaults.

Schlossverwaltung
Villa Ludwigshöhe
Villastraße 65
67480 Edenkoben

Telephone
+49 63 23/9 30 16

E-Mail
bsa@gdke.rlp.de
villaludwigshoehe@
burgen-rlp.de

Internet
www.burgen-rlp.de

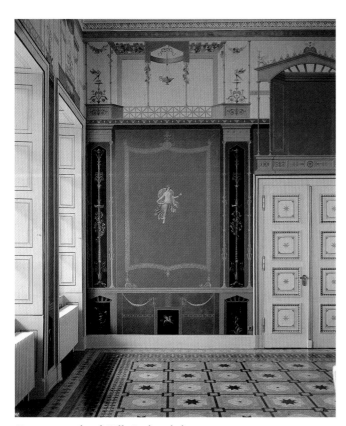

Dining room detail, Villa Ludwigshöhe

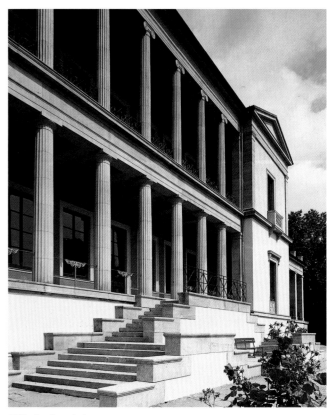

Villa Ludwigshöhe

Igel Column near Igel/
Mosel

bsa@gdke.rlp.de

www.burgen-rlp.de

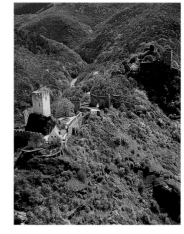

Sterrenberg Castle Ruins
56341 Kamp-Bornhofen
Rhein-Lahn-Kreis

+49 67 73/3 23

bsa@gdke.rlp.de

www.burgen-rlp.de

Fax +49 67 73/93 89

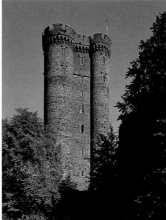

Kasselburg Castle Ruins
near Gerolstein
54970 Gemeinde Pelm

bsa@gdke.rlp.de

www.burgen-rlp.de

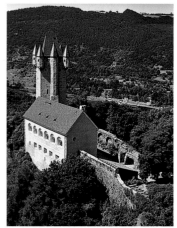

Nassau Castle Ruins
Rhein-Lahn-Kreis
56377 Nassau

+49 26 04/94 29 54

bsa@gdke.rlp.de

www.burgen-rlp.de

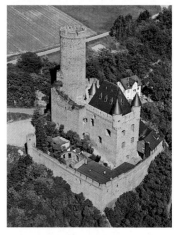

Schwalback Castle Ruins
Burgschwalbach
Paul-Morant-Allee 5
65558 Burgschwalbach

+49 64 30/66 11

bsa@gdke.rlp.de

www.burgen-rlp.de

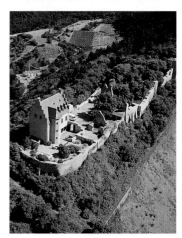

Altenbaumburg Castle
Ruins
55585 Altenbamberg

+49 67 08/35 51

bsa@gdke.rlp.de

www.burgen-rlp.de

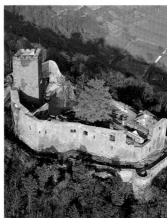

Landeck Castle Ruins
76889 Klingenmünster

+49 63 49/87 44

bsa@gdke.rlp.de

www.burgen-rlp.de

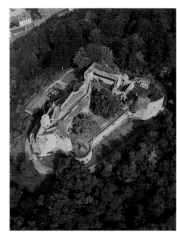

Nanstein Castle Ruins
66849 Landstuhl

+49 63 71/1 34 60

bsa@gdke.rlp.de

www.burgen-rlp.de

Saxony

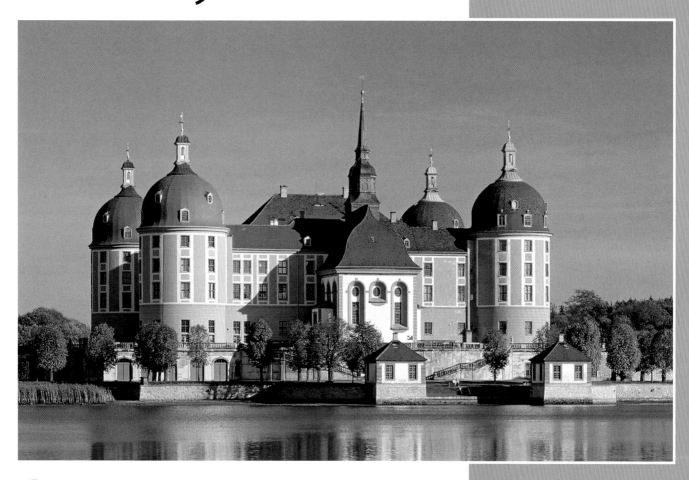

SCHLÖSSERLAND SACHSEN
STAATLICHE SCHLÖSSER, BURGEN UND GÄRTEN

www.schloesserland-sachsen.de

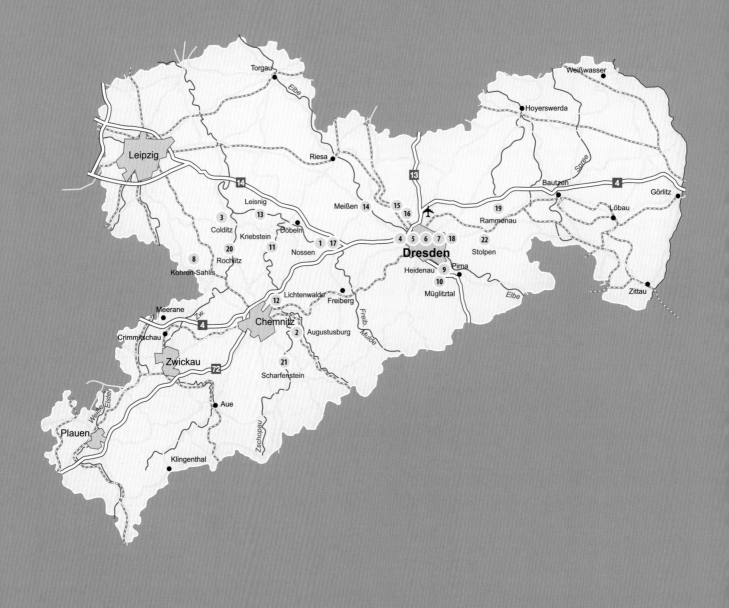

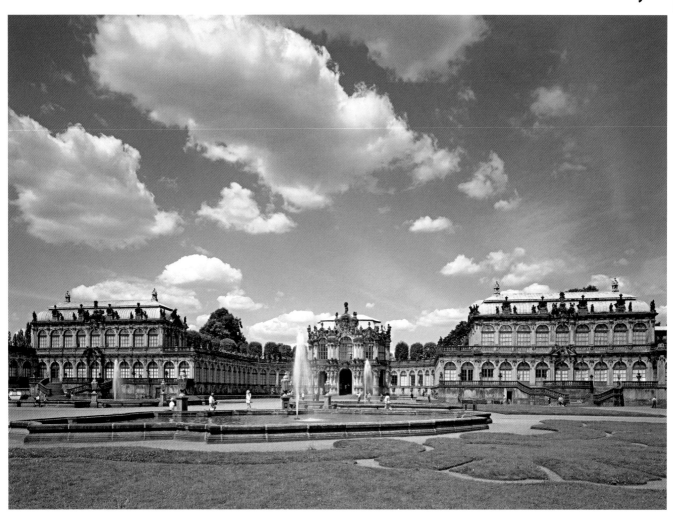

Wallpavillon in Dresden Zwinger

Old Splendor in New Glory

For more than 800 years, the Saxons lived under a single ruling family. The artistically-minded margraves, dukes, electors, and kings from the house of Wettin continuously had first-rate architects and artists associated with their court, especially in the Baroque era, during the brilliant reign of the "Saxon Sun King" August the Strong and his son, Friedrich August II. The world of the Wettins is a unparalleled visual feast, drawing millions of visitors to the countryside of the Elbe coast.

Saxony lies within the heart of Middle Europe, at the intersection of great cultures where the flow of traffic between the North and Adriatic Seas, as well as between Russia and Flanders frequently overlapped. Those who wished to assert themselves amidst the confusing melange of secular and church interests required a permanent stronghold which could not easily be taken by storm. Later, as diplomacy, legacy laws, and marriage politics superseded medieval robber baronry, many of these castles were transformed into representative palaces.

The supporters of culture were not only the nobility, but also the church: Notable libraries and art treasures were housed behind thick monastery walls. classic languages were fostered amidst the silent passages of chapter houses and monasteries, as were the arts of medicine, garden design, and crafts. After the Reformation, which famously built its first "feste Burg" in Sachsen, many monasteries were converted for secular use.

The imperial state of Dresden has evolved into one of the most lovely cities in Germany, richly adorned with sumptuous architecture and unique art. A wealth of dazzling cultural monuments of the highest quality also emerged in many other areas of Saxony. In the 19th century, "new rulers" were added: mining princes and mass industrialists built mansions whose splendor equals that of the feudal residences in every aspect but age.

The task of the State Palaces, Castles, and Gardens is to preserve the wealth of cultural monuments and to make them come to life.

Altzella Monastery Park

Klosterpark Altzella
Zellaer Straße 10
01683 Nossen

Telephone
+49 3 52 42/5 04 50

E-Mail
altzella@
schloesserland-
sachsen.de

Internet
www.schloesserland-
sachsen.de

As the waves of the European Reformation broke across the land, German princes who had converted to the Lutheran faith drove the monks from their monasteries. What remained were neglected monastery complexes, in which only history enthusiasts could hear an echo of monastic activity. This was also the case in Altzella, after Henry the Pious, the Saxon territorial prince, ordered the secularization of the Cistercian monastery located there. The grounds, which the monks had cultivated since 1175, fell into ruin: its bricks were used for other buildings, while its library, containing nearly a thousand books, was handed over to the University of Leipzig. Because Altzella was also the burial ground for the Wettin noble family, the land continued to spark the interest of the Dresden royal court. In 1787, Prince August III had a mausoleum built in the Neoclassical style, while his gardener, Johann Friedrich Hübler, enclosed the white graves with a Romantic landscape park. The man-made, yet natural-looking landscape with its old pointed arches, its fixed gables, and broken columns soon drew the attention of promising German painters such as Caspar David Friedrich and Ludwig Richter, who found abundant inspiration in Altzella. What was fascinating to the Romantics back then can still be experienced by all who allow themselves to be taken in by the old monastery's quiet splendor.

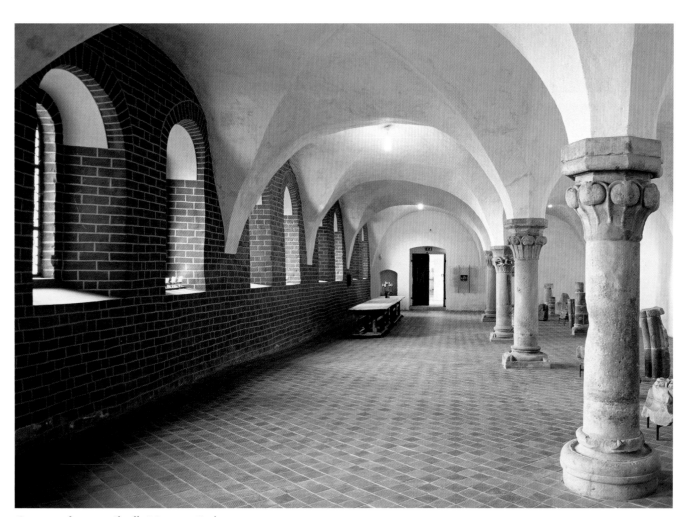

Conversi refectory in Altzella Monastery Park

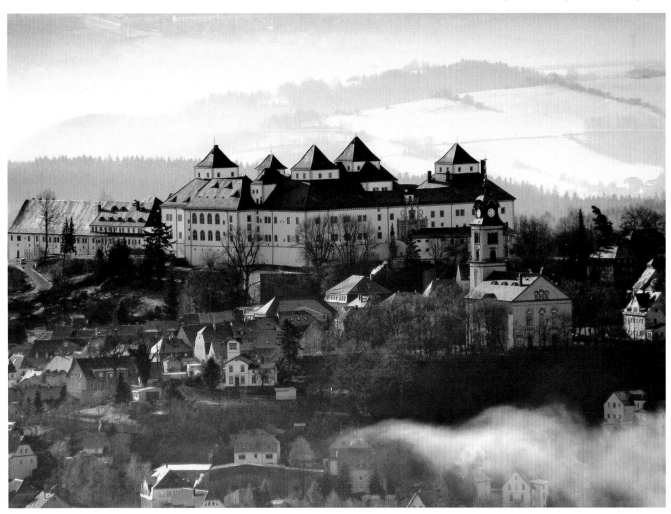

Augustusburg Castle

Augustusburg Castle

Where stallions once breathed heavily before stately carriages can now be heard the roar of horse-powered engines. Augustusburg Castle is one of the most popular destinations for motorcycle enthusiasts, for it contains the largest motorcycle museum in Europe. Countless original examples from the history of this fascinating means of travel are on display here, and during the "Winter Reunion" of the motorcycle community, Augustusburg becomes a magnet for thousands of motorcycle fans. The monumental Renaissance palace is located at a well-chosen site. Visible from afar, the old hunting lodge set upon a porphyry cone rises above the Zschopau Valley and is known as the "Crown of the Ore Mountains" based upon its roof shape. Completed in 1572, the imposing structure has lost none of its aura in the course of four centuries.

Not only does the historically-rich atmosphere of Augustusburg make an impact, but its ample space is also put to optimal use. Hardly any castle in Germany contains such a diversity of cultural and educational programs within its walls. In addition to the motorcycle museum, visitors will find other exhibitions worth investigating, as well as an observation tower. An aviary for falcons and eagles allows visitors to have a first-hand experience of these majestic birds of prey. Art aficionados will delight in the view of the castle's church altarpiece by Lucas Cranach the Younger. This is one of the most significant art works of its kind and has never been removed from its original location since the church's dedication. Lastly, those who become fatigued from having seen so many sights are welcome to stay, for the castle grounds also contain a youth hostel.

Augustusburg –
Scharfenstein –
Lichtenwalde
Schlossbetriebe GmbH
Schloss 1
09573 Augustusburg

Telephone
+49 3 72 91/38 00

E-Mail
augustusburg@
schloesserland-
sachsen.de

Internet
www.schloesserland-
sachsen.de

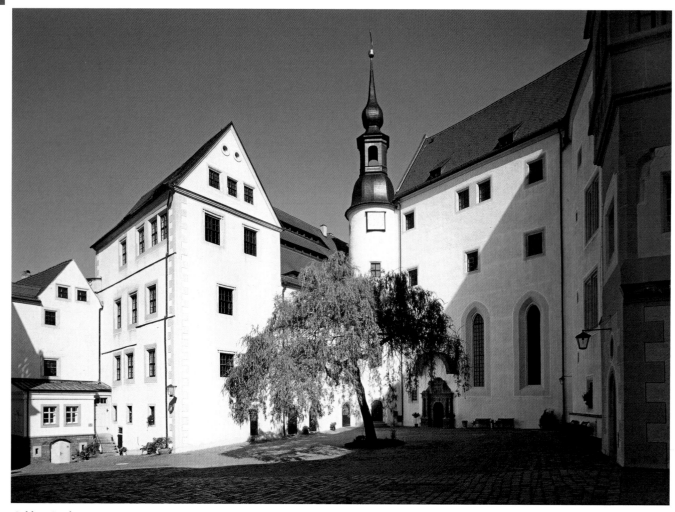

Colditz Castle

Colditz Castle

Kultur/Museum –
Gesellschaft Schloss
Colditz e.V.
Schlossgasse 1
04680 Colditz

Telephone
+49 3 43 81/4 37 77

E-Mail
colditz@
schloesserland-
sachsen.de

Internet
www.schloesserland-
sachsen.de

A ruling seat, hunting lodge, and widow's residence – with its white gables, Colditz Castle is one of the most beautiful and stylistically unadulterated architectural monuments of 16th-century central Germany. Yet when travelers from all corners of the world assemble along the grounds, it is not so much due to an interest in Renaissance architecture. The reason behind the crowd goes back to more recent history. During the Second World War, the sprawling castle was an important internment camp for high-ranking officers of the Western Allies, later becoming world-famous through the book, "The Colditz Story" as well as the film of the same name. British, Dutch, and French military personnel were mainly kept prisoner here, including the nephew of Winston Churchill and the nephew of the former king of England, George VI. The prisoners of the "Oflag (officer's camp) IVC" however, were only minimally impressed by the lovely atmosphere of the castle and wanted one thing above all else: to escape. Approximately 300 documented escape attempts, some of which display astounding creativity and include a number of successful efforts, are now legends of military history. Secret radio rooms maintained contact with home countries, tunnels forced their way through walls, and even a glider was built. To be sure, the "Escape Museum" thoroughly considers this aspect of the castle's history. Yet the old battlements with its powerful walls, the tower with the Welsh dome, and the old stone bridge impress visitors time and time again. Also located here are the Saxon State Music Academy and the Colditz Castle Youth Hostel.

Dresden Fortress

The remnants of Dresden Fortress, whose modest entrance is hidden between the Art Academy and the Albertinum, bear witness to a tumultuous history of courtly splendor, of feuds and crusades. Powerfully-immured walls around the over 400-year-old brick gate enclose the visitor, here, in his laboratory deep beneath the bastions (Jungfernbastei), where Johann Friedrich Bötter invented Europeann porcelain in 1707. Already militarily insignificant by this point, the fortress could not prevent the Prussians from pillaging the Saxon capital during the Seven Years' War. At one point, the Saxons displayed greater virtuosity in creating splendor than in managing their troops or choosing military allies.

Above the darkness of the defensive casemates lies Bruehl's Terrace, which was built at the orders of the influential court favorite Heinrich von Bruehl. Originally a defensive structure, this Dresden landmark was converted into an observation terrace. It is referred to as Europe's Balcony, for people from all corners of the world have met there ever since. The view of the Elbe and the white steamboats are essential components of every visit to Dresden. The Dolphin Fountains still recall the era of Imperial Count Bruehl – the Albertinum with the Gallery of the New Masters, the Art Academy of Saxony with its prominent dome, and the countless monuments and statues are already symbols of the pride and artistic sensibility of Dresden's citizenry.

Next page: Bruehl's Terrace, Dresden

Schlösser
und Gärten Dresden
Georg-Treu-Platz 1
01067 Dresden

Telephone
+49 3 51/4 38 37 03 20

E-Mail
festung.dresden@
schloesserland-
sachsen.de

Internet
www.schloesserland-
sachsen.de

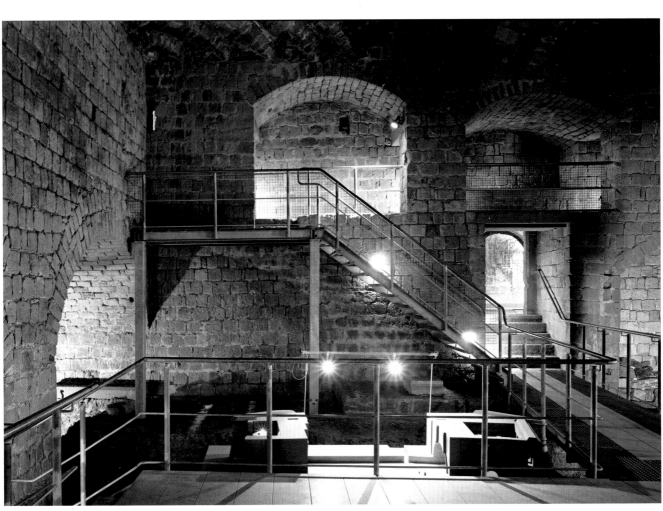

Interior view of Dresden Fortress

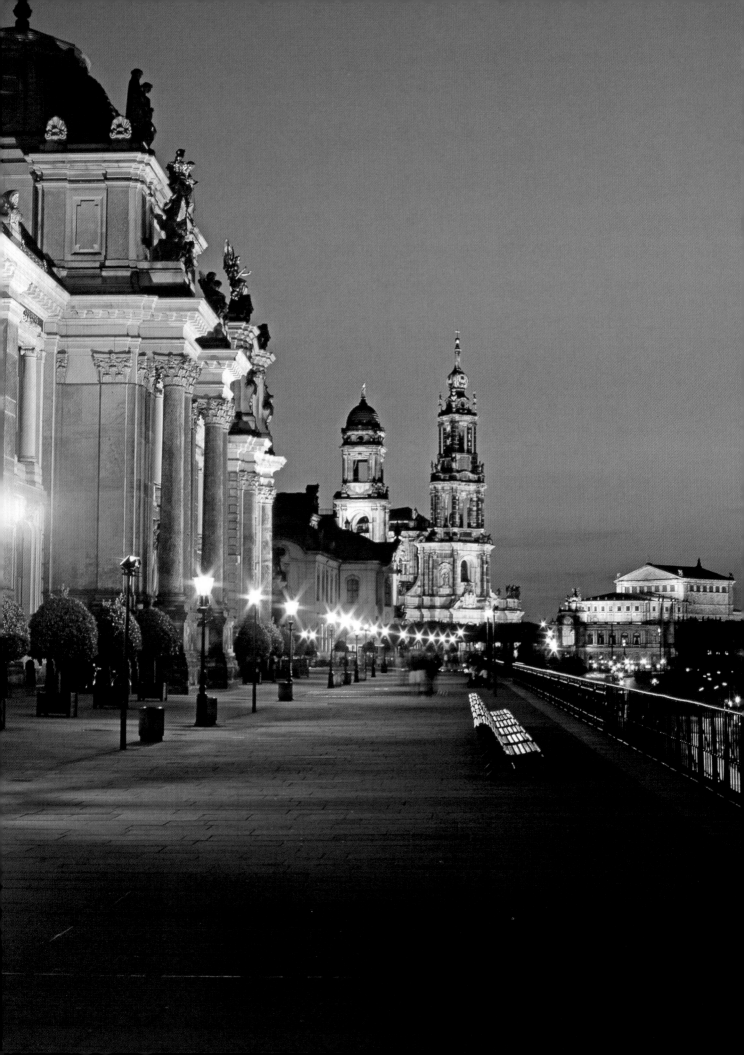

Grand Garden in Dresden

In its own right, the Saxon capital is a large landscape garden. Only a few major cities are so close to nature, in a vast green space made up of extensive gardens, grand parks and generous meadows for recreation and relaxation. The most impressive park within the green metropolis of Saxony is the 147-hectare space of the Grand Garden. It was begun by Prince Johann Georg III in 1678 with the construction of the French-styled, most popular park grounds in Dresden, with its arrow-straight avenues. The palace at the main intersection of avenues is a jewel of Early Baroque architecture. It continues to be used as a venue for festive events within a verdant setting. During the warm weather season, the open-air stages and the Puppet Theater of the Grand Garden are popular destinations. Additional attractions are the Botanical Garden and the Zoo, while the Volkswagen's "Glass Factory" production of luxury cars creates a modern accent at the edge of the park. To reach the distant landscape of attractions, visitors both young and old can take advantage of the Dresden Park Railroad, which is traditionally operated by Dresden schoolchildren.

Schlösser und Gärten Dresden Geschäftsstelle Großer Garten/Kavaliershaus G, Hauptallee 5 01219 Dresden

Telephone
+49 3 51/4 45 66 00

E-Mail
grosser.garten@ schloesserland-sachsen.de

Internet
www.schloesserland-sachsen.de

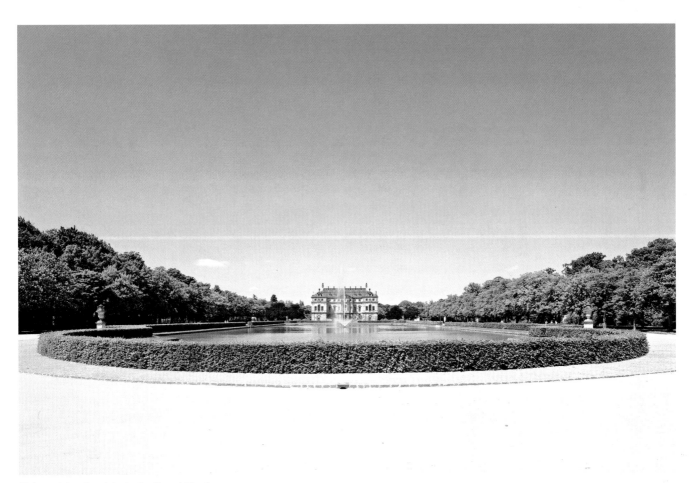

Palace with palace lake in the Grand Garden

Dresden Stable Courtyard

Schlösser und Gärten
Dresden
Geschäftsstelle Zwinger,
Brühlsche Terrasse,
Stallhof, Theaterplatz
01067 Dresden

Telephone
+49 3 51/4 38 37 03 12

E-Mail
stallhof@
schloesserland-
sachsen.de

Internet
www.schloesserland-
sachsen.de

In the middle of the city, between the palace and the Church of Our Lady, is a piece of rare Renaissance architectural culture: the stable courtyard, bordered by the former stables known as the "Kurfürstlich Reissiger Stall" and the colonnade ("Langer Gang") with its Tuscan columns. Behind it, the 102 meter-long Processsion of Princes ("Fürstenzug") commands attention. 25,000 tiles from the Meissener porcelain manufacturer immortalize the rulers of Saxony. The stable courtyard, which was originally built to hold tournaments and festivals for the court and nobility, now serves as a romantic backdrop for riding tournaments, theatrical performances, and the medieval Christmas market.

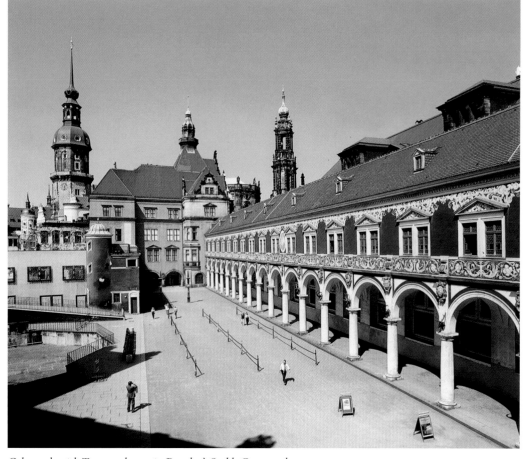

Colonnade with Tuscan columns in Dresden's Stable Courtyard

Dresden Zwinger

A Zwinger, or compound, is merely the free space between the outer and inner ring of the city walls. Yet in Dresden, the capital of Saxony, the splendid compound was created in the early 18th century for the magnificent festivities of the European nobility. Propelled by the architectonic zeal of August the Strong, the initially simple plans for a new orangery suddenly acquired breadth and height. The architectural genius Matthäus Daniel Pöppelmann and the sculptor Balthasar Permoser created an artistic entity for the court. While an adjoining palace was never brought to fruition, its place was filled by Gottfried Semper's picture gallery and opera house. Modern-day visitors to the Zwinger will find the State Art Collection of Dresden, which includes the Porcelain Collection and the Old Master Gallery of Paintings. During the summer, the Zwinger forms a resplendent backdrop for a series of open-air events, while the clandestine nymph baths with their light-hearted waterworks satisfies the visitor's need for quiet.

Nexpt page: Wallpavillon in Dresden Zwinger

Schlösser und Gärten Dresden Geschäftsstelle Zwinger, Brühlsche Terrasse, Stallhof, Theaterplatz 01067 Dresden

Telephone
+49 3 51/4 38 37 03 11

E-Mail
zwinger@
schloesserland-
sachsen.de

Internet
www.schloesserland-
sachsen.de

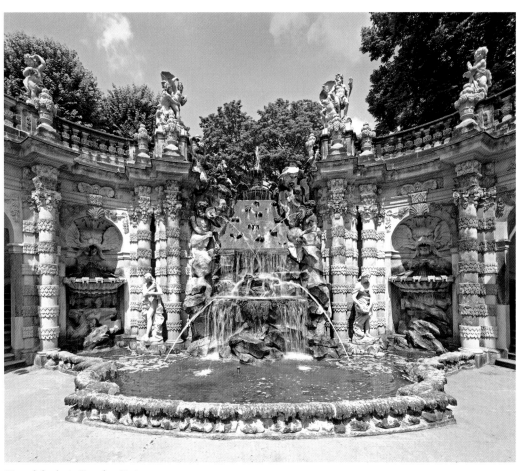

Nymph baths in Dresden Zwinger

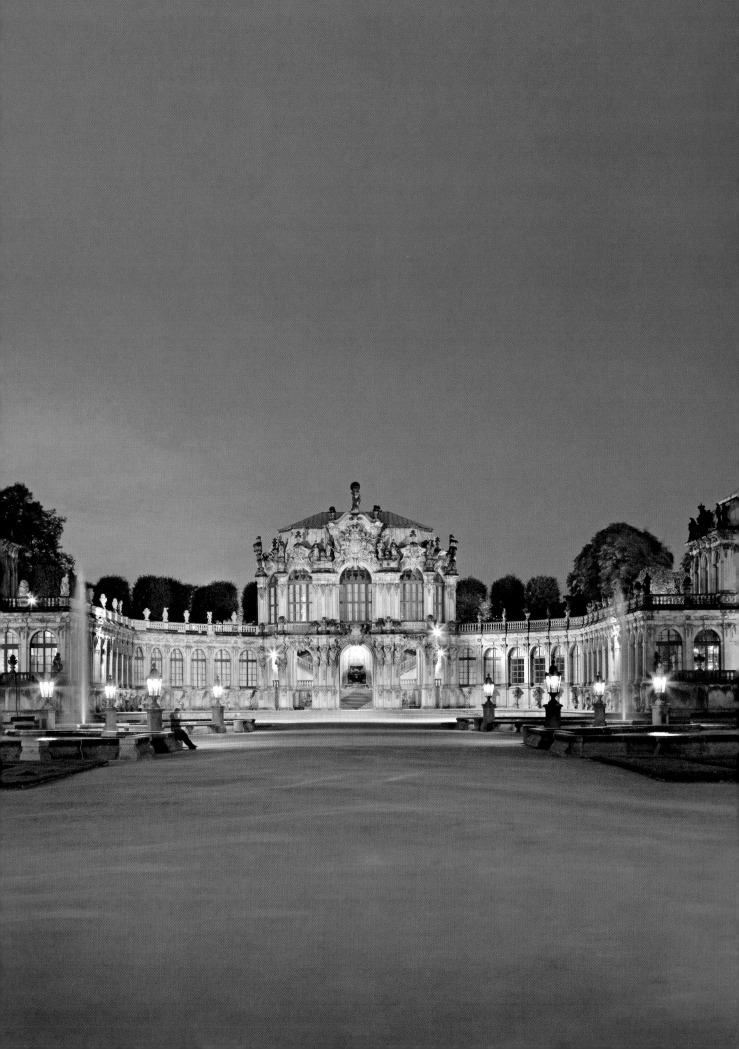

Gnandstein Castle

The most well-preserved Romanesque fortress in Saxony stands not far from the "Töpferstadt" (City of Pottery) of Kohren-Sahlis. The castle lords came from an old Meissen family of nobles, the family von Einsiedel. Given that "einsiedlerisch" signifies being closely connected to a place far away from the hustle and bustle of the world, the family was appropriately named, for they uninterruptedly lived in Gnandstein from the late 14th century until the end of the Second World War, without ever having lost possession of the castle key. This may explain why despite numerous renovations and expansions, the complex is one of the castles within Germany which evokes the spirit of a bygone age. The keep, compound, battlements, and defensive walls – the fortress high above the small Wyhra River is a dream come true for those interested in the Middle Ages. Upon ascending the keep, which was the final refuge for its citizens in wartime, or when visiting the Late Gothic chapel, it is possible to imagine oneself in that turbulent era, in which Saxony's well-being was in the hands of armor-clad warriors. In addition, an old legend exists that there is still a treasure awaiting discovery upon the castle grounds. Even without finding gold or precious gems, visitors depart Gnandstein Castle feeling richly spoiled, for an exhibition of the Gross Collection allows the visitor a view of approximately 400 valuable objects amassed over seven centuries.

Burg Gnandstein
Burgstraße 3
04655 Kohren-Sahlis

Telephone
+49 3 43 44/6 13 09

E-Mail
gnandstein@
schloesserland-
sachsen.de

Internet
www.schloesserland-
sachsen.de

 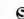

Gnandstein Castle

Gross-Sedlitz Baroque Garden

Barockgarten
Großsedlitz
Parkstraße 85
01809 Heidenau

Telephone
+49 35 29/5 63 90

E-Mail
grosssedlitz@
schloesserland-
sachsen.de

Internet
www.schloesserland-
sachsen.de

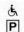

Gross-Sedlitz is among the most notable garden ensembles in Germany. Its extraordinary significance resides in the fact that its form reveals the imprint of a prominent Saxon ruler. After the imperial count of Wackerbarth had his residence for retirement built here in 1719, he sold it – albeit not quite by choice – to August the Strong. The new owner had the land completely restructured, with plans executed by his own hand. Nothing less than a Saxon Versailles was to be built here, but ultimately, Gross-Sedlitz was left unfinished – an acute shortage of funds at the traditionally extravagant court of Dresden led to the shattering of the creative fantasy. Still, even the twelve hectares which were ultimately completed are so magnificent that it is almost impossible to imagine how the park would have appeared with all 96 hectares completed. The sprawling terraced grounds are an gardening work of art with two orangeries, water features, and approximately 60 sculptures. A tour of the grounds continuously reveals new vistas, which even now, demonstrate their elegant planning. Particularly during the summer months, when exotic plants and orange trees fill the park with fragrance and color, visitors can envision the imaginative power of Gross-Sedlitz's high-born creator.

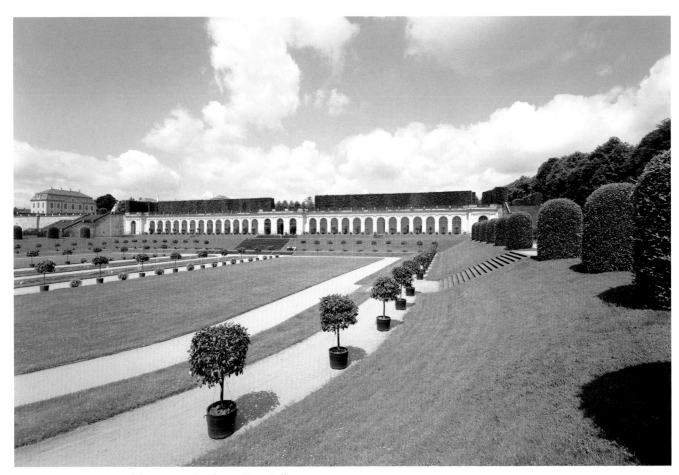

Lower orangery parterre of the Baroque Garden at Gross-Sedlitz

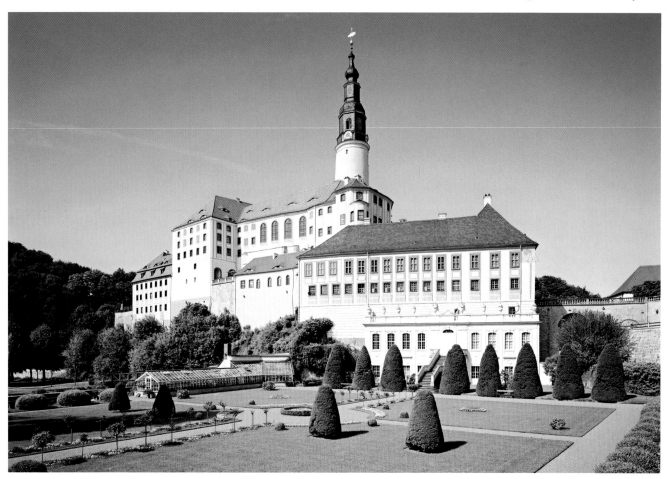

Weesenstein Castle with castle park

Weesenstein Castle

In the manner of a pearl, Weesenstein grew layer upon layer. The castle has towered above the Müglitz Valley for over 700 years. It underwent continuous renovation, was partially torn down, and altered to suit modern tastes, which explains why Gothic to Neoclassical stylistic elements are to be found here. In this way, a rarity among Saxon castles came into existence. Over centuries, it was expanded along the hill, occasionally overwhelming its inhabitants. It was here in his favorite residence that the sophisticated Prince Johann worked on his translation of Dante's Divine Comedy before becoming king of Saxony. Today, visitors can explore his rambling stairwell, stumbling across a horse stables on the fifth floor, while the 18th- and 19th-century noble chambers replete with sumptuous wall coverings are located one floor beneath the cellar. In the meantime, the stray ghost of a former palace inhabitant haunts "Monk's Way." Perhaps the illusionist painted façades prevent him from finding peace amidst all this chaos – in this strange castle, even the windows are often an illusion, for every third one is merely a painting. In sum, those who enjoy mazes and the unexpected shall inevitably discover a small adventure in the mysterious residence of King Johann. A respite from activity is provided by a subsequent walk in the palace park, a restaurant visit at "Königliche Schlossküche," or a mug of Weesenstein Schlossbräu, whose tradition dates back to the 16th century.

Schloss Weesenstein
Am Schlossberg 1
01809 Müglitztal

Telephone
+49 3 50 27/62 60

E-Mail
weesenstein@
schloesserland-
sachsen.de

Internet
www.schloesserland-
sachsen.de

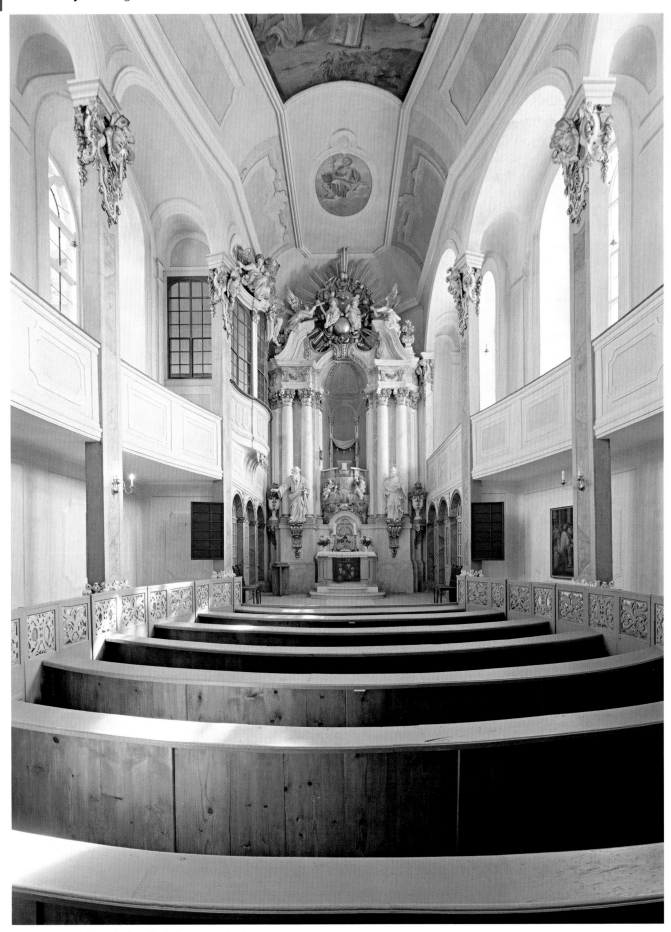

Interior view of the castle chapel at Weesenstein Castle

Kriebstein Castle

Raftsmen used to make the sign of the cross when they reached the steep cliff of the ochre-colored Kriebstein Castle. From this point, the Zschopau River was somewhat tame and the countryside was safe – at least during times of peace. The steepest road in Saxony now leads up to the protective, rugged granulite rock, upon which the Late Gothic jewel was built at its furthermost tip. Already unique is the 45-meter-high tower with its six dormer windows, which over 600 years ago, served as a residential seat for the castle's first owner, Dietrich von Beerwalde. It contains the completely painted Kriebstein Room from approximately 1423. Equally unparalleled are the illusionist wall paintings in the 15th-century treasury vault, the Marian scenes in the chapel of 1410, and of course, the Alexius Altar. In 1986, a treasure was discovered in the tower's chimney, whose jewels are now on display in the treasury vault. A diverse program of events provides cultural life on its steep rocks, such as a medieval festival, the "Castle of Fairy Tales," rock concerts, elegant chivalric banquets, and spine-tingling tours of the ancient walls.

Nexpt page: Kriebstein Castle

Burg Kriebstein
09648 Kriebstein

Telephone
+49 3 43 27/95 20

E-Mail
kriebstein@
schloesserland-
sachsen.de

Internet
www.schloesserland-
sachsen.de

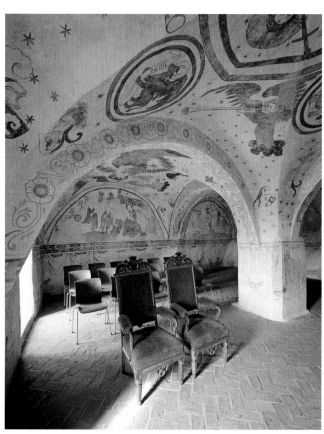

Chapel of Kriebstein Castle

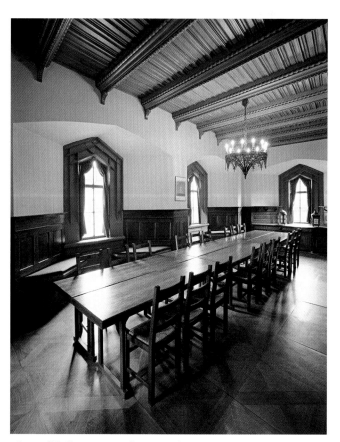

The small ballroom at Kriebstein Castle

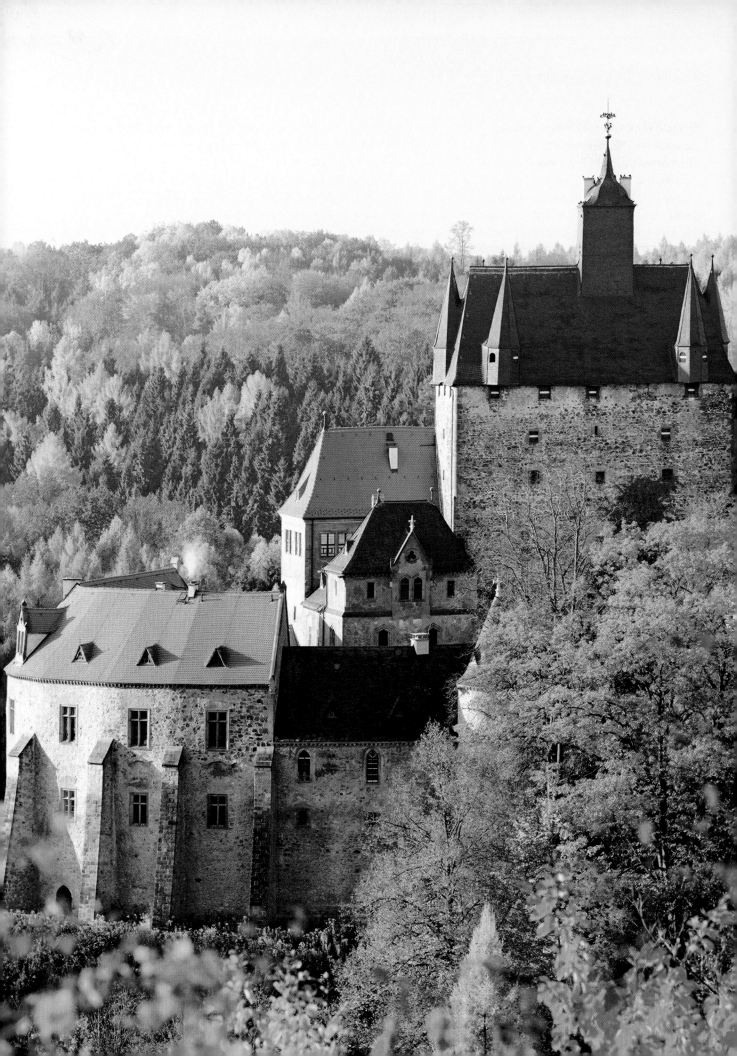

Lichtenwalde Castle and Park

Distinguishing Lichtenwalde from all other Saxon castles is its tremendous abundance of water features. 100 of them, with a total of over 400 individual streams of water, are distributed throughout the Baroque garden and connected by an intricate circulating system. Especially in the spring, visitors can experience a symphony of rustling leaves, splashing fountains, and the fragrance of flowers – it is not without reason that Lichtenwalde was chosen as one of Germany's most beautiful parks. Approaching the castle via the avenue, one is nearly rendered speechless by the sophisticated design of this verdant sphere of tranquility. The terraced park, which splendidly illustrates the transition from Baroque to Rococo, is never revealed in its entirety. Instead, one's gaze is permanently distracted by playful details, such as the ancient amphorae, statues, or circular flowerbeds, or beyond the man-made garden to the pristine nature of the Zschopau valley that is now a natural preserve. The castle itself houses numerous ethnological collections, which with themes such as "Encountering Cultures" are dedicated to the civilizations of Asia and Africa. Visitors should without fail pay a visit to the Silhouette Museum with its filigree, two-dimensional treasures, for it is one of the very few of its kind in Germany.

Schloss & Park
Lichtenwalde
Schlossallee 1
09577 Lichtenwalde

Telephone
+49 3 72 91/38 00

E-Mail
lichtenwalde@
schloesserland-
sachsen.de

Internet
www.schloesserland-
sachsen.de

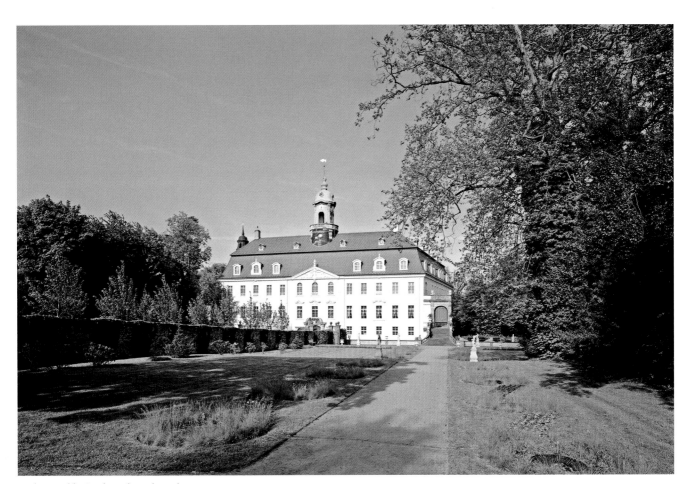

Lichtenwalde Castle with castle park

Mildenstein Castle

Burg Mildenstein
Burglehn 6
04703 Leisnig

Telephone
+49 3 43 21/6 25 60

E-Mail
mildenstein@
schloesserland-
sachsen.de

Internet
www.schloesserland-
sachsen.de

The powerful castle of Mildenstein ranks among the oldest in Saxony, its name documented as early as 1046. One after another, Salian kings held court here, to be followed by the Hohenstaufens under Emperor Barbarossa, who had the castle generously expanded, and thereafter by the Wettin margravial court. Under the margraves, Mildenstein became a court of law and a notorious prison. Even today, its instruments of torture and numerous door bolts behind meter-thick walls thrill those visitors who just moments before had been amused by the view of the 3.7-meter-high giant boot of Doebeln. Significant from an architectural-historical point of view are the wooden construction of the Gothic granary floor, the keep, the Romanesque castle chapel with its three-winged altar, and the medieval knight's halls. The sheer size of the castle grounds allow it to be used in multiple ways, with exhibitions and concerts held throughout the year. Delicacies that were once served to the electors in festively-lit halls are still served by stewards and pages on St. Martin's Day. Moreover, the rustic knight's halls can be used for private functions and those who intend to marry are welcome to rule the castle for one day. A permanent exhibition at the castle's front provides information about the nearly 1000-year-old history of this rocky symbol of power, vividly resurrecting the era in which the castle was a site of not always careful feudal jurisdiction.

Mildenstein Castle

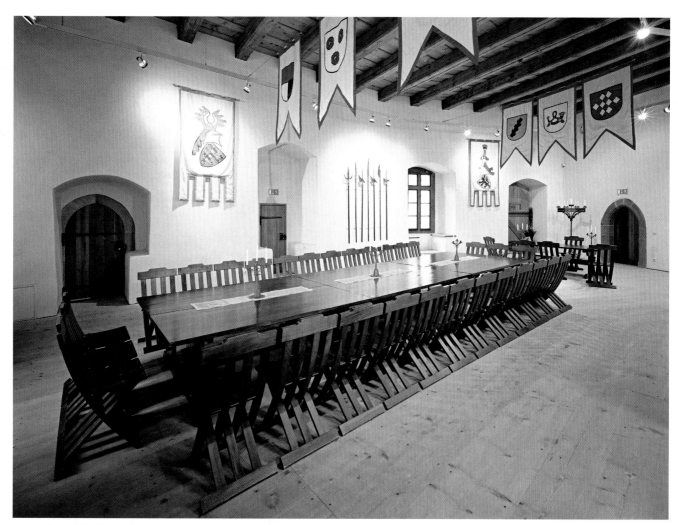

Large Knight's Hall at Mildenstein Castle

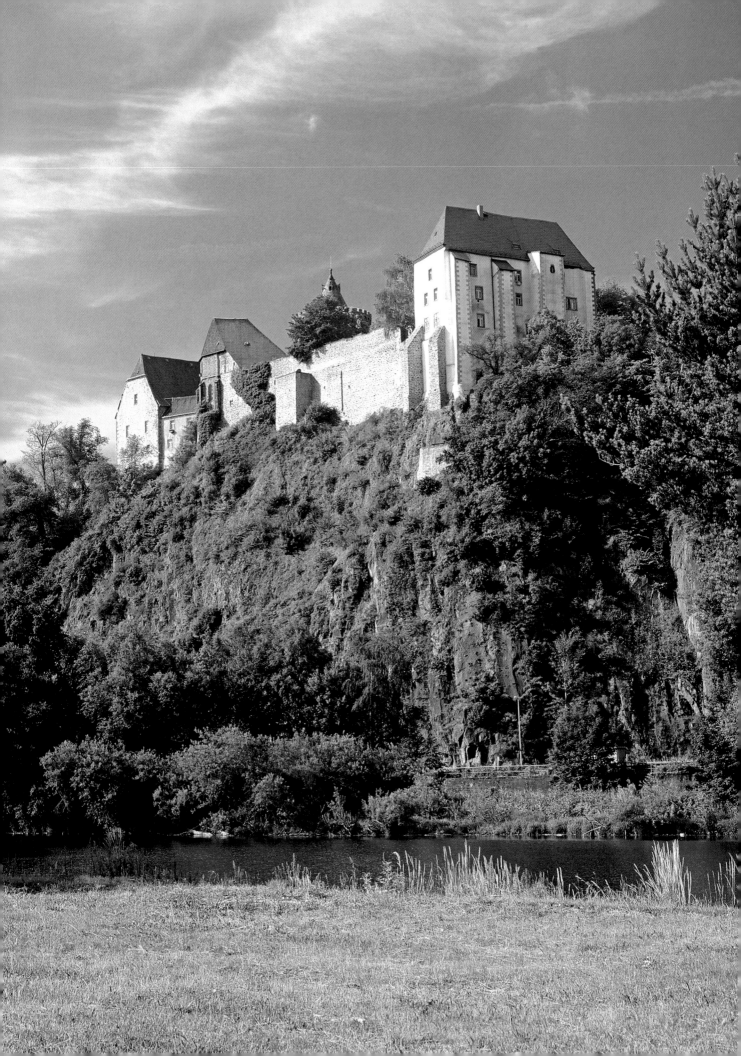

Albrechtsburg Castle

Albrechtsburg Meissen
Domplatz 1
01662 Meißen

Telephone
+49 35 21/4 70 70

E-Mail
albrechtsburg@
schloesserland-
sachsen.de

Internet
www.schloesserland-
sachsen.de

An old German verse asks, "Where is the hill where three castles soar and along which the waters of three rivers pour?" ("Wo ist der Berg, darauf drey Schlösser steh'n und nebenher drey Wässer gehen?"). The answer to the riddle is "Meissen," for here, where the castle hill is surrounded by the rivers of the Elbe, Triebisch, and Meisa, margraves, bishops, and burgraves once lived high above the city. The presence of this power within such a confined area clearly demonstrates the former significance of the "cradle of Saxony." With Albrechtsburg Castle, the first German palace and masterly piece of architecture was created, whose bold architectonic solutions and design concepts still impresses visitors today. High spires, bright façades, and expansive window surfaces reflect the waters of the Elbe and shape the panorama of the valley. Yet the tragedy of its history is that this precious jewel upon a high cliff remained virtually unused for centuries. The will of August the Strong breathed new life into the castle in 1710 with the first European porcelain manufacturer, and the "White Gold" which was produced by Meissen made its triumphant march throughout Europe. A exhibition over three floors recalls this stroke of Western inventive genius, and beneath richly-decorated arches behind magnificent arched windows, visitors shall discover a true picture book of Saxon history. The neighboring dome, a Gothic masterpiece, also encourages a visit, as does the still-intact ancient city of Meissen, with its red tiled roofs.

Böttger is presenting the arcanum to August the Strong

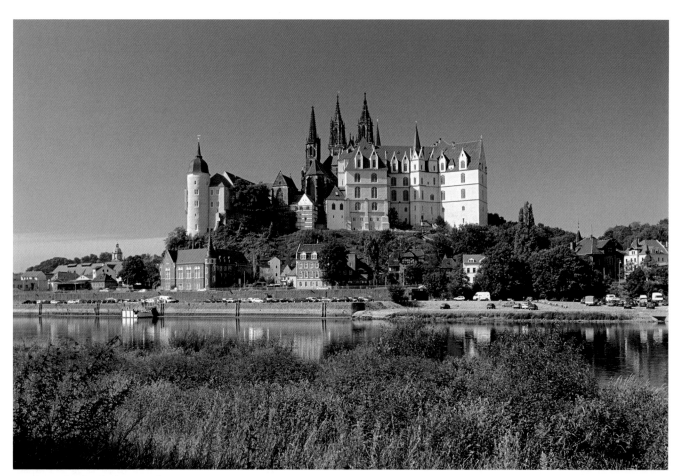

Meißen with Albrechtsburg Castle

Chf Augusto werden die Arcana
der Fabrik gezeiget. A 1710.

Pheasant Castle Moritzburg

Schloss Moritzburg und
Fasanenschlösschen
01468 Moritzburg

Telephone
+49 3 52 07/87 30

E-Mail
fasanenschloesschen@
schloesserland-
sachsen.de

Internet
www.schloesserland-
sachsen.de

 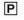

Because this jewel is simply too small for large crowds, only a few visitors are granted admittance. Thus, a tour through Pheasant Castle remains an exclusive pleasure, just as it was in earlier times. Situated east of the hunting lodge of Moritzburg, this magnificent castle was built in 1770 for the Dresden court and is the only remaining Late Rococo castle in Saxony. Owing to a generous donation by an anonymous benefactor, the castle was completely restored into all of its former glory and is now open to the public. Built upon a small floor plan in the Chinoiserie style that was highly modern at the time, the small palace contains a complete royal household in small format. Originally-restored furniture, stoves, and wall paintings, as well as a collection of stuffed birds attract attention in the interior. By taking a stroll along the park grounds, visitors can go back in time to the world of the 18th-century court. Especially picturesque and whimsical are the jetty and the red-white brick lighthouse nearby, which illustrate the spirit of the age. Here, the nobility of landlocked Saxony dreamed their dreams of glorious sea battles, which in the absence of a genuine fleet could be carried out with extras, a manageable number of vessels, and a certain amount of imagination. At the very least, Pheasant Castle offered its rulers a room with a real "sea view" – which even guests without royal blood may access as well.

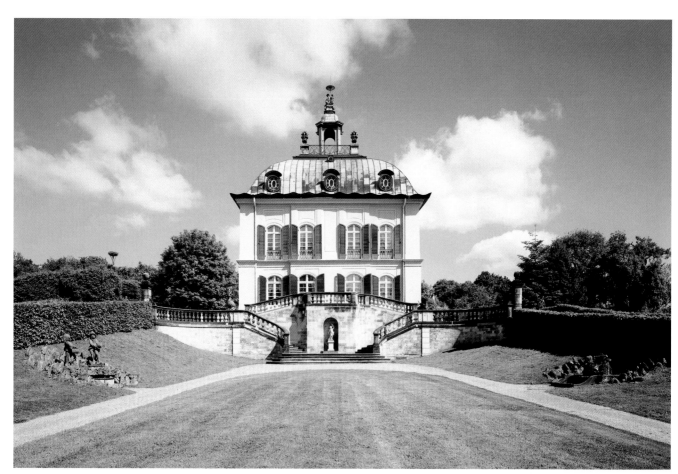

Pheasant Castle Moritzburg

Moritzburg Castle

Named after Duke Moritz, who had a hunting lodge built in 1542 near his residence in Dresden, Moritzburg is probably the most splendid moated castle in Saxony. Beginning in 1723, Elector August the Strong hired Matthäus Daniel Pöppelmann – known as the architect of the Zwinger in Dresden – to convert the castle into an approriate and magnificent setting for his lively parties. In the middle of a sprawling lake and park complex, an ochre and white, four-towered jewel came into existence, whose splendor was reflected in the man-made lake. It was not surprising that the castle was used as a backdrop for the movie, "Three Wishes for Cinderella." One of the most outstanding collections of hunting trophies is just one of the treasures of the castle. The "Feather Room" was awarded with the "European Prize for Cultural Preservation" – more than a million colored bird feathers were combined to make a unique work of art: the magnificent bed of August the Strong. Just as impressive are the painted gold leather wall coverings upon the walls of the electoral refuge. The visitor to Moritzburg should not pass up a side trip to Pheasant Palace, which can be reached in a few minutes on foot or by horse-drawn carriage. Even today, Moritzburg has lost little of its cultural significance, as evidenced by the annual "Moritzburg Festival" for chamber music and the autumnal "Stallions' Parade" in the former royal stud farm beyond the castle gates.

Next page: Grand Room in Moritzburg Castle

Schloss Moritzburg und Fasanenschlösschen
01468 Moritzburg

Telephone
+49 3 52 07/87 30

E-Mail
moritzburg@
schloesserland-
sachsen.de

Internet
www.schloesserland-
sachsen.de

 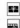

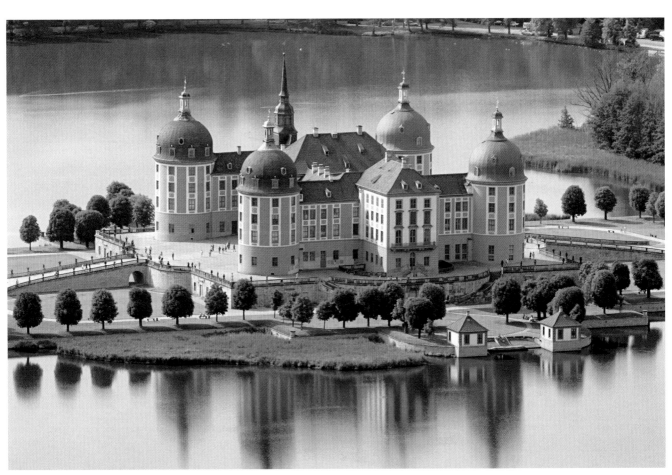

Moritzburg Castle

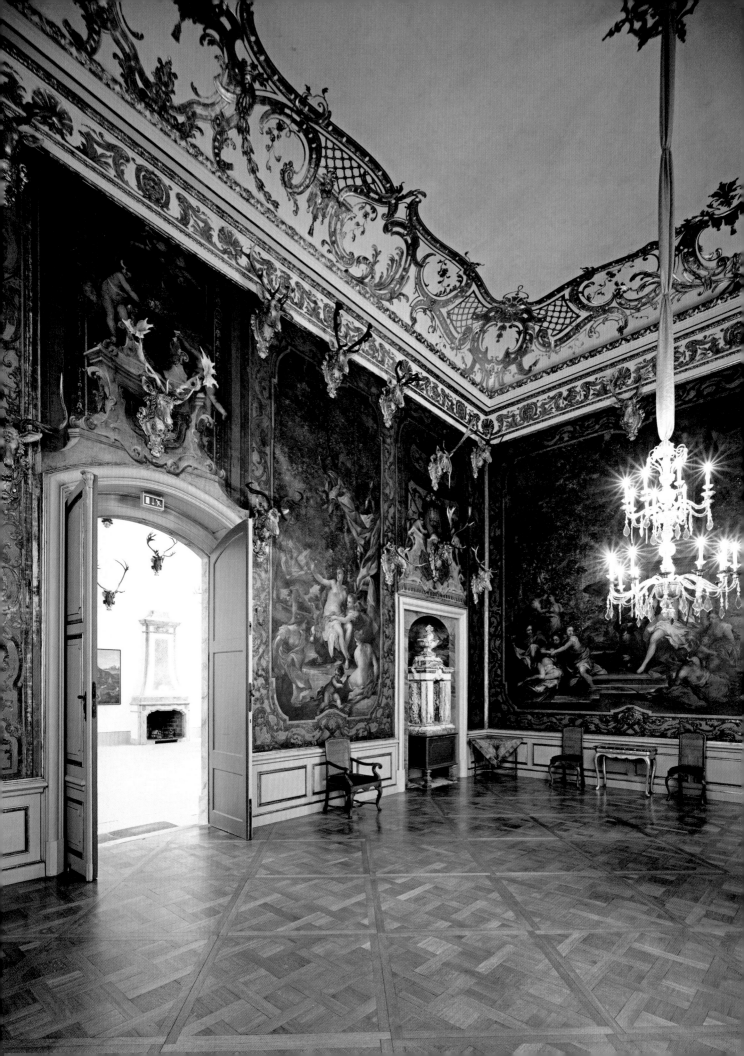

Nossen Castle

Particularly delightful buildings are created by changing fates, as is especially the case for Nossen Castle. The ancestral building of a knight's castle was first mentioned in 1185 in a legal dispute by its owners, the lords of Nuzzin. Beginning in 1554, Elector August rebuilt the old walls into a Renaissance hunting lodge, giving the formerly dark fortress a certain degree of ease. Even now, it conveys the spirit of cultural awakening in that era of European history. Former prison cells and authentic replicas of medieval instruments of torture testify to the dark side of this place, where harsh court sentences were handed down for many years. In addition, Countess Co-esl, the famous mistress of the pleasure-loving ruler of Saxon, August the Strong, is a part of the history of Nossen Castle. In 1716, the gravely-ill mistress was tended to for thirty days before being brought to Stolpen Castle, where she was to die in solitude 49 years later. Today, Nossen Castle houses a unique historic library with 6,000 volumes, whose leather-bound treasures attract scholars from afar. In the exhibition rooms, visitors who are interested in the history of the Saxon nobility may embark upon a fascinating journey through the chronicles of the blue-blooded house, who ruled between Vogtland and Lusatia for many centuries.

Schloss Nossen
Am Schloss 3
01683 Nossen

Telephone
+49 3 52 42/5 04 30

E-Mail
nossen@
schloesserland-
sachsen.de

Internet
www.schloesserland-
sachsen.de

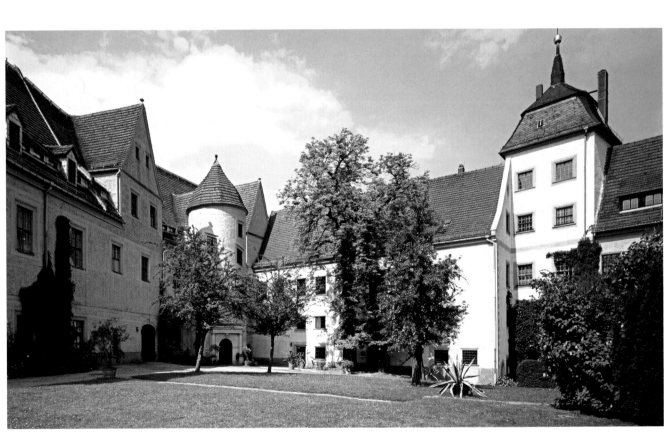

Nossen Castle

Pillnitz Castle and Park

Schlösser
und Gärten Dresden
Geschäftsstelle
Schloss & Park Pillnitz
August-Böckstiegel-
Straße 2
01326 Dresden

Telephone
+49 3 51/2 61 32 60

E-Mail
pillnitz@
schloesserland-
sachsen.de

Internet
www.schloesserland-
sachsen.de

Elector August the Strong, ruler with his over-dimensional appetite for women, originally acquired this castle for his favorite, Anna Constantia of Cosel, who immediately began with its Baroque transformation. As Saxony's most famous mistress fell out of favor "for various reasons," August himself had the hillside and waterside palaces built using sketches by the Baroque architect, Matthäus Daniel Pöppelmann. The grandiose palace and park grounds, which lie directly at the banks of the Elbe River, are considered a classic example of the Chinoiserie style, merging the architecture of the Far East with that of the Baroque. The best way to approach the pleasure palace with its striking pagoda roofs is by Elbe steamboat, for the former inhabitants of this castle also frequently traveled by water and enjoyed riding along the Elbe with creatively-designed gondolas. The English, Dutch, and Chinese gardens encourage visitors to take a leisurely stroll along the expansive grounds, while the orangery and the newly-restored Palm Greenhouse invite plant enthusiasts to appraise their exotic treasures, such as the famous 250-year-old Japanese camelia. This notable tree is so valuable that it has its own home. In the castle itself, the Craft Museum is open to visitors in the springtime. The Castle Museum features a permanent exhibition detailing the turbulent history of the former Saxon summer residence, which never wished to be anything more than a highly noble "pleasure castle," far removed from the adversites of everyday political life in the royal city of Dresden.

Detailed view of Waterside Palace,
Pillnitz Castle and Park

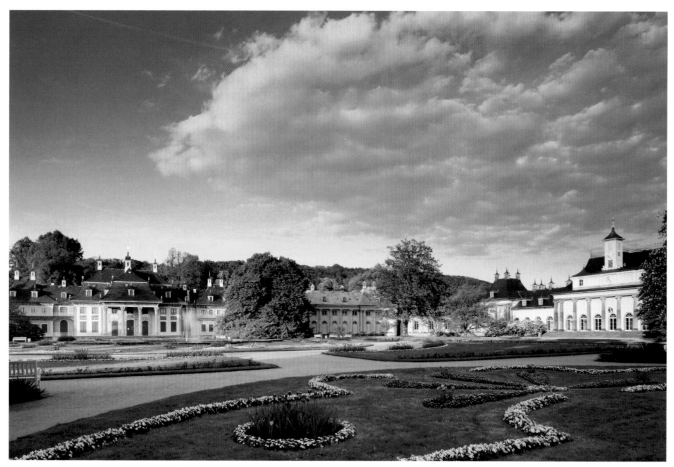

Pleasure Garden, Hill Palace, and New Palace, Pillnitz Castle and Park

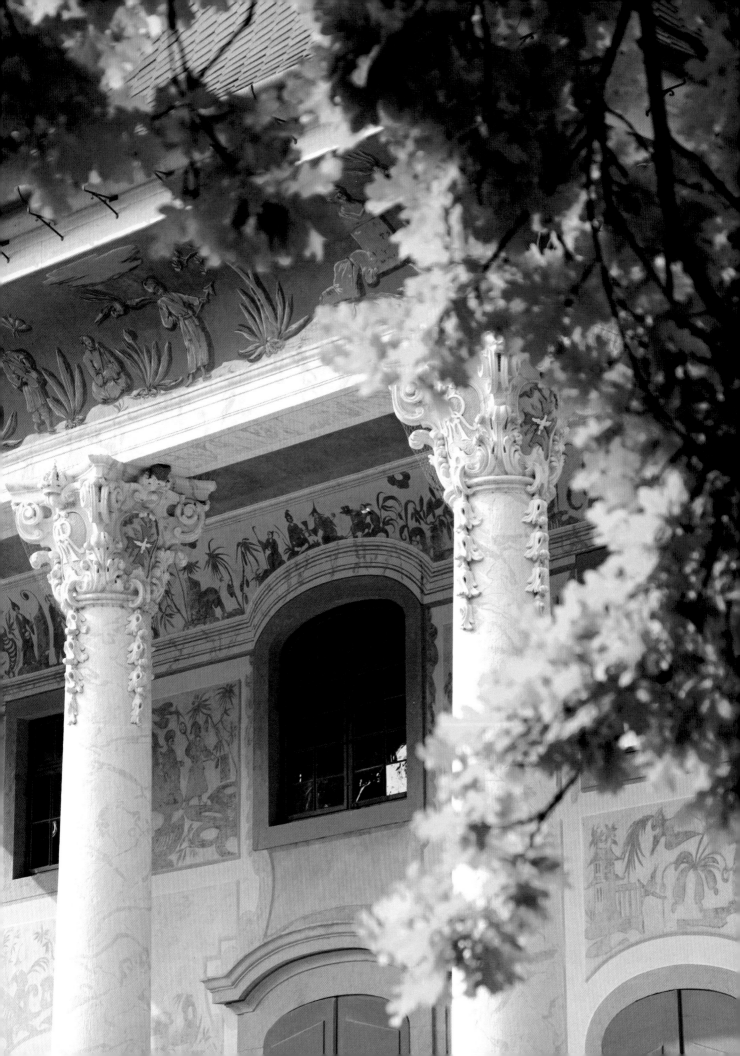

Rammenau Castle

Barockschloss
Rammenau
Am Schloss 4
01877 Rammenau

Telephone
+49 35 94/70 35 59

E-Mail
rammenau@
schloesserland-
sachsen.de

Internet
www.schloesserland-
sachsen.de

Located at the base of the Lusatian mountains is the only completely preserved manor complex in Saxony. Completely restored, Rammenau Castle shines as a masterpiece of Saxon rural Baroque. After the construction of the mansion had financially ruined its first owner, the von Hoffmann family acquired the grand estate by auction. Their most famous scion was Johann Centurius von Hoffmann, Imperial Count von Hoffmannsegg, botanist, and highly-respected entomologist – a stroke of luck for science in Saxony, for the new inhabitant of the castle gave a new home to intellectual creativity and education in Rammenau. The castle's interior is a varied treasure trove of Late Baroque and Neoclassical room decoration. The Chinese and Pompeiian Rooms, Bird Room, Peacock Room, Hunting Room, and the stair-well with its wall paintings demonstate the spirit of the educated country nobleman. In the imposing Mirror Room, music can still be heard on a regular basis. Perhaps the special genius – which can be felt in every corner of the castle – provided the crucial impetus to its oldest son, for Johann Gottlieb Fichte, one of the leading philosophers of his time, was born in Rammenau in 1762. Diversity and aesthetic depth are not only to be found in the interior, but also in a culinary sense. In the castle's historic dining rooms, the kitchen chef and the chambermaids serve extraordinary dishes that expertly combine Lusatian steadfastness and Mediterran freshness.

Hall of Mirrors at Rammenau Castle

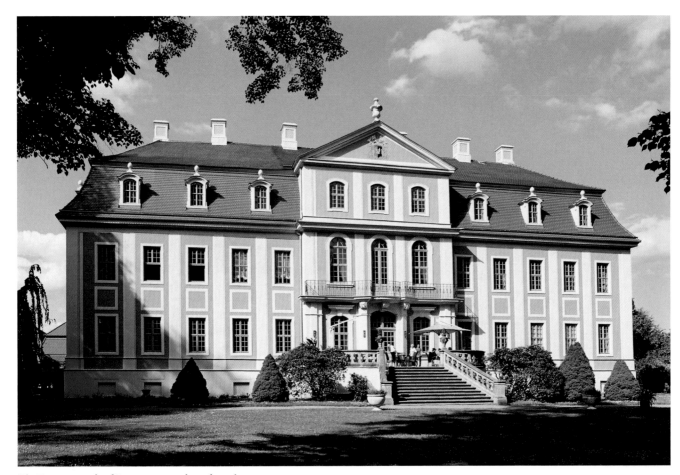

The Baroque castle of Rammenau with castle park

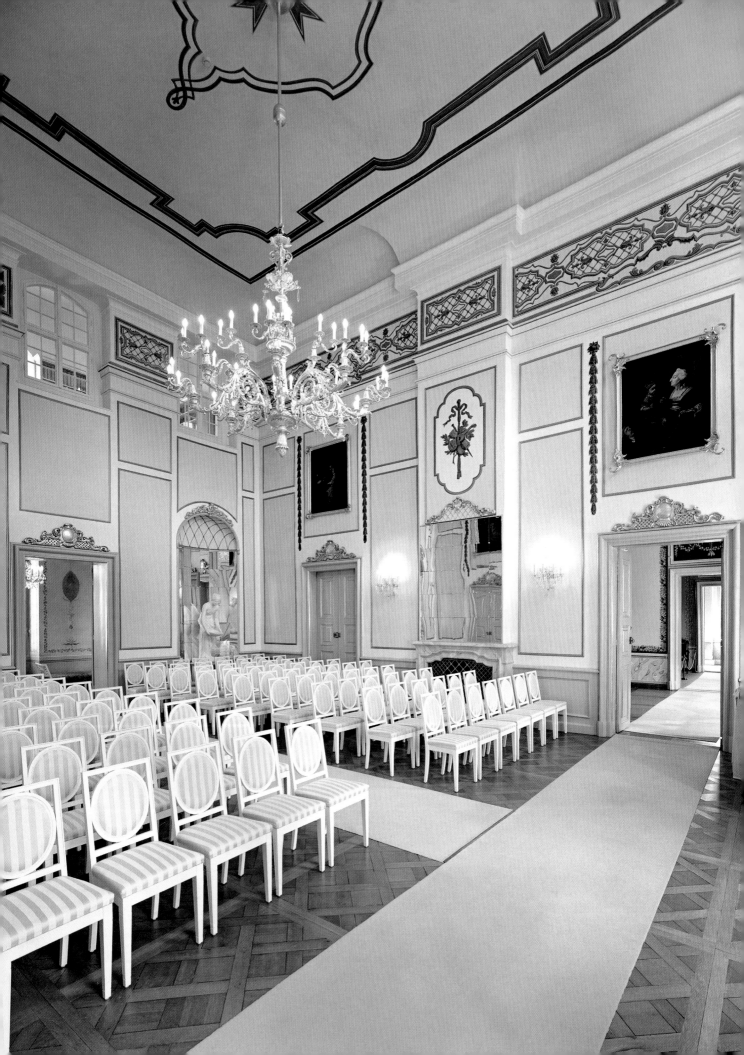

Rochlitz Castle

Rochlitz Castle

Schloss Rochlitz
Sörnziger Weg 1
09306 Rochlitz

Telephone
+49 37 37/49 23 10

E-Mail
rochlitz@
schloesserland-
sachsen.de

Internet
www.schloesserland-
sachsen.de

In the 10th century, this fortress served to retain the hard-won victory over the West Slavs. Today, more than a milennium later, the Rochlitz towers of "Light Jupe" and "Dark Jupe" still tower above the Zwickauer Mulde, making the castle appear like a fortified cathedral. Those who allow themselves to be drawn into this place shall experience something of its turbulent history which accompanied the German eastward expansion during the High Middle Ages. Later, emperors, kings, and electors maintained their courts here. War and sieges were also equally a part of its history – the powerful walls still bear scars from the Thirty Years' War. Yet the history of Rochlitz Castle has a lighter side as well. Dedo von Groitzsch had the inpenetrable forests cleared and encouraged the settlement of the land around Rochlitz, Margrave Wilhelm the One-Eyed and later, Electors Ernst and Albrecht had the sturdy castle converted into a residential palace. Duchess Elisabeth of Saxony devoted herself to the introduction of the Reformation and attempted to mediate between the two sides of the Schmalkaldic War (1546–1547). Each generation of castle rulers made its imprint upon Rochlitz, and there are many jewels to be discovered within its interior. Gothic windows, filigree ribbed vaults, dungeons, the large court kitchen, and the torture chamber cast a spell over everyone who enjoys being transported back to a bygone era. A special attraction of the castle is the exhibition, "Living Processions of Princes," which with its splendid costumes, brings the protagonists of the famous Dresden wall paintings to life.

Scharfenstein Castle

For centuries, the Ore Mountains lived from its namesake, with the silver mines above all else transforming this picturesque mountain range into a prosperous region. Yet as the miners brought less and less white ore from the tunnels, the people who lived there were forced to seek out other sources of income. Thus what had formerly been a diversion on long winter nights became a way to earn a living: the manufacture of wooden toys and Christmas decorations. Today, the fruits of this rich artisan tradition can be viewed at Scharfenstein Castle, for with its Martin Collection, the nearly 800-year-old castle possesses a unique treasure of folk art and toys from the entire mountain region. Scharfenstein is considered the "Castle for Families and Fun" within Saxony, for here it is possible to experience and to be astounded, to play and to discover, to experiment and to participate to the fullest. Fairytale weekends, sculpting, painting, and carving workshops for children are also a part of the offerings for young visitors. Yet adults can also be entertained by the exhibitions about folk art traditions, the history of the castle, and the "Robin Hood of Ore Mountain," Karl Stülpner, as well as learn about the cultural region of West Saxony. Those who wish to experience the carved wooden animal, the Räuchermann (an incense-burning figure), the Schwibbogen (candle arch), and the Christmas pyramid as closely as possible should make a hasty retreat to Castle Scharfenstein!

Burg Scharfenstein
Schlossberg 1
09435 Scharfenstein

Telephone
+49 37 25/7 07 20

E-Mail
scharfenstein@
schloesserland-
sachsen.de

Internet
www.schloesserland-
sachsen.de

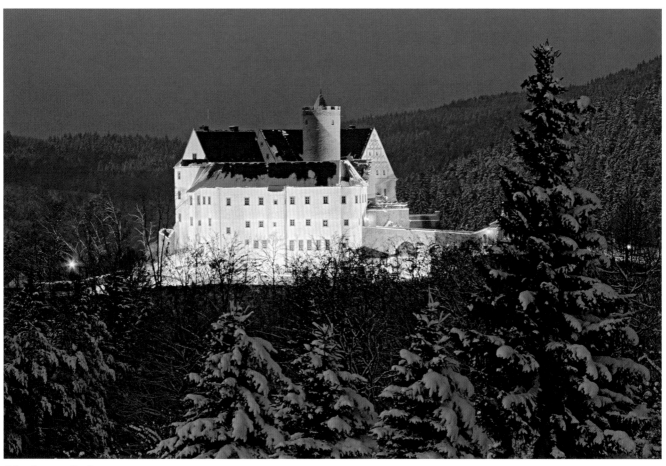

Scharfenstein Castle

Stolpen Castle

Burg Stolpen
Schlossstraße 10
01833 Stolpen

Telephone
+49 3 59 73/2 34 10

E-Mail
stolpen@
schloesserland-
sachsen.de

Internet
www.schloesserland-
sachsen.de

A fortress "of ruined wood" is said to have already been standing here in 1100, where Stolpen Castle now is on display. The castle was first mentioned as secured in 1222. The following eight hundred years were full of light and even more shadow, for Stolpen suffered repeatedly over the course of European feudal storms. The Hussites, Swedes, Prussians, and the French left their scars upon the fortress, as did pestilence and fire. The castle did not achieve true fame through the forces of war and catastrophe, but rather through the intrigue at the Saxon court, to which Stolpen owes its most famous and long-term resident. For nearly half a century, until her death in 1765, Imperial Countess of Cosel, Anna Constantia, was forced to endure exile behind the walls of the castle. The lively, beautiful, and clever woman, the long-time mistress of August the Strong and the mother of their three children, had made enemies at the court of Dresden through her apparent involvement in political affairs, ultimately becoming a victim of political opportunity of her princely bedfellow. Just as hard as her fate was the stone upon which the castle is built. Basalt, which gives the fortress a base practically carved from nature, was first scientifically described in Stolpen, and explains why the characterstic stone of the castle mountain as well as the deepest, unbuilt basalt fountains in the world has achieved the status of a national geotope.

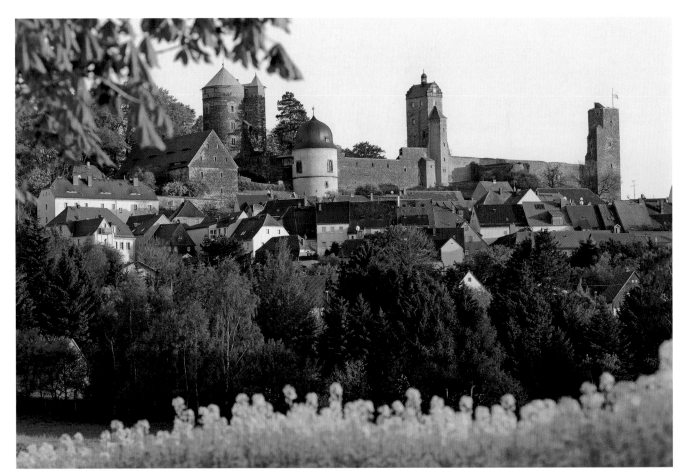

Stolpen Castle

Saxony-Anhalt

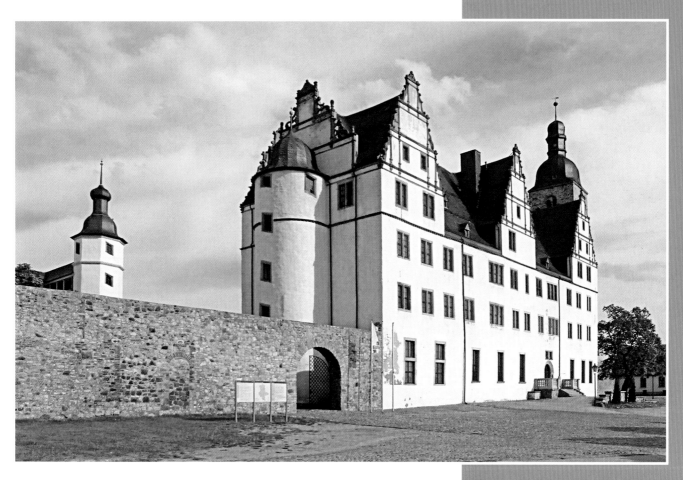

Stiftung Dome und Schlösser
in Sachsen-Anhalt

Stiftung
Kloster Michaelstein

Musikakademie Sachsen-Anhalt
für Bildung und Aufführungspraxis

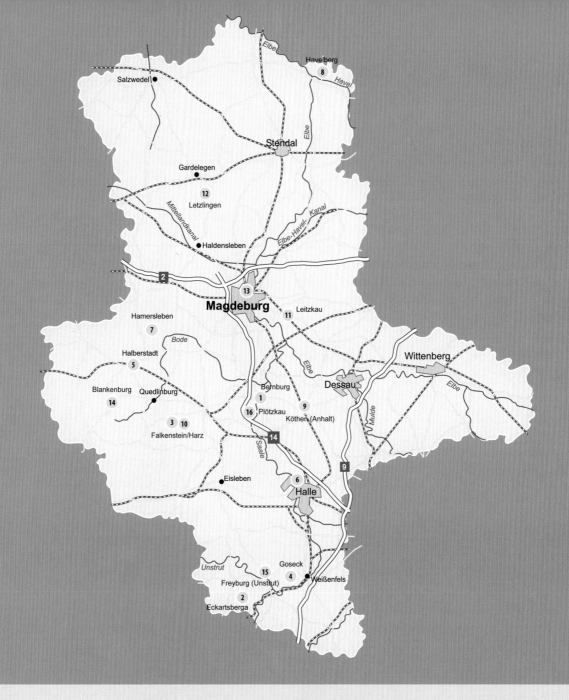

Schoolchildren take part in a museum project at Falkenstein Castle

Stiftung Dome und Schlösser in Sachsen-Anhalt

Saxony-Anhalt boasts an extraordinarily rich and manifold stock of listed buildings from Germany's varied architectural history. In many places, these stone witnesses of the past – castles and stately homes, as well as churches, cathedrals and abbeys – offer us insights into history.

In 1996, the State of Saxony-Anhalt created a public foundation to manage the castles and palaces in its possession which were significant in terms of regional history or the history of architecture and art. It was charged with managing and maintaining the sites, conducting scientific research and providing public access. The same aims were invoked in establishing a public foundation for the state's major religious buildings. In 2005 the two merged into the Stiftung Dome und Schlösser in Sachsen-Anhalt, with its seat in the Renaissance palace at Leitzkau. The new Foundation is responsible for the Schlösser (palaces) of Leitzkau, Köthen, Bernburg and Plötzkau, the hunting lodge at Letzlingen, the palaces of Neuenburg and Goseck as well as the castles Eckartsburg, Konradsburg and Burg Falkenstein. It also manages the cathedrals at Magdeburg, Havelberg, Halberstadt and Halle as well as the Stiftskirche (collegiate church) in Hamersleben, with the Church retaining its rights of usage and investiture. The Stiftung also holds the Halberstadt cathedral plate, and is responsible for its conservation. This responsibility extends to the state-owned art and cultural treasures stored at Schloss Wernigerode. This has permitted a number of special exhibitions and enriched the permanent exhibitions in the Foundation's museums. Another important task is the administration of Stiftung Kloster Michaelstein, the musical academy of Saxony-Anhalt, which is dedicated to education and performance.

The primary focus of the Stiftung Dome und Schlösser in Sachsen-Anhalt is the preservation of the cultural heritage placed within its trust. This encompasses both thorough, sustainable refurbishment and restoration of listed buildings and valuable artworks, and the use and presentation of these assets in a manner concomitant with their preservation requirements. Most of the palaces and castles also incorporate museums, which are either run by the Foundation itself or by other institutions. Active congregations and cultural events help to maintain the houses of worship. The preservation and teaching of our musical heritage brings Kloster Michaelstein to life.

The Stiftung's castles and palaces, cathedrals, churches and abbeys look forward to your visit. Follow the celebrated tourist trail "Strasse der Romanik" (Romanesque Road) through the architecture of the High Middle Ages, experience the shining highlights of Gothic style, discover treasures of the Renaissance and enjoy the arts in unique historical surroundings.

The Foundation can be contacted by phone on +49 (0) 3 92 41/93 40, by e-mail at leitzkau@domeschloesser.de or via the Web at www.dome-schloesser.de

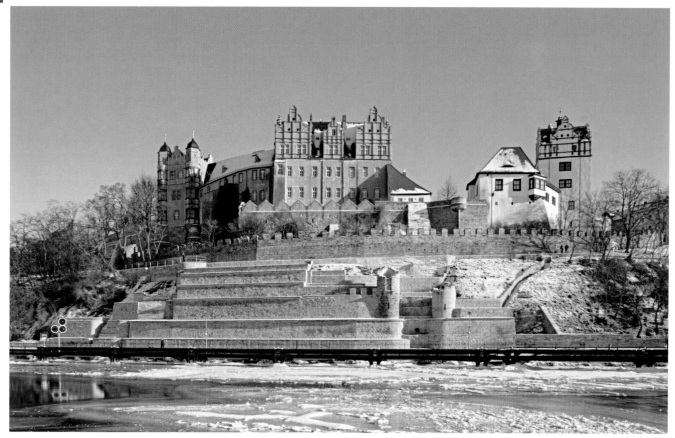

Schloss Bernburg, with the Wolfgang Wing and its "lanterns" on the left

Schloss Bernburg

Schloss Bernburg
Schlossstraße 24
06406 Bernburg

Museum
Schloss Bernburg

Telephone
+49 34 71/62 50 07

Internet
www.museum
schlossbernburg.de

www.dome-
schloesser.de

Wilhelm of Kügelgen waxed lyrical about the "Crown of Anhalt", enthroned high above the Saale valley. Its predecessor, the "Berneburch" had been stormed and burned to the ground in 1138. Not long after, Albert the Bear had his mother's dowager residence rebuilt. The imposing guard tower, or "Eulenspiegel's Tower", bears testament to its Romanesque defences. Parts of the former castle chapel also remain. Further essentially medieval buildings are the "Altes Haus" (Old House), "Krummes Haus" (Bent House) and "Blauer Turm" (Blue Tower) with their Gothic forms.

In the 16th century the castle was redeveloped into one of central Germany's most splendid Renaissance palaces. In 1538 Prince Wolfgang of Anhalt, a friend of Martin Luther and supporter of the Reformation, commissioned Andreas Günther for the task. The two round oriels known as "lanterns" on the western side of the Wolfgang Wing were a landmark visible from afar. Especially no-

table are the bas-reliefs of Protestant noblemen and Emperor Karl V. Joachim Ernst of Anhalt, Wolfgang's successor, had the building extended from 1567 to 1570. The work was entrusted to Nickel Hoffmann, who like Andreas Günther was one of the leading master builders in central Germany at the time.

Between 1603 and 1765 the palace was the residence of the Princes of Anhalt-Bernburg, who continued the modifications into the 18th century. However, they later preferred Ballenstedt as their permanent residence. Following the extinction of the Anhalt-Bernburg line, all Anhalt lands were united in 1863 and the palace became the property of the state.

Today a number of cultural institutions are open for visitors. Many interesting things about the Anhalt-Bernburg residence and the history of the town can be discovered in the Schloss Bernburg museum. The German Cabaret Archives run changing exhibitions on issues of political satire.

Eckartsburg

The ruins of the Eckartsburg are located on a spur forming part of the Finne Ridge above the town of Eckartsberga. The fortress was erected by Thuringian landgraves of the Ludovingian dynasty, Ludwig III and especially Hermann I, who was at the same time extending Neuenburg Castle. No trace has yet been found of a building with the same name, thought to have been founded as early as 998 by Margrave Ekkehard I of Meissen and documented in 1066. The castle changed ownership several times in the following centuries. When the last Ludovingian ruler died, Henry the Illustrious of the House of Wettin succeeded in conquering the Eckartsburg. His son, Albert the Degenerate, chose it as his favourite residence. From 1457 to 1462 Duke William III banished his wife Anna of Austria to the fortress.

From the early 16th century onwards, the Eckartsburg increasingly lost its protective function.

Initially serving as the residence of district officials, later even as a grain store and a prison, it was only scantily maintained. On 14 October 1806 the castle was the scene of military conflict once more. When in 1815 the Saxon Electorate's district of Eckartsberga and with it the castle ruins fell to Prussia, interest was rekindled by the nascent Romantic movement. Johann Wolfgang von Goethe himself was captivated by it, apparently composing the "Ballad of Faithful Eckart" outside its walls. For more than 150 years the Eckartsburg has been a popular destination for excursions. A restaurant featuring a "Great Hall" tempts diners. The keep contains a diorama of the twin battles of Jena and Auerstedt. A multifunctional new building was erected in 1998 over the ruins of the former nucleus, offering a variety of thrilling opportunities to experience history and culture.

Eckartsburg
Burgstraße
06648 Eckartsberga

Telephone
+49 3 44 67/2 04 15

E-Mail
eckartsburg@t-online.de

Internet
www.eckartsburg.de

www.dome-schloesser.de

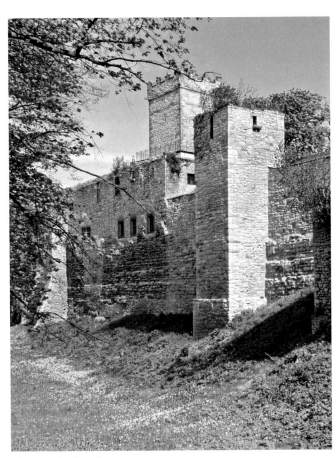

The ruined Eckartsburg

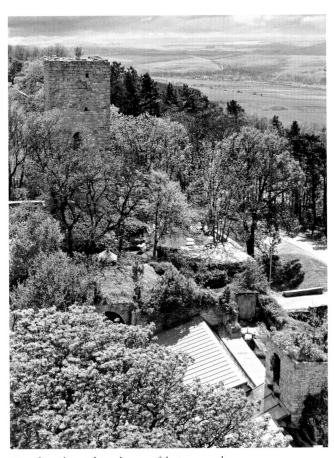

View from the residential tower of the inner castle

Falkenstein Castle in the Harz

Stiftung Dome
und Schlösser in
Sachsen-Anhalt
Museum
Burg Falkenstein
OT Pansfelde
06543 Falkenstein/Harz

Telephone
+49 3 47 43/53 55 90

E-Mail
falkenstein@
dome-schloesser.de

Internet
www.burg-
falkenstein.de

www.dome-
schloesser.de

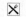 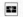 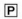

From a craggy spur above the River Selke rises one of the most beautiful and well preserved castles in the Harz Mountains. The Falkensteins were first mentioned in 1120. The dynasty's most famous member is probably Graf Hoyer II. The Count sponsored the legal scholar Eike of Repgow. There is a legend told that Eike compiled his famous legal code, the "Sachsenspiegel", at this castle. In 1334 the dynasty died out, and their possessions fell to the Bishops of Halberstadt. They in turn passed them to the Lords of the Asseburg, who – as Counts of Asseburg-Falkenstein from 1840 – remained the castle's owners until 1945.

The layout of the original 12th century complex is still recognisable. Seven gates, wards and a bailey served for its defence. The three-sided inner keep is protected to the east by a massive fortifying wall, with the main guard tower towering above it. Its ground plan, drop shaped with a sharp spur, is unusual in the region. The narrow courtyard is surrounded by buildings for living and working, where modifications continued into the 17th century. At the end of the 15th century, a residential building was erected on the southern side. It includes the Late Gothic kitchen, one of the very few castle kitchens in Saxony-Anhalt that is still functioning. The castle chapel dates back to the castle's early days, although its interior fittings and ceiling paintings essentially originated in the 16th century. During the Renaissance, the Asseburgers added an upper floor over the western wing in a uniform timber-frame style, with rich ornamentation that is among the finest in the Eastern Harz. In the 1830s, some rooms were refurbished in the Gothic Revival style by Prussia's court architect, Friedrich August Stüler.

The castle opened to visitors very early – in 1800. Since 1946 there has been a museum to describe the building's history and use and the story of the "Sachsenspiegel". Stüler's "royal rooms" are now used for events and weddings.

Eastern elevation with bastion, protective wall and tower

Great Hall at Falkenstein Castle

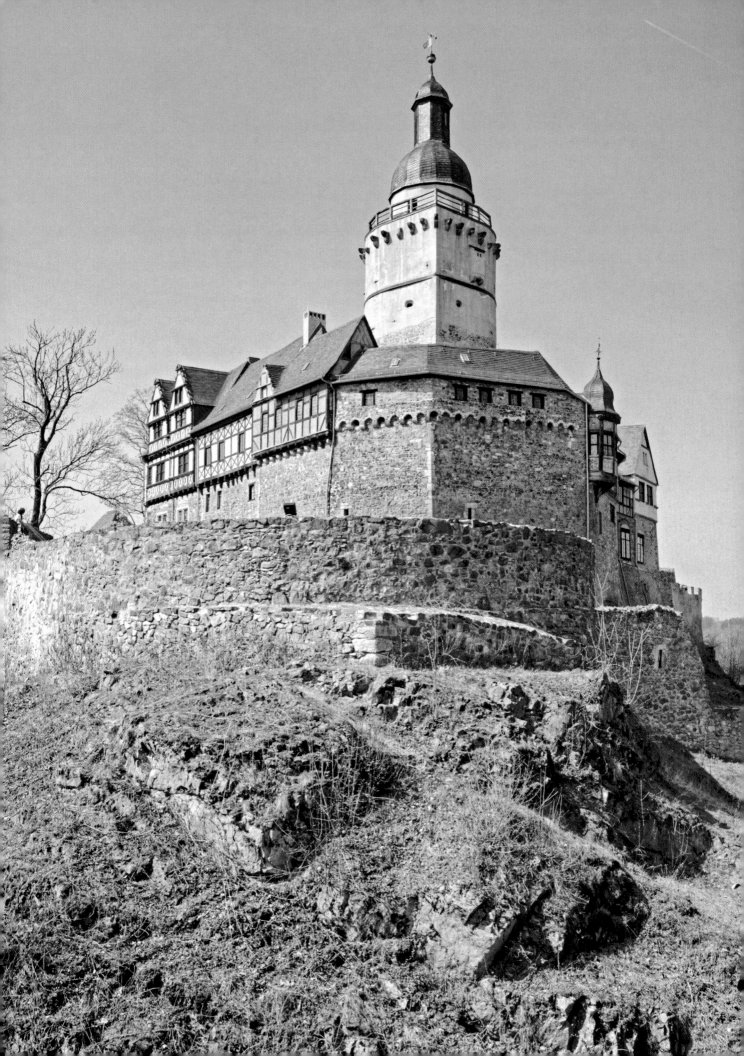

Schloss Goseck

Schloss Goseck
Burgstr. 53
06667 Goseck

Telephone
+49 34 43/28 44 88
(Schloss Goseck e. V.)

E-Mail
brief@schlossgoseck.de

Internet
www.schlossgoseck.de

www.dome-
schloesser.de

Telephone
+49 34 43/37 94 78
(Gosecker Sonnen-
observatorium e. V.)

E-Mail
verein@sonnenobserva
torium-goseck.info

Internet
www.sonnenobserva
torium-goseck.info

Telephone
+49 34 43/20 58 01
(Gosecker Heimat- und
Kulturverein e. V.)

Internet
www.heimatverein-
goseck.de

Schloss Goseck – located between Naumburg and Weissenfels – stands atop a steep cliff above the Saale. Mentioned back in the late 9th century in the Hersfeld tithe registry, by the year 1000 Goseck was the family seat of the Counts Palatine of Saxony. By 1041 the sons of the first Count Palatine gave up the castle, turning it into a Benedictine abbey. Archbishop Adalbert of Bremen, a son of the first Count Palatine, consecrated the church in 1053.

The abbey period ended in 1540. Falling first to Maurice of Saxony, it changed hands several times. After 1600 another busy period of building commenced. A simple Renaissance palace emerged, incorporating earlier abbey buildings. The gate crest of Franz of Königsmarck and his wife Katharina of Hoym and the epitaph of Bernhard of Pöllnitz in the chapel still remind us those who commissioned it. From 1840 to 1945, the Counts of Zech-Burkersroda resided at Goseck. Following their expropriation the palace and surrounding buildings temporarily housed social institutions such as the elementary school and a youth hostel. The church, meanwhile, remained largely unused, falling into neglect and decay. By the end of the 1990s the entire complex was empty.

Thanks to comprehensive refurbishment, large parts of the palace are accessible today. The association "Schloss Goseck e. V." is active locally. The numerous events held by the "Europäische Musik- und Kulturzentrum" find an enthusiastic audience. Those with an interest in history can find out more about Goseck's sun observatory, the world's oldest archaeological evidence for systematic observation of the skies. In the coach house, Goseck's "Heimat- und Kulturverein" maintains a small exhibition on the history of the palace and town of Goseck.

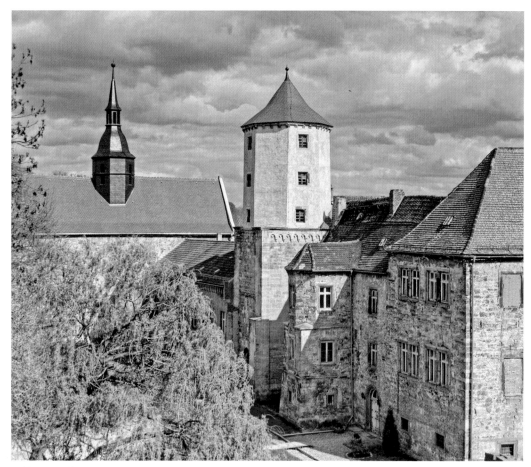

Schloss Goseck

Cathedral of St Stephen and St Sixtus

Halberstadt, in the northern foothills of the Harz, became a missionary Bishopric for the areas between the Harz and the Elbe River around the year 804. The consecration of its first cathedral took place in 859. Further cathedral buildings were to follow: in 992 the Ottonic cathedral, in 1220 the vaulted church. Further works commenced in the 1230s. Influenced by French Gothic, one of the most beautiful Gothic cathedrals in Germany was built in the years to 1486, and the completed building was consecrated in 1491.

The Reformation arrived in 1591. It is extraordinary that until the time of its dissolution the cathedral chapter had members of both denominations. After 1810 the buildings became state property. The Protestant chapter used the cathedral as a parish church. It suffered badly in an air raid in April 1945, requiring major refurbishment, but the cathedral was back in use as a house of worship from 1956. Its outstanding works of art include the Romanesque font, the Crucifixion group on the rood dating from around 1220, and the medieval stained glass in the ambulatory.

The cathedral plate is a unique collection which illustrates the original furnishings of the Bishop's church. Predominantly medieval, it consists of over 650 items and is the largest collection of church treasures extant in Germany. It embraces every genre and was intended to be used in worship here. The items grant an insight into the liturgy of a diocesan church and are simultaneously an important source for historians of the Bishopric.

Following extensive reorganisation, around 300 of these items are on display in the cathedral cloister. Some of the masterpieces, including textiles and plate, are of world-ranking significance. These include a splendid reliquary, exquisite altar accessories, priceless liturgical vestments and large Romanesque and Gothic tapestries.

Dom St. Stephanus
und St. Sixtus
Domplatz
38820 Halberstadt

Telephone
+49 39 41/2 42 37

E-Mail

mail@dom-und-
domschatz.de

Internet
www.dom-und-
domschatz.de

www.dome-
schloesser.de

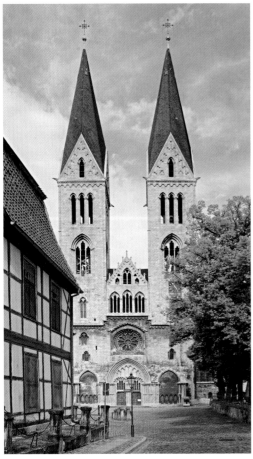

Halberstadt Cathedral

Archangel Michael, detail from the Abraham Angel Tapestry, the oldest hand-woven tapestry in Europe, made around 1150

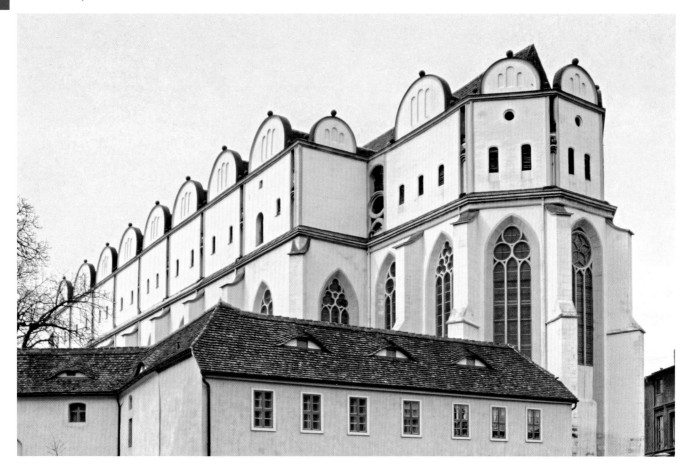

Halle Cathedral

Cathedral

Dom zu Halle
Domplatz 3
06108 Halle

Telephone
+49 3 45/2 02 13 79
(Protestant-Reform
Cathedral Parish)

E-Mail
kontakt@dom-halle.de

Internet
www.dom-halle.de

www.dome-
schloesser.de

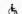 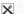

This sacred building on the edge of Halle's old town was originally founded by Dominicans. The building of this hall church, which lacks both a transept and a steeple, began in 1271. It was completed around 1330.

The most important period in the history of the building is inseparably linked to the activities of Cardinal Albrecht of Brandenburg. The Archbishop of Magdeburg had chosen the Dominican building as the church for his "Neuer Stift", as his monastic order was known. As the repository of the "Hallesches Heiltum" (his famous collection of relics) and the cardinal's future burial place, it became, along with Magdeburg Cathedral, the most prominent sacred building in the Archbishopric of Magdeburg.

This contrasted with the sober form of the church itself, which had once served a mendicant order. Bastian Binder, who had previously worked as master builder on the cathedral in Magdeburg, was charged with directing its prestigious conversions. There were contributions from Matthias Grünewald, Lukas Cranach the Elder and Peter Schro and their workshops. The project created an overall work of art which represents a milestone of German Renaissance architecture. A wreath of rounded gables, used for the first time north of the Alps, crowns the building. Also remarkable is the cycle of pillar statues by Peter Schro, which are among the finest specimens of German sculpture in the 16th century.

When Cardinal Albrecht had to leave Halle in 1541, he had the precious interior removed. The building was used as a court church by secular administrators of the Archbishopric of Magdeburg in the 17th century, when baroque extensions were added. During this period, Samuel Scheidt and Heinrich Schütz worked in the cathedral. In 1688 the building was granted to a community of exiles from the Palatinate who belonged to the German Reform Church. A young Georg Friedrich Handel was in their service as a cathedral organist. Today the cathedral is the place of worship for the Reformed Protestant congregation.

Church of St Pancras

Hamersleben, north of Halberstadt on the edge of the "Grosser Bruch", is blessed with one of the most important High Romanesque buildings in central Germany in the form of the Collegiate Church of the Canons Regular. The community of Augustine canons regular was founded in the early 12th century by Bishop Reinhard of Halberstadt, initially on the Bishop's estate in Osterwieck, only later relocating to Hamersleben. Around 1111/12 they began building the church. Completed before 1150 on its cruciform ground plan, this basilica with a nave and two side aisles and a triple choir was a masterpiece of technical craftsmanship. It is also remarkable for its high quality ornamentation within. The capitals are among the best examples of High Romanesque architectural sculpture. Its embellishment, both ornamental and figurative, becomes more elaborate as we proceed from east to west towards the altar. The most complex detail faces towards the nave. By the end of the 13th century, the canons were already deep in debt. It was not until the middle of the 15th century that a second economic boom created the conditions for further construction. The cloisters were added on the north side. Around 1500 works were carried out inside the church. While the Late Gothic improvements were implemented with caution, baroque revamping carried out after the 1680s increasingly overwhelmed the spatial feel that had been established in Romanesque times. The cloisters also saw significant changes in the early 18th century.

In 1804 the site was secularised, the land transferred to an estate and the church given over to the Catholic parish for use. From the mid-19th century until the present, restoration and repair work have carefully retrieved the Romanesque spatial order, while respecting major decorative features from later periods.

Stiftskirche St. Pankratius
Klosterhof
39393 Hamersleben

Telephone
+49 3 94 01/4 83
(Catholic Rectory)

Internet
www.dome-schloesser.de

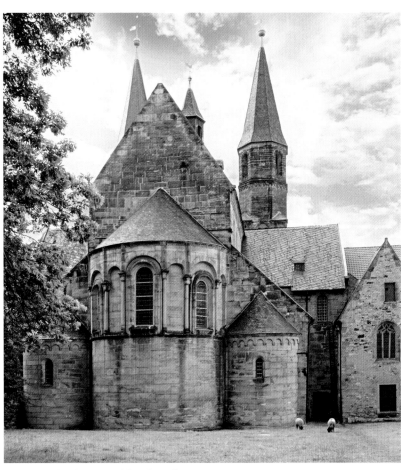

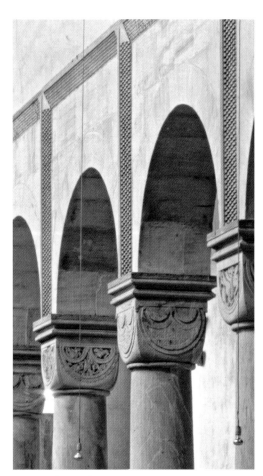

Collegiate church Hamersleben from the east

Decorated capitals

Cathedral of St Mary

Dom St. Marien
Domplatz 1
39539 Havelberg

Telephone
+49 3 93 87/2 14 22
(Prignitz Museum)

E-Mail
prignitz-museum@
gmx.de

Internet
www.prignitz-
museum.de

www.dome-
schloesser.de

Havelberg is one of the oldest Bishop's residences east of the Elbe and was founded in the mid-10th century by Otto I as a missionary Bishopric. Driven out again by the Slavic revolt of 983, the Bishops spent over 150 years in exile. It was not until 1147 that Havelberg was retaken. Bishop Anselm settled Premonstratensian canons regular here and had a cathedral erected. In 1170 the Romanesque cathedral was consecrated.

Around 1200 the solid western slab of greywacke was topped off with bell storey made of brick. Following a fire, the Romanesque basilica was given a Gothic reworking after 1279. The new additions, all brickwork, began in the east and transformed the chancel, central nave and side aisles. The combination of Romanesque and Gothic styles is clearly apparent.

The reworking gave rise to numerous decorative features of great value, such as the monumental Crucifixion group on the rood arch, the sand-stone candleholders, as well as the choir stalls, which are among the oldest in Germany. The rood screen with impressive relief and sculpture depicting the Passion of Christ was made around 1400. The stained glass in six windows of the northern aisle dates back to the early 15th century.

The Premonstratensian canons were reorganised as a chapter of diocesan priests in 1507. They retained these functions until the Reformation in 1561, when the chapter became Protestant. As a result of secularisation during the early 19th century, the Prussian state became the new owner. The Protestant congregation worshipped in the cathedral and the Paradise Hall in the former cloister, and the Catholic congregation in the Chapel of St Norbert. The Prignitz Museum has also been accommodated here since 1904. Its collection documents more than 1000 years of history about the Bishopric, the various chapters and the construction of the cathedral.

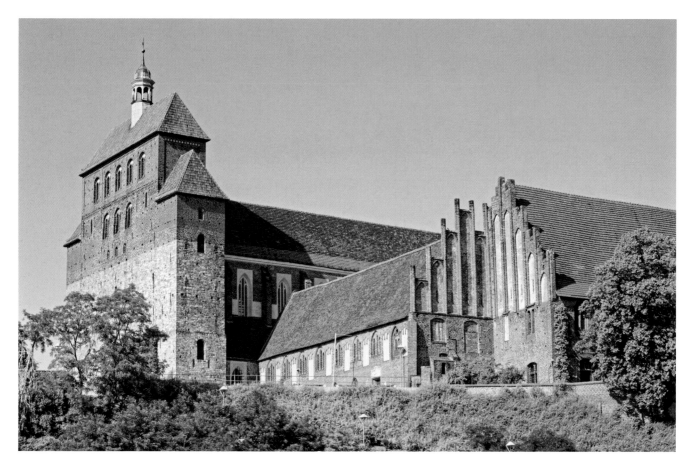

Havelberg Cathedral

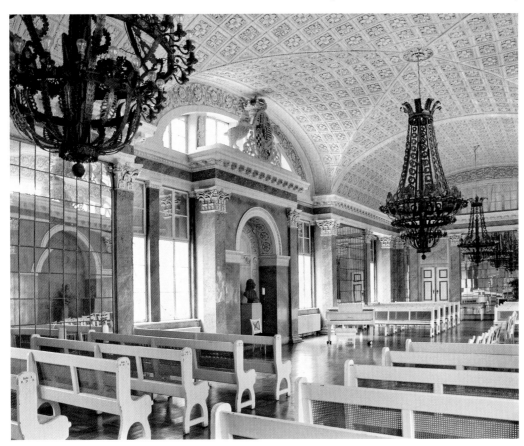

Schloss Köthen, Hall of Mirrors

Schloss Köthen

Schloss Köthen was erected between 1597 and 1608 by the brothers Peter and Franz Niuron, after a fire had damaged its Askanian predecessor. The Renaissance complex, a moat embracing the Johann Georg wing and the Ludwig wing, was completed in the 1820s by the Ferdinand wing created by Gottfried Bandhauer. The ensemble includes stables, the ruins of the riding arena and the coach house. The park, relandscaped in the English style, is a reminder of once celebrated gardens. From the mid-19th century the palace served no representational function, and was used as a school, district court and prison.

Today the Historical Museum of Central Anhalt and the Bach memorial celebrate the importance of the former princely residence. In the early 17th century it was among the most important intellectual and cultural centres in the German-speaking world. For decades it was the home of the "Fruchtbringende Gesellschaft" (or Fruitful Company), the largest association of linguists and scholars in the baroque period, founded by Ludwig I of Anhalt-Köthen in 1617. Johann Sebastian Bach played a noteworthy role at the court of Prince Leopold. As court Kapellmeister, he composed significant secular works in Köthen between 1717 and 1723, including the first part of the "Well-Tempered Clavier".

Today, the Events Centre completed over the former riding arena in 2008 provides an elegant setting for numerous concerts. Selected musical highlights take place in the Hall of Mirrors, initially created by Gottfried Bandhauer as a throne room.

The Naumann Museum in the Ferdinand wing has been caring since 1835 for the birds collected by Johann Friedrich Naumann, the founder of the ornithology in central Europe. It still uses the original display cases from the Biedermeier period, with painted backdrops and natural props.

Schloss Köthen
Schlossplatz
06366 Köthen (Anhalt)

Telephone
+49 34 96/21 25 46

E-Mail
historisches-museum@
bachstadt-koethen.de
naumann-museum@
bachstadt-koethen.de

Internet
www.bachstadt-
koethen.de

www.dome-
schloesser.de

Konradsburg

Konradsburg
06463 Falkenstein/Harz
OT Ermsleben

Telephone
+49 3 47 43/9 25 64
(Förderkreis Konrads-
burg e.V. Ermsleben)

E-Mail
kontakt@
konradsburg.com

Internet
www.konradsburg.com
www.dome-
schloesser.de

The castle on an elevation near Ermsleben, in the foothills of the Harz, was once the family seat of the nobles of the Konradsburg. After 1120 it was abandoned in favour of Falkenstein above the Selke valley and turned into a collegiate church, soon taken over by Benedictine monks. Legend has it that the castle's owners thereby atoned for the death of Adalbert of Ballenstedt.

All that remains of that abbey are remnants of the church erected around 1200. While the choir stands out for its simple forms, the undercroft is an outstanding example of Romanesque architecture in the Harz region, with its wealth of sculpted ornament on the capitals and imposts of pillars and columns. The early art historian Georg Dehio admired these "splendid specimens of Romanesque decorative art when it flourished most". Also impressive is the late Romanesque rood Crucifixion, one of the "great Crucifixions" in Saxony, akin in form and expression to the monumental figures of Christ in Halberstadt and Freiberg cathedrals and the abbey church at Wechselburg.

After the abbey was stormed by rebel peasants in 1525, the Carthusians then living there abandoned it. When an attempt at resettlement failed, large parts of the complex were demolished. Only the eastern part of the church was preserved. New buildings have appeared since the 18th century in the course of agricultural use. This includes the covered well dating from around 1800, which contains a rare technological monument in the form of a functioning donkey treadmill.

After 1945 the Konradsburg temporarily housed refugees. A civic initiative formed to prevent its impending dilapidation in 1982 gave rise in 1990 to the association "Förderkreis Konradsburg". It offers guided tours, education programmes for schools and numerous cultural events.

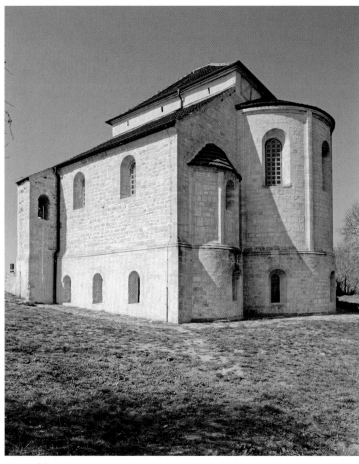

Konradsburg

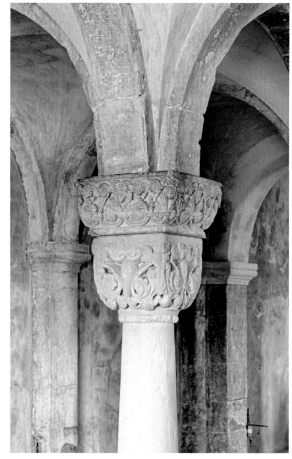

Decorated capital in the crypt

Schloss Leitzkau

Leitzkau, which was first documented as far back as 995, was particularly significant as one of the starting points for winning back those Brandenburg territories that had been lost in the course of the Slavic uprising of 983. Bishop Wigger of Brandenburg established a Premonstratensian Prince-Abbot's fief here in 1138/39. This was the order's first establishment east of the Elbe River. In the 1140s they had already begun constructing an imposing abbey, and its church, "Sancta Maria in monte", was consecrated in 1155. The entire monastery moved in not long after. For several years, Leitzkau held the rank of a Bishop's residence and played a decisive part in the re-establishment of Brandenburg's cathedral chapter. At Easter 1564, Hilmar of Münchhausen, one of the most important mercenary commanders of his time, acquired the secularised fief. He began the abbey's transformation into a palace, which his son Statius completed. By 1600 a grand Renaissance ensemble had been created, including the Neuhaus, Althaus and Hobeck palaces, a church, a gatehouse and various utilitarian buildings. Hilmar and Statius of Münchhausen imported formal elements and motifs to Leitzkau which were widespread in their own homeland, the Weser region. At the same time they had prototypes by foreign master builders and artists adapted. These influences coalesced into an overall work of art which Georg Dehio described as "the most important palatial building of that period in the mid-Elbe region". The palace and its estate were in the possession of the Münchhausen family until 1945. Having suffered heavy war damage, Schloss Althaus was demolished in 1950. Schloss Neuhaus, which was mostly undamaged, initially served as emergency housing for refugees and then as a school. Since 1996 the Stiftung Dome und Schlösser in Sachsen-Anhalt has used the palace for its administrative headquarters. A permanent exhibition displays information about the history of its construction and use. The "Förderkreis Kultur und Denkmalpflege e. V." offers guided tours.

Stiftung Dome und
Schlösser in Sachsen-
Anhalt
Schloss Leitzkau
Am Schloss 4
39279 Leitzkau

Telephone
+49 3 92 41/93 40
+49 3 92 41/41 68
(guided tours)

Internet
www.dome-
schloesser.de

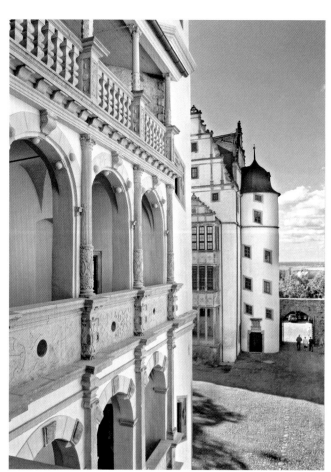

Schloss Leitzkau, the Althaus loggia (left) and the Neuhaus bay window and stair tower from Hobeck

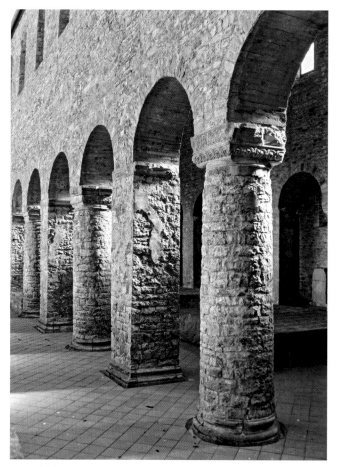

Row of columns in the basilica

Letzlingen Hunting Lodge

Stiftung Dome und
Schlösser in Sachsen-
Anhalt
Jagdschloss Letzlingen
Schlossstr. 10
39638 Letzlingen

Telephone
+49 3 90 88/80 89 70

E-Mail
letzlingen@dome-
schloesser.de

Internet
www.dome-
schloesser.de

The Gothic Revival hunting lodge, Jagdschloss Letzlingen, lies amid the Letzlinger Heide, heathland rich in game, with a strong tradition of hunting by the House of Hohenzollern. From 1843 onwards King Friedrich Wilhelm IV of Prussia had it redesigned by the architects Friedrich August Stüler and Ludwig Ferdinand Hesse, based on his own ideas. By the 1860s there was a new church, and the Cavalier's House and Castellan's House had also appeared.

It replaced an earlier building for Johann Georg of Brandenburg, constructed between 1559 and 1562. His son Joachim Friedrich shared his interest in the castle, which was surrounded by a moat. However, it then faded into oblivion.

The Prussian king did not just awaken the old "Hirschburg" to new life, but also tapped into the tradition of the hunt. From 1843 onwards, courtly hunts (the "Letzlinger Hofjagden") took place in late autumn, to which royal and princely guests, high-ranking officials of the Prussian state and influential personages were invited. The last in a line of 59 court hunts took place in November 1912.

As the property of the Prussian state since 1918, most of the palace inventory was sold off in 1922. Until 1933 the palace was the location of the "Freie Schul- und Werkgemeinschaft", a private boarding school based on progressive education ideals. The building was briefly a leadership academy for the Nazi SA, became a military hospital even before 1945, and remained in use as a hospital until 1991.

Following comprehensive refurbishment, the palace re-opened to visitors in 2001. There is a permanent exhibition with information on the history of hunting in the Letzlinger Heide. The museum area is to be extended in 2012 to commemorate the final court hunt. It is currently possible to arrange weddings in the former imperial dinner hall. Furthermore, rooms can be hired for conferences, seminars and receptions. A hotel has opened in the Cavalier's House and Castellan's House.

Across the moat to Letzlingen Hunting Lodge

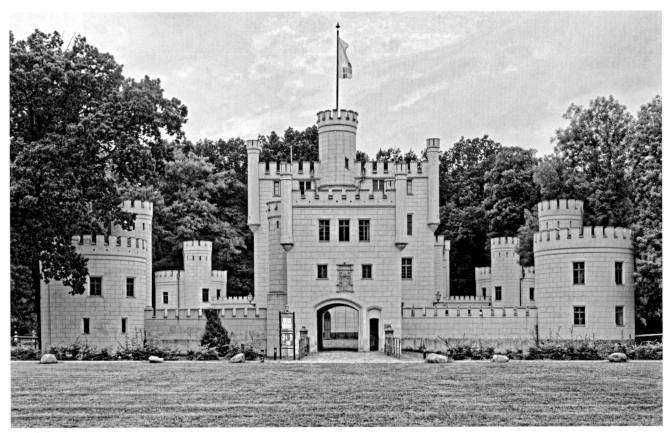

Letzlingen Hunting Lodge, the only Hohenzollern palace to survive in Saxony-Anhalt

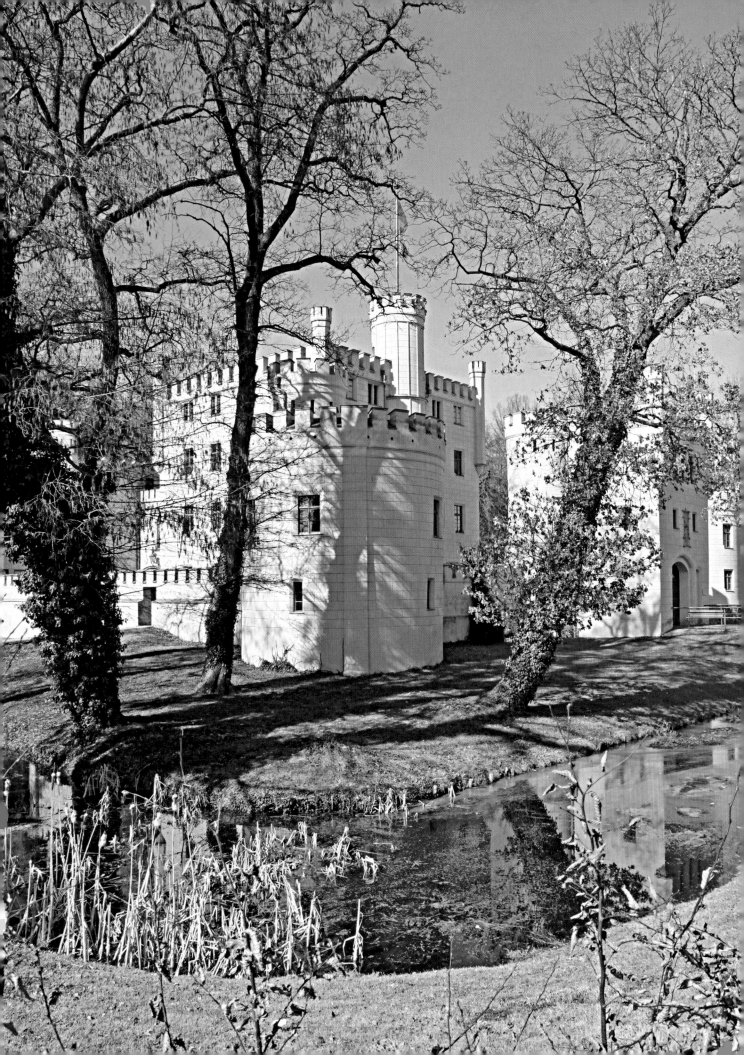

Cathedral of St Maurice and St Catharine

Dom St. Mauritius und
St. Katharina
Domplatz 1
39104 Magdeburg

Telephone
+49 3 91/5 41 04 36

Internet
www.magdeburger
dom.de

www.dome-
schloesser.de

Otto I established a Benedictine monastery at Magdeburg in 937. From 955 the first cathedral was erected on this spot. By integrating vestiges of late Classical buildings from Italy, Otto was pressing his claim to be a direct successor to the Roman Emperors. He also transformed Magdeburg into one of the most important missionary bases for the Christianisation of the Slavs east of Elbe and Saale. 968 saw the founding of the Archbishopric of Magdeburg under his patronage, and the cathedral was its main church. After his death, Otto I was laid to rest in the cathedral. A town fire damaged the cathedral in 1207, and in 1209 work began on a successor. By 1520 this had become the first cathedral on German soil built to a Gothic plan and elevation. The master builders, trained in the German, late Romanesque tradition, succeeded in creating a new architectural quality by implementing early French Gothic ideals in their own way. By re-using the plundered Classical remains from the Romanesque cathedral and placing the Emperor's sarcophagus in the high chancel, the Archbishops of Magdeburg consciously presented themselves as heirs to the Ottonic legacy.

The cathedral's interior betrays extraordinary quality. Apart from the late Classical spoils, features of particular note are the baptismal font made of porphyry, the bronze covers over the tombs of Archbishops Friedrich of Wettin and Wichmann of Seeburg, the late Romanesque capitals in the ambulatory, the realistic Gothic statuary, the Renaissance pulpit, baroque epitaphs to the cathedral's masters and the 20th-century artworks.

The cathedral chapter was dissolved in the early 19th century and the cathedral became state property. Extensive refurbishments have since taken place. In addition to its function as a church, today's cathedral exercises an enormous attraction as a cultural site and the distinctive landmark of the city of Magdeburg.

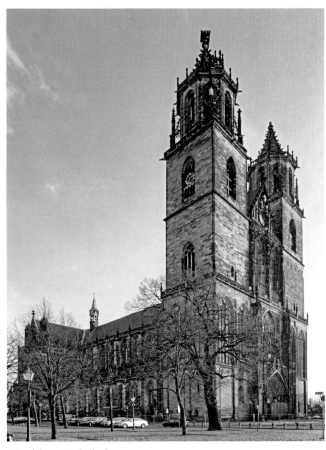

Magdeburg Cathedral

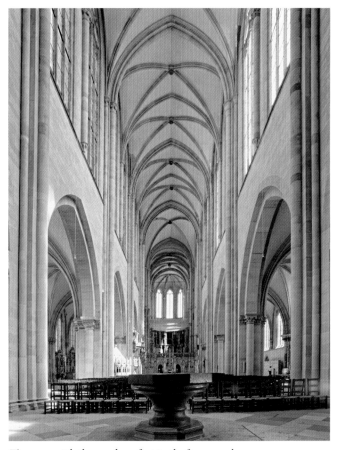

The nave, with the porphyry font in the foreground

Michaelstein Abbey

Somewhat aside from the gates to the town of Blankenburg, the former Cistercian abbey of Michaelstein is located on the idyllic fringes of the Harz Mountains. The abbey, founded in 1146, experienced prolonged commercial prosperity in the Middle Ages. During the German Peasant's War the monastery and church were severely damaged. After the Reformation the Cistercian abbey became the property of the Counts of Blankenburg-Regenstein, who founded a monastic school in Michaelstein in 1544. The latter remained even when the Blankenburg fief was extinguished and its possessions passed to the Dukes of Brunswick in the late 16th century. In the early 18th century, Duke Ludwig Rudolf commissioned extensive construction works, and installed a theological seminary. Following the period of French foreign rule, Michaelstein served merely commercial purposes, which the abbey estate pursued in diverse forms of ownership, even after the land reform. Since 1968 the listed site has been used for musical purposes. It now houses the Musical Academy of Saxony-Anhalt, dedicated to education and performance.

Its varying uses and respective modifications have given the abbey an unmistakable imprint. Thanks to extensive refurbishment, the buildings from the late Romanesque and Gothic periods are well preserved.

Two abbey gardens, a herb and spice garden on the southern side and a vegetable garden on the eastern side, have been laid out in accordance with medieval records and drawings, and are another point of interest.

Historical musical instruments have been collected at the abbey since 1977. There are now about 900 items dating from the 18th to 20th centuries. Among other themes, the exhibition illustrates the development of these instruments from the baroque period to the present day. Visitors can hear how some of the keyboard instruments actually sounded.

Stiftung Kloster Michaelstein – Musikakademie Sachsen-Anhalt für Bildung und Aufführungspraxis Michaelstein 3 38889 Blankenburg

Telephone
+49 39 44/90 30-0

E-Mail
rezeption@kloster-michaelstein.de

Internet
www.kloster-michaelstein.de

www.dome-schloesser.de

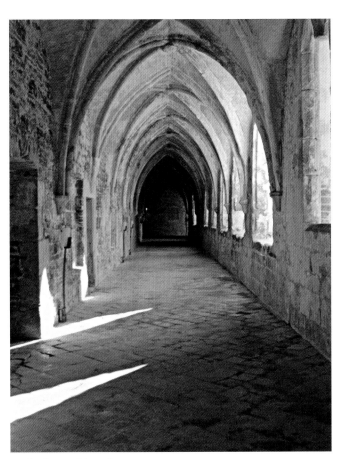

Michaelstein Abbey, cloisters

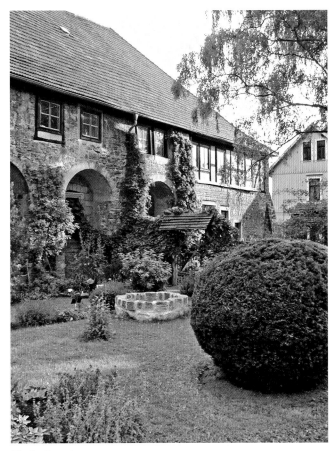

The herb garden

Schloss Neuenburg

Stiftung Dome
und Schlösser in
Sachsen-Anhalt
Museum Schloss
Neuenburg
Schloss 01
06632 Freyburg (Unstrut)

Telephone
+49 3 44 64/3 55 30

E-Mail
info@schloss-
neuenburg.de

Internet
www.schloss-neuen-
burg.de
www.dome-
schloesser.de

High above Freyburg sits the mighty edifice that is the Neuenburg. The sister castle of the Wartburg was established around 1090 by the Thuringian Count Ludwig the Leaper and splendidly extended by the Landgraves of Thuringia. Between 1150 and 1230 an extensive castle complex evolved, with a grand display of prestige. Totalling approx. 30,000 square meters in area, it was about three times the size of the Wartburg. An architectural gem is the twin chapel erected around 1170/75 with its rare decorations, dedicated to St Elisabeth of Thuringia in the late Middle Ages. Famous names such as Emperor Barbarossa and the poet Heinrich of Veldeke bear ample testimony to a glorious history. Around 1185, Veldeke was commissioned by Count Palatine Hermann I of Saxony (who was Landgrave of Thuringia from 1190) to write the "Eneas Roman", the first chivalrous epic poem in the Middle High German language. The Neuenburg reached the peak of its high medieval heyday under Landgrave Ludwig IV and his wife St Elisabeth.

In 1247 the castle came into the possession of the margraves of Meissen. From the 16th to 18th century, under the Electors of Saxony and the Dukes of Saxony-Weissenfels, it was rebuilt into a residential palace and hunting lodge. In 1815 Schloss Neuenburg passed to the Prussians. In 1935 the first museum opened here. From 1970 to 1989 the entire complex was closed. Completely neglected, it might have been forgotten altogether. But today the Neuenburg is one of the most-visited museums in Saxony-Anhalt.

The exhibition "Burg und Herrschaft" is dedicated to medieval castles and power. An abundant variety of activity is on offer – from wine museum and other exhibitions to the children's area and special events. An annual highlight is the "montalbâne" festival, celebrating the culture of chivalry.

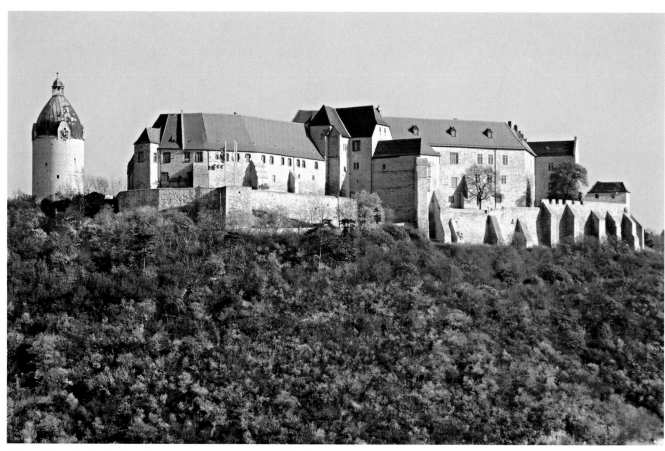

Schloss Neuenburg high above the wine-growing community of Freyburg

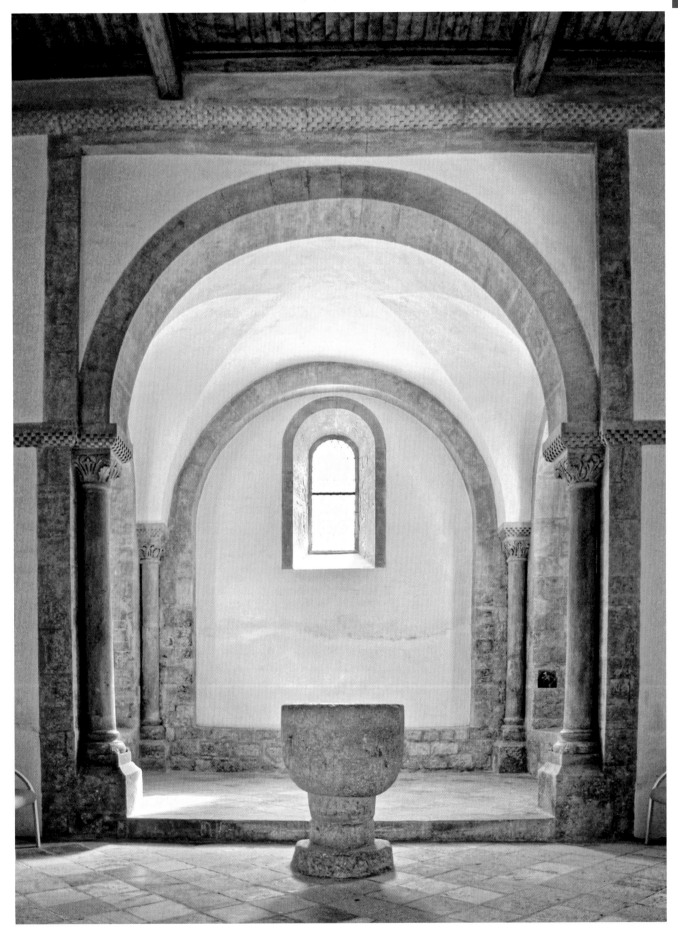

The lower level of the twin chapel

Schloss Plötzkau

Schloss Plötzkau
Schlosshof
06425 Plötzkau

Telephone
+49 3 46 92/2 89 44

Internet
www.schloss-
ploetzkau.de

www.dome-
schloesser.de

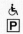 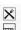 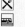

Perched on a spur of rock over the Saale flood plain, the Counts of Plötzkau have held sway since the 11th century. Their castle was destroyed in 1139 but rebuilt after 1152.

Bernhard VII of Anhalt commissioned a conversion of the dilapidated building in 1566. The Renaissance structure owes its striking appearance to a wreath of dormers and the keep, which was raised several floors but is still essentially Romanesque. More than 70 habitable chambers, halls and parlours were built. The Prince's Hall contains a sandstone fireplace bearing the crest of its first owner. The splendid top, made in 1567, is attributed to sculptor Georg Schröter from Torgau. After Bernhard's death in 1570, Prince Joachim Ernst of Anhalt had the works completed by 1573. Following the partition of the Principality of Anhalt in 1603 into the four lines Bernburg, Dessau, Köthen and Zerbst, Prince August formed the Plötzkau line in 1611. The palace became the residence of one of the smallest German territorial states, which lasted until 1665. In the early 18th century the palace once again served as a lordly residence. A stucco ceiling carved in 1716 with the initials "VF" refers to Victor Friedrich of Anhalt-Bernburg, who commissioned baroque modifications.

Soon afterwards the palace lost all its official functions. From 1741 some of the rooms became a paint factory. Between 1841 and 1874 it was an "institution for punishment and correction" and housed "vagabonds, drunkards and similar workshy rabble" as well as former prisoners. After 1945 it temporarily housed refugees, and later the Prehistory Museum in Halle used several rooms as a depot for its collections.

Today the association "Schloss Plötzkau e. V." keeps the complex open for visitors and offers guided tours as well as a special programme for children.

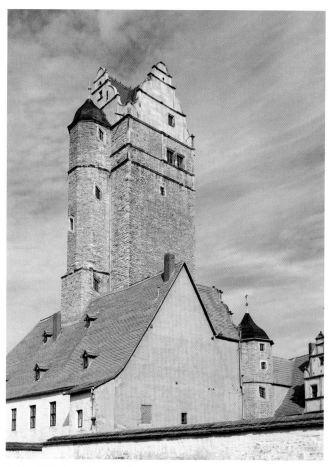

Schloss Plötzkau, the tower keep

In the courtyard

Dessau-Wörlitz

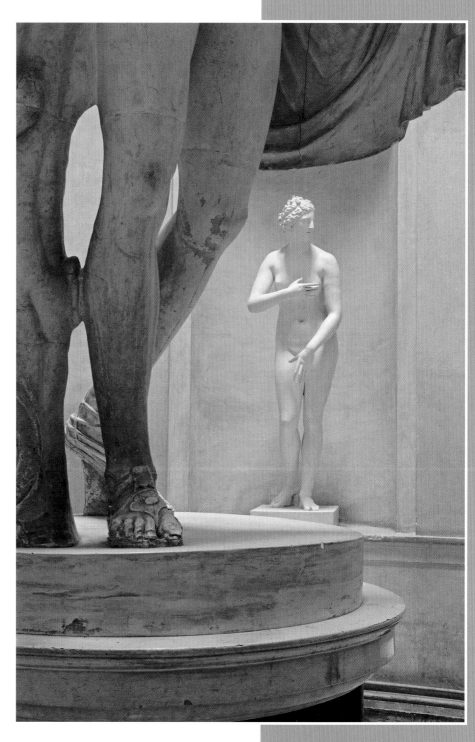

Kulturstiftung
DessauWörlitz

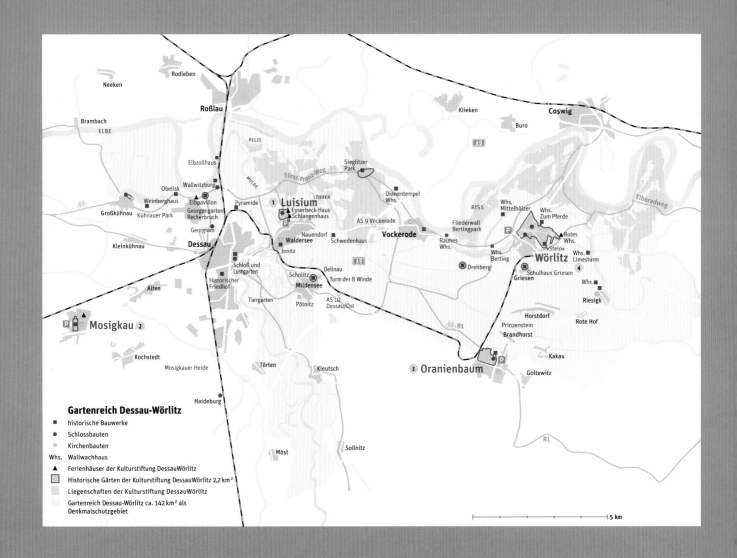

Gartenreich Dessau-Wörlitz

- ■ historische Bauwerke
- ● Schlossbauten
- ○ Kirchenbauten
- Whs. Wallwachhaus
- ▲ Ferienhäuser der Kulturstiftung DessauWörlitz
- ▢ Historische Gärten der Kulturstiftung DessauWörlitz 2,2 km²
- ▨ Liegenschaften der Kulturstiftung DessauWörlitz
- ▨ Gartenreich Dessau-Wörlitz ca. 142 km² als Denkmalschutzgebiet

5 km

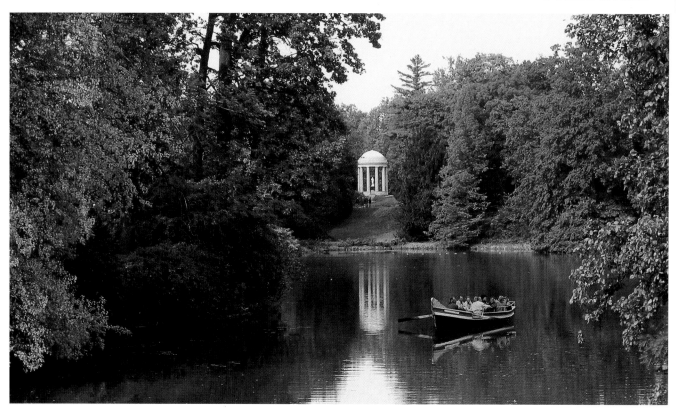

Kleines Walloch (Small Dike Hole) with Venus Temple in Wörlitz

The Most Beautiful Gardens in the Land

In the heart of Sachsen-Anhalt, at the Middle Elbe between the Bauhaus city of Dessau and Lutherstadt Wittenberg, the Garden Kingdom of Dessau-Wörlitz spans an area of about 150 square kilometers.

This broad riparian landscape was chiefly designed by Prince Leopold III Friedrich Franz of Anhalt-Dessau (1740-1817, assumed power in 1758), with the goal of a widespread "beautification of the land." The latest architecture and newest techniques, combined with the art of the English garden, as well as his pedagogical intentions for the masses, based upon the humanist ideas of the Enlightenment, unite here to form an unparalleled artistic entity.

The geographic incorporation into the Middle Elbe's biosphere reserve, as well as the historic Garden Kingdom of Dessau-Wörlitz's inclusion into the list of UNESCO's World Heritage Sites, emphasize the distinct significance of this cultural landscape that has evolved over centuries.

Hundreds of thousands of visitors view the Wörlitz gardens, which are among the earliest and still-preserved specimens of their kind. Together with the Neoclassical palace, as well as the Gothic House that was built at nearly the same time, they form an incomparable ensemble of European cultural heritage.

Beyond Wörlitz, the Kulturstiftung DessauWörlitz supervises nearly 100 independent monuments and monument ensembles of various dimensions and with it, the core area of the historic Garden Kingsdom of Dessau-Wörlitz. The Baroque park grounds with the palaces of Oranienbaum and Mosigkau alternate with later creations of garden and palace architecture in the castles of Luisium and Großkühnau, with their partially original interiors and artworks of the highest caliber. All of this dovetails into a natural landscape that remains virtually intact to this day.

The primary goals of the Kulturstifutung DessauWörlitz are to restore and maintain these artistic gardens with their authentic architectural creations and at the same time, to reconstruct these buildings with their original furnishings.

With their scientific work, the Kulturstiftung DessauWörlitz documents their responsibility towards the heritage that has been entrusted to them. Moreover, the Foundation maintains international relationships and is instrumental in coordinating the care and development of this monument-rich landscape and making it accessible to the public. In addition to special exhibitions, the Foundation offers an annual comprehensive program of cultural events.

Yet even without them, all visitors shall discover ongoing diverse possibilities for relaxation and enjoyment, be it a tour of one of the palaces, a walk in the garden, a gondola tour upon the Wörlitz waters, a party with a horse carriage through the Elbe wetlands, or a bicycle tour along the European bike path where the Garden Kingdom Dessau-Wörlitz is accompanied by the Elbe.

Luisium

Kulturstiftung
DessauWörlitz
Schloss Großkühnau
06846 Dessau-Roßlau

Telephone
+49 3 40/64 61 50

E-Mail
ksdw@ksdw.de

Internet
www.gartenreich.com

Schloss Luisium
06844 Dessau-Roßlau/
OT Waldersee

Telephone
+49 3 40/21 83 70

E-Mail
schloss-luisium@
ksdw.de

 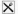

The Luisum, located at the edge of the city of Dessau, is a small and intimate complex. Prince Franz dedicated it to his wife Luise, a princess from Brandenburg-Schwedt (1750–1811). Here, Classical and Neo-Gothic buildings are in turn combined and harmoniously embedded into the artistic landscape, forming an ensemble of distinguished quality. The Neoclassical house (1774–1778) is a masterpiece of Erdmannsdorff's architecture. Like the exterior, his interiors feature balanced proportions. The banquet hall on the ground floor, with its reliefs and paintings and dark green stucco marble pilasters, is shaped by severe contours. The smaller rooms and chambers on the upper floor, with their delicate stucco decoration and wall paintings, appear cheerful and elegant.

A special attraction is the restored orangery which also contains a restaurant. The lyrical garden comes to life with garden sculptures, such as the Pegasus Fountain and the two hermai which line the path, while the Flower Garden House also encourages visitors to linger.

From the west path can be seen the somewhat remote building of the newly-restored Stud Farm. Horses, sheep, and goats graze upon a vast meadow, creating a picturesque image characteristic of the 18th-century garden landscape.

Luisium Castle, Graphics Room

Luisium Castle

The Schlangenhaus (Snake House) in Luisium Park, like the Eyserbeck House, is available as a vacation rental.

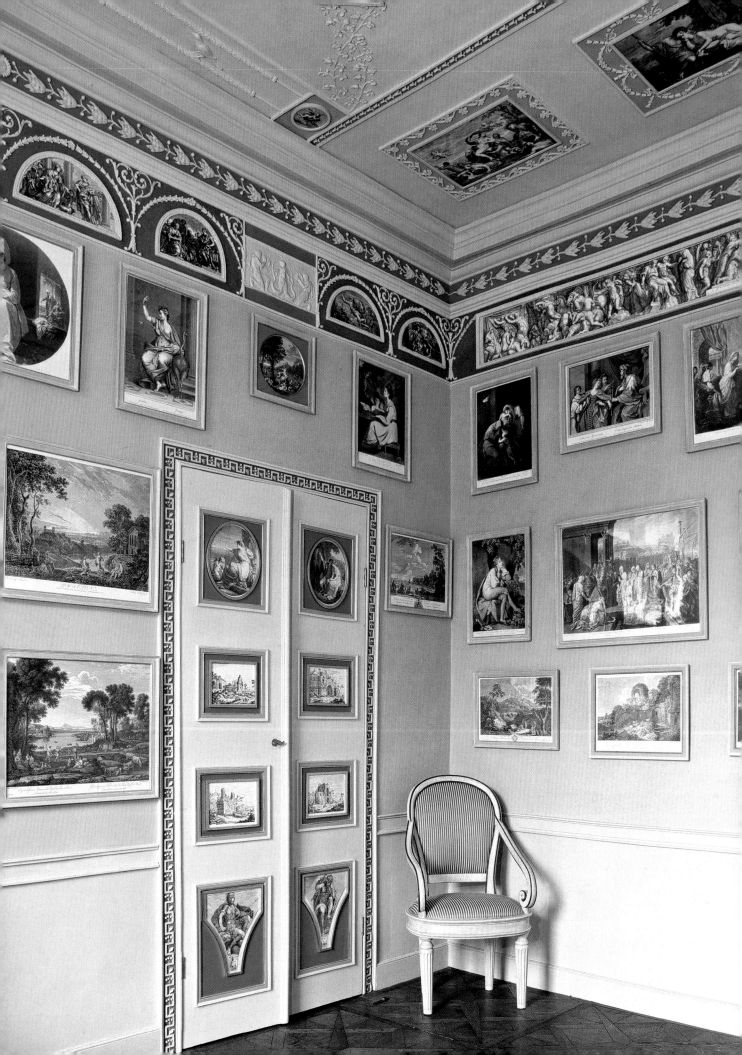

Mosigkau

Schloss Mosigkau
Knobelsdorffallee 2/3
06847 Dessau-Roßlau

Telephone
+49 3 40/52 11 39

E-Mail
schloss-mosigkau@
ksdw.de

Internet
www.gartenreich.com

Only a few kilometers west of the center of Dessau, the Rococo palace of Mosigkau was built between 1752 and 1757. Princess Anna Wilhelmine of Anhalt-Dessau hired the architect Christian Friedrich Damm for its construction, with the first designs probably originating from the architect of Sanssouci, Georg Wenzeslaus von Knobelsdorff. It was through a generous gift of land and a considerable appanage from her father, Prince Leopold I of Anhalt-Dessau – who was known by many as the "Old Dessauer" – that Anna Wilhelmine was able to build a splendid palace and garden complex. The import of the palace cannot be exaggerated, for it is among the few mostly-preserved Rococo ensembles in Central Germany.

The core area and art historical highlight of the architecture in the corps de logis, or central block, is the Gallery. The room, furnished with rich stucco decoration, contains an uniquely Baroque, uninterrupted display of paintings in recessed wall areas by mostly Flemish and Dutsch masters such as Peter Paul Reubens, Anton van Dyck, Jacob Jordaens, Hendrick Goltzius, and Gerard van Honthorst. Yet the palace also houses paintings by contemporary paintings, for example, those of the court painter of Prussia, Antoine Pesne and Christoph Friedrich Reinhold Lisiewsky, the court painter of Dessau. Additional rooms connected to the Gallery, such as the finely-decorated "Yellow-Silver Room" and the "Brown Room," named for its wooden appearance, both on the west side, as well as the Music Room on the east side, have been preserved in their original condition. Moreover, 17 rooms contain a portion of their original furnishings as well as handicrafts and paintings from the 17th and 18th centuries.

A central attraction of the largely-preserved Rococo garden is the orangery with its rare and centuries-old potted plants.

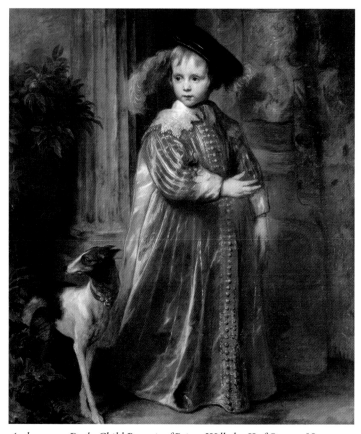

Anthony van Dyck; Child Portrait of Prince Wilhelm II of Orange-Nassau

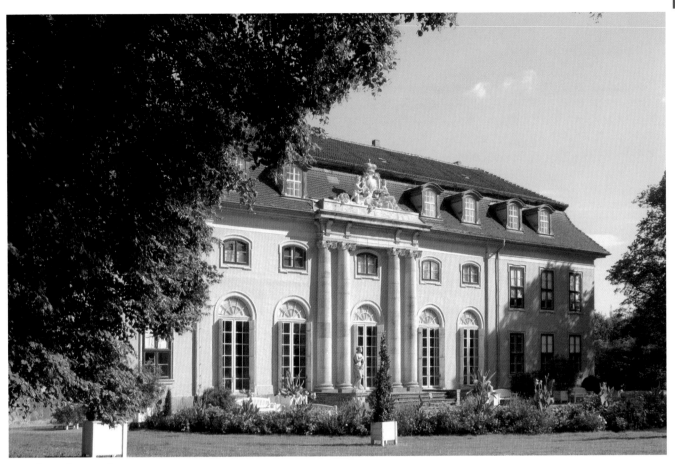

Mosigkau Palace, south view

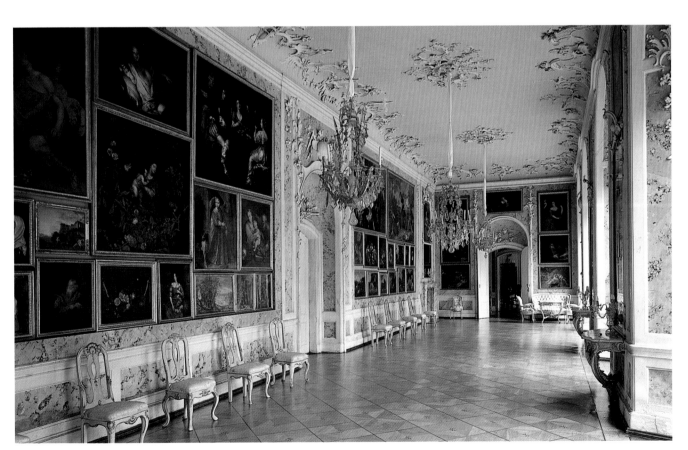

Gallery, Mosigkau Palace

Oranienbaum

Schloss Oranienbaum
06785 Oranienbaum

Telephone
+49 3 49 04/2 02 59

E-Mail
schloss-oranienbaum@
ksdw.de

Internet
www.gartenreich.com

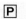 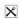

Oranienbaum, a notable Baroque city palace and park ensemble, is located a few kilometers from Wörlitz. Its construction began in 1683 for Henriette Catharina (1637–1708), a princess from Orange-Nassau and the wife of Prince Johann Georg II of Anhalt-Dessau. The city was named for the house of Orange.

The corps de logis of the palace was built by the Dutch architect Cornelis Ryckwaert and after his death in 1693, was expanded into the present complex. In the summer of 2003, the palace, which was not accessible to the public for nearly 60 years, was reopened to visitors. In addition to original furnishings in the rooms that for the most part had not been restored, Baroque floors, stucco work, together with Chinoiserie furniture from the late 18th century have been preserved. Truly spectacular is the hall in the north wing (the former porcelain gallery), which is completely adorned with gilt-leather wall coverings and features a magnificent faience and porcelain display on both front walls. The summer dining hall, with its Dutch decorated tiles, has been completely preserved. Special exhibitions take place at the palace on a regular basis.

The orangery, whose 176 meters makes it one of the longest in Europe, stores valuable plants during the cold season. Especially noteworthy is the cultivation of citrus plants, a tradition which was revived in 1989. During the summer, historical carriages from the surrounding region are placed on display.

Particularly striking is the English-Chinese section of the garden, which Prince Franz had made between 1793 and 1797. Today, it is the only preserved garden of this type in Germany. Garden design and architecture – a pagoda, a Chinese house, and various bridges – are united into an impressive artistic synthesis.

Pagoda in the English-Chinese garden at Oranienbaum

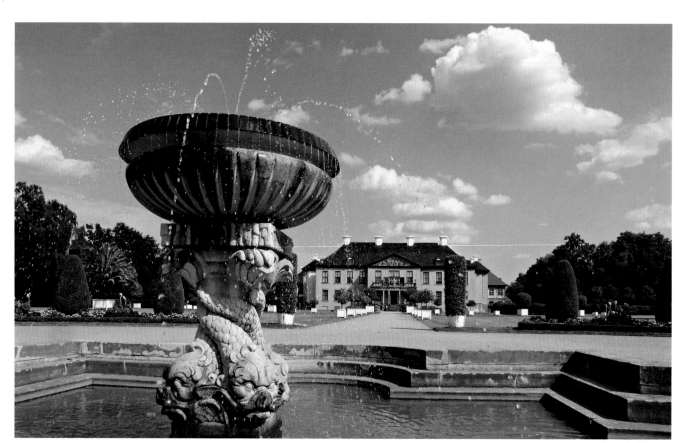

Oranienbaum Palace, west view

Wörlitz Complex

Schloss Wörlitz
06786 Wörlitz

Telephone
03 49 05/4 09-0

E-Mail
schloss-woerlitz@
ksdw.de

Gotisches Haus
06786 Wörlitz

Telephone
03 49 05/2 03 02

E-Mail
gotisches-haus@
ksdw.de

Insel „Stein"
und Villa Hamilton

Telephone
03 49 05/3 04 60

Internet
www.gartenreich.com

Wörlitz is the artistic highlight of the Garden Kingdom, which Prince Leopold III Friedrich Franz of Anhalt-Dessau (1740–1817) designed in the second half of the 18th century with his friend and consultant, the architect Friedrich Wilhelm von Erdmannsdorff (1736–1800).

Making use of the natural qualities of the Elbe wetlands, an artistic entity took shape that united garden design and architecture in a harmony hitherto unknown.

Its contemporary audience was delighted by the sensational new complex, with the English-style landscape garden, as well as the elegant, harmonious proportions of the "Country House" (1769–1773), the founding Neoclassical structure in Germany. The palace, whose original interior decoration has been preserved, houses valuable collections even today, such as sculptures from Antiquity, paintings, and vessels by the famous Wedgwood manufacturer.

There is no fence separating the garden from the city, for even at that time it offered free access to everyone. In fact, the palace was also open to visitors, who flocked here from numerous countries in order to admire the Wörlitz grounds.

Countless sources of inspiration were discovered by Prince Franz and Erdmannsdorff during their educational travels to England, France, the Netherlands, and of course, Italy, the land of the honored Antique era.

Some buildings recall Roman precedents, such as the Flower Temple, the Venus Temple, and the Pantheon in the east section of the garden; Rock Island, with the only artificial volcano in Europe, and the recently-restored Villa Hamilton, whose furnishings reflect the spirit of the Enlightenment. Providing a counterpoint and an element of surprise to the visitor are the Neo-Gothic buildings. With its canal front, the Gothic House (1773–1813) is reminiscent of a Venetian church and with the side which faces the garden, assumes the contours of an English Tudor Gothic structure. Inside, it contains an unparalleled collection of primarily Swiss glass paintings from the late 15th to 17th centuries, as well as noteworthy Neo-Gothic furnishings.

Wörlitz Palace, south view

Eruption on Rock Island

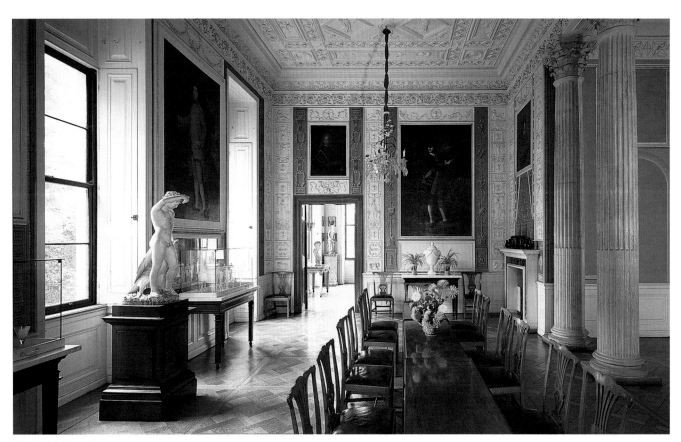

Wörlitz Palace, dining room

Wörlitz Complex, view from the Gothic House towards the Palm House and court nursery (left) as well as the Flower Temple (right)

Wörlitz Complex, Pantheon *Rousseau Island, Wörlitz Complex*

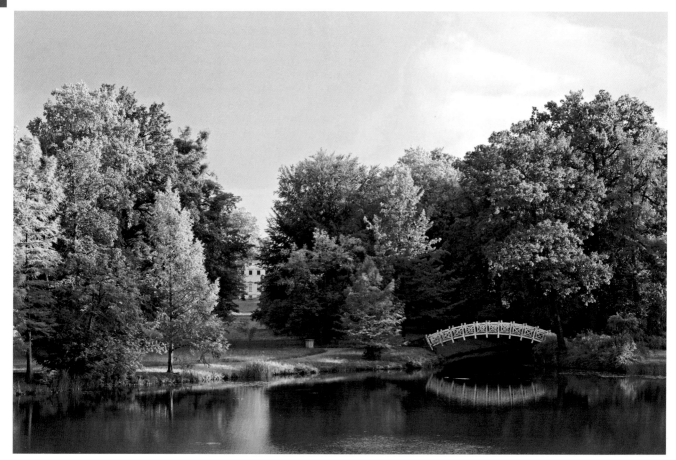

Wörlitz Complex, stepped bridge

Wörlitz Complex, gondola pier

Wörlitz Complex, Gothic House

Wörlitz Complex, view of the Golden Urn

The Association of Friends of the Garden Kingdom of Dessau-Wörlitz

The Gesellschaft der Freunde des Dessau-Wörlitzer Gartenreiches e.V, (Association of Friends of the Garden Kingdom of Dessau-Wörlitz) was founded in May 1993. The Association has approximately 1300 members who are not only from Sachsen-Anhalt, but from all parts of Germany and abroad.

The Association combines a great interest for historical landscape gardens, the love of the Wörlitz complexes with their European buildings, and the desire to recall and safeguard the reformist and Enlightenment-linked traditions of Prince Franz.

As a new member among friends, you can experience the beauty and diversity of the Dessau-Wörlitz Garden Kingdom. Your interest and participation helps to protect and preserve this unique artistic entity as a valuable cultural heritage of humanity.

Gesellschaft der Freunde des
Dessau-Wörlitzer Gartenreiches e.V.
Haus der Fürstin
06786 Wörlitz

Phone: (+49) 03 49 05 / 3 08 70

E-Mail: info@gartenreich.info

Internet: www.gartenreich.info

The Advantages of Membership

In addition to free access to all gardens, parks, and complexes in the Dessau-Wörlitz Garden Kingdom, you will also receive:

· with your personal membership card, free entry to the numerous historical buildings of Wörlitz, Oranienbaum, Mosigkau, and Luisium

· free use of the gondolas and transport ferries on the lakes and canals of Wörlitz

· a 10% discount on all publications which are printed on behalf of the Kulturstiftung DessauWörlitz

· a complimentary copy of the Kulturstiftung DessauWörlitz's annual program

· a biennial financial report of the Kulturstiftung DessauWörlitz

· personal invitations to all functions of the Kulturstiftung DessauWörlitz, such as exhibition openings, concerts and lectures, and the International Garden Festival

· within the framework of the annual general meeting, a special lecture featuring a prominent guest and an attractive supporting program

· additional invitations to special Foundation events

· the satisfaction of knowing that your participation contributes to the care and future preservation of historical buildings, monuments, and landscape gardens

Thuringia

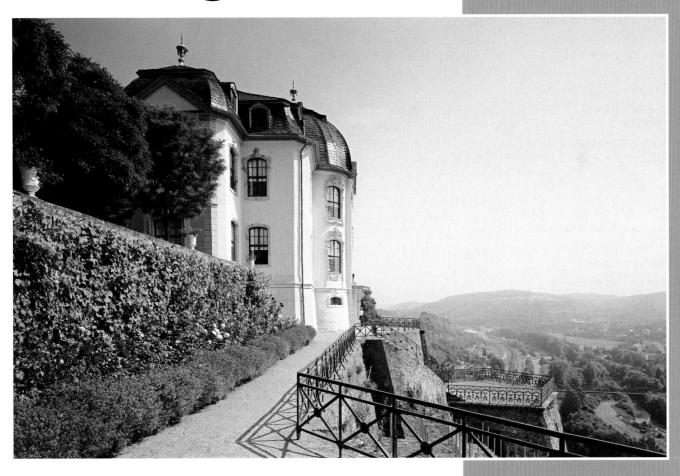

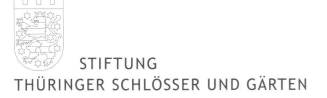

STIFTUNG
THÜRINGER SCHLÖSSER UND GÄRTEN

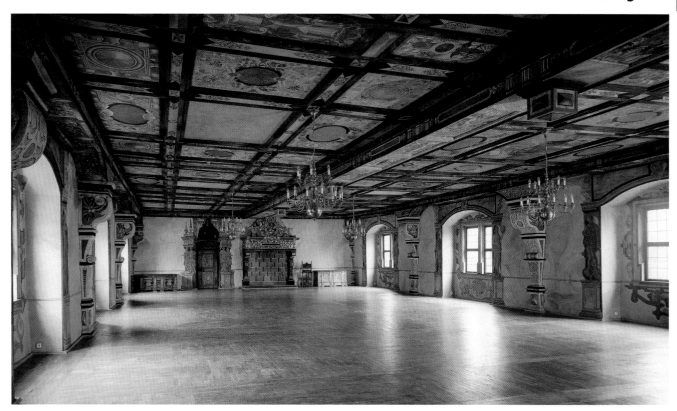

Wilhelmsburg Palace in Schmalkalden, Ballroom

Pearls of a Cultural Landscape
The Treasures of the Thuringian Castles and Gardens Foundation

Thuringia's cultural landscape displays a unique wealth of major castles, palaces, gardens, parks, and cloisters which has accumulated over the course of several centuries. Through frequent divisions of land and territories, an extraordinary diversity of small states with competing residences came into existence during the Middle Ages, creating the framework for a rich artistic milieu. It is precisely this diversity in the area that shapes the cultural profile of the land today. The rich legacy of court culture is articulated in a series of culturally notable palaces and accompanying collections, which altogether comprise the Treasury of Thuringia. The architectural, art historical, and culturally distinctive castles and gardens as a whole also play an important part in the cityscapes and landscapes of Thuringia, which have long since reflected the close intertwining of political and cultural ambitions.

Founded in 1994, the task of the Thuringian Castles and Gardens Foundation is to care for, revive, appropriately use, and develop this fragile treasure of traditional cultural monuments for future generations. It oversees 31 of the states's most significant historical complexes, including the residences of Friedenstein Palace in Gotha, Heidecksburg Palace in Rudolstadt, Sonderhausen Palace, and the Dornburg Castles. To this can be added the well-known cloisters of the Hirsau architectural school, such as Paulinzella and the monastery church of Saints Peter and Paul in Erfurt. With the park complexes in Greiz and Altenstein, outstanding examples of decorative gardens modeled after the English landscape garden are also represented.

The Foundation is dedicated to the renovation, maintenance, restoration, administration, and scientific supervision of the monuments in their care, but also to making them publicly accessible. These objectives are carried out in close cooperation with communal support and with state institutions, who are committed to similar objectives.

The Foundation is also obligated to the princely dynastic traditions which promoted the art and culture in their areas of sovereignty and assembled art collections, natural history and curio collections. In contrast to similar organizations in Germany, the museums located within the Thuringian castles have for the most part, their own administrative bodies. The local museum institutions are especially familiar with the moving historical furnishings and collections, as well as the individual nature of a given exhibition. In addition, castles, palaces, and cloister complexes often have permanent display rooms at their disposal, which provide information about the history and significance of the site.

Altenstein Palace and Park near Bad Liebenstein

Schloss- und Park-
verwaltung Altenstein
Schloss Altenstein
36448 Bad Liebenstein

Telephone
+49 3 69 61/7 25 13

E-Mail
schloss-altenstein@
t-online.de

Internet
www.thueringer-
schloesser.de

In its present form, the park at Altenstein Palace near Bad Liebenstein is an outstanding decorative garden of the late 18th and 19th centuries. The park owes its existence to Dukes Georg I, Bernhard II, and Georg II from the house of Sachsen-Meiningen, who made this their summer residence in connection with the early spa activity in what was to become Bad Liebenstein. The natural qualities of the area provided the garden artists, including Prince Hermann von Pückler-Muskau, Carl Eduard Petzold, and Peter Joseph Lenné, with ideal terrain to create a landscape park. Additional views over Werra Valley and toward the distant mountain range of the Rhön are incorporated into the garden's design. The park and landscape meld into an entity now rarely seen in Germany. A tour through the garden leads to numerous romantic park buildings, such as the Neo-Gothic Knight's Chapel or the restored Devil's Bridge, which offers a splendid view across a ravine. Evidence of Altenstein's turbulent early history is included, for example, with the legendary site where the missionary Boniface preached at one of the rocky cliffs. Early tourist guides praised the ambitious, large ornamental flowerbed near the castle. The palace, which replaced a Baroque predecessor, was built between 1888 and 1890 according to the English style. In 1891 and 1895, the composer Johannis Brahms enjoyed the hospitality of the Meininger ducal couple. Despite a fire which destroyed sweeping portions of the interior, the former summer residence is a prominent example of Historicist castle architecture in Thuringia.

Altenstein Park, Knight's Chapel, east view

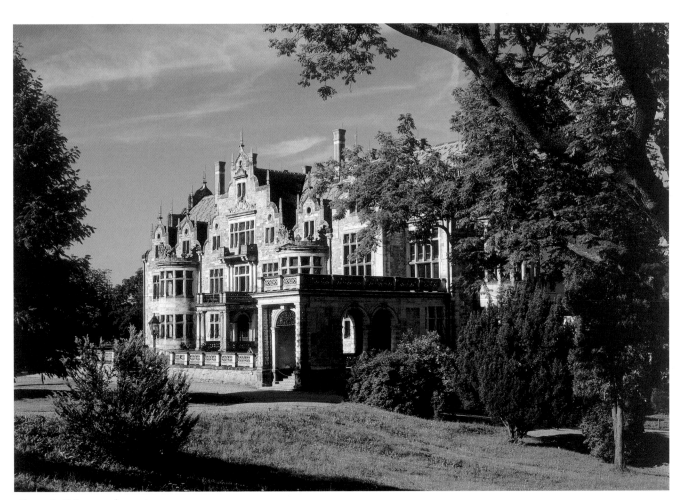

Altenstein Palace, northeast view

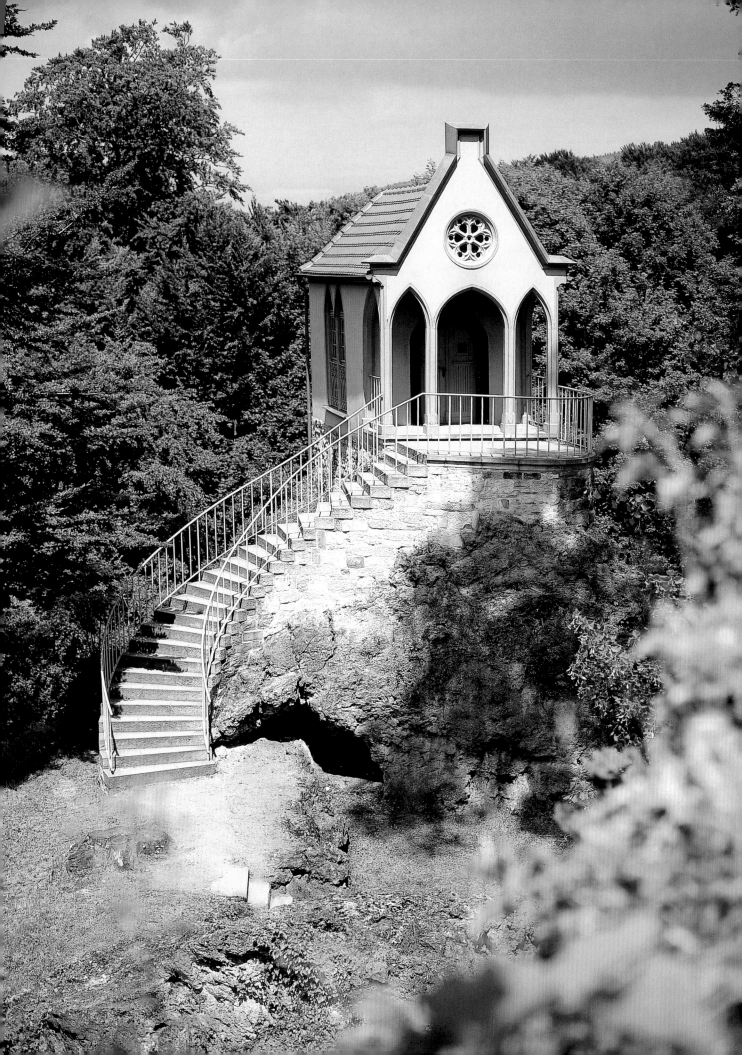

The Dornburg Castles

Schlossverwaltung
Dornburger Schlösser
N.N.
Max-Krehan-Straße 4
07778 Dornburg

Telephone
+49 3 64 27/2 22 91 (cassa)

E-Mail
stiftung@thueringer
schloesser.de

Internet
www.thueringer
schloesser.de

Atop a vine-clad hillside, the three Dornburg Castles tower above the Saale Valley. The inspiring atmosphere of the unique complex had already been admired by Johann Wolfgang von Goethe. To the east, the former complex of the Old Castle, which dates back to an Ottonian imperial palace, was continuously expanded. Under the Sachsen-Ernestine builder Nikolaus Gromann, the castle was given its current appearance in the 16th century. At the western-facing manor, an estate house was built according to Renaissance forms during the 16th century and is now known as the Renaissance or Goethe Castle. In the summer of 1828, the princely scribe retreated here to engage in creative activity, after Grand Duke Carl August had the castle, together with the south extension, remodeled into his residential palace in 1826/27. Between the two buildings arose the Rococo Castle, designed by Gottfried Heinrich Krohne for Duke Ernst August I of Sachsen-Weimar. Of the planned three-winged complex, the corps de logis (principal block) has survived. Its compact architecture with simultaneously differentiated room structures is modeled after the French maison de plaisance (pleasure house). The side pavilions had to be torn down as early as the 18th century. Several gardens transform the plateau in spring and summer into blooming terraces. The Rose Festival takes place here on an annual basis. The Rococo Castle contains an exhibition about architectural and decorative history. The Renaissance Castle recalls the sojourn of Johann Wolfgang von Goethe. The Old Castle serves as a seminar room and meeting point.

Dornburg Castles, southwest view

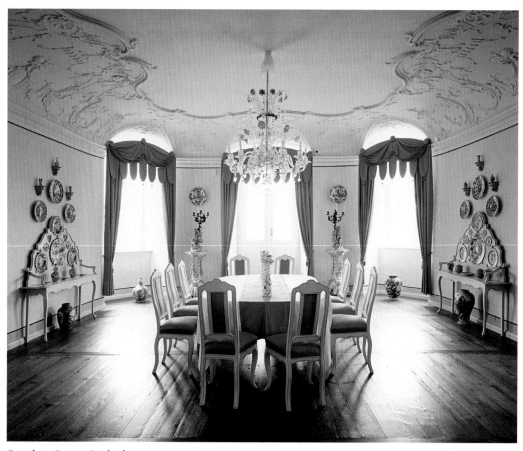

Dornburg Rococo Castle, dining room

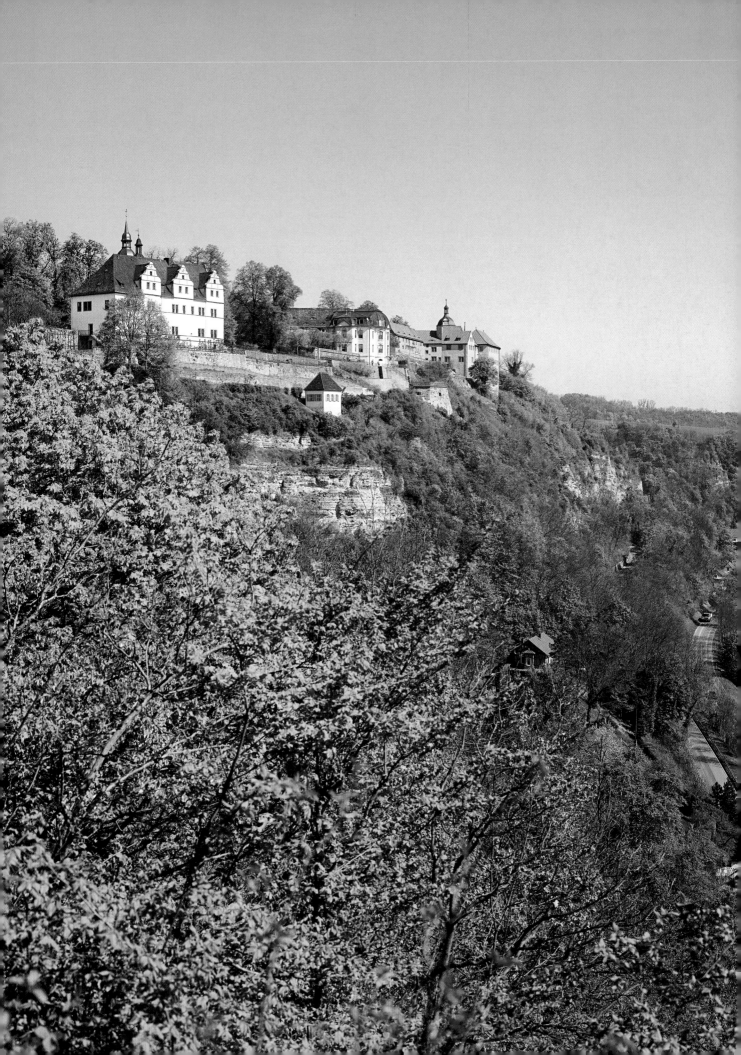

Friedenstein Palace and Park in Gotha

Schlossverwaltung
Schloss Friedenstein mit
Park
Postfach 10 03 19
99853 Gotha

Telephone
+49 36 21/82 34 64

E-Mail
schloss-friedenstein@
gmx.de

Internet
www.thueringer
schloesser.de

During the Thirty Years' War, Duke Ernest I, known as Ernest the Pious, had Friedenstein Palace built as the residence of Sachsen-Gotha's new duchy. Work commenced in 1643 using sketches by Caspar Vogel. It is among the largest German palaces of this era, replacing the previously-destroyed Grimmenstein Castle. Save for its decoration, the complex built upon a single plateau was completed by 1656 and by 1687, the palace was equipped with a modern fortification. Subsequent rulers had the interior decoration completed by major artists and artisans such as Giovanni Caroveri, Gottfried Heinrich Krohne, Giovanni Francesco Marchini, Carl Gotthard Langhans, and Friedrich Wilhelm Doell. In this manner, the Palace Church, the richly stuccoed ballroom, the audience chamber, and duchess apartments reflect various stages of its decoration. In the west tower is the Baroque theater with its preserved stage machine (1681–1687). It is the oldest theater in the world which is still in use today.

The Ekhof Theater was named after the "father of German theater" Konrad Ekhof, who contributed here. Friedenstein Palace features extensive gardens and parks. One of the oldest-preserved gardens is the orangery garden of 1747, which was significantly influenced by Gottfried Heinrich Krohne. Prince Ernest II had John Haverfield the Younger from Kew Gardens design one of the first English gardens of the European continent. Additional gardens can be seen at the outer Wall Garden, the Duchess Garden with the Small Tea Palace, the Rose Garden at the south side of the castle, and the Pine Garden. Since the resignation of Carl Eduard in 1918, Friedenstein Castle has been in public hands and currently houses the Museums of the Freidenstein Castle Foundation, the Thuringian State Archives, as well as research facilities of the University of Erfurt.

Friedenstein Rococo Palace, south view

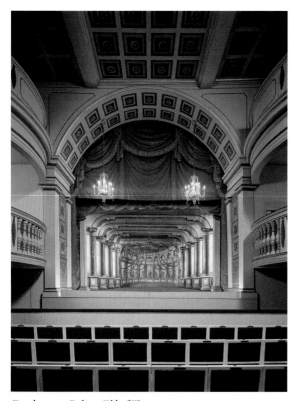

Friedenstein Palace, Ekhof Theater

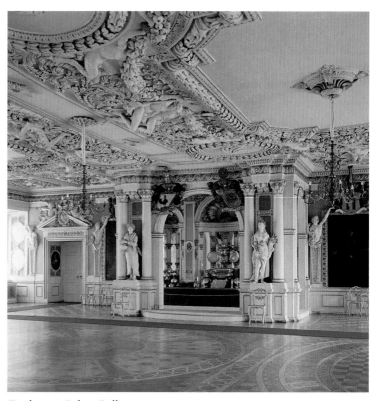

Friedenstein Palace, Ballroom

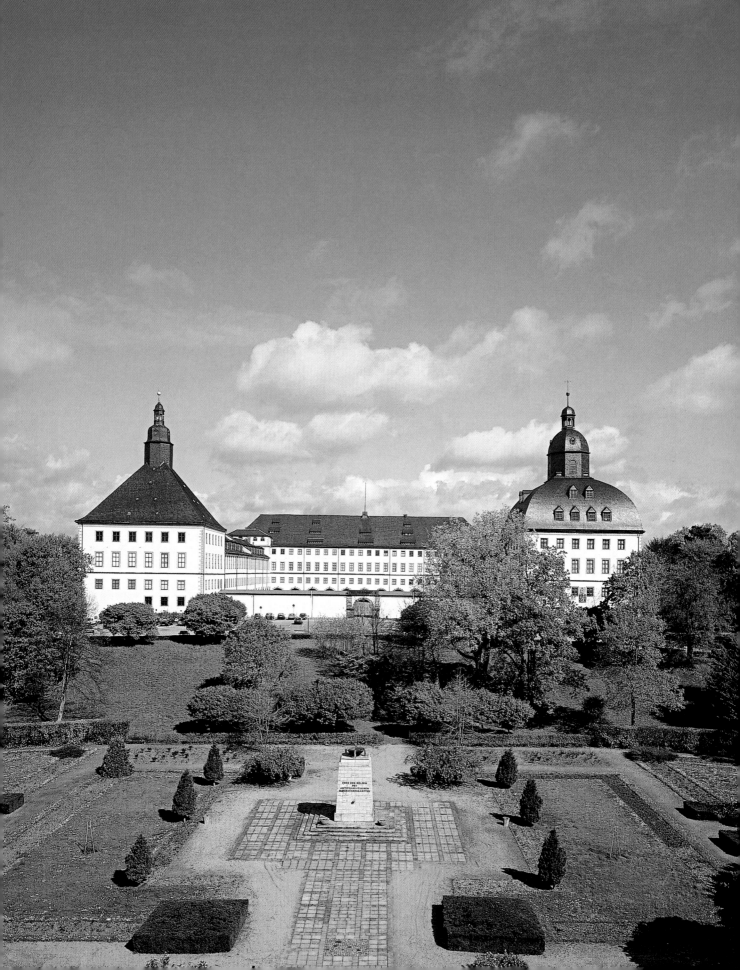

Greiz Summer Palace and Park

Schlossverwaltung
Sommerpalais Greiz
Marstallstraße 6
07973 Greiz

Telephone
+49 36 61/70 58 19

E-Mail
info@sommerpalais-
greiz.de

Internet
www.thueringer
schloesser.de

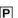 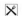

With the summer palace in Greiz, Heinrich XI, ruler of the smallest Thuringian principality of Reuss Elder Line had a pleasure palace (Lustschloss) built in the last third of the 18th century that was intended – as the pediment inscription indicates – as a "Maison de belle retraite." With that, the palace became a place where the sophisticated prince sought to carve out a niche for private activities away from the courtly sphere. Granted, the splendor of a residence was not called for, yet the grandeur of its patron was clearly reflected in the elegance of the architecture, which fully relied upon proportional clarity and streamlined beauty. Based upon the trends in French architecture that were modern at the time, it is possible to envision the extraordinary architectonic quality of the building. In doing do, it points to the education and worldliness of Heinrich XI. The orangery, which was constructed at the same time, forms the heart of the modern-day park. In 1800, work began to remodel the architectonically-designed complex into a decorative landscape garden. Putting important impulses into play in 1830 was Johann Michael Sebastian von Riedel, the imperial-royal Schlosshauptmann from Laxenburg near Vienna, whose plan anticipated countless plantings and the visual incorporation of the surrounding mountains. However, the plans of the former Muskauer garden director, Carl Eduard Petzold, which were applied in a somewhat altered form, gave the park its current appearance. With the integration of the surrounding landscape, its spaciousness, the stage-like progression of plantings via individual trees and groups of trees, as well as the clever guiding walkways, Greiz Park ranks among the greatest accomplishments of 19th-century landscape art. The rooms of the summer palace contain the State Book and Copper Collection, as well as the Satiricum Collection.

Greizer Park, view towards the lake (bulrush pond)

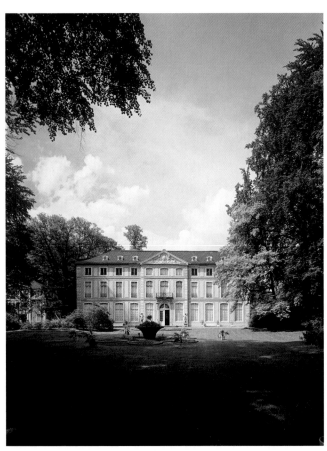

Greiz Summer Palace, south view

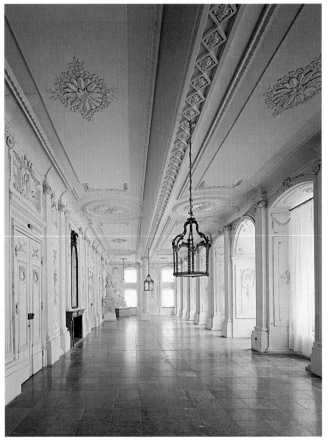

Greiz Summer Palace, Garden Hall

Heldburg Castle

Schlossverwaltung
Veste Heldburg
Burgstraße 215
98663 Bad Colberg-
Heldburg

Telephone
+49 3 68 71/3 03 30

E-Mail
veste-heldburg@
t-online.de

Internet
www.thueringer
schloesser.de

Built upon a steep hilltop, Heldburg Castle is an outstanding example of a castle complex which dominates the surrounding landscape. From a distance, it is also referred to as the Franconian Lantern. In 1317, it was first officially mentioned as the administrative and judicial seat for the Counts of Henneberg. Some centuries later, the castle fell to the Wettin dynasty, who during the 16th century – particularly under the reign of the Ernestine duke, Johann Friedrich von Sachsen – had it converted into a Renaissance palace. At the beginning of this renovation phase, the Jungfernbau (Maiden Wing) was also redesigned. The former palace chapel is located here, along with a fresco by Lucas Cranach which displays numerous images of holy figures, the Fourteen Holy Helpers and the Holy Kinship. After having been used for a variety of purposes and suffering as a result, the fresco was restored in the 20th century. A high point of this expansion is Nikolaus Gromann's French Wing, a masterpiece of German Renaissance palace architecture. Especially outstanding are the so-called men's and women's bays at the court side of the French Wing. The sculptural program of the two bays addresses the ideal qualities of a ruler, such as strength and artistic elements.

In the 19th century, a dilapidated Heldburg fell to the Sachsen-Meiningen ducal house. Georg II arranged for its renovation, although the historic substance of the building was somewhat altered in keeping with the Romantic ideals of the Middle Ages. The duke had the palace rebuilt into a refuge for himself and his third wife, Ellen Franz, Baroness of Heldburg. Also from this period is the so-called baroness chamber, whose Neo-Gothic decoration draws from the Late Gothic forms of the exterior building. Beginning in 2013, visitors will be able to visit the German Castle Museum.

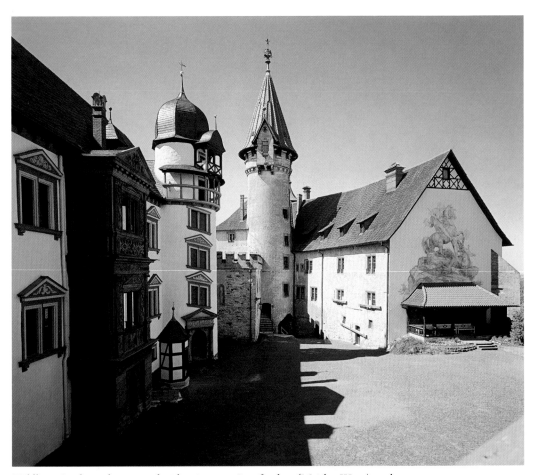

Heldburg Castle, castle courtyard with stair tower, Jungfernbau (Maiden Wing), and tower

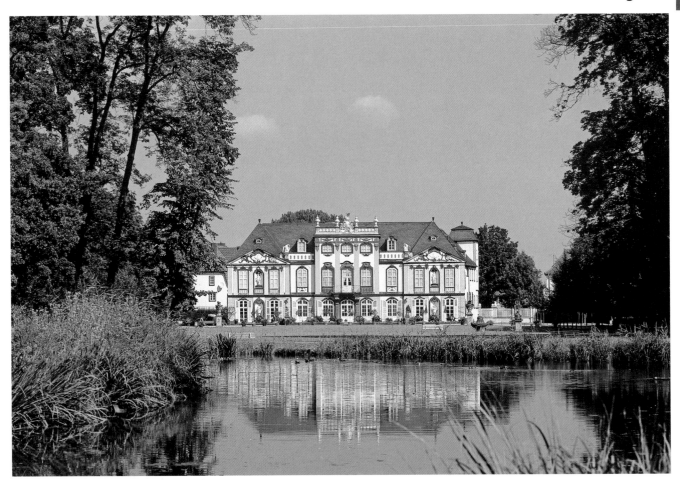

Molsdorf Palace and Park, south view

Molsdorf Palace and Park

Molsdorf has been mentioned as early as 1114. In 1432, the property fell into the hands of the von Witzleben family and in 1530, to the house of Thüna. It was then at the latest that a moated castle was built. Its ownership changed hands at a frequent pace. The first renovation projects began in 1713. Since the third decade of the 18th century, Gustav Adolf von Gotter, a man of common origins who ascended to the status of an imperial count, had the old manor expanded into a sumptuous Baroque palace and garden complex. The close contact which Gotter shared with the most important courts of his day ensured that he was able to acquire the most prestigious artistic personalities to execute his architectural plans. Thus, the planning for the palace was handed over the master architect from Sachsen-Weimar, Gottfried Heinrich Krohne. The decoration of the ballrooms can be traced to the painter Johann Kupetzky and the stuccoer Johann Baptist Pedro-

zzi, artists from Bayreuth's circle of the margravial court. The Prussian court painter Antoine Pesne was also said to have contributed to the interior decoration with a ceiling fresco in the Marble Hall. After Gotter's death, the palace was acquired by Duke Friedrich III of Sachsen-Gotha-Altenburg. Molsdorf became a landed estate and the surrounding moat trench was filled. In the first half of the 19th century, Rudolph Eyserbeck, son of the famous court gardener from Wörlitz, Johann Friedrich Eyserbeck, transformed the then-Baroque garden into a small paradise of the Romantic imagination, an ideal which was apparently anticipated by the naturalness of the garden. The countess of Gneisenau from Berlin, who acquired Molsdorf in 1910, later had notable art nouveau furnishings installed, such as the marble bath. Today, the palace houses an exhibition of erotic art and the estate of the natural painter, Otto Knöpfer.

Schlossverwaltung
Schloss Molsdorf
Schlossplatz 6
99192 Molsdorf

Telephone
+49 3 62 02/2 20 85

E-Mail
schlossverwaltung.
molsdorf@erfurt.de

Internet
www.thueringer
schloesser.de

The Cloister Ruins at Paulinzella

Paulinzella 3
07422 Rottenbach

Schlossverwaltung
Schloss Heidecksburg
Schlossbezirk 1
07407 Rudolstadt

Telephone
+49 36 72/44 72 10
Touristinformation:
+49 3 67 39/3 11 70

E-Mail
schloss-heidecksburg@
thueringerschloesser.de

Internet
www.thueringer
schloesser.de

Named after its founder, the Saxon noble Paulina, the former Benedictine cloister Paulinzella is among the most notable Romanesque building monuments in the mid-German region. Already in Paulina's lifetime, construction had begun on the triple-naved columned basilica. After her death in 1107, construction slowed and was completed in 1160. Because the church – as was standard at the time – was built from east to west, the east altar could be used ahead of time. The dedication of the church took place in 1124. Lastly, the lower church was built with two towers. Stone slabs indicate the original flow of the walls where they no longer exist. The 12th-century, partially-preserved cloister is an important testimony to the Hirsau architectural school, whose strict forms sought to achieve architectural clarity and simplicity. Worth noting is the columned portal between the lower church and the nave, which is most likely one of the first of its kind within the German-speaking region. The impressive row of columns has characteristic cubiform capitals with the cusps typical to the Hirsau monastery. Also representative of Hirsau architecture is the horizontal checkerboard frieze with its vertical extensions at the upper wall of the central nave. Up until the middle of the 14th century, the complex was used as a dual cloister, and thereafter as a monastery alone. With the advent of the Reformation, the cloister was renovated in 1534 and was acquired by the countess of Schwarzburg, who used the estates as a residence and hunting grounds. For this reason, the old abbot's quarter was expanded into a hunting lodge from 1620 to 1623. In the 19th century, Paulinzella rapidly became an object in need of preservation. Its ruined condition offers the sentimentally-inclined romantic a place for reflection and to contemplate the transience of worldly things.

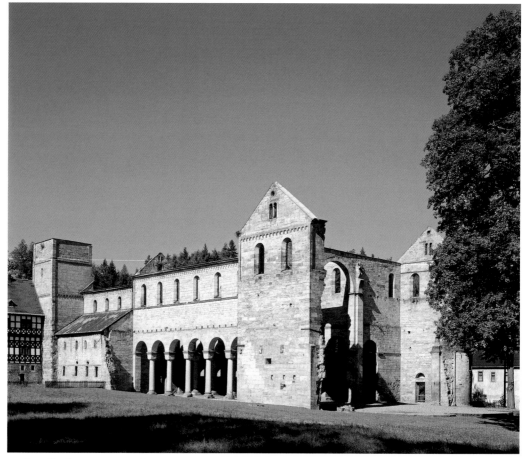

Paulinzella cloister ruins, south view

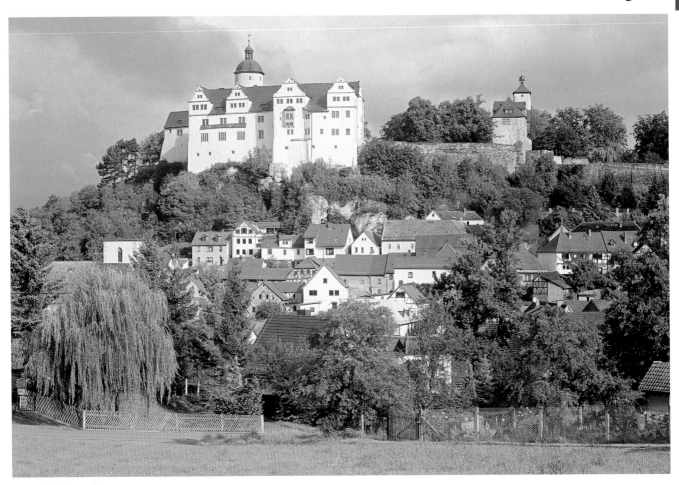

Ranis Castle, south view

Ranis Castle

Crowning the cityscape of Ranis is the imposing architectonic vision of Ranis Castle. The long-reaching and looming former castle was first mentioned in 1199 as the seat of the imperial ministerialis. The complex was an imperial estate and occupied an important position in the Saale-Orle district as the border fortress against the Slavs. Despite a major fire in 1646, significant remnants from the 12th century are nonetheless visible. In 1220, the earls of Schwarzburg were enfeoffed by Emperor Friedrich II with Ranis. They initiated the essential expansion of the complex in the first half of the 13th century. Extensive sections of the main castle with chapel and ancillary rooms, as well as the bailey, originate from this period. After numerous changes in ownership, the castle was transferred to the rulers of Breitenbach. From that point on, they gave the castle a Renaissance palatial character with the construction of the south wing. The well-proportioned pediment which faces the city reveals the influence of Nikolaus Gromann, the most famous Thuringian Renaissance architect, who also participated in the building of the Weimar residence and Heldburg Castle. Building components from nearly all of its historical periods have been preserved. Even today, the complex continues to be characterized by its strong fortress-like character. At the same time, the expansions of the 17th century refer to the comfort of the former palace. In this way, Ranis Castle serves to mirror the grand architecture in Thuringia. The complex currently houses an exhibition which covers the history of castles, regional history, and seismology, while the south wing is also used for literary events.

Schlossverwaltung
Burg Ranis
Burg Ranis
07389 Ranis

Telephone
+49 36 47/41 39 71

E-Mail
burg-ranis@t-online.de

Internet
www.thueringer
schloesser.de

Heidecksburg Palace in Rudolstadt

Schlossverwaltung
Schloss Heidecksburg
Schlossbezirk 1
07407 Rudolstadt

Telephone
+49 36 72/44 72 10

E-Mail
schloss-heidecksburg@
thueringerschloesser.de

Internet
www.thueringer
schloesser.de

Like a crown, Heidecksburg Palace rises high above Saal Valley and the city of Rudolstadt. In 1334, it was acquired by the Schwarzburgers, who had the upper castle rebuilt after both castles were destroyed in 1345. From it, the palace appears in its current form. Under Earl Albrecht VII of Schwarzburg-Rudolstadt, Heidecksburg eventually became a residence. After a fire in 1573, work began on a large-scale reconstruction, upon which the existing wing sequence with a southeast-facing courtyard is still based. As a conclusion to these building measures, stables with noteworthy facade paintings of a riding tournament were built at the so-called middle terrace. The new construction and expansion at Rudolstadt Palace, which took place in 1735 after fire-related damages, was financed by the increasing demands of the house of Schwarzburg-Rudolstadt, who eventually achieved princely status. Following conventional room arrangements of the Late Baroque era, a magnificent ballroom was built in the center of the west wing, upon which every side features a representative sequence of rooms. Prince Friedrich Anton then had entrusted the Saxon master architect Johann Christoph Knöffel with the planning process, but replaced him with the Saxon-Weimar architect Gottfried Heinrich Krohne in 1743. From the latter, designs were created for the stucco work in the banquet rooms, which were masterfully executed by Johann Baptist Pedrozzi. The castle's current room decorations rank among the most distinguished German Rococo architectural interiors. At present, the castle houses the Thuringian State Museum of Heidecksburg, the Thuringian State Archives of Rudolstadt, and is the seat of the Thuringian Castles and Gardens Foundation.

Heidecksburg Palace, Ballroom

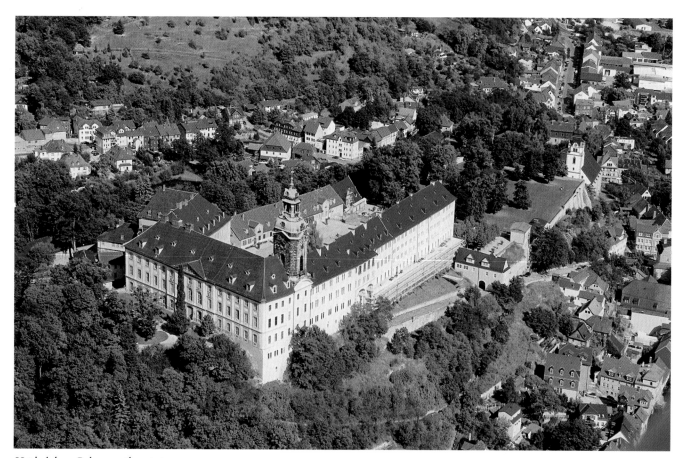

Heidecksburg Palace, southwest view

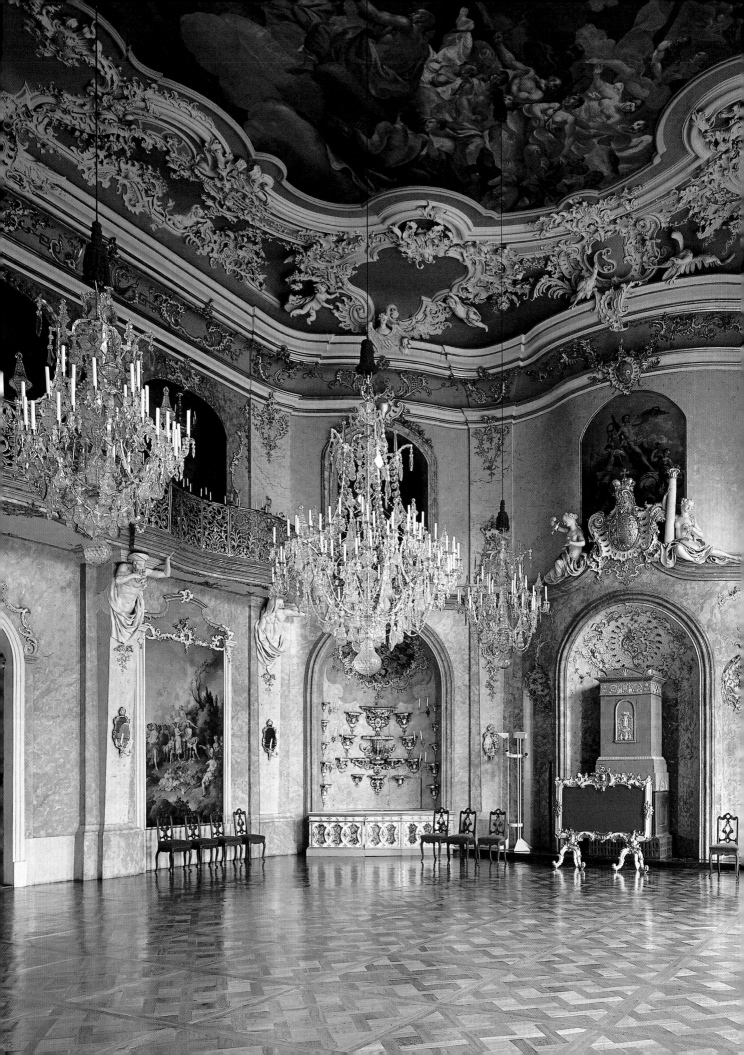

Bertholdsburg Palace in Schleusingen

Schlossverwaltung
Schloss Bertholdsburg
Burgstraße 6
98553 Schleusingen

Telephone
+49 3 68 41/53 12 14

E-Mail
bertholdsburg@web.de

Internet
www.thueringer
schloesser.de

As early as the 13ᵗʰ century, Bertholdsburg was expanded into a residence of the notable house of Henneberg. The Hennebergs were among the oldest Franconian families and received the title of burgrave from the city of Würzburg. Due to the shift of residence from Henneberg to Schleusingen, Count Berthold V began building in order to adapt the castle complex to its new functional demands. The current form of Bertholdsburg Palace, however, was shaped by the building initiatives from the late 15ᵗʰ and early 16ᵗʰ centuries, as the characteristic pediments and richly-articulated, two-storied Renaissance loggia in the inner courtyard were built. The existing, mostly three-storied building was supplemented with timber-framed upper floors and the height of the new palace tower was increased. Later, a new entrance to the upper city was built in the east part of the palace, which serves as the current main entrance. In front of the west wing, a palace garden was laid down in 1563/65 and the terrace was planted with espalier fruit. It is likely that the two-storied, eight-sided fountain house in the northeast corner of the garden also took shape at that time and is the only remaining structure from the Renaissance garden. The most significant preserved interiors of the palace are located in the first upper floor of the north wing – a hall with floral stuccoed ceilings and a vaulted room with grisaille paintings using a secco techniques from about 1600. Shown in oversized format are the twelve deeds of Hercules. It is one of the largest secular Renaissance pictorial cycles in Middle Germany. Today, Bertholdsburg Palace houses the Natural History Museum, as well as an exhibition about the castle and the city's history.

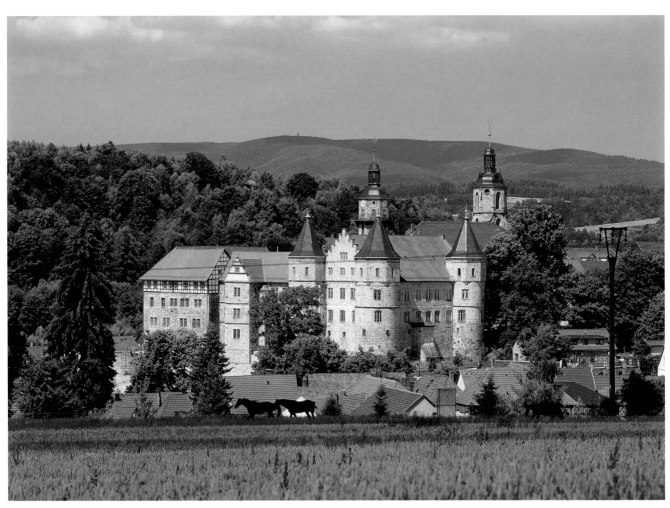

Bertholdsburg Palace, southwest view

Wilhelmsburg Palace in Schmalkalden

Rising above the city of Schmalkalden at the south edge of the Thuringian Forest is Wilhelmsburg, the Renaissance palace of the Hessian landgrave Wilhelm IV and his son Moritz. Most likely with the help of court artist Wilhelm Vernukken (a Dutch artist from the court of Kassel), architects Hans and Christoph Müller began work on the standard four-winged complex im 1585. With its wall paintings and stucco work of the highest quality, the Wilhelmsburg features Renaissance and Mannerist interior art with a richness and thoroughness that is scarcely paralleled elsewhere in Germany. Especially remarkable is the palace chapel, which is among the major accomplishments of German Renaissance architecture. The architectonic structure – a hall with a three-storied arcade – is attached to the palace chapel in Torgau. As Protestant church architecture was still in its early stages, the vertical alignment of the altar, pulpit, and organ along the main axis of the interior turned out to be a point of orientation. The historic organ is the oldest within Thuringia and is thought to be one of the most outstanding instruments of Renaissance organ construction. Also distinctive is the so-called great hall, with its recently-restored coffered ceiling and featuring ninety canvas paintings attributed to Jost von Hoff. This room ranks among the most representative and largest ballrooms of this era within Germany. Next to the entrance portals of the room are frescoes with oversized portraits of the so-called Trabanten, the bodyguards of the duke. The palace museum contains exhibits about the palace's history, the era of the Refomation, and the Schmalkaldic War.

Schlossverwaltung
Schloss Wilhelmsburg
Schlossberg 9
98574 Schmalkalden

Telephone
+49 36 83/40 19 76

E-Mail
schloss-wilhelmsburg@
t-online.de

Internet
www.thueringer
schloesser.de

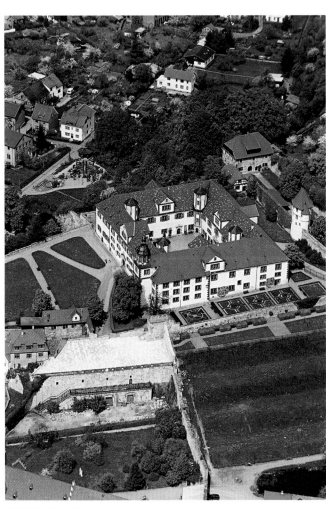

Wilhelmsburg Palace, west view

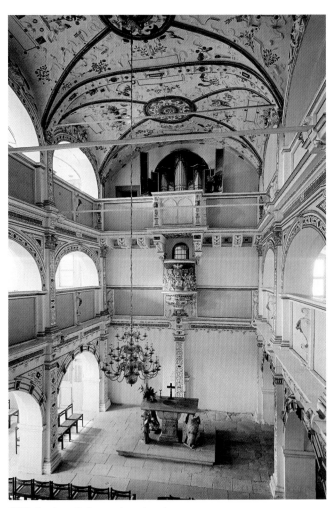

Wilhelmsburg Palace, palace chapel

The Palace and Park at Sondershausen

Schlossverwaltung
Schloss Sondershausen
Schloss Sondershausen
99706 Sondershausen

Telephone
+49 36 32/62 24 02

E-Mail
schloss@
sondershausen.de

Internet
www.thueringer
schloesser.de

Sonderhausen Palace of northern Thuringia is the most outstanding architectural legacy of the counts and later imperial princes from Schwarzburg-Sonderhausen. In their possession from 1356 to 1918, the complex records several centuries of dynastic and domestic cultural history. Of particular interest is the decoration of the state apartments from the Renaissance and Baroque periods. The quality of figural and ornamental painting discovered from the 16th century suggests an association with the Cranach workshop. By contrast, the vaulting at the stair turret of 1616 is a prominent and rare testimony to Late Mannerist stucco work in Germany. The program, whose motifs lean upon templates by Virgil Solis, Hendrik Goltzius, and Jakob Matham, illustrate the humanist cultural standards of its patrons. The Baroque stucco decorations from the workshop of Nicola Carcani are featured in a total of twenty rooms. The sixteen oversized figures of gods in the so-called Grand Hall convey an especially lively impression of the monumental stylistic convictions of the Baroque era. Also noteworthy is the octagonal house west of the stables. The building, with its splendid stucco work and painted ceilings was built for a carousel in 1709/1710. The palace's ideal scenic location was practically created for a landscape garden. After the first alterations by the garden inspector Tobias Ekart, Carl Eduard Petzold, a student of Pückler, was successfully hired to design it, integrating views of the surrounding environs such as the Frauenberg. The Prussian king Friedrich Wilhelm IV once noted: "Your princely Highness lives in such a beautiful landscape that constantly calls to mind the master paintbrush of Claude Lorraine!"

Sonderhausen Palace, octogonal room

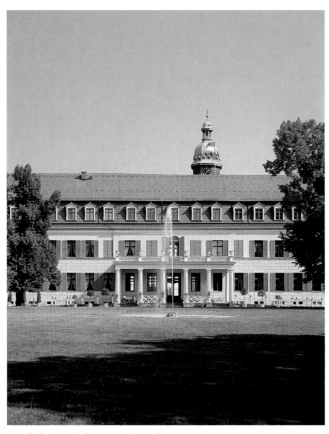

Sonderhausen Palace, view from the west

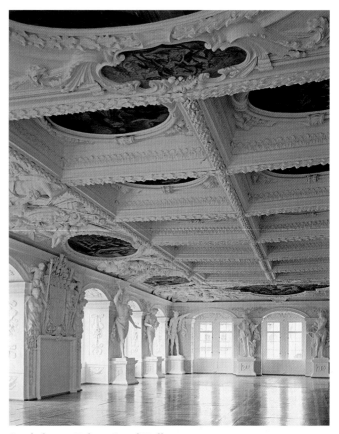

Sonderhausen Palace, Grand Hall

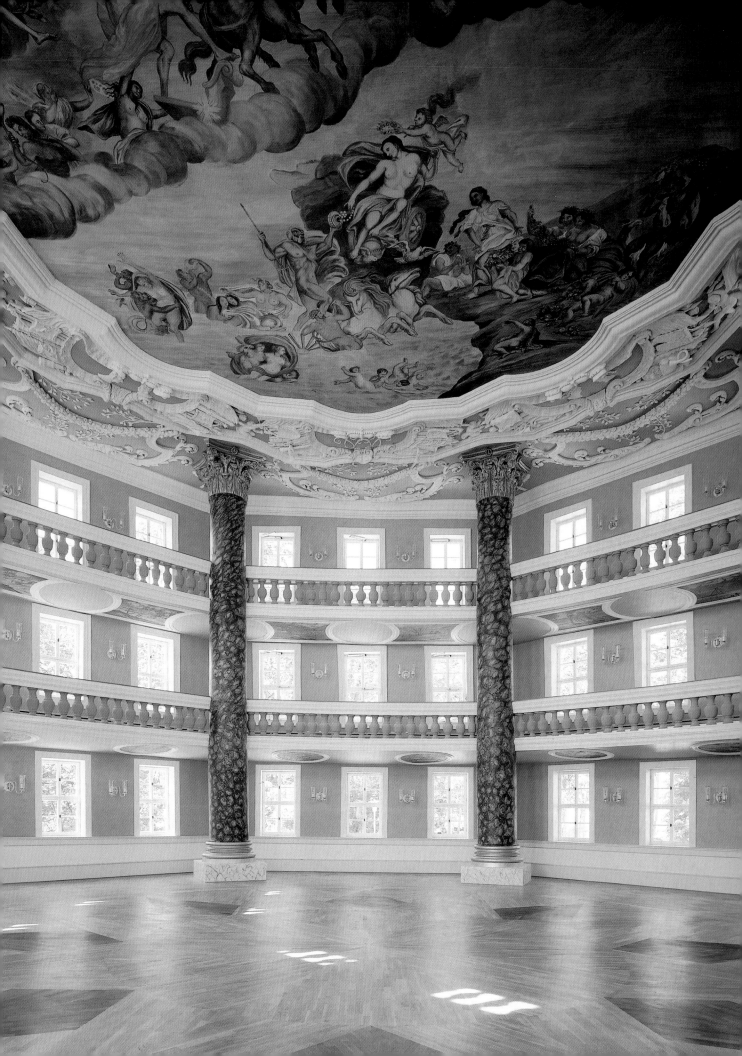

Schwarzburg Palace

Schlossverwaltung
Schloss Heidecksburg
Schlossbezirk 1
07407 Rudolstadt

Telephone
+49 36 72/44 72 10

E-Mail
schloss-heidecksburg@
thueringerschloesser.de

Internet
www.thueringer
schloesser.de

Förderverein Schloss
Schwarzburg e.V.
Schlossstraße 5
07427 Schwarzburg

Telephone
+49 3 67 30/3 29 54

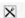 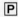 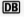

Surrounded by the river Schwarza, Schwarzburg Palace stands atop a picturesque ridge of the northeastern Thuringian Forest. The preceding building was the former ancestral castle of the Schwarzburg counts and later imperial princes, who in 1349 even briefly included a Roman Catholic king with Günther XXI. Schwarzburg Palace and its earlier building occupy a unique position in the regional history of Thuringian castles and palaces. Beginning in the 16th century, the castle was gradually transformed into the summer residence of the counts of Schwarzburg-Rudolstadt. A catastrophic fire, which destroyed additional sections of the complex, provided an opportunity for Prince Friedrich Anton to rebuild the palace in 1726. However, the Late Baroque building fell into ruin when it was converted into a guesthouse of the Third Reich (Reichsgästeheim), which began in 1940 and was then discontinued by the National Socialists. The multi-storied, unique building of the Imperial Hall still bears witness to its former Baroque splendor. Located north of the garden terrace, it connects the functions of an orangery and a dynastic temple of glory, or Ruhmestempel. The paintings and medallions from approximately 1720, featuring emperors and kings from the Roman and Holy Roman Empires, from Julius Caesar to Karl VI in the Imperial Hall – among them, Günther XXI from Schwarzburg-Arnestadt – displays a comprehensive and room-oriented program and with it, the dynastic expectations of the Schwarzburgs after their elevation to the status of imperial princes in 1710. Also part of the palace ensemble is the arsenal, which was first mentioned in 1550/1560 and despite renovations, is still the oldest building of the entire complex. It once safeguarded the important Prunkwaffen collection, which is now in the Heidecksburg Palace Museum in Rudolstadt. Following the restoration of the arsenal, the collection shall be presented in its traditional setting.

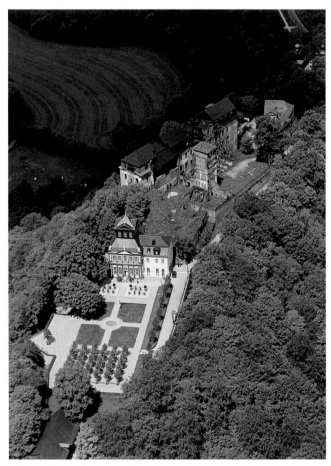

Schwarzburg Palace, aerial view

Schwarzburg Palace, Imperial Hall

Weißensee Castle/ Runneburg in Weißensee

Weißensee Castle or Runneburg is among the most eminent architectural monuments of Germany's Hohenstaufen era. The Romanesque castle complex, which was constructed by the Thuringian landgraves of Ludowinger during the second half of the 12th century, was handed over with its great hall and keep intact. Countless remains of the Romanesque columns are to be found here, including a branch-shaped one with a wonderfully modeled capital. The design is a markedly rare medieval sculptural motif and is one of the most high-quality works of its kind. The castle was occupied by troops belonging to King Philip of Swabia (1204) and Emperor Otto IV of Braunschweig (1220). Although the castle was not destroyed, it was modernized and refitted to conform to new standards in the subsequent period. At the east side is a cell door from the early 13th century. Its exterior, which faces the city, features an imposing blended structure with lateral plaster strips and an overlaying arched and roulette frieze. A palatial remodeling ensued from 1554 to 1581, which had an a particular effect upon the great hall and the keep. The east section of the great hall was provided with an additional floor and pediment, ceilings with pressed stucco were added to the main floor, and the tower was endowed with its distinctive dome. In 1609, it was possible to complete the gatehouse, which still survives today. In 1726, the carriage house was placed between the gatehouse and the keep. Despite these alterations, the preserved buildings of the Runneberg allow for an undistorted view of medieval secular architecture, which in terms of its architectonic forms and sculptural décor of the imperial buildings, remain unparalleled.

Schlossverwaltung
Burg Weißensee/
Runneburg
Runneburg 4
99631 Weißensee

Telephone
+49 3 63 74/3 62 00

E-Mail
sv.runneburg@
freenet.de

Internet
www.thueringer
schloesser.de

 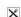

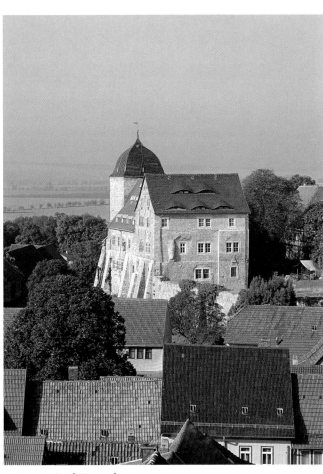

Weisensee Castle/Runneburg, east view

Weisensee Castle/Runneberg, arched window in the great hall

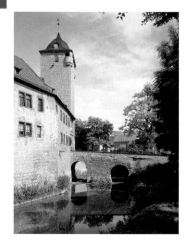

Wasserburg
Kapellendorf
Palace Administration
Wasserburg
Kapellendorf
Am Burgplatz 1
99519 Kapellendorf

+49 3 64 25/2 24 85

wasserburg-
kapellendorf@
t-online.de

www.thueringer
schloesser.de

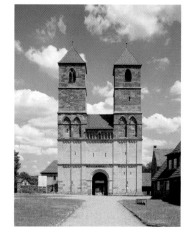

Veßra Cloister
Veßra Cloister Palace
Administration
98660 Kloster Veßra

+49 3 68 73/6 90 34

info@museumkloster
vessra.de

www.thueringer
schloesser.de

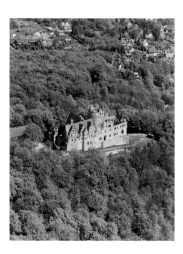

Oberschloss Kranichfeld
Oberschloss Kranichfeld
Schlossverwaltung
Schlossberg 28
99448 Kranichfeld

+49 3 64 50/3 04 60

oberschloss-kranich
feld@freenet.de

www.thueringer
schloesser.de

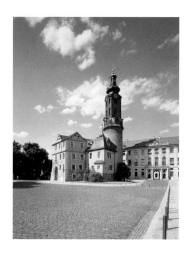

Weimar Residential
Palace, Bastille Ensemble
Burgplatz 4
99423 Weimar

Temporary Foundation
Administration
Schloss Heidecksburg
Schlossbezirk 1
07407 Rudolstadt

+49 36 72/44 71 31

stiftung@
thueringerschloesser.de

www.thueringer
schloesser.de

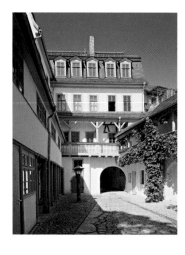

Kirms-Krackow-Haus
in Weimar
Jakobstraße 10
99423 Weimar

Objektverwaltung
Weimar
Friedensstraße 10
99423 Weimar

+49 36 43/85 03 84

haus-hoehnl@
t-online.de

www.thueringer
schloesser.de

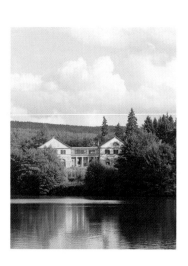

Wilhelmsthal Palace and
Park near Eisenach
Wilhelmsthal 20
99819 Wilhelmsthal

Temporary Foundation
Administration
Schloss Heidecksburg
Schlossbezirk 1
07407 Rudolstadt

+49 36 72/44 71 31

stiftung@thueringer
schloesser.de

www.thueringer
schloesser.de

Image credits

Baden-Württemberg:
Dirk Altenkirch: p. 19
Landesmedienzentrum: p. 16 left and right, 18, 20, 21, 24, 25, 26 left and right, 33, 34, 36, 37, 38, 40, 42, 43, 48 bottom left and right, 49 top left, 49 middle, 49 bottom right, 50 middle right, 50 bottom left and right
Luftbild Elsässer GmbH: p. 15, 27
Staatliche Schlösser und Gärten Baden-Württemberg: p. 22, 23, 50 top
Staatliche Schlösser und Gärten Baden-Württemberg, Achim Mende: p. 11, 13, 17, 28, 30, 31, 32, 35, 41, 44, 45, 49 top right, 49 bottom left, 50 middle left
Staatsanzeiger Verlag: p. 39
Tourist Information Alpirsbach: p. 29

Bavaria:
ambild Finsing: p. 69, 84
Bavaria Luftbild: p. 68, 89 middle left
Josef Beck, Eschenlohe: p. 81
Bildagentur Huber/R. Schmid: p. 88 left and right
Bildarchiv Monheim, Meerbusch: p. 77
Feuerpfeil Verlags GmbH Bayreuth: p. 62
Klaus Frahm, Börnsen: p. 59
Helicolor: p. 76
W. Klammet, Ohlstadt: p. 61, 57
E. Lantz, Bayer. Landesamt für Denkmalpflege: p. 58
Wolf-Christian von der Mülbe: p. 72 right
Nürnberg Luftbild, Hajo Dietz: p. 90 bottom left
Konrad Rainer, Salzburg: p. 86
Schöning Verlag, Lübeck: p. 88 top left
Zenkel: p. 89 bottom right
Bayerische Schlösserverwaltung/Anton Brandl: p. 66, p. 87, Rainer Herzog: p. 86 middle left, Philipp Mansmann: p. 74 left
Bayerische Schlösserverwaltung/Rainer Herrmann, Tanja Mayr, Ulrich Pfeuffer, Maria Scherf, Lucinde Weiss and others: all other photos

Berlin-Brandenburg:
All pictures: SPSG, photos: Hans Bach, Leo Seidel, Wolfgang Pfauder, Roland Handrick, Gerhard Murza, Daniel Lindner
Maps p. 92 top: © GeoBasis-DE/LGB 2007, Nummer GB – D 04/10, based on: DTK400

Hesse:
MHK, photo: Gabriele Bößert, Kassel: p. 143
MHK, photo: Ute Brunzel, Baunatal: p. 141
MHK, photo: Roman von Götz, Dortmund: p. 139
MHK, photo: Arno Hensmanns, Kassel: p. 136, 138, 140
MHK, photo: Norbert Miguletz, Frankfurt/M.: p. 137
MHK, photo: Frank Mihm, Kassel: p. 123
MHK, photo: Wiedemann Fotografie, Kassel: p. 142
Saalburg, Foto: Saalburg, Bad Homburg: p. 154 unten links
VSG, photo: Michael Bender, Darmstadt: p. 132, 133
VSG, photo: Anja Dötsch, Bad Homburg: p. 147, 149, 154 middle left, 154 top right
VSG, photo: Matthias Ernst, Alsbach-Hähnlein: p. 154 top right
VSG, photo: Inken Formann, Bad Homburg: p. 131
VSG, photo: Werner Jagott, Oberursel: p. 150
VSG, photo: Gerd Kittel, Bad Homburg: p. 152, 153
VSG, photo: Margit Matthews, Frankfurt/M.: p. 126
VSG, photo: Roman von Götz, Dortmund: p. 125, 127, 128, 129, 130, 144, 145, 146, 148, 151, 154 middle right
VSG, Foto: VSG, Bad Homburg: p. 134, 135, 154 top left

Mecklenburg-Western Pomerania:
Thomas Grundner: p. 155, 160–161, 169
Carsten Neumann: p. 157, 159, 164, 168, 173
Wolfhard Molter: p. 158
A. Bötefür, Landesamt für Kultur und Denkmalpflege: p. 162–163, 165, 172
Ulrich Kache: p. 166
Thomas Helms: p. 167
Dirk Laubner: p. 170
Friederike Drinkuth: p. 171
Rainer Cordes: p. 174

Rhineland-Palatinate:
Landesamt für Denkmalpflege, Heinz Straeter: p. 177, 178, 184 right, 185 right, 186, 188 left, 188 right, 189 left, 193, 194 left, 194 right, 195 left, 196 second left
Landesamt für Denkmalpflege, Sigmar Fitting: p. 179, 182
BSA-Bilddokumentation: p. 180

Michael Jordan: p. 181, 191
Landesmedienzentrum -Rheinland-Pfalz: p. 183, 184 left, 185 left, 187 (together with logo page), 189 right, 195 right, 196 first left, 196 third left, 196 forth left, 196 first right, 196 second right, 196 third right, 196 forth right
Armin Kraft: p. 192
Wolfgang Grube: p. 190

Saxony:
All pictures: Staatliche Schlösser, Burgen und Gärten Sachsen.

Saxony-Anhalt:
Norbert Perner: logo page, p. 234–248, 251–252
Stiftung Dome und Schlösser: p. 233, 239, 250 (both T. Tempel)
Stiftung Kloster Michaelstein (photo archive): p. 249

Dessau-Wörlitz:
Kulturstiftung DessauWörlitz, Marie-Luise Werwick: p. 261
Hans-Dieter Kluge, Espenhain: p. 263 bottom
Lutz Winkler, Leipzig: p. 265
Kulturstiftung DessauWörlitz, Heinz Fräßdorf: all other photos

Thuringia:
Stiftung Thüringer Schlösser und Gärten, Constantin Beyer: p. 269, 271, 274, 275, 276, 277, 278, 280, 281, 282, 283, 285, 287, 288, 289, 290 right, 291, 292 top left, 292 top right, 292 middle right, 292 bottom left, 292 top right
Stiftung Thüringer Schlösser und Gärten, Ralf Kruse & Thomas Seidel GbR: p. 287, 290 left, 292 middle left
Stiftung Thüringer Schlösser und Gärten, Dirk Laubner: p. 284
Stiftung Thüringer Schlösser und Gärten, Helmut Wiegel: p. 272, 273, 279, 286

All maps: Fa-Ro Marketing, München
Editing: Florian Knörl,
Erhardi Druck GmbH, Regensburg

Index and list of addresses

Sites

List of addresses

**Staatliche Schlösser und Gärten
Baden-Württemberg** · Schlossraum 22a
76646 Bruchsal
Tel.: +49 (0)7251/74-2724
E-Mail: info@vb-bw.fv.bwl.de
http://www.schloesser-und-gaerten.de

**Bayerische Verwaltung der staatlichen Schlösser,
Gärten und Seen**
Schloss Nymphenburg, Eingang 16
80638 München
Tel. +49 (0)89/17908-0
E-Mail: info@bsv.bayern.de
www.schloesser.bayern.de

**Stiftung Preußische Schlösser und Gärten
Berlin-Brandenburg** · Postfach 601462
14414 Potsdam
Tel. +49 (0)331/9694-0
E-Mail: info@spsg.de
www.spsg.de

**Verwaltung der Schlösser und Gärten
in Hessen** · Schloss · 61348 Bad Homburg
Tel.: +49 (0)6172/9262-0
E-Mail: info@schloesser.hessen.de
http://www.schloesser-hessen.de

Museumslandschaft Hessen Kassel
Schloss Wilhelmshöhe
Schlosspark 1 · 34131 Kassel
Tel.: +49 (0)561/31680-0
E-Mail: info@museum-kassel.de
http://www.museum-kassel.de

**Staatliche Schlösser und Gärten
Mecklenburg-Vorpommern**
Werderstr. 4 · 19055 Schwerin
Tel.: +49 (0)385/509-0
E-Mail: info@mv-schloesser.de
www.mv-schloesser.de

**Rheinland Pfalz, Generaldirektion Kulturelles
Erbe** · Direktion Burgen, Schlösser, Altertümer
Festung Ehrenbreitstein · 56077 Koblenz
Tel: +49 (0)261/6675-0
E-Mail: info@burgen-rlp.de
http://www.burgen-rlp.de

Schlösserland Sachsen · Staatliche Schlösser,
Burgen und Gärten Sachsen
Stauffenbergallee 2a · 01099 Dresden
Tel.: +49 (0)351/56391-1311
E-Mail: service@schloesserland-sachsen.de
http://www.schloesserland-sachsen.de

**Stiftung Dome und Schlösser in
Sachsen-Anhalt** · Am Schloss 4 · 39279 Leitzkau
Tel.: +49 (0)39241/934-0
E-Mail: leitzkau@dome-schloesser.de
http://www.dome-schloesser.de

Kulturstiftung DessauWörlitz
Schloss Großkühnau
06846 Dessau
Tel. +49 (0)340/64615-0
Tel. +49 (0)340/64615-10
E-Mail: info@gartenreich.com
http://www.gartenreich.com

Stiftung Thüringer Schlösser und Gärten
Schlossbezirk 1 · Schloss Heidecksburg
Postfach 100 142 · 07391 Rudolstadt
Tel.: +49 (0)3672/447-0 (Direktion)
Tel.: +49 (0)3672/447-120 (Öffentlichkeitsarbeit)
E-Mail: stiftung@thueringerschloesser.de
http://www.thueringerschloesser.de